The Shopkeepers

Storefront Businesses and the Future of Retail

gestalten

The Shopkeepers

Storefront Businesses
and the Future of Retail

Preface

Objects of Desire:

Resurrecting Mercantilism in the Twenty-First Century

How a shop presents the goods for sale can instantly attract or instantly repel. Some display their goods analytically, organizing by brand, product typology, or price. Others take a more personal and instinctual approach, arranging their inventory by feeling and a desire to tell a story through the curation of a certain mood or atmosphere. The role of visual merchandising represents a powerful strategy for marketing and provokes a feeling of connection between customer and product. What visitors see first, how they move through

Shopping isn't what it used to be. At this point, everything can be bought online for the lowest price and maximum convenience … everything except a unique experience. Amazon, eBay, Etsy, and all the other online powerhouses market an unarguable ease of transaction. If you don't want to leave your house to get what you want, you don't have to, and that's a compelling selling point. However, this form of digital commerce lacks the human

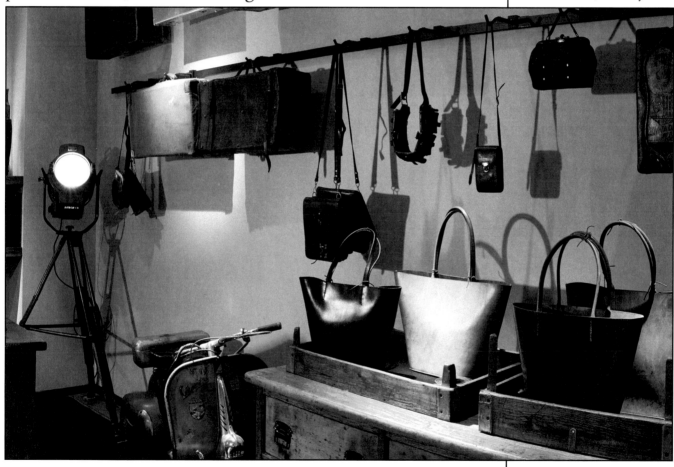

Meisterschuh, p. 60

factor and customer service that keeps people returning to physical storefronts. The trouble is, most of our real world shopping takes place in anonymous malls and shopping centers. Both the virtual

the space, the way the store windows and cashier desk are staged, and so on each serve as fertile testing grounds for transmitting your passion for the merchandise to the customer.

continued from page 5

If you build it, they will come … or so the saying goes. This statement, at least for a shopkeeper, is really only partially true. Location matters. Picking the right neighborhood, the most desirable street corner, the quaint nook down a little lane, or the most visible storefront can be the defining factor in whether or not your business will become an institution that stays open for generations or simply falls into the here today and gone tomorrow category.

Time and again, a store's physical address proves as important (if not more so) as what it sells. Sure, people do love the niche pilgrimages and the off-the-beaten-path gems, but to survive for the long haul, you must go to where the people are rather than depending on them coming to you. At the same time, you must choose your location according to the demographic you intend to attract. By establishing a visible presence in a place your ideal customers frequent, the odds of being more than just a one-hit-wonder increase considerably. But how do you account for continuity over time? People change, places change. While your shop may stay the same, the context that surrounds it can look dramatically different just a few years later.

Accepting and anticipating the fact that urban environments inevitably change

puts you ahead of the game when choosing your location. This awareness acts as a reminder to not just consider where your neighborhood is but who your neighbors are. Ideally you will put down roots next to key landmarks and complementary businesses, strategically avoiding the stark competition unless you have a soft spot for challenge. Accessible parking and plentiful foot traffic will naturally encourage potential customers to add you to their shopping circuit.

The most successful shops avoid all generic location solutions, especially the mall. These visionary shopkeepers typically opt into one of three roles: the edgy outsider in the slightly seedy but up-and-coming neighborhood (The Cactus Store), the understated mainstay discreetly tucked into a romantic part of town (MIWA), or the timeless icon optimally located in a beloved district where people habitually congregate (Scheer). In the end, the choice for where to settle proves extremely personal and tied to the vision of each shopkeeper. If you identify yourself more as a risk-taking pioneer and hope to attract a cultish but niche following, then cheaper rent might prove more valuable than prime exposure. Once you decide what you and your store are all about, the location often ends up revealing itself.

and physical retail landscape has been lacking the personal touch that an individual shopkeeper can bring. Here, customers forge lasting relationships with the vendors. Establishing a sense of trust and belonging, the clientele learns about products to make more informed choices as consumers while engaging with their fellow shoppers. This level of personalized interaction helps sell not just the products but also a sense of place.

So how do I get out of the corporate world? What if I took over my parent's trade? Wouldn't it be great if I ran a shop filled with things I like, things I can make and offer better than anyone else? And wouldn't doing so make me a much happier person? Each of the business owners featured in *The Shopkeepers* asked themselves these very questions at some point. Although these diverse entrepreneurs came to a point of reflection and soul searching for different reasons, the

The reach of your business can and should extend far past your store. In the digital age, your customers can come from anywhere if you set up the proper infrastructure to support their ease of purchase. For those not lucky enough to enjoy physical access to your store, an online shop does wonders for carrying your voice to as wide an audience as possible. From

simple online advertising via websites announcing news, sales, products, stories, and events to a comprehensive e-commerce store for those who might never make it into your actual shop, the importance of maintaining an online presence should not be underestimated … unless part of your branding strategy is to remain illusive. How your shop uses its

online platform—as a tool for communication, social media presence, or international sales—remains as personal and nuanced as the business itself.

continued from page 6

creative responses demonstrated here speak to a spreading call for craft and heritage through mindful commerce.

The shops we frequent define our daily lives and personal rituals. These places of commerce also shape our collective beliefs about local culture, helping us delineate our social functions and economic relationships. From the corner baker to the reliable shoe repairman or favorite grocery store, our shops of choice become a vital tool for mapping the city. The network of shops we favor casts a broad reach, extending from the very local spots we frequent daily or weekly to those in other cities or parts of the world that we travel to regularly. These places make even faraway cities feel more like home. While the role of mercantilism has been an established system influencing city life for centuries, the culture of shopkeeping underwent a dramatic erosion following the Industrial Revolution. The rise of big box, mass-produced commercial solutions swept through cities around the world, blanketing their unique characters in a universal corporate sameness. Once met with a warm welcome, the reign of the large brand temple now faces its most worthy opponent—the contemporary shopkeeper. As commercialism has succeeded in making all major cities look alike, a new generation

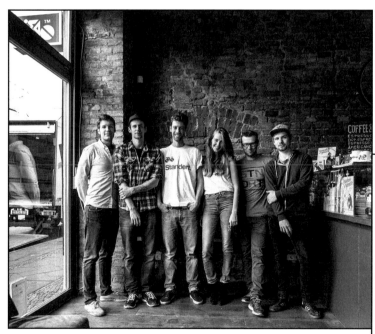

Standert Bicycle Store & Café, p. 166

«Employee of the Month»
(4/11)

A shop proves only as good as the people who work there. How to find good staff and build a strong team plays as important of a role as the goods for sale. Diligent hiring practices and the ability to attract and keep a competent staff affect both the internal and external operations of the business. From within, shop owners need a reliable workforce that they can train and depend on. From the outside customer perspective, these same employees must feel approachable yet not overly present. Before recruiting personnel, consider what characteristics and skills would make your job as owner easier and hire accordingly.

«The Regulars»
(5/11)

Who is your target audience? Once you have identified your ideal crowd, work toward them, with them, and for them. Understand what they are after, what they care about, and what they want from you. Finding the sweet spot between how much and how little customers actually need allows business owners to further tailor their retail models to local demographics, customer personas, and everyday observations. Depending on whether or not your business works better for regular customers or relies more exclusively on one-off visitors and tourists, these clientele considerations must be identified and factored into your business model sooner than later. You can't run a successful business without accounting for its context—the age range, gender, and income bracket of your audience impacts not only your operating price point but also the demand for your products.

«Brand It»
(6/11)

continued from page 7

has stepped in to finally counteract the trend. This new guard of shopkeepers resurrects the mercantile ideals that once made shopping as much an errand as a method for community building. *The Shopkeepers* celebrates the renaissance of the storefront, telling the stories behind the owners and their businesses.

These inventive and risk-taking shopkeepers mold their passions and daily lives into a single endeavor. Rejecting our all too often fragmented lifestyles where our work has little to do with our dreams, these business owners use their passions to sculpt the market for their ideas. The care given to each detail in both the content and the setting of the shops makes even the most idiosyncratic storefront hard to resist. For instance, candymaker Lisa Ericson

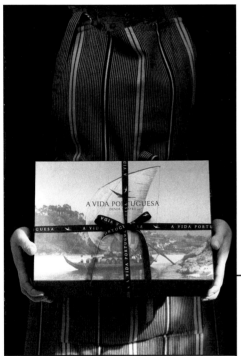

A Vida Portuguesa, p. 234

Branding can make or break a business. Picking a logo that best visualizes your personality and vision is just the tip of the iceberg. The shop, the sign outside, the bag customers take away their products in, the uniforms the staff wear, all reinforce your branding agenda. In your face or chicly understated, these marketing decisions reinforce how people perceive a business and its philosophy. Active advertising or relying on editorial mentions and word of mouth set in motion distinctly different business models that attract their own types of clientele. What you decide your shop should be known for can vary from selling a key item or dish to a novel marketing campaign. Each technique roots your brand deeper into the consumer psyche, so make sure whatever technique you apply you use it well and wisely.

«Rumor Has it»
(7/11)

If a business owner successfully tackles the areas of branding, staffing, customer service, and presentation, customers will do the rest. If you do what you do the right way, word of mouth travels fast. Building a reputation while establishing customer trust, today's shopkeepers do more than just mind their own business. Instead, retailers take initiative and responsibility for their neighbors and their communities. By participating in civic engagement, philanthropic efforts, and neighborhood improvement, businesses get more by giving back.

(the mind behind the Stockholm sweet shop Pärlans Konfektyr) infuses her love for all things vintage into her products, their packaging, and the store she sells them in. Her charming staff even evoke an unmistakable 1930s glamour with their delicately coiffed hair, bright red lipstick, and retro uniforms. The ephemeral value of these deeply personal touches are what gets lost when making a purchase online. Customers end up frequenting the store as much to satisfy a craving as to satisfy their curiosity. Such subtle entrepreneurial details fuse the best of capitalism with the best of craftsmanship. Rather than just selling any old thing to turn a profit, these shopkeepers craft, sell, and curate what they truly value.

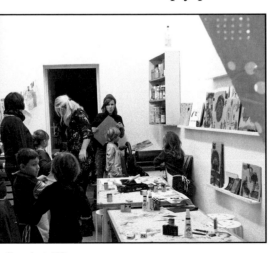

Krumulus, p. 188

continued from page 8

Many shopkeepers inherit the family business. Such family-run endeavors pass down from generation to generation and shape the face and structure of the cities they occupy. Not only do the businesses themselves change hands, but also the crafts and skills required to run them. This lineage-based model holds the most historical precedent but has grown increasingly rare with the spread of globalization and mass production. Such businesses include the dying trades of shoemaking, millinery, darning, and more. Vienna's own legendary shoemaker family, Scheer, have been lovingly crafting 300 pairs of bespoke leather shoes per year since 1816. The elegant shop, tended to by seven generations of Scheers, has maintained its unsurpassed commitment to quality for just short of two hundred years. Others keep age-old recipes alive like the Berley brothers who recently took over Shane Confectionery in Philadelphia, following a century of

Old Faithful Shop, p. 100

«Everything but the Kitchen Sink»
(8/11)

The range of products a store sells need not be vast to be memorable. In fact, many shops excel at selling just a single thing. Glove makers, milliners, button stores, and rice shops—just to name a few—each build successful business models around doing one thing but doing it well. Other retail strategies exercise a knack for thoughtful product curation that showcases a certain spirit and joie de vivre on the part of the owner. These curated product ranges suggest a certain way of life and an active stance toward quality and craft.

Some stores develop a reputation for always stocking a certain kind of thing while others provoke a sense of wonder on the part of the customer for seeing what comes next. The latter type of project range, one that always stays in flux, can evolve based on specials, branded collaborations, thematic explorations, and the changing seasons. Never static, these shops attract a curious and loyal following awaiting the latest incarnation of the store and its products. Temporary limited editions and product launches foster a feeling that each item is in fact a one of a kind or a finite resource that must be snapped up accordingly.

Price point is yet another aspect informing product range. Whether catering to just one type of client or providing product options for a spectrum of budgets, the price range of the goods for sale determines who will end up frequenting your store. The idea of price leads into another consideration of product turnover. Based on how often a person will buy a product for sale also directly impacts the spectrum of goods needed for the store to feel balanced and comprehensive. Certain shops may sell one high-end product or statement piece, bespoke shoes or a large furniture item that will last a life time, while others—often those in the food industry or places that carry merchandise that gets depleted over time like art supply stores—craft more short-term product lines that depend on rapid turnover and a repeat customer base. What you sell and how you sell it impacts not only the structure of your store but how a customer integrates your business into their lives, both short and long term.

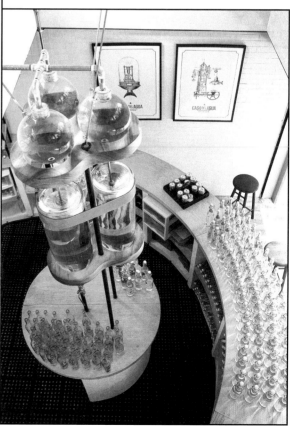

Casa del Agua, p. 233

continued from page 9

«The Happy Customer»
(9/11)

j Adis, p. 191

Impressions matter. A customer's experience can begin long before they enter a store and end well after they leave the premises. Deciding where the retail journey begins and ends represents part of the artistry of savvy shopkeeping. How someone first hears and reads about a store to their first encounter with the physical location colors their experience and their likelihood to return. Intentional first visits or those that simply occur from passing by each rely on a positive customer exchange to inspire further interaction. Business owners must work towards crafting that crucial first impression as well as the one customers take away after fully engaging with the store and its products. The consideration of how a guest's reading evolves and develops beyond the single purchase takes into account how the customer feels to the point of curating what they hear, see, and even smell. In conjunction with more sensorial considerations, how customers relate with both staff and products influences their response as well as the likelihood of them coming again and telling their friends.

Those shopkeepers who make it their mission to have their customers leave feeling heard and treated fairly elevate the customer experience into an art form. So much of the customer experience also relies on the goods for sale. Preventing buyer's remorse by only selling products worth selling, a brand becomes a welcome addition to a clients' shopping circuits and their homes. The quality goods bought embed into a person's daily life, continuing to shape the new owner's impression. Ideally falling in love with the product, story, owner, and storefront, customer's have grown to expect a certain level of professionalism, service, and craft to warrant the effort of shopping in person rather than virtually. Customer experience serves as the only thing setting your shop apart from an online vendor. With that in mind, go forth and craft a storefront consumers will not only never forget but long to return to.

management under a single family. The brothers spare no detail and ensure that all the candy crafted retains the same quality standards as it did when the Shanes first started preparing the tempting sweets over one hundred years ago. Some return to their family's historical model by re-envisioning their lineage in a new way. Sisters Wenyi and Jiayi Huang channeled their intimate experience with quality fish gleaned from their childhoods spent around their parents' seafood business into an updated and designed version of a local fishmonger playfully named Little Catch. Such clever evolutions, like giving a personal update to an established tradition, help keep commitment to the trade alive between generations.

Those who were not born into a trade often become shopkeepers via surprisingly circuitous routes. Many leave careers in competitive fields ranging from corporate trading to marketing, design, and everything in between. Despite their undeniable success, these businessmen and women struggle with a nagging feeling that their professional pursuits don't in fact align with their passions. Disenchanted with their lives and work, these unconventional thinkers take a risk to follow their vision. Two recently opened Los Angeles-based stores, the wonderfully nostalgic Milk Jar Cookies and the captivatingly eccentric Cactus Store, are the products of owners embarking on their second careers. Courtney Cowan left her bright career as a television producer to pursue her talent for baking. Now working on her own terms, she enjoys a cultish following of local cookie

continued from page 10

monsters hooked on her special recipes and freshly baked varieties. Echo Park's latest best-kept secret, the Cactus Store, represents a multigenerational career change for two family members. Feeling unfulfilled with his work in the design world, Carlos Morera decided to help his bonsai expert uncle, John, finally realize his dream to run an unorthodox nursery filled with only the strangest cactus specimens. This family passion project has delighted customers to such an extent that most of the curious, furry, and prickly inventory tucked into the tiny space turns over in just a matter of days. The husband and wife operation of Poszetka evolved organically, sparked by businessman Tomasz Godziek spotting a handsome pocket square worn by a colleague during a meeting and asking his seamstress wife, Joanna, to try to recreate it for him. 9,000 orders later, the duo are now the go-to place for pocket squares in Poland. Ilse Böge, yet another corporate defector, gave up her life as an economist to open the first licorice store in Germany, Kadó. She now supplies the people of Berlin with more than 340 varieties of licorice, some that she makes herself and others that she sources from across Europe.

A compelling storefront can sell many things or just one. By staging a curated experience, whatever choice a customer makes feels right because it has already been pre-selected. These shopkeepers share a sensibility for quality and an inherent understanding of the craft behind the products they carry. Square footage and diversity prove secondary to identifying a niche—the quirkier the better. Most shopkeepers fall into one of two categories: the makers or the curators. The makers immerse themselves in their craft, producing and selling their products

«Extra, Extra!»
(10/11)

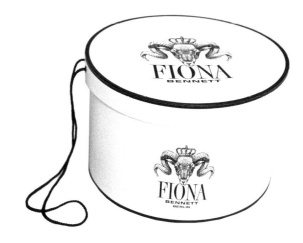

Fiona Bennett, p. 76

Unparalleled service transforms a customer into a regular. Deciding to go that extra mile can take the simplest forms as long as such extra offers are executed with care. Bespoke services that make one business stand out from the next range from custom gift wrapping to special delivery options, follow-up support, and even the grace with which returns and referrals are handled. Not only catering to customer wishes but anticipating them beforehand, the attention to each detail of the retail experience lures in loyal customers and keeps them coming back for more.

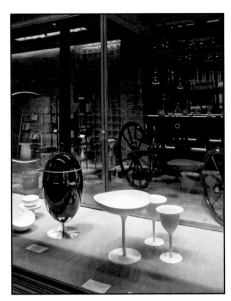

Atelier Courbet, p. 88

continued from page 11

with an uncompromisingly infectious fervor. The curators count on their instinct and vision, selling a story of surprise and discovery rather than a bargain. Kamiel and Martijn Blom, brothers and owners of the Amsterdam business Blom & Blom, combine these two concepts. Their fondness for defunct vintage industrial items matches their ability to bring them back to life. By pre-curating what they pick to fix and sell, they establish a singular vernacular that sets them apart. Curating a lifestyle as much as a product, these businesses showcase a refined vision of their owners, whether they personally create the goods for sale or not. Those who sell many varieties of the same thing often transform that element into the key design tool of their space. Both the New York institution Tender Buttons and the Lisbon family tile business Cortiço & Netos let their products speak for themselves without prominent design intervention.

Philanthropy and work don't have to be two different ideas. Many of the shops presented here make it a point to give back to their communities and preserve their local heritage. Bicycle stores and local barbers alike integrate cafés, free wifi, and inviting spaces for people to gather and do more than just shop. These community building storefronts sell both experience and product in equal doses. Others foster collaborative working models that breathe new energy into the business environment while supporting local craft. Atelier Courbet in New York and Portugal's A Vida Portuguesa have made businesses out of championing and celebrating handcraft industries that were on the brink of extinction before their

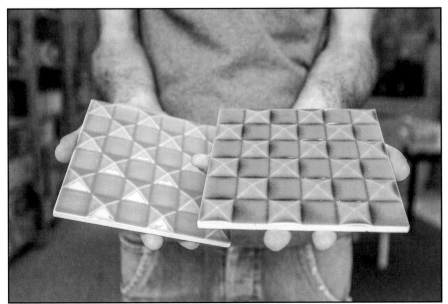

intervention. These companies align themselves with the philosophy of buying fewer but better things.

The seduction of mass advertising to sell us mass-produced items doesn't cut it any longer. This constant marketing and push toward

Cortiço & Netos, p. 192

continued from page 12

unconscious consumerism stands as part of a larger corporate model where people work to live and live to shop. Fortunately, this prescribed system for living no longer feels like enough. Due in no small part to the economic collapse of 2008, when the concept of job stability simply vanished overnight, consumers are no longer buying what big business is selling. Instead, customers show a newfound interest in individual businesses that share the distinctive character and personalities of their owners. Whimsical treasure troves and one-off wonders, the contemporary storefront rekindles a retail experience filled with objects we long for. A revival of craft, heritage, and conviction, the shops take old world lessons related to our social, cultural, and historical needs and synthesize them into sophisticated and modern storefronts. The acumen, imagination, and inspired business models of today's shopkeeper present novel approaches encouraging people to get off their computers and back out into the streets, their neighborhoods, and ultimately, their stores.

The success of the contemporary storefront relies as much on what it sells as how it looks. Now that nearly everything can be bought online, the design of physical retail spaces becomes more important. How to catch and keep the curiosity of passersby depends on the development of approachable, alluring, and one-of-a-kind retail experiences. The most successful models of storefront design balance the unique and memorable with a sense for the practical and user-friendly. This combination of aesthetics and pragmatics proves critical for keeping customers feeling dazzled, inspired, and welcomed.

Lighting, color, sound, and material play key roles in achieving a desired interior atmosphere. Cheerful or serious, a temple or an accessible haven, timeless or of the moment, the thoughtful use of color, lighting design, and general materiality help define a space's mood and atmosphere. Cooler colors and bright lighting can give off a more clinical or futuristic feeling while warmer values, depending on the degree of intensity, can saturate the senses or produce an inviting ambiance. These same ideas hold true when considering the materiality of the interior. Material choices, layout, storage options, and built-in ammenities not only reinforce the branding vision for the storefront but impact a customer's reading of and experience in the space. Cladding a storefront in rustic reclaimed wood will produce a far different effect than a shop covered in simple tiles, bold graphics, or simply the product itself.

Getting customers to stop represents the first design challenge, making them linger stands as the second. How customers move through the space and how they encounter and engage with the merchandise has everything to do with how comfortable they feel inside. The more at ease the customer and the better the story told, the longer they stay. The longer they stay, the more likely they are to make a purchase. Cultivating this type of retail environment requires just a few subtle amenities that make the space feel personal. These design touches can include basic seating areas with overstuffed couches, intriguing product displays and browsing sections, and hands-on elements that encourage visitors to get involved.

To get people off their computers and into stores, the interior design of the contemporary storefront must offer what internet shopping can't: an original experience. These sanctuaries of shopping become a way for connecting people to products but also to their surroundings. So before you begin, ask yourself: what is my product about and whom do I hope it will attract? From there, the look and feel of your store will begin to take shape.

«Staging Spaces»
(11/11)

Marie-Stella-Maris Archives, p. 141

The
Shopkeepers

Storefront Businesses
and the Future of Retail

Projects

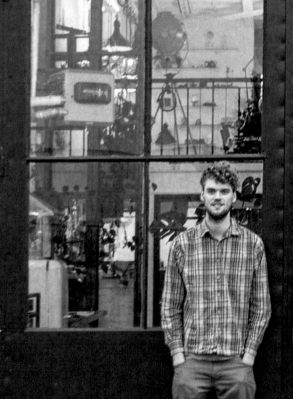
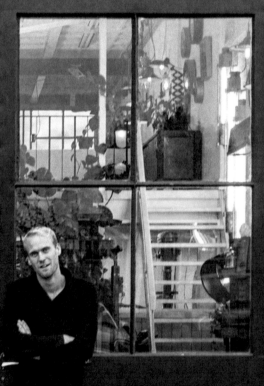

Blom

Industrial
Authentics

Blom & Blom

Berli
Amster

Open

& Blom

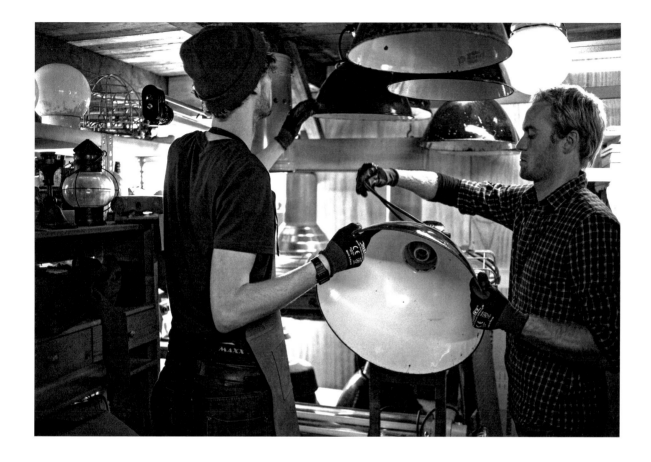

Making the old new again, brothers **Kamiel** and
Martijn bring their favorite industrial fixtures rescued
from defunct Eastern Bloc factories back to life inside
their timeless Amsterdam workshop and storefront.

The brothers also design their own fixtures made with salvaged wood bases.

Sharing a passion for forgotten items and forgotten places, two like-minded brothers transformed their hobby for giving the broken and abandoned new life into a career. Brothers Kamiel Blom and Martijn Blom founded their 1,935-square-foot Amsterdam workshop, office, and showroom in 2012. The duo has expanded to a team of six since their opening. Together, the hands-on team carefully restores and modernizes a curated collection of reclaimed furniture, clocks, esoteric accessories, and more. With a personal respect for each object's past, the Blom & Blom restoration process integrates skill with mindfulness.

Every object has a story and the Blom brothers make sure that story never gets lost. Each item for sale comes with a passport describing the item's origin to help ensure that its rich history passes along with it. The unique products filling both the physical storefront and

track, Martijn began questioning his choice of employment and whether or not this work was in fact what he wanted to be doing for the long haul. Before specializing in business, communication policy, and strategy, Martijn had studied architecture. When the two brothers finally decided to join forces, they combined their strengths from their different but complementary backgrounds. Martijn, now more in charge of the business side of things, worked closely with his brother throughout the design and construction of the storefront and workshop space.

A typical day at Blom & Blom begins with a leisurely walk to work. With both brothers located in Amsterdam Noord, Martijn lives 800 meters from the shop while Kamiel prides himself on his even more central location just 300 meters away. Each day, Kamiel brings his dog and store mascot Volta to work. Aptly named after Alessandro Volta, the inventor of

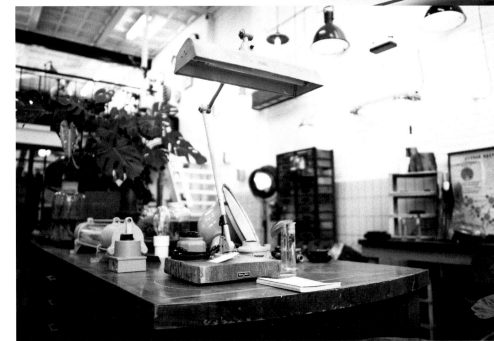

Every object has a story and the Blom brothers make sure that story never gets lost.

online shop were all, at some point, discarded and left to perish. Adventurous backstories tracing to periods of growth and industry are resurrected alongside their respective artifacts. Committed to giving these rare salvaged items a second life, the brothers collect, restore, and redesign an assortment of industrial lighting fixtures and furniture.

Both brothers reached a turning point in their professional lives at about the same time. This period of transition made the decision of going into business together a natural next step. Previously, Kamiel ran an online design agency with a group of friends. After three years of living in Berlin and working on this online platform, he started having second thoughts about a career solely rooted in the digital world. Martijn, on the other hand, was just finishing his last degree. During his studies, he worked at Brunel doing project management and recruiting for the company. Also three years into this career

No two fixtures seem alike at Blom & Blom

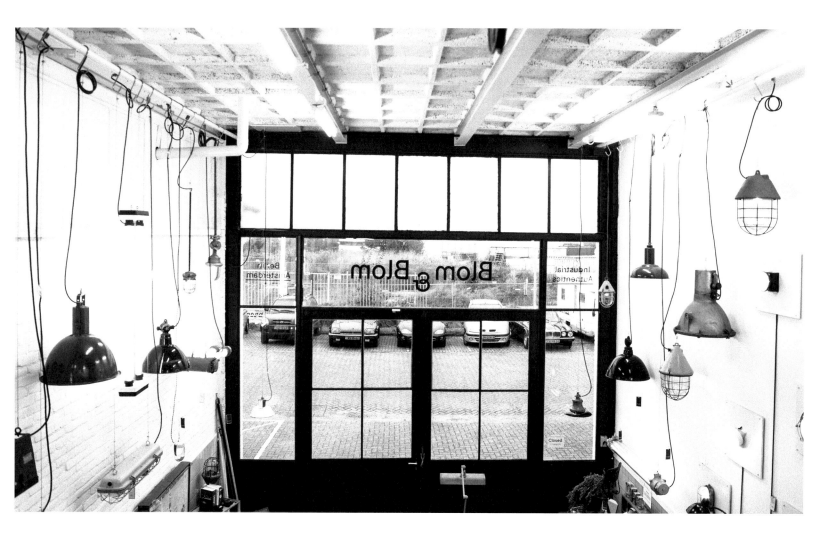

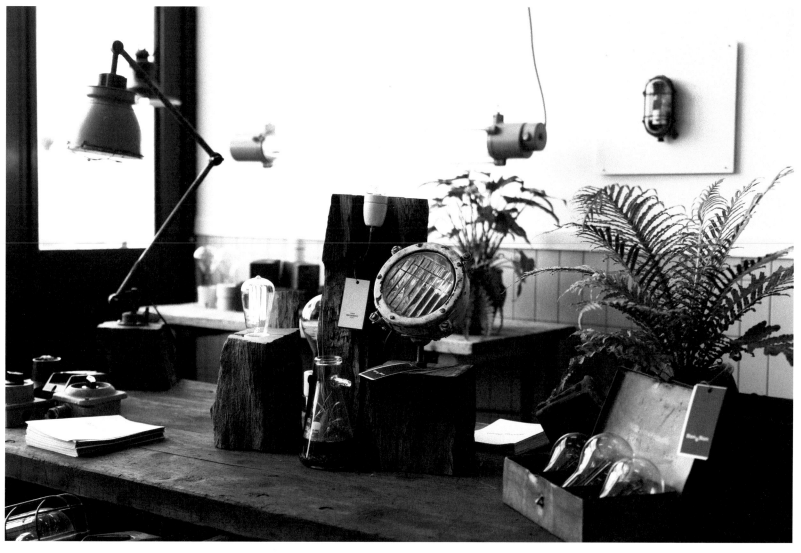

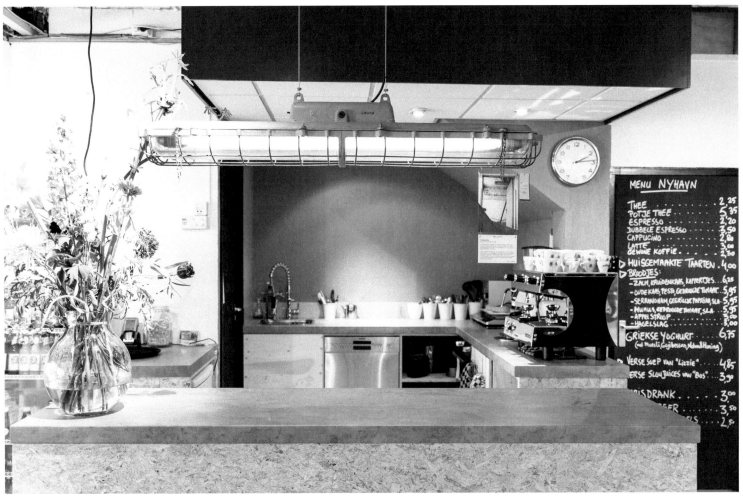

Lighting for NYHAVN Concept Store

the first electrical battery, the handsome chocolate-colored hound serves as a loyal fixture at Blom & Blom. Although each workday starts at 9 a.m., no two days are ever the same. The team fills orders from around the world, developing passports for each object and prepping them for transportation. Approximately 35 percent of all orders comes from outside the Netherlands. In addition to a popular client base in the United Kingdom, Scandinavia,

Switzerland, and even their country of origin, Germany, these period pieces have reached new homes as far away as Hawaii, Australia, and Asia. The brothers tackle more personal projects when time permits. These labors of love usually entail repairs to lamps that call for more time and creativity to return to working order. The more challenging the job, the more fulfilling when the fixture finally lights up for the first time this century.

The Amsterdam storefront occupies an elegant double-height converted warehouse space. A large glass façade showcases the vintage wares within and draws in curious passersby. Like the products it displays, the lightly renovated showroom embraces its industrial heritage. Aside from the relatively contemporary and minimalist product displays, few clues ground the shop in the present. Exposed brickwork painted white, open rafters, hearty tiles, and original ironwork round off the time capsule-esque character of the space. Signature fixtures hang down from the rafters casually illuminating old suitcases, restored wooden tool cabinets, rustic tables, work stools, indoor plants, and so on. The curated display only features one lamp of each style at a time. This pared-down approach instead highlights the many reclaimed fixture options available, and the charming diversity between them. A series of wall-mounted fixtures and independent lamps and spotlights round off Martijn and Kamiel's lighting selection. From the large and dramatic to the petite and demure, all the lights share a robust and classic quality that only comes with time. And let's not forget the impressive collection of rehabilitated wall clocks available on the premises too. These classic pieces make one wonder how cell phones ever challenged the streamlined analogue timekeepers.

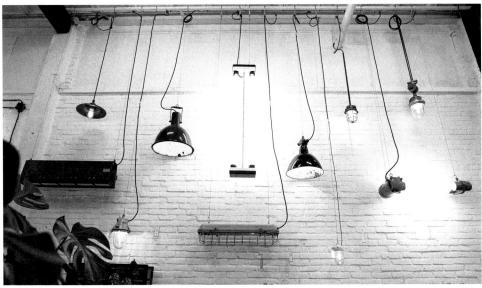

Part of the store's charm comes from seeing the range of one-off fixtures displayed together as a collection

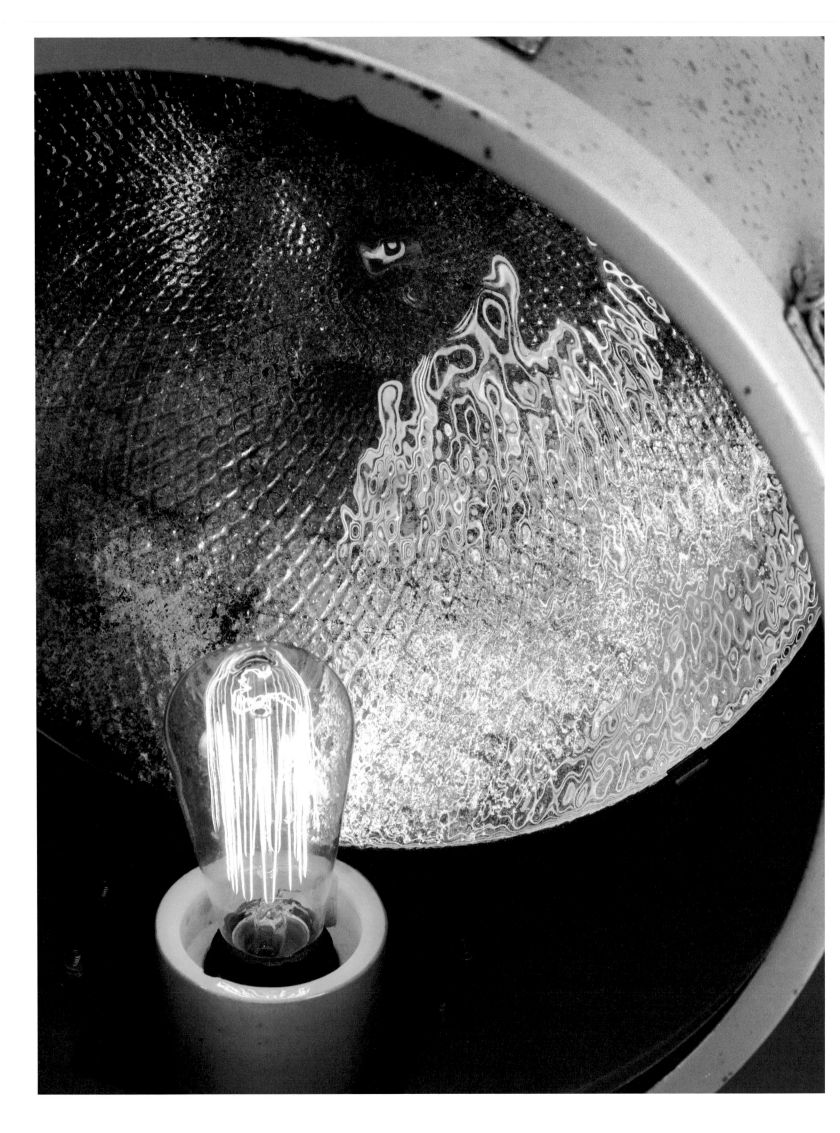

Although based in the Netherlands, the brothers spend a considerable amount of time scouting abandoned factories in former East Germany for relics of the GDR era. Traversing treacherous conditions and exploring buildings that no one has set foot in for decades, Kamiel and Martijn embark on regular hunts for pre-war bounty. The partners comb through these industrial ruins and rarely come back empty-handed. The duo uncover unusual remnants ranging from rusty hooks to sturdy chairs, and period lighting pieces hidden between overgrown vines or proudly displayed on eroding walls from a bygone manufacturing heyday.

While the two collect practically everything, they share a special passion for lamps. Both brothers bond over their soft spot for pure and functional designs. When bringing a selected piece back to life, Martijn and Kamiel purposefully shy away from making anything look too perfect. Rather than striving for "good

as new," they let the rust and the scratches remain as markers of time. This patina of imperfections adds to the charm of each object and helps communicate its story to future owners. A few of their in-house specialties include customized spotlights and bulbs mounted on rugged chunks of wood, the slender wall-mounted rhino fixture available in a number of sizes and colors, and the standing lamp lovingly named the Great Grey Python.

Blom & Blom also design interiors from concept to realization centered around the shop's one-of-kind collection. Many of the restored items find new homes accenting, illuminating, and accessorizing contemporary interior projects. These timeless pieces appear in restaurants, offices, and homes where they play a central role in defining the novel interiors. The brothers maintain fruitful partnerships with a number of architects and interior designers from around the world including Michaelis Boyd, Cepezed, and The Design Agency.

Signs of age are celebrated in this detail of an original aluminum fixture

Details of aluminum steel plates and reclaimed Azobé wood

Fixture detail made of green steel aluminum plates and glass

The lifespan of most products has declined considerably over the years. Once built to last, modern-day goods are designed with an inherent and, in some cases, expected expiration date. These short-lived items reflect a culture increasingly interested in the new and the next. Kamiel and Martijn reject this model of obsolete consumerism. With grace, ingenuity, and curiosity, the pair take these old items and reinvent them. Understanding that good design never goes out of style, the brothers light the way for a new guard of designers and artisans, collectors and homeowners interested in enhancing their modern life with elements from the past. Everything you feast your eyes upon at Blom & Blom is a part of history. Walking through this museum-like showroom reminds visitors that we just don't make 'em like we used to. And why should we? There's still plenty of lost treasure to go around thanks to the enterprising Blom brothers. More than just repairmen, the family business gladly takes on the role of seasoned storyteller as they weave narratives of the past back into the contemporary world.

The Black Mamba lamp stands as a Blom & Blom customer favorite

Owners/Designers: Kamiel Blom and Martijn Blom
Corporate identity: Till Wiedeck/HelloMe
Founded: 2012
Location: Chrysantenstraat 20A, Amsterdam, The Netherlands

Lunettes Selection

Eyewear Extraordinaire, Berlin, Germany

Vintage frames from this Berlin retailer are sure to catch the eye. Owned, operated, and curated by Uta Geyer, both stores "honor the past while living in the now." The child of an artistic family, Geyer grew up in the German countryside near the historic reconstructed city of Frankfurt am Main. She regularly tagged along with her sculptor father on trips through countless museums and historical buildings—an activity that trained her eye. Geyer went on to study film history, graphic arts, and paint-

wear never goes out of style. The refined stores, dotted with mid-century details, carry signature eyewear dating back to 1900. A crash course in the history of glasses, the pared-down shops have something for everyone. The original vintage glasses and sunglasses are hand-selected from limited stock throughout Europe and well-known manufacturers around the world. Peruse the velvet-lined drawers organized by era, brand, shape, and material to find the one-of-a-kind gem best suited for you. These understated

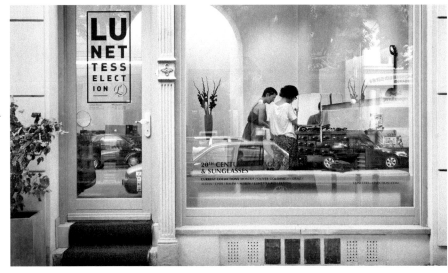

Inviting red stairs and a generous glass façade lead guests into the store

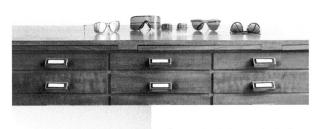

cabinets of curiosity reveal pair after pair of sophisticated and iconic frames ready to give you an instant makeover. Thanks to local and international success, Geyer has now added her own brand of eyewear, Lunettes Kollektion, to her treasure trove of throwback frames. Whether a pair of 1950s horn-rims or a retro 1980s look is in order, Lunettes remains the place to go to see and be seen.

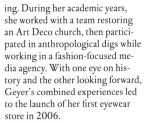

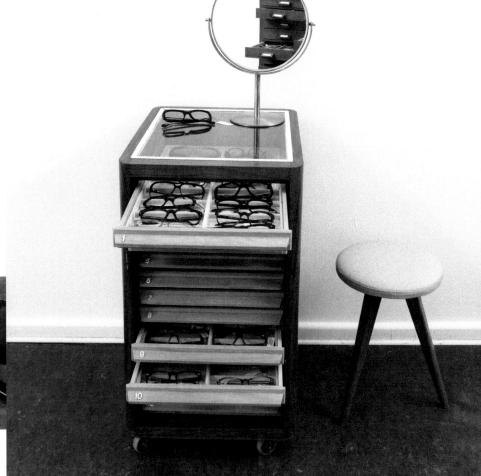

ing. During her academic years, she worked with a team restoring an Art Deco church, then participated in anthropological digs while working in a fashion-focused media agency. With one eye on history and the other looking forward, Geyer's combined experiences led to the launch of her first eyewear store in 2006.

The shops act as mainstays for design conscious customers as well as reliable outfitters for film, television, and theater productions. With two locations in the chic Mitte and Prenzlauer Berg neighborhoods, the timeless storefronts and tasteful curation prove that classic eye-

Owner/Designer: Uta Geyer
Founded: 2006
Location: Torstraße 172, Berlin, Germany

Antique storage cases encourage visitors to explore the inventory

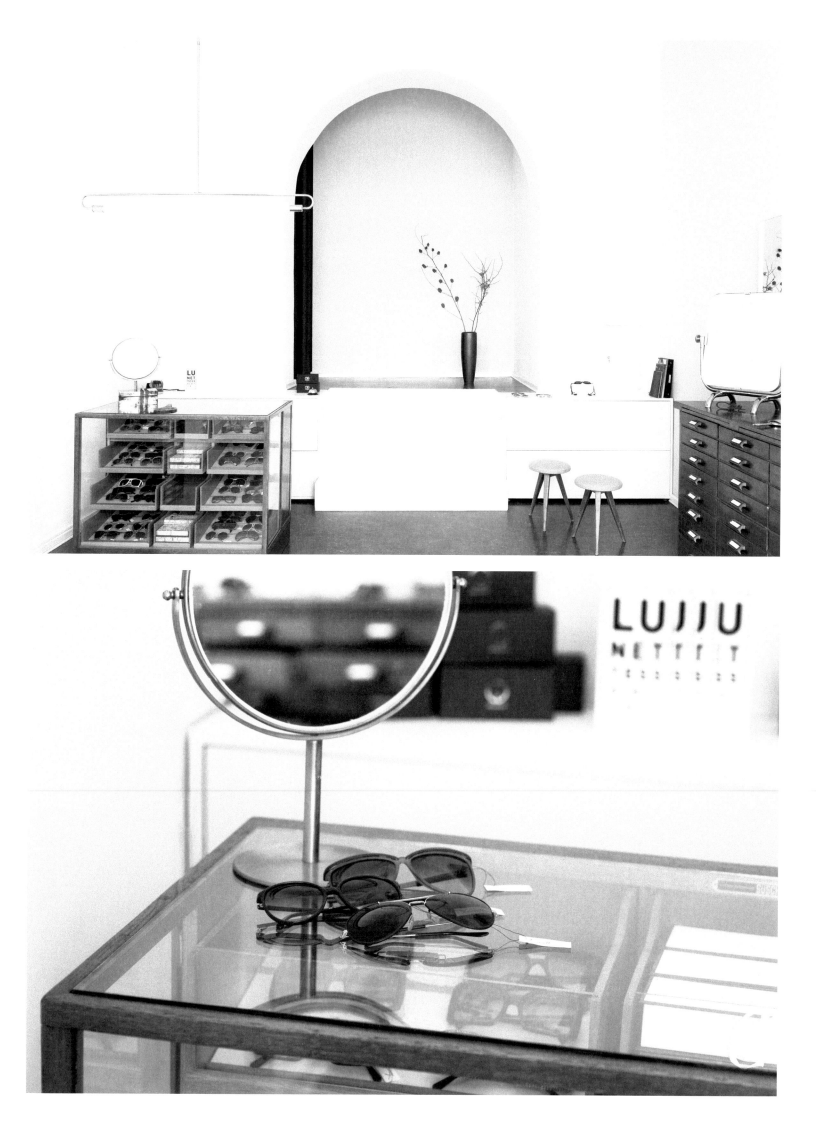

Candlestick Makers, Paris, France

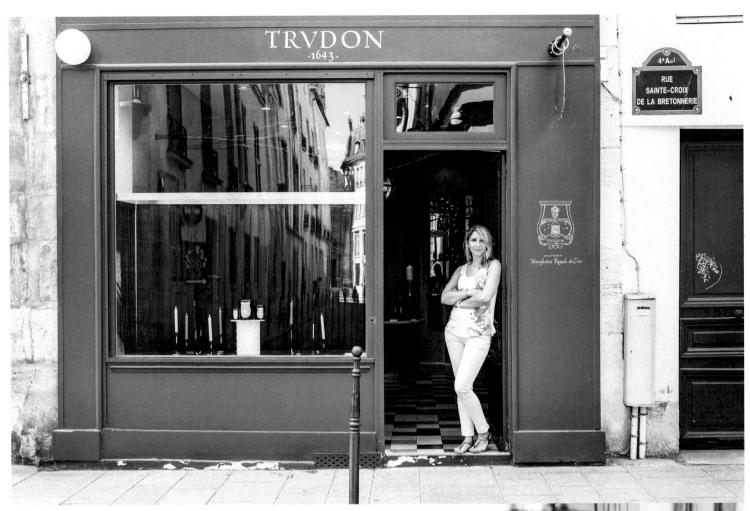

Four centuries of candlestick secrets rest inside this Parisian storefront

This luxury candle making company has been illuminating the most discerning French households for nearly 400 years. In 1643, a salesman named Claude Trudon arrived in Paris and became the owner of a store on Rue Saint-Honoré. He was a grocer but also a wax merchant and supplied his customers with candles to light their homes and the parish. On the eve of Louis XIV's reign, Trudon began his small family manufacturing business which would carry his name forward for centuries to come. The enterprise and trade would be passed down from generation to generation of Trudons beginning with Claude's son Jacques. By the eighteenth century, the growing company served the Queen and exclusively lit the French court, the most important churches, and even the palace of Versailles. As Napoleon's wax producer during the Empire, the company survived the French Revolution, the arrival of domestic lighting, and the birth of the electric revolution. The resilient

Trudon brand continued its work throughout the centuries, without ever interrupting its activity. Still crafting traditional candles for the greatest names, Trudon enjoys its title as the oldest and most prestigious wax manufacturer in the world. This intimate location celebrates the brand's history and quality product. From the Queen's palace to your own home, relish the fact that the candlesticks you bring back for your next dinner party have the royal seal of approval.

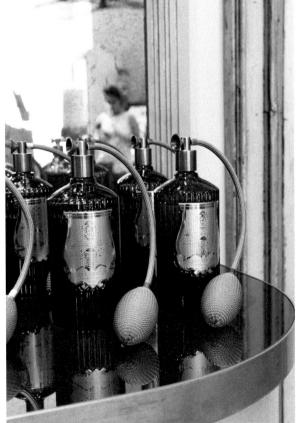

The heritage brand also carries a line of signature scents

Owner: Maison Trudon
Design: Dimore Studio
Launched: 2014
Location: 11, rue Sainte-Croix de la Bretonnerie, Paris, France

Sukha Amsterdam

Lifestyle Curators, Amsterdam, The Netherlands

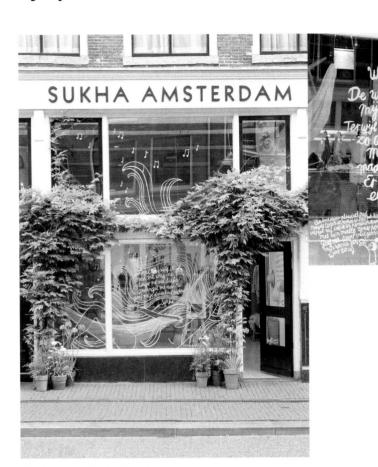

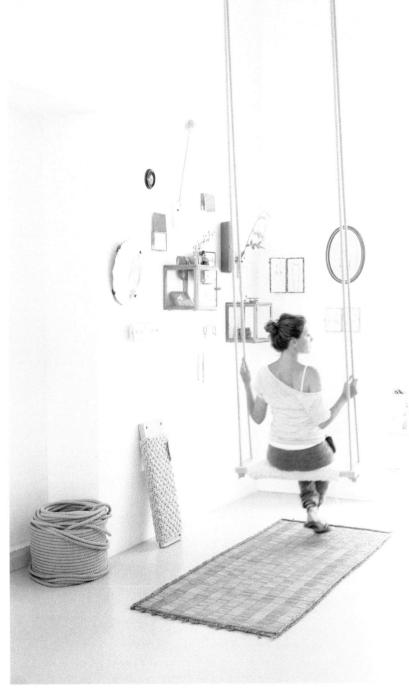

Changing window displays keep passers-by ever curious

Shopkeeper Irene Mertens named her storefront after the Sanskrit word for "joy of life," stocking it full of goods that reflect this attitude. The bright, airy, and inviting shop features a collection of simple and honest products and labels, many of which are handmade. In addition to existing brands, Mertens's fondness for giving things a second chance informs her rotating assortment of recycled goods for sale across the space. The idea for her store grew from her travels through India, Portugal, and beyond. Creating a place where all customers feel at home, her business captures the peace and tranquility she found on her journeys. This longing to build a real sense of place led her to begin writing down her thoughts and dreams about the business each morning. One day when her book was finally full, she closed it and got to work executing her idea. Following a major renovation, her storefront opened to the public in March of 2011 and continues to be met with an overwhelmingly positive response from local clientele.

Mertens, with the help of her team and two creative carpenters, reinvents the window displays every few weeks. From tipis to illustrated poems, these whimsical displays lure in customers and keep them coming back for more. Mertens diligently researches all of the labels and products in her store. Aside from being aesthetically pleasing, each product must be produced in a sustainable way. These small batch items are typically Dutch designed and locally produced. After realizing her first dream of the storefront, Mertens then realized her second—the launch of her own product label, Atelier Sukha. This evolving product line now includes over 50 items ranging from fine woolen scarves to daybeds, cardigans, and garlands for decorating the house. The label, started together with fellow world traveler Sam IJsbrandy, engages exclusively natural materials such as wool, linen, wood, cotton, and cashmere produced in a responsible manner. In addition to the storefront and label, Mertens also oversees the Sukha Foundation, which provides aid to the children of Nepal. Each purchase made inside the quirkily endearing storefront supports local and fairly sourced design and children in need. What's not to like?

Owner / Designer: Irene Mertens
Founded: 2011
Location: Haarlemmerstraat 110, Amsterdam, The Netherlands

The light, open, and airy space invites guests to linger, explore, and interact with the tastefully curated goods

Curiosity Collectors, Culver City, CA, USA

Staged like a museum, theatrical shifting displays keep customers and the curious coming back for more

New York transplant Ray Azoulay opened this bona fide cabinet of curiosities in Venice, California after driving his eccentric collection of objects across country in a rental truck back in 2001. The Main Street mainstay fluctuates between museum and showroom. Known for staging dramatic shifting displays of the one-of-a-kind wares, Azoulay brings together vintage knick-knacks, rare furniture, lighting fixtures, and eccentric artworks from around the globe. Guests of the high-end treasure trove will encounter everything from hundred-year-old wooden saints to prize pieces of taxidermy and rustic chests of drawers hauled back from Portugal and topped with 1970s Italian lamps. Obsolete stands as Azoulay's second career path. After retiring from the menswear business, he found himself with an unexpected amount of free time. A collector by nature, Azoulay became taken with the idea of opening a shop that displayed antiques and artwork side by side. More interested in crafting an unforgettable experience than worrying about the bottom line, his uncompromising vision has won him a dedicated following of big budget design enthusiasts in search of the one-off and unusual. A time warp in every sense of the word, Azoulay's storefront walks the line between dream and sideshow spectacle as he makes the obsolete useful again.

Owner / Designer: Ray Azoulay
Founded: 2001
Location: 11270 Washington Boulevard, Culver City, CA, USA

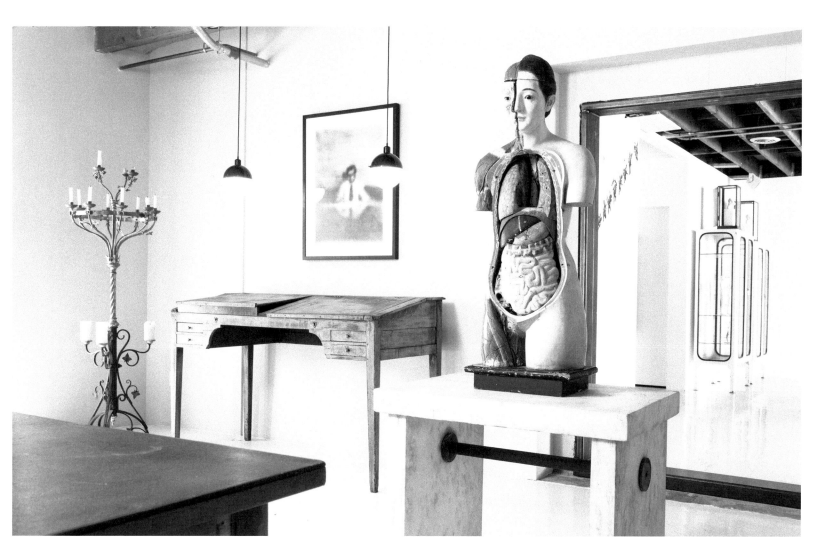

Via Garibaldi 12 Lifestylestore
House and Home Experts, Genoa, Italy

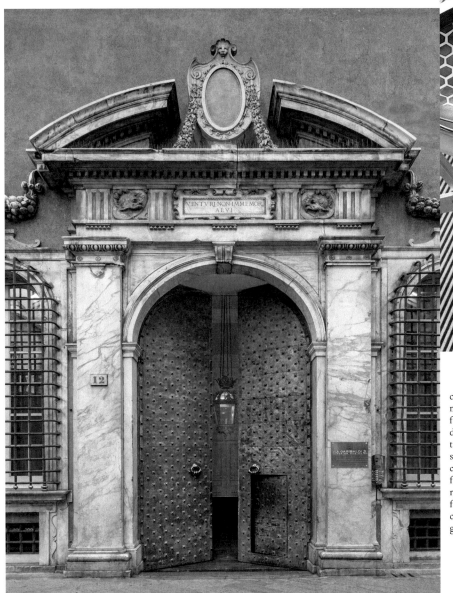

Palace or storefront? You decide

character of the Genoese, the Bagnara family purposefully shy away from extravagant store window displays. Instead, shoppers venture up the marble staircase of the sixteenth-century palazzo to uncover the treasure trove of home furnishings spread over eight rooms with baroque detailing and fresco paintings. When the design community makes its annual pilgrimage to the Salone del Mobile in Milan, many include a side trip to Genoa to visit the Bagnaras. The building, often confused with a museum, resides in the port city's historic center as part of a UNESCO World Heritage site. An ongoing conversation piece inside and out, the family stays busy signing up couples for their sought-after wedding registry and helping discerning customers find their perfect statement piece.

Owners: Renzo, Graziella, Lorenzo and Giorgio Bagnara
Designer: William Sawaya
Founded: 2001
Location: Via Garibaldi 12, Genoa, Italy

Part concept store, part traditional neighborhood retailer, this Italian shop has become a favored destination for design buffs all the way up to royalty keen on stocking up on well-made objects for the home. A family business, Renzo and Graziella Bagnara have run the 600-square-meter storefront with their sons Lorenzo and Giorgio since 2001. Lorenzo holds a degree in art history and completed his dissertation on the building's impressive history. Giorgio inherited an unwavering passion for beauty, luxury, precision, and design from his family that inspires his line of sensual, leather-clad objects and home furnishings that he crafts specially for the shop. Inside the Genoa staple, buyers find modern furniture, tableware, and glassware from established brands like Hermès, Baccarat, and Tom Dixon, set next to pieces from up-and-coming designers. Certain corners of the space house displays dedicated to gardening, electronics, home appliances, luggage, and books. The store also doubles as a showroom for leather accessories produced under Via Garibaldi 12's own Giobagnara label. Appealing to the more reserved

Brothers Lorenzo and Giorgio run day to day operations of their family business

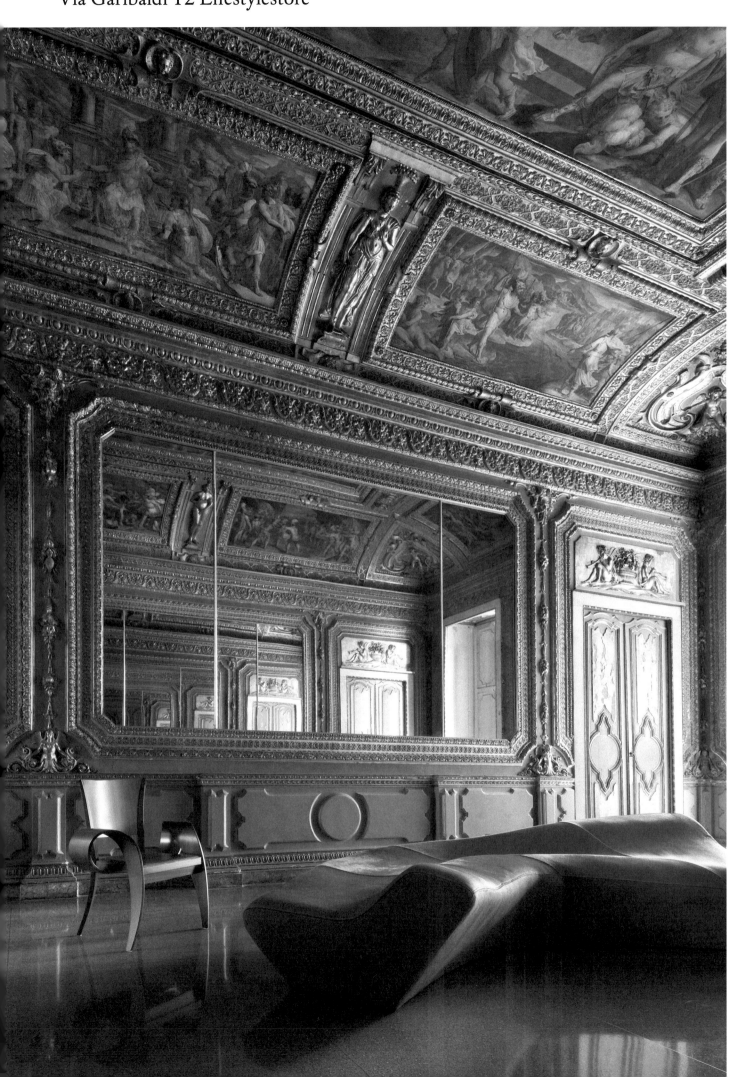

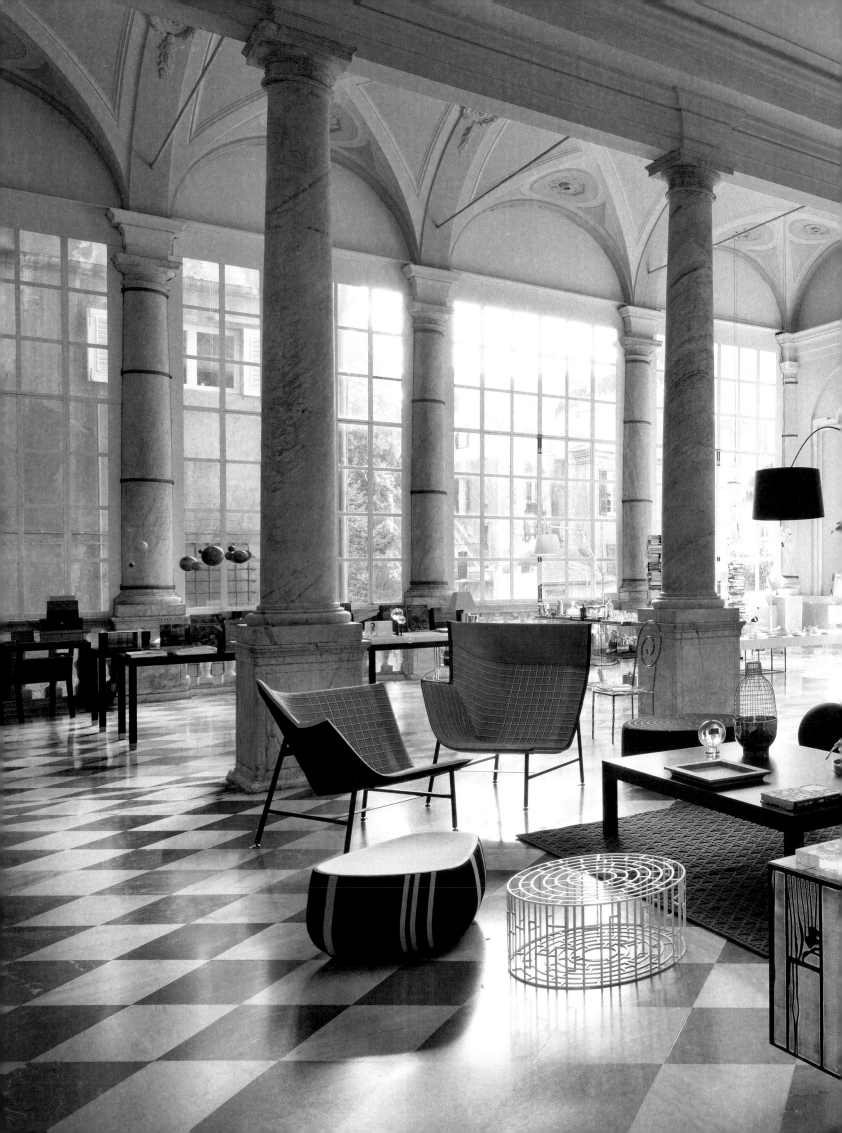

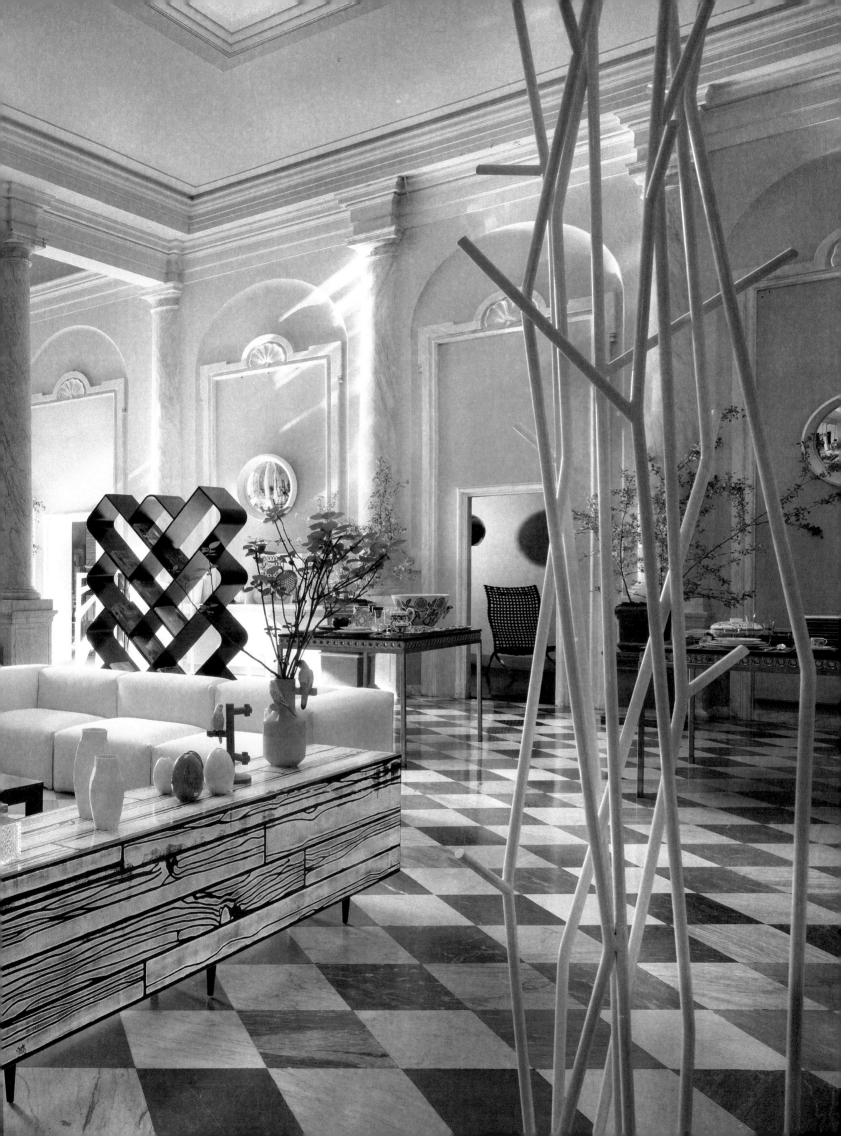

Le Comptoir

Général

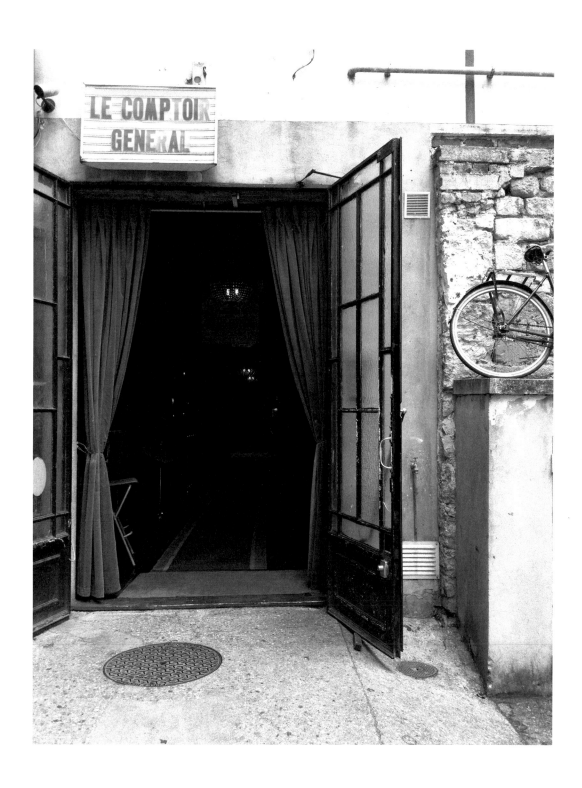

A haven celebrating alternative cultures and phenomena,
Le Comptoir Général is an eclectic venue involved in
fashion, music, cinema, botany, and zoology.

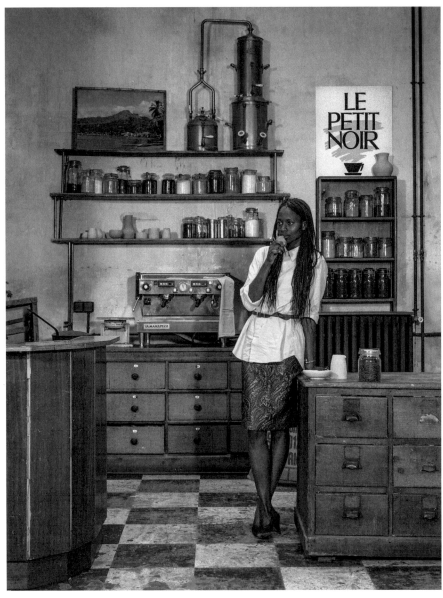

Le Petit Noir is Le Comptoir Général's coffee spot serving the best exotic blends

stay for a spice-infused dinner, linger to browse the concept store's vintage knick-knacks, and leave with a carnivorous plant to brighten up their own interior. The center also regularly hosts events ranging from film screenings to DJ sets and pop-up shops. "We are lucky to have many people approach us with event proposals, and we host a lot of interesting ones every week. For instance, we once hosted a conference about the 'twerk' craze with choreographers and anthropologists from La Sorbonne university," Aurélien shares.

A fascination for the marginal and the mystical inspired Aurélien's vision for Le Comptoir Général as a temple of exoticism. This interest can be traced back to the neighborhood he grew up in, Porte d'Orléans, on the outskirts of Paris—an area that served as an infinite source of fantasies and urban legends. For a while, Aurélien tried his hand at fashion photography and filmmaking, and then became a restaurant owner, developing and fine-tuning his taste for unusual collections and interior design. In 2009, he imagined a playful and museum-like world that came to life a year later as Le Comptoir Général. The space has evolved throughout the years and continues to do so, but its purpose and vibrant ambiance have remained intact.

Places like Le Comptoir Général are breathing new life into a city which young people often complain is lacking novel forms of entertainment, thus helping to put Paris on the map as an exciting destination for a more varied audience, beyond honeymooners and traditional art lovers. The vivid colors, diverse clientele, and joyful atmosphere of the Comptoir generate

Hidden at the end of a passageway on the banks of the Canal Saint-Martin in Paris's 10th arrondissement, Le Comptoir Général is a haven celebrating alternative cultures and phenomena. Stepping into the vast venue, visitors find themselves in a whimsically ambiguous space: dust-covered chandeliers, worn-out black and white checkered tiles, decrepit walls, wild plants, and mismatched furniture are all part of the charm of this one-of-a-kind urban hideout that defies categorization.

Founded in 2010 by Aurélien Laffon, Le Comptoir Général was conceived as a cultural center dedicated to exotic ventures, out-of-the-box creativity, hidden secrets, and lost causes, housed in a museum of curiosities where all are welcome to enjoy the site's eclectic atmosphere. The foundation's mission is carried out in various forms including food, music, fashion, botany, and zoology, and has won the hearts of a diverse crowd, attracting an average of 5,000 people per week. They come for a Tiki cocktail,

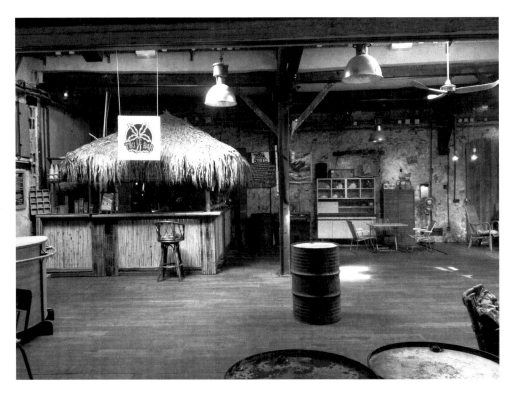

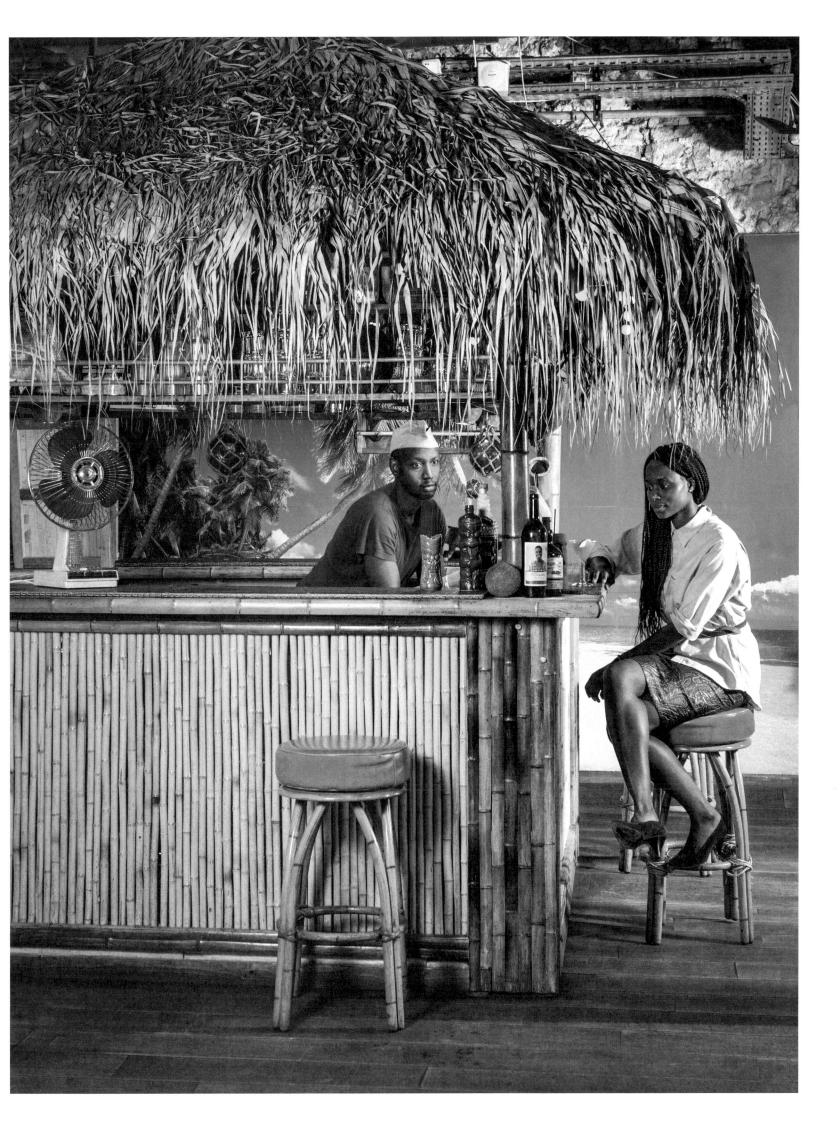

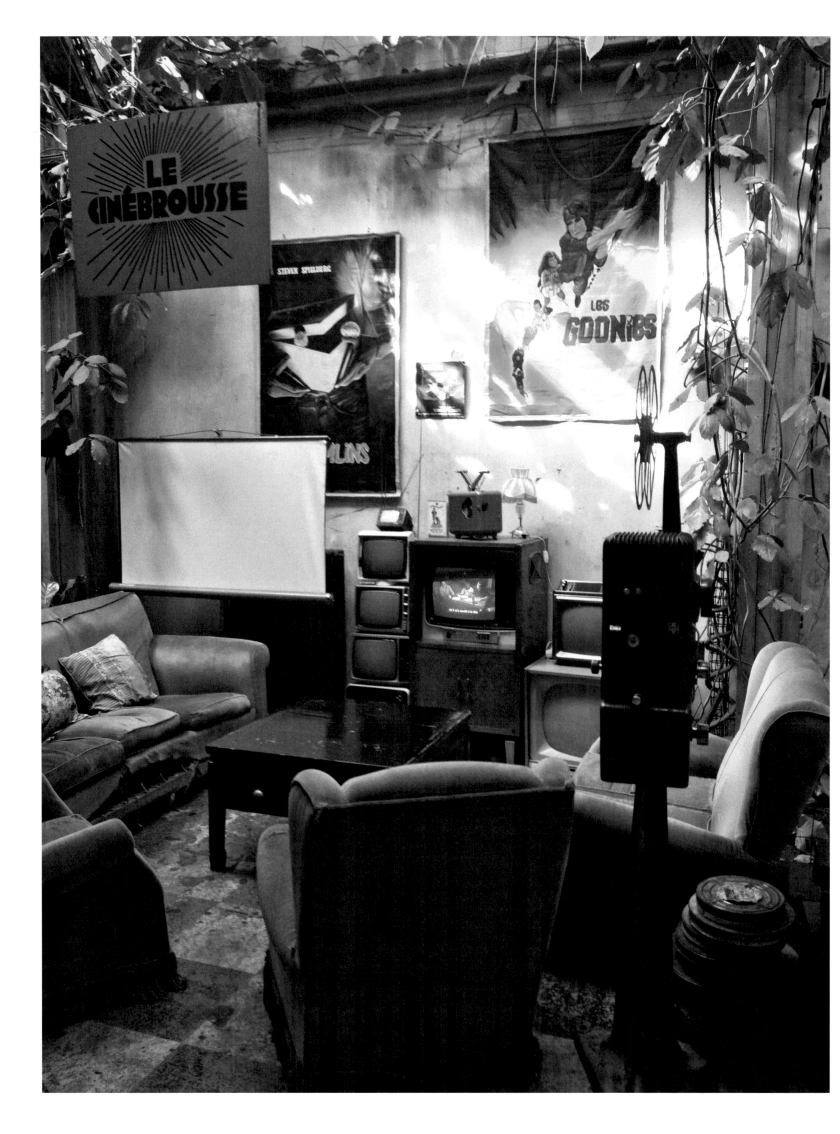

a sense of community that stands out in Paris's cultural scene: together, the foundation's multicultural and multidisciplinary aspects encourage the hip Parisian and international crowds to look beyond themselves and be curious about other parts of the world that might not be on their radar.

Almost everything you see at the Comptoir is for sale, so its treasure hunters are always on the lookout for new exotic trinkets and trifles to adorn the venue. The hired hunters include stylist Amah Ayivi, botanist Sylvie Da Costa, "ragpicker" Martine Husère, and explorer Michel Ballot. With a team like that, no wonder the quirk-filled location looks like it could be a Wes Anderson film set. Amah is a fashion guru and bargain hunter originally from Togo. He exhibits and sells his finds from his headquarters dubbed the Marché Noir (Black Market) on the mezzanine of Le Comptoir Général, and

Vintage knick-knacks from all over the world can be found at the Comptoir

Almost everything you see at the Comptoir is for sale, so its treasure finders are constantly on the lookout for new exotic trinkets and trifles to adorn the venue.

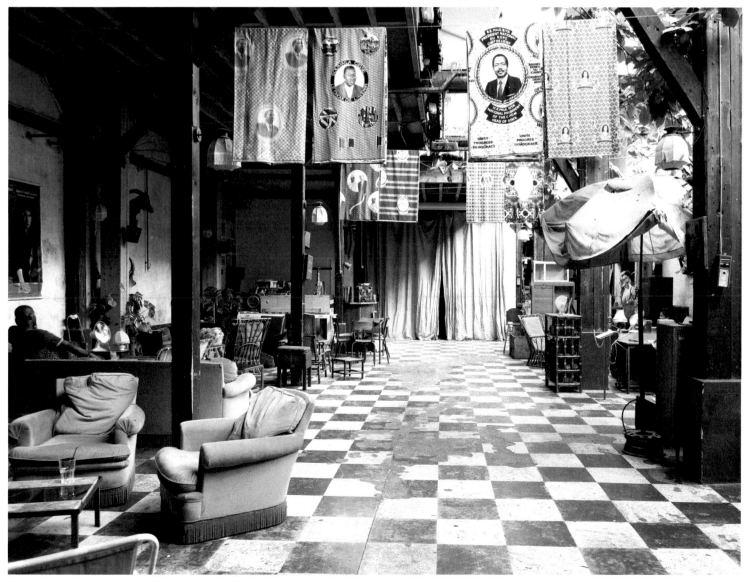

Old checkered floors and colorful second-hand furniture set the scene in this spacious venue

provides expert style advice to whoever is interested in broadening their sartorial horizons. Sylvie is responsible for the Comptoir's urban jungle feel, where lush nature has reasserted itself. She also oversees La Petite Boutique des Horreurs (The Little Shop of Horrors), a lair filled with exotic, rare, therapeutic, "and sometimes even dangerous plants," she teases—or maybe not.

Le Comptoir's social engagement is further channeled through the foundation's *biffine* or "ragpicker," Martine Husère. "Everyone has seen ragpickers, but few people really know them. These modern-day rag-and-bone merchants rummage through bins and pace the city looking for abandoned treasures, which they then resell on the sly, even on the streets. Martine is a ragpicker who has been working with us for several years. She supplies the concept store with her finds and has been tasked with uniting this motley community around a project called the Centre des Objets Perdus (Centre of Lost Property), which is a storage, sorting, and recycling facility we set up in Montreuil in 2014," Le Comptoir explains. Thanks to Martine and her team, Le Comptoir's store stocks otherworldly and unusual finds such as frames, clocks, vintage phones and radios, artworks, trinkets, and other curios that are a delight to sift through.

Explorer and biodiversity consultant Michel Ballot adds yet another dimension and touch of eccentricity to the venue. With a passion for studying animals that are not recorded by traditional science, Michel has found himself on the trail of a legendary animal that the pygmies call the Mokèlé-mbèmbé for more than fifteen years, regularly going to the tropical forest in southeast Cameroun in order to do so. Since 2012, Michel has been working very closely with Le Comptoir Général to produce a participatory adventure dubbed Looking For The Mokèlé-mbèmbé (the same name as the title of a book he wrote documenting his wild search), which includes lectures and a travel agency offering scientific expeditions. Needless to say, Le Comptoir Général is unlike any other cultural center in Paris, or anywhere else for that matter.

Art, politics, religion, fashion, education, botany … Le Comptoir addresses a significant part of the wealth of human heritage through an unconventional lens, in an unusual setting, and with an exceptional team. They see the space as a "temple devoted to exotic cultures, off-piste explorations, and more generally all little-known, misinterpreted, and unloved phenomena," shedding light on "marginal cultures and artistic expressions that lurk in the shadows." The center's unique approach to the consumption of goods and services relating to these themes makes for a memorable experience—one that is unprecedented in Paris's cultural landscape.

Art, politics, religion, fashion, education, botany … Le Comptoir addresses a significant part of the wealth of human heritage through an unconventional lens, in an unusual setting, and with an exceptional team.

Owner: Aurélien Laffon
Founded: 2010
Location: 80, quai de Jemmapes, Paris, France

Hivernacle

Catalan Nursery, Barcelona, Spain

Ignasi Rossinés Bayó founded the nursery in 1967

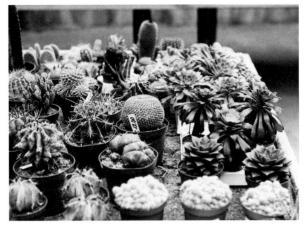

Josep Amargós in 1884. An excellent example of the iron and glass based architecture from the same period, the structure originally hosted the 1888 Universal Exhibition (World's Fair). Today, the building houses a coffee shop and a broad assortment of plant species. The space also can be rented for concerts or exhibitions. A striking juxtaposition between the historic architecture and the verdant greenery makes for an immersive and exceedingly subtle retail experience. Inside, the extensive greenhouse cultivates large cacti, elegant indoor plants, gracious ferns, and much more. Pick out some handsome plants for your home or simply escape the Barcelona rush while lingering over a cup of coffee. The secret hideout will make a gardener out of even the brownest thumb.

A hidden oasis inside a romantic industrial complex caters to plant enthusiasts and architecture lovers alike. The dramatic setting merges the worlds of architecture and gardening into a singular experience. Now more than forty-five years old, the company started by owner and designer Ignasi Rossinés Bayó in 1967 grew into its current location in 1997. Lush and mysterious, the impressive greenhouse and plant center host more than 1,000 square meters of gardening services. The glass, red brick, and steel construction was designed by

Owner/Designer: Ignasi Rossinés Bayó
Founded: 1997
Location: Melcior de palau 32–36, Barcelona, Spain

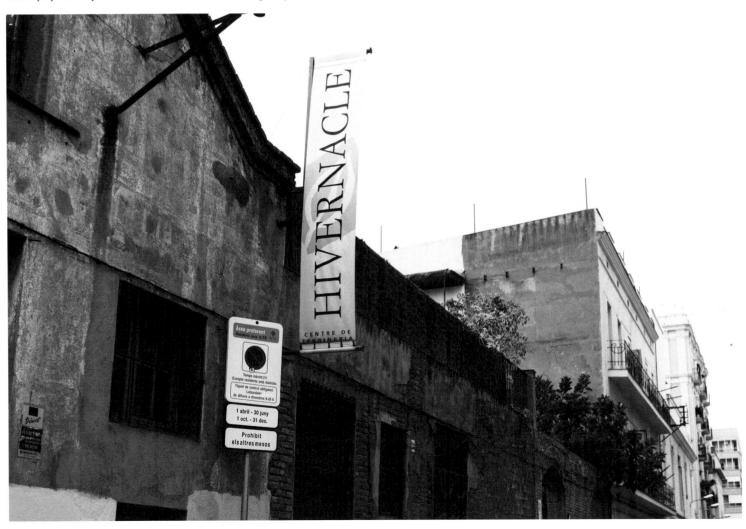

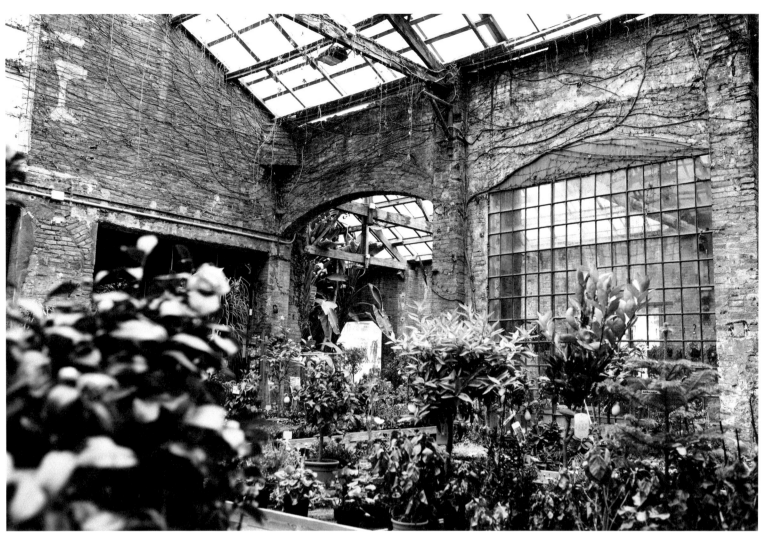

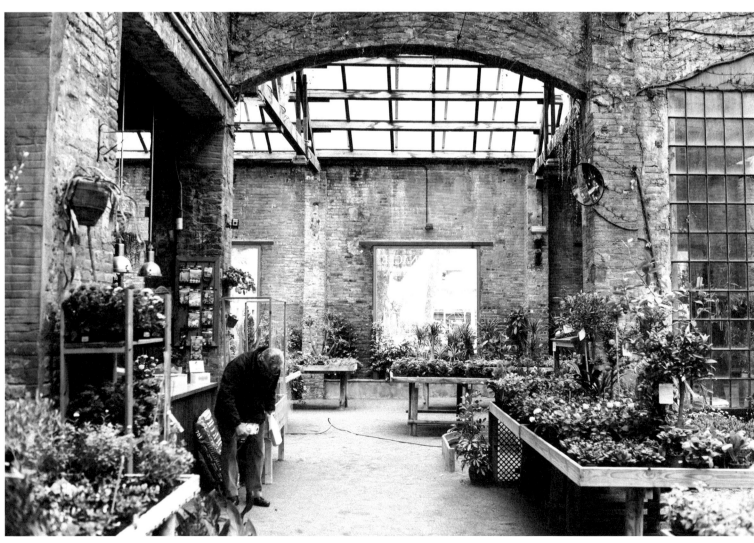

Cactus Whisperers, Los Angeles, CA, USA

Before being hit by an unprecedented drought with no end in sight, it was easy to forget that Los Angeles is in fact a desert. As local residents tear out their lawns and begin replacing them with low-water usage xeriscaping, the cactus has never been more in vogue. Carlos Morera and his uncle John opened their compact and succinctly named Cactus Store in December of 2014. John, a former bonsai guru and veteran nursery man, dreamt of starting an eccentric nursery or plant store for years before the family project finally took shape. Before the launch of the store, his nephew Carlos had just banded together with a group of friends in the hopes of exploring some unusual projects. The friends became the design group Help Ltd. and found a studio space in the neighborhood of Echo Park. The avid cactus collectors decided to help John make his dream of opening a bizarre plant store become a reality. They brought in 2,000 pounds of cacti and 800 pounds of cinder block and the Cactus Store took root. John now acts as the in-house cactus whisperer. His deep connection

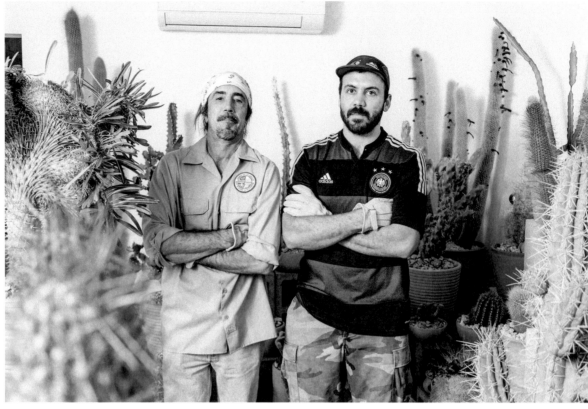

John Morera and his nephew Carlos have run this tiny Echo Park cactus store since 2014

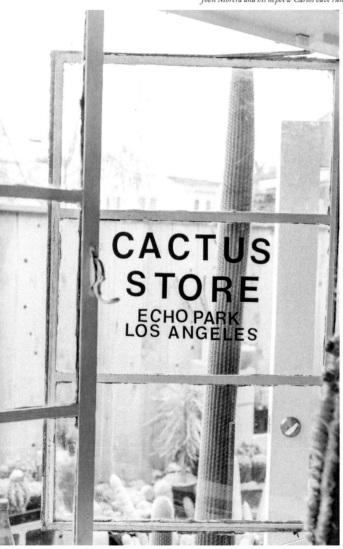

Glass doors open onto a section for outdoor cacti

with the plants relies less on following the rules and more on responding to the individual needs of each cactus.

The tiny shoe box of a shop packs in as many huge, quirky, old, and rare cacti as can fit inside the 250-square-foot interior. Highlighting the impressive variety within this plant family, the shop sells one-of-a-kind specimens that range in price from 24 up to 2,000 dollars. The Moreras and their team of five staff members take pride in diverse curation and never display more than two varieties of the same cactus at a time. Scouring the U.S. deserts and buying from farmers and collectors several times a month, the driven family work tirelessly to uphold the variety and character of the store. All cacti are sold potted, alleviating the stressful at-home transplanting process. Sourced from Mexico, the elegantly understated pots come in a range of colors and glazes.

Clients prove as varied as the merchandise. Each cactus exudes a unique character that attracts its like-minded owner. Like finding a new friend, the cactus shopping process ends up focusing on intuition and first impressions. The tradition of collecting cacti by botanists and general enthusiasts dates back to the Enlightenment.

Nurturing this century's old tradition with humor and spirit, the Moreras bring the love of the cactus to a whole new demographic. Follow your heart and don't worry if your new inanimate best friend ends up being six feet tall and not fitting in your car—local delivery can be arranged for most purchases.

Owners: John and Carlos Morera
Design: Help Ltd
Founded: 2014
Location: 1505 1/2 Echo Park Ave, Los Angeles, CA, USA

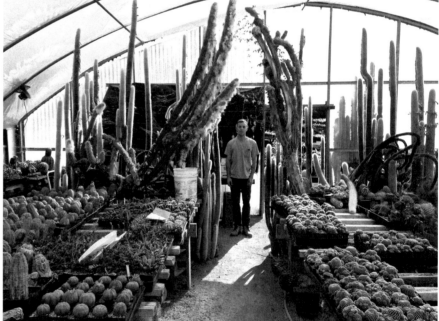

Cactus stockpiles in the off-site greenhouse

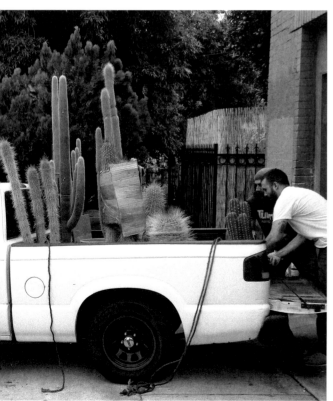

Deliveries around Los Angeles can be arranged for a nominal fee

Gestalten Pavilion

Concept Store & Café, Berlin, Germany

Gestalten Pavilion opened its doors on the roof terrace of the iconic Bikini Haus complex in 2014 as an extension of the values promoted in the publishing house's books, including relentless innovation, quality craftsmanship, and discreet luxury. The Pavilion is home to a café, bar, and store with a meticulously curated assortment of items from off-the-beaten-track labels and covetable brands from across the globe. Whether home accessories, jewelry, culinaria, or design and art books, the selection has been made with the same insight that defines Gestalten publications. The store also showcases Gestalten's exclusive products, which stem from collaborations with both emerging and established international creatives.

Gestalten's publisher Robert Klanten and his wife, architect Lena Klanten, designed the 5,700-square-foot interior as two distinct spaces that meld into each other. In the café section, solid oak tables by the Klantens and heavy leather chairs by designer Jamie Hayon create a cozy yet sophisticated atmosphere. The mixture of hardwood floors and bare concrete walls in the shop section allows visitors to imagine how the products on display might work in their own interiors.

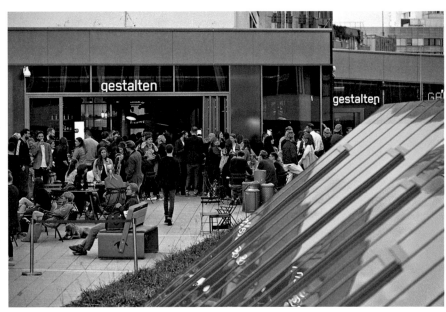

The Pavilion's café and bar extend onto the roof terrace of the famed Bikini Haus

Owner: Robert Klanten
Designers: Robert and Lena Klanten
Founded: 2014
Location: Budapester Straße 38–50, Berlin, Germany

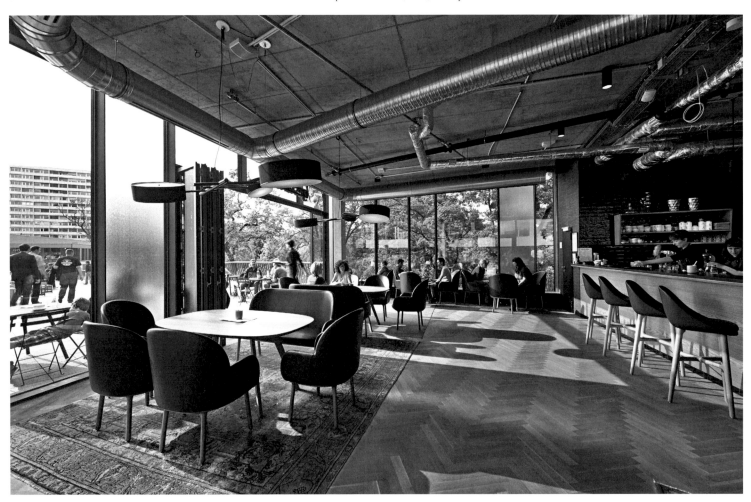

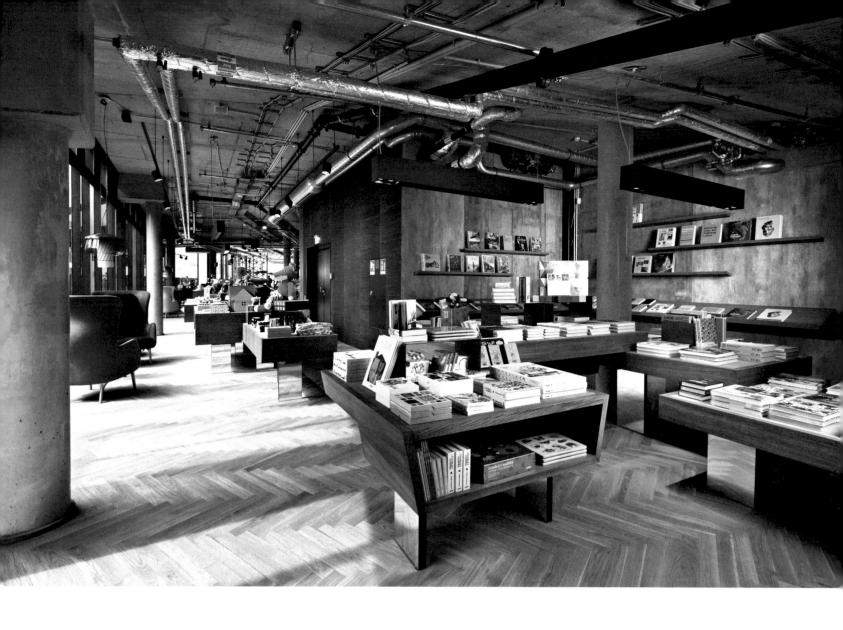

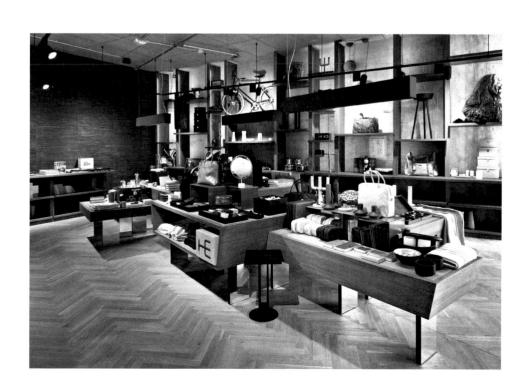

Bazar Noir

Life and Lifestyle, Berlin, Germany

A hovering light wooden staircase in an otherwise all black interior sets the stage for this Berlin retailer's flair for the dramatic and mysterious to take shape. Located in the heart of Kreuzberg between busy Bergmannstrasse and scenic Viktoriapark, the visually provocative brainchild of Catherine Pfisterer offers rare goods from local and international brands and designers. Born and raised in France, she now lives within walking distance of her shop with her husband and two children. Her shop, a combination of the word black in French and a bazar filled with hidden treasures, captures her meticulously idiosyncratic character. Before opening the showroom in 2014, she spent years scouring the globe for objects of desire to fill her home. Her friends quickly responded to her unconventional style and inquired about purchasing her selections for themselves. This positive response from her personal network planted the seed for what would become Bazar Noir.

The striking interior, designed by the Berlin-based studio Hidden Fortress, showcases a carefully selected mix of handcrafted small furniture, objects, books, and art inspired by her family holidays in Morocco. Each one-off item handpicked by Pfisterer shares a simple yet avant-garde camaraderie with the other objects in the space. Of-the-moment designs sit alongside traditional vintage objects, each with an intriguing story about their origin and maker. The 645-square-foot main floor and a more intimate 270-square-foot mezzanine level present a series of ever-changing exhibitions and limited editions exclusive to the shop. Explore every nook and cranny of the sultry space to make sure not to miss any of the intriguing artifacts awaiting their chance at a second life.

Catherine Pfisterer oversees her dramatically staged home and lifestyle goods store in Berlin

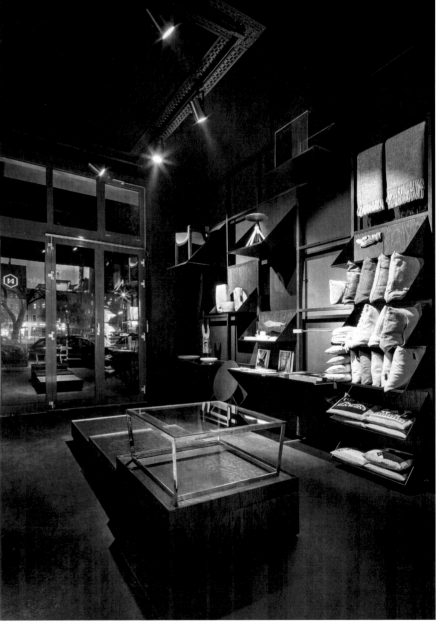

Owner: Catherine Pfisterer
Design: Hidden Fortress
Founded: 2014
Location: Kreuzbergstraße 78, Berlin, Germany

The all black interior highlights the unique product range

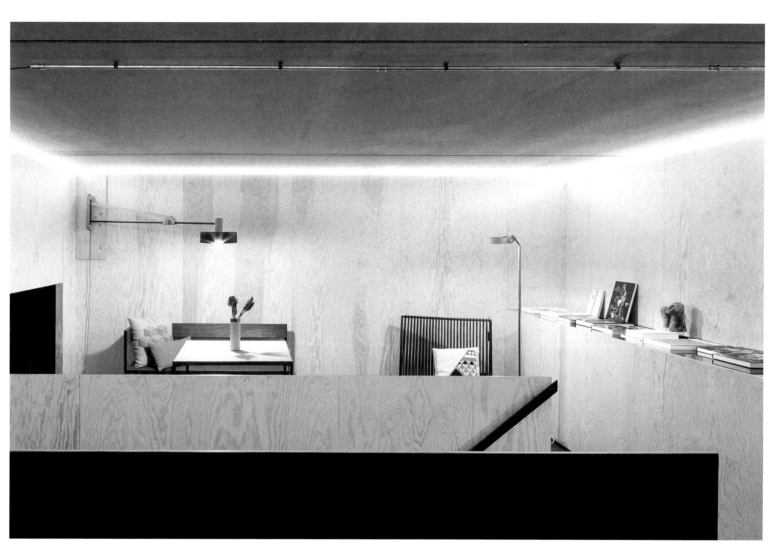

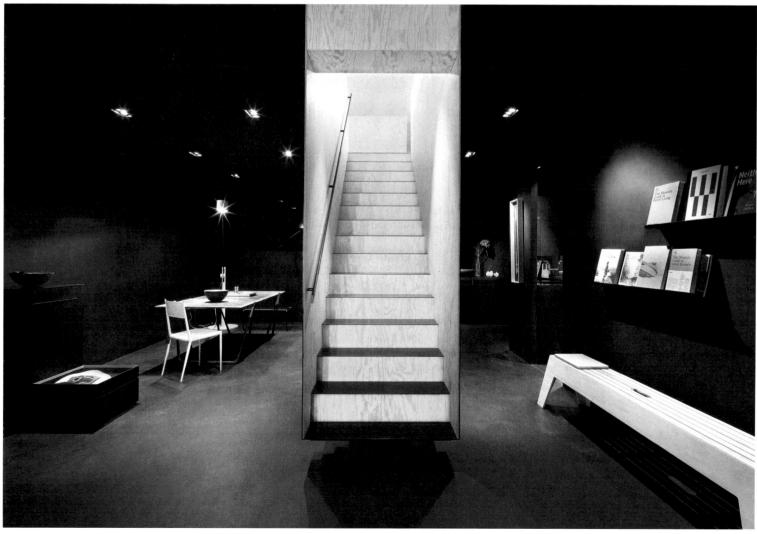

Joseph Cheaney Flagship Store
Shoemaker, London, UK

A shoe lover's paradise, this London flagship honors the heritage and craft of men's footwear. Cousins William and Jonathan Church acquired the English shoemaker in 2009 in a management buyout from Prada. Together, they have overseen the opening of five retail locations in London and developed the brand into new export markets. Checkland Kindleysides designed the 720-square-foot flagship in 2014. Adorned in wooden shoe molds, the shop captures the spirit of the brand's rich history which dates all the way back to 1886.

The legacy brand couldn't have been handed over to a better family. The Church cousins, who descend from five generations of shoemakers, remain committed to the continued production of high-quality handmade shoes. In fact, the family-owned endeavor still uses the same Northamptonshire factory in operation since 1896. From the cutting of the leather to the final polishing, little has changed in the brand's production line and the Church's commitment to quality. Leaving no detail overlooked, each pair of shoes takes eight weeks to make and involves more than one hundred and sixty manual operations. Drop in for a custom fitting and rest easy knowing that your feet are in the hands of experts.

Owners: William and Jonathan Church
Design: Checkland Kindleysides
Founded: 2014
Location: 21B Jermyn Street, London, UK

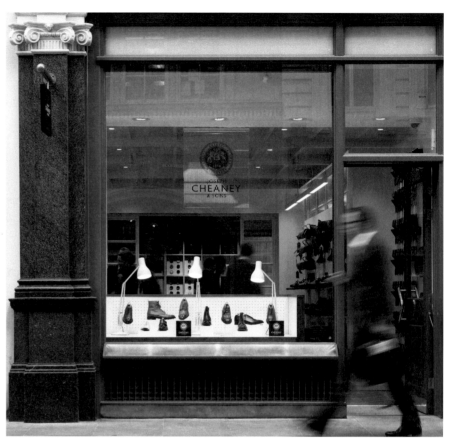

The handsome storefront showcases its custom leather men's boots and dress shoes

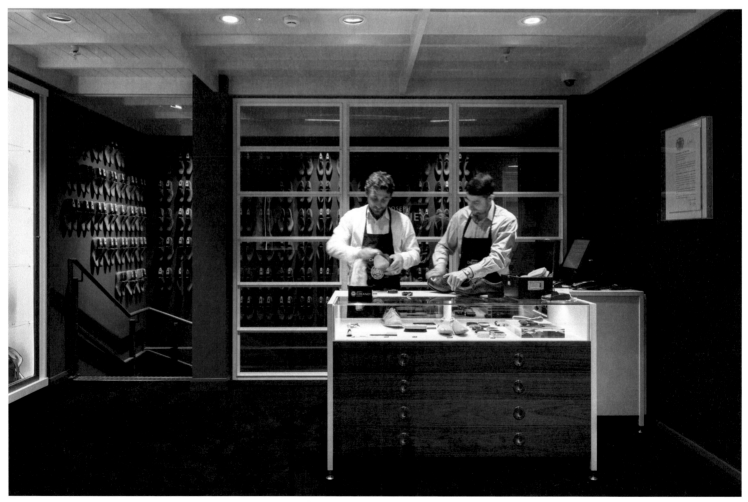

More than one hundred years of expertise informs the quality shoemaking process

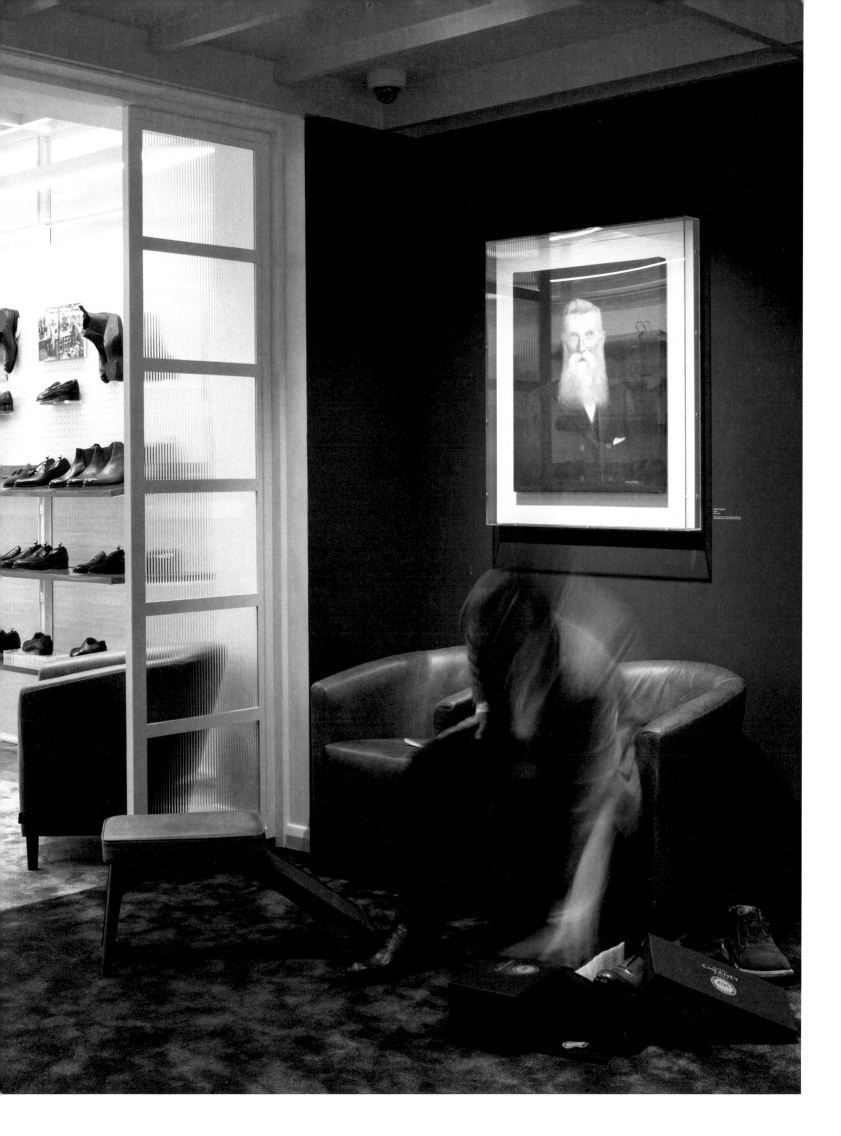

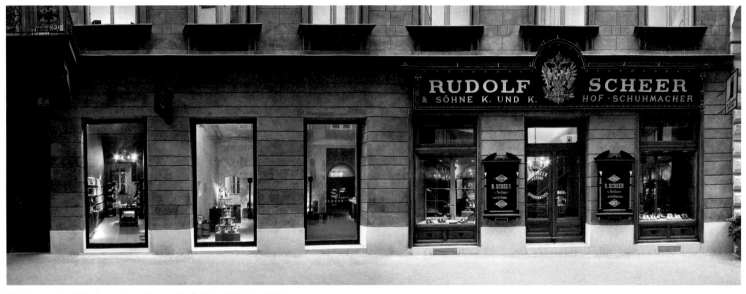

This city center location has been continuously operated by the Scheer family since 1866

The luxury of designing a shoe tailored to one's own foot remains as appealing now, if not more so, as it was when a daring Austrian shoemaker first founded this renowned brand back in 1816. Son of a humble vintner, Johann Scheer decided to break from the family trade and delve into the manufacturing of fine shoes. Under the management of his grandson Rudolf, the business grew during the second half of the nineteenth century to become Europe's most lustrous maker of shoes. Rudolf's virtuosity as an artisan and his winning of a gold medal at the World Fair in 1873 led to Scheer earning the title of "imperial and royal shoemaker to the court" in 1878. Soon, the company became synonymous with the brand of royalty and customers from emperors to kings lined up for their personal fittings in Vienna.

With Rudolf's death came difficult times for the business. The turbulences of the early twentieth century took their toll on the shoemakers' craft. After decades of uncertainty and the end of the First World War, Scheer Schuh—under the leadership of Carl Ferdinand Scheer—entered calmer waters. Carl Ferdinand knew that if things were to remain the same, a lot would have to change. A pioneer in shoe design, he believed a shoe must not only be beautiful and excellently crafted but also good for the foot.

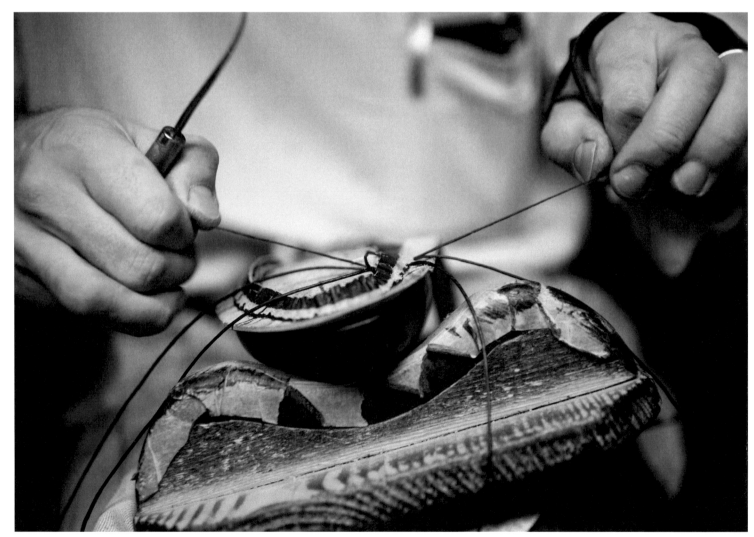

Only 300 pairs of the handcrafted shoes are produced per year

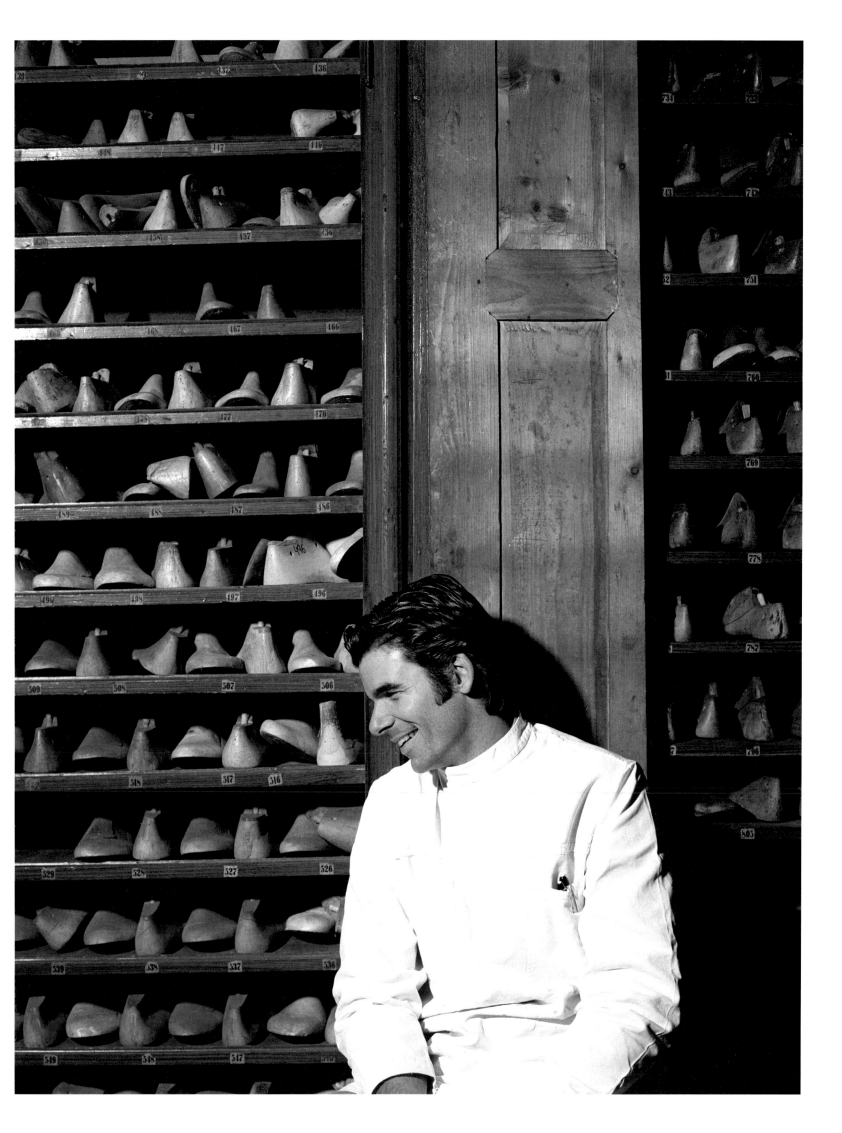

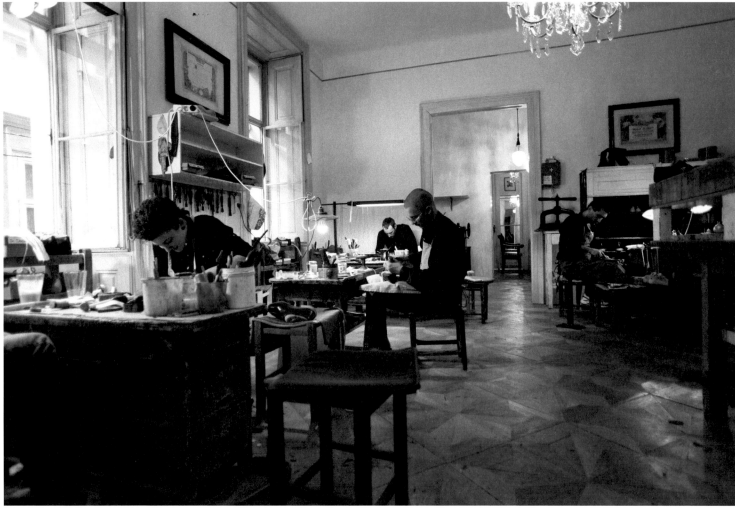

Inside the workshop, master shoemakers work with the same tools and techniques in place for generations

continued from page 56

continued from page 56

Carl Ferdinand experimented with new, more ergonomic designs and worked as a couturier.

The business's rich traditions remain the foundation for new things to develop. Occupying the same space in the city center since 1866, Scheer Schuhe remains an integral part of the family's legacy and local community. Carl Ferdinand's grandson, Markus Scheer, carries on the brand's commitment to quality and style. Following intensive studies in both the craft of shoemaking and medicine, he took over the management of Scheer Schuhe in the mid-nineties. He runs the business in a manner that honors his rich family heritage while continuing their proclivity toward innovation.

Artisanal and uncompromising in detail, the Scheers know that a good shoe takes time. The family trade of bespoke shoemaking has now passed through seven generations of Scheers.

The workshop fashions a maximum of 300 pairs of shoes annually. Each pair requires sixty hours of hand crafting, uniting aesthetic and anatomical considerations. This commitment to handcraft has governed every stitch and cut in the Scheer workshop since 1816. The same awls, stippler brushes, rasps, and stock knives used for nearly two centuries are still in use today. Natural leathers collected over decades are stored in the Scheer family's own material storehouse. To be good to one's feet is to be good to oneself, so why walk in someone else's shoes when you can walk in your own?

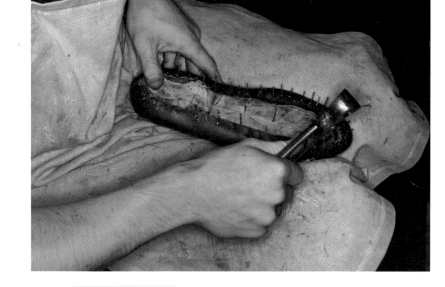

Owner: Markus Scheer
Founded: 1816
Location: Bräunerstraße 4–6, Vienna, Austria

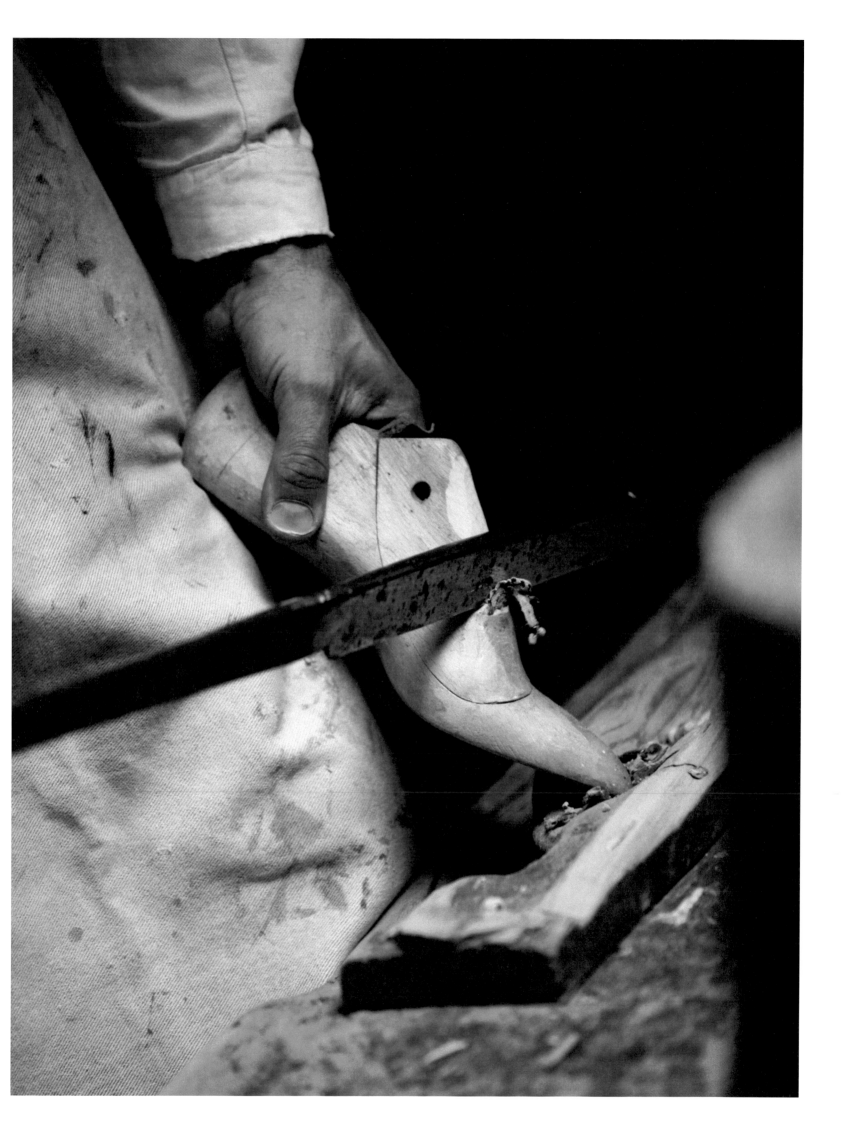

Meisterschuh

Master Shoemaker, Berlin, Germany

Shoemaking, one of the oldest trades, remains alive and well in Berlin thanks to the master cobbler Simon Schäfer. Schäfer and his team of 11 have operated out of a handsome 2,800-square-foot space designed by Simon Schäfer since 2009. The orthopedic, made-to-measure shoemaker keeps the traditional trade alive, preserving classic techniques and tools. Meisterschuh has earned its well-deserved excellent reputation thanks to Schäfer's uncompromising perfectionism, attention to detail, and innate understanding of shape, color, and proportion. Schäfer and his team design and craft shoes from scratch and help recapture the original splendor of their customers' favorite pairs. The exceptional craftwork takes place right in front of the customer. This large and open workroom enables clients to experience the smell, feel, and construction process first hand. Schäfer's unparalleled and deeply insightful cobbling work is sure to return the spring to your step.

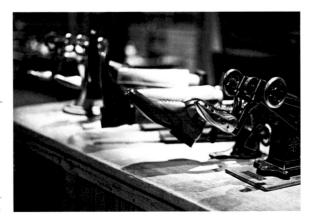

Owner/Designer: Simon Schäfer
Corporate Identity: Elena Anna Rieser
Founded: 2009
Location: Engeldamm 64, Berlin, Germany

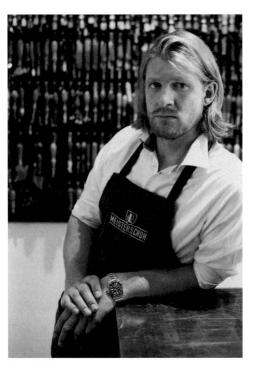

Simon Schäfer, the owner

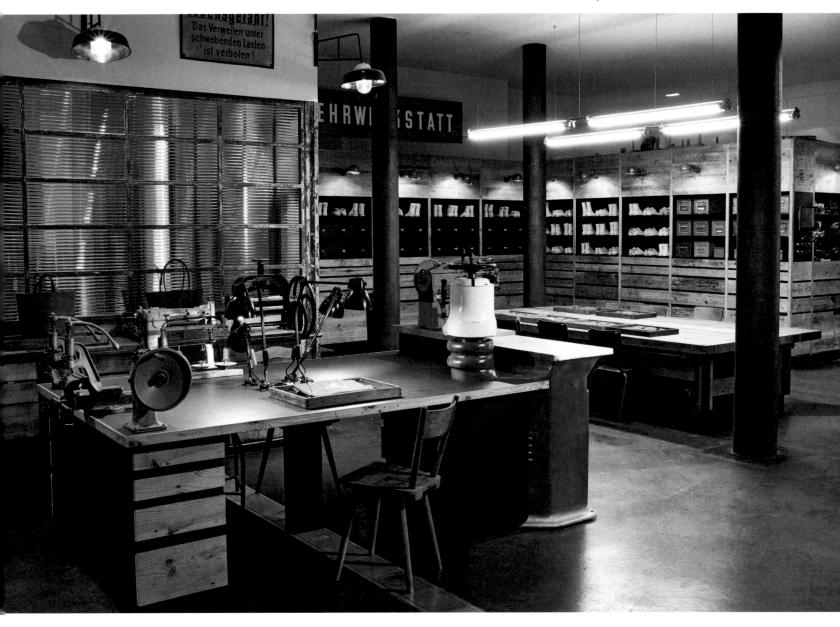

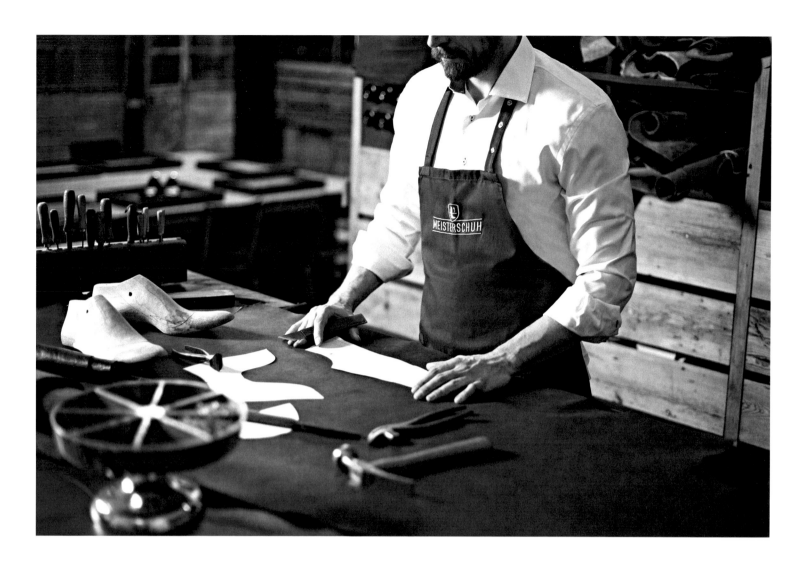

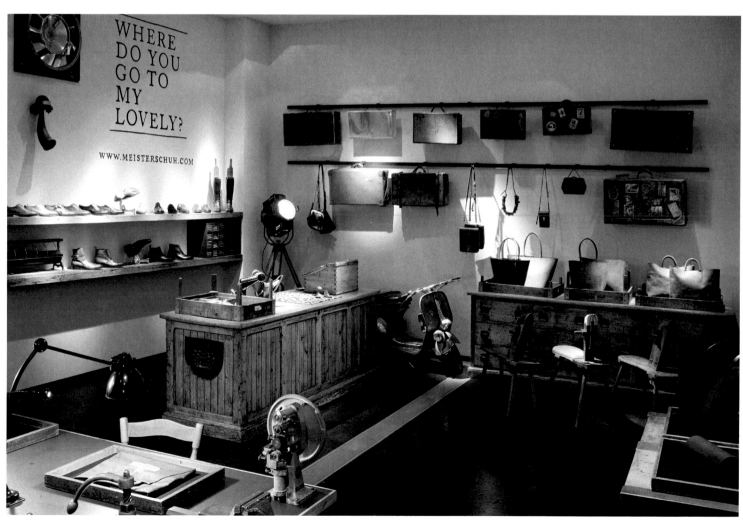

WHERE
DO YOU
GO TO
MY
LOVELY?

WWW.MEISTERSCHUH.COM

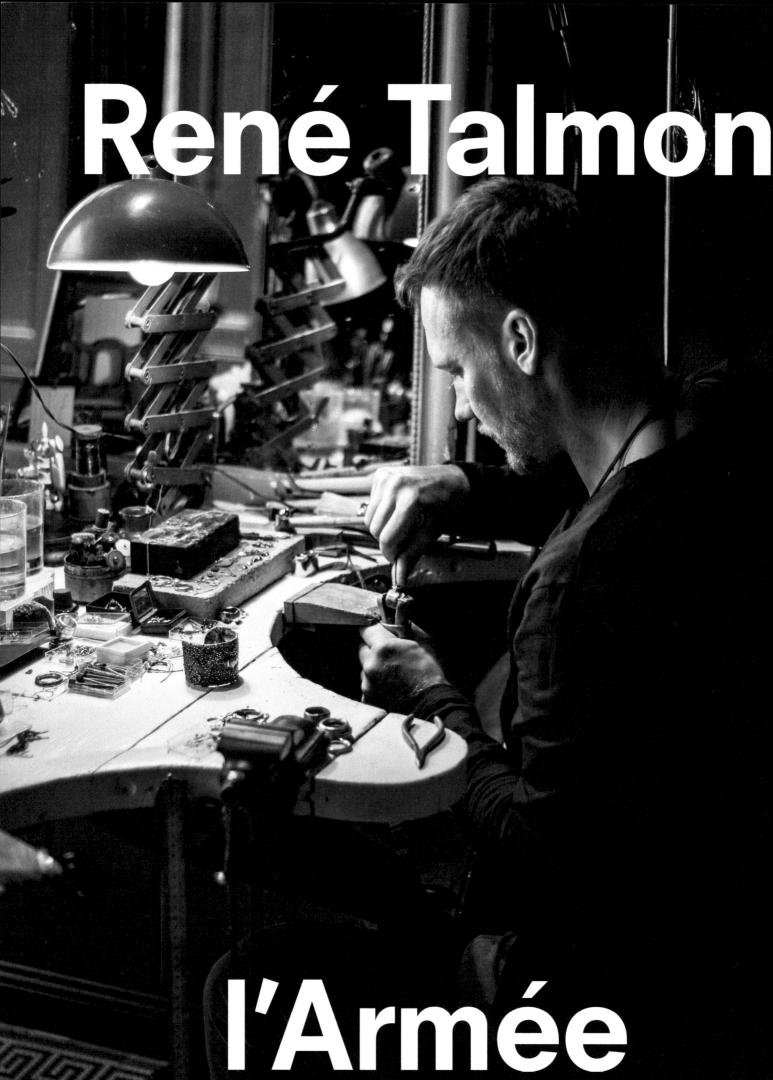

René Talmon

l'Armée

A classically trained jeweler, **René Talmon l'Armée** brings rigorous craftsmanship to ruggedly rebellious designs.

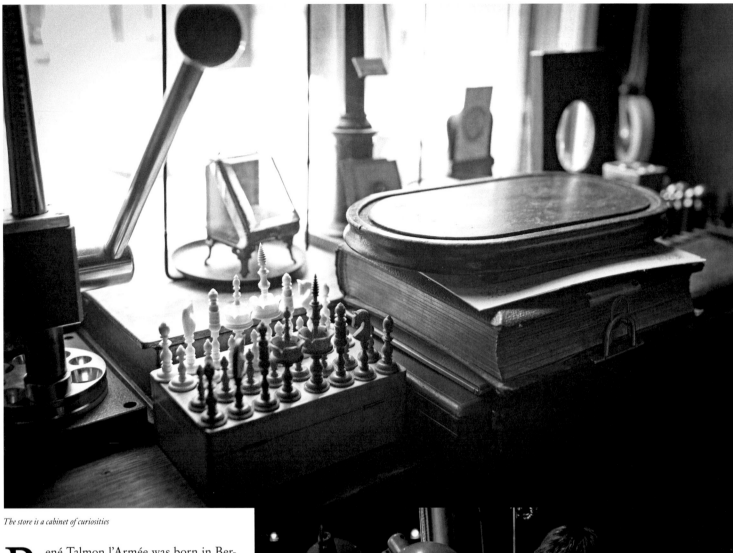

The store is a cabinet of curiosities

René Talmon l'Armée was born in Berlin to a family with origins tied to eighteenth-century French craftsmen. A love of artisanship clearly in his genes, he went on to receive traditional training as a goldsmith in his home country before reuniting with his French lineage and moving to France in 1995. There, René worked in a prestigious jewelry workshop with top-tier clients including the famed fashion house Hermès. In 2001, he opened his own atelier nestled behind the Saint-Nicolas-des-Champs church in Paris's third arrondissement. "The Paris store has been around for 15 years now, yet some of our clients are still surprised to discover our shop," shares René. Certainly the charm of a hidden gem. "It was originally a jewelry factory; it inspired me the minute I walked in and continues to do so." Along with the space came various original tools such as hammers, anvils, and jewelry magnifying glasses. René still uses these vintage instruments to craft his entirely hand-made pieces with a distinctly intimate approach to each new refined yet edgy creation—whether for his collections, special editions, or made-to-order bespoke pieces including wedding rings.

In 2011, René opened a second shop in his hometown in the historical district of

René knew very early on that he was passionate about fine jewelry making

Scheunenviertel, an old artisans' quarter that now hosts the gallery scene of the trendy Mitte neighborhood. Commenting on his two stores, René notes, "These places have a soul—you have to feel good in a space in order to create beautiful things. The two ateliers are in the center of Paris and Berlin. They are at once in the heart of the city and tucked away in calm corners to bring out the best in artisanal work, which demands tremendous concentration." Indeed, all of the jewelry displayed in René Talmon l'Armée stores are handmade with

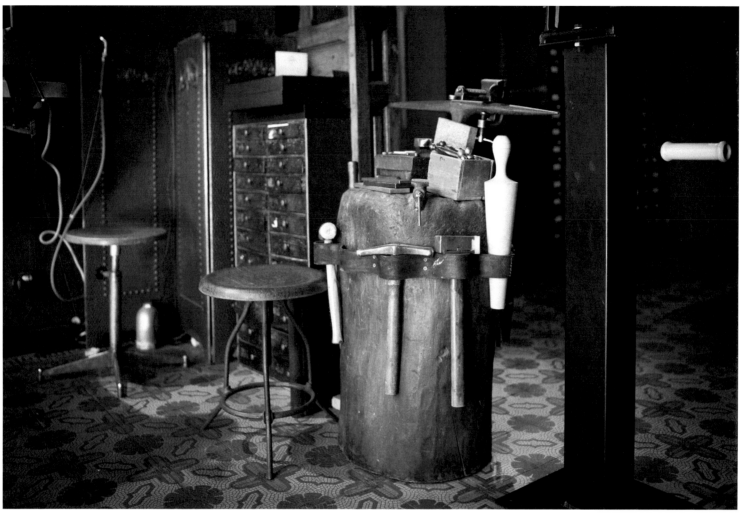

René uses original tools such as hammers and anvils that date back to the early traditions of jewelry making

only the finest available materials: "I mostly work with oxidized silver and gold to give my pieces their distinct RTA look, which is very recognizable. We give them a dark, somber, and mysterious patina, and with time this oxidization wears off, letting the silver be revealed. Therefore, the older the piece of jewelry gets, the more the surface of the object will be interesting. I choose rough diamonds of various natural colors in tune with my materials, motifs, and desires in organic forms."

Nature, old jewelry, and noble metals inspire René. One of his most recent designs is an equestrian-inspired ring in oxidized silver with

outside of the realm of classical jewelry designs and espouses a more avant-garde aesthetic. His workshops appear as anterooms into mysterious domains with old, dark wooden tables, and period-style chairs and display cases. René explains, "As a result of collecting beautiful things over a long period of time, I've naturally put some of them in my stores—objects from all over the world. I've always loved the atmosphere of a cabinet of curiosities. I like the idea of having drawers everywhere, so that customers can imagine their own treasures lying inside, and I like showing the tools we use to create the jewelry, to have that direct link between the making pro-

of our jewelry; people who are passionate about craftsmanship and with whom a connection is therefore easily and quickly established. Many great encounters!"

With respect to the two store locations, René shares that he believes "Berlin brings to Paris its free-loving spirit and its modern and raw art, and Paris brings to Berlin its poetry as well as rich history." The two cities have such different—and at times even opposing—reputations that it might seem incongruous to house a brand's two storefronts in these spots, yet beyond family ties and origins, it makes perfect sense for René Talmon l'Armée to have done so: his creations show classically-trained artisanship infused with Parisian rigor alongside a rougher, unpolished edge that resonates with Berlin's youthful rebelliousness.

For René, creativity has no limits and it must be expressed. "To anyone who is thinking of opening their own storefront, I would say: Know how to share your passion. Each project is unique, and you just have to find a way to bring it to life and to share it." As a physical representation of a brand's values and aesthetics beyond a simple means of immediate commerce and product presentation, a shop is a space that allows for elaborate staging, for

I've always loved the atmosphere of a cabinet of curiosities. I like the idea of having drawers everywhere, so that customers can imagine their own treasures lying inside.

a finely cut flat gray diamond of several carats. Its color is intense, underlined by a yellow gold thread, and shines radiantly. Every one of René Talmon l'Armée's rings clinch natural rough diamonds, in yellow, brown, and gray hues. Known mostly by those attracted to resolutely non-mass production creations, René works

cess and the resulting product." Over the years, the René Talmon l'Armée brand has grown to have a real client network, with many customers becoming returning clients: "People who come into our store without knowing the brand usually do so because they are attracted to the store aesthetic, and so by extension to the aesthetic

A shop is a space that allows for elaborate staging, for a universe to unfold.

a universe to unfold. René sees his spaces as such: "Once inside and surrounded by rugged yet precious treasures in the form of various colored rough diamonds, oxidized silver, gold, leather-textured alloy prints, and aquamarine and cabochon stones, visitors realize they have entered into a unique dimension: a singular blend of old-world goldsmith artisanship and haute jewelry techniques with intuitive, daring creativity."

Many René Talmon l'Armée pieces are unisex, which in and of itself sets René apart from most jewelry designers. Using traditional techniques and subverting them to create nontraditional pieces is an integral part of René's identity as a craftsman. His work appeals to a wide range of customers, from people looking to expand their ornamental horizons and experiment with something a little more daring to clients who already embrace a more rugged style and are looking for a special piece to add to their collection that will last them a lifetime.

René knew at a very young age that he was passionate about the art of high-quality jewelry making, yet it was a few years before he was old enough to get the proper training, so he got a first job helping restore churches and apartment buildings in the meantime. The diligence and attention to detail that this type of work requires has undoubtedly had a lasting impact and came in handy during the prestigious training he was later able to receive. René now welcomes a few lucky apprentices into the atelier in his Paris storefront from time to time, passing on his passion to eager novices.

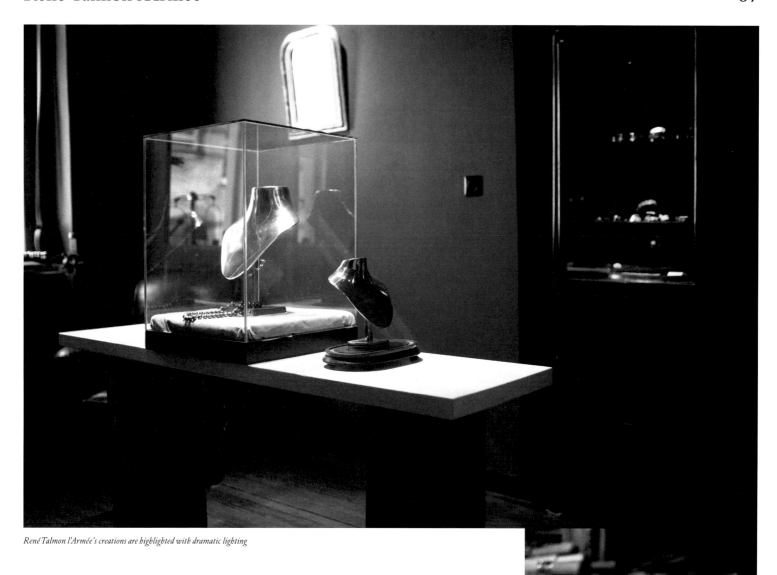

René Talmon l'Armée's creations are highlighted with dramatic lighting

Owner: René Talmon l'Armée
Founded: 2001 (Paris) / 2011 (Berlin)
Locations: 3, rue Cunin Gridaine, Paris, France /
Linienstraße 109, Berlin, Germany

The Footwear Fix, Melbourne, Australia

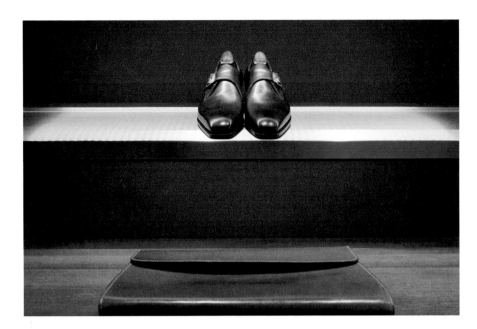

Bringing the best of English handmade shoes to Australia, two brothers redefine the fashion down under one foot at a time. Nick and Chris Schaerf began their careers in extremely different fields. With one specializing in medicine and the other in law, the brothers decided to try something new and turn their passion for shoes into a family business. In 2013, they set out to share their fondness for foot-

wear with the general public. The duo opened an immersive bespoke shoe store in Melbourne designed by Antony Martin of MRTN Architects.

The brothers in their saloon-like shop welcome aficionados and novices alike to gather and ruminate over waxed laces and trouser cuff lengths. All of the custom shoes available inside are made by hand

using the finest leathers. Elevating shoe shopping to an art, each purchase slips into a velvet bag that gets wrapped in tissue and presented in a printed box. Although not made in-house, the timeless and bespoke nature of the trade permeates all aspects of the store's presenta-

tion and culture. The shop's warm stained timber, copper sheeting, and pool table velvet craft a layered universe of classic luxury. Within this setting, customers linger over the products and conversation. A step in the right direction for Melbourne style, the shop begins and

ends with shoes. Mixing the elegance of the finest retailers with the familiarity of a home parlor, the Schaerf brothers ensure that the quality, craft, materials, and history that go into each pair play a key role in each customer's experience and takeaway memory.

Owners: Nick and Chris Schaerf
Design: MRTN Architects
Founded: 2013
Location: Smith Street, Fitzroy, Melbourne, Australia

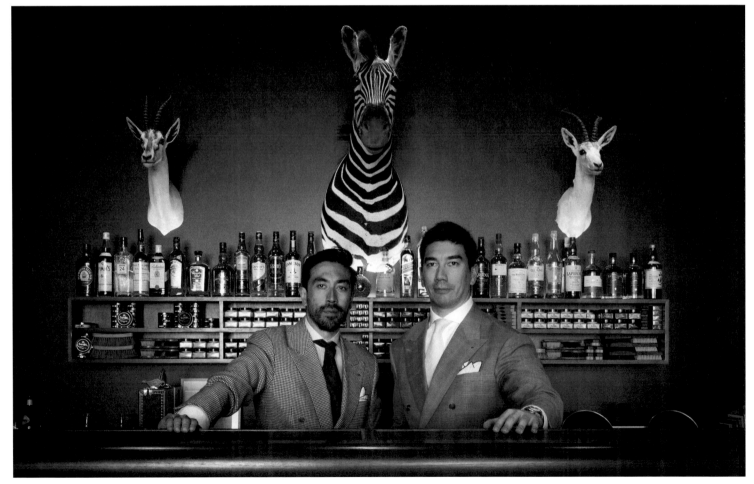

The owners Nick and Chris Schaerf

P.G.C. Hajenius

The Tobacco Temple, Amsterdam, The Netherlands

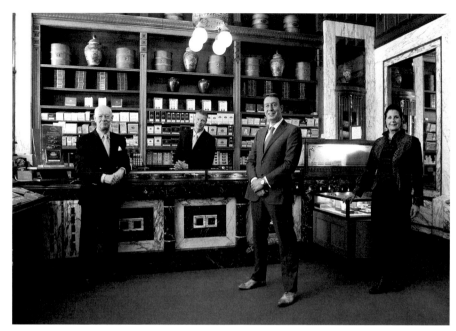

Owner: Scandinavian Tobacco Group
Designer: Brothers Van Gendt
Founded: 1826
Location: Rokin 96, Amsterdam, The Netherlands

fied town of Doesburg for Amsterdam to realize his dream of opening a store selling only the finest cigars. A born businessman, his first store opened in the elegant Hotel Rijnstroom on the Vijgendam. The prime location set Hajenius just a stone's throw away from the Tobacco Exchange, thirty small cigar factories, and a prosperous clientele. From here, he partnered with the region's top cigar makers that sourced the choicest tobacco for his signature brand of cigars. An A-list clientele made the store an immediate success, attracting prominent industrialists and even royalty.

The market for a Hajenius cigar soon extended far beyond national borders. Pressed for space and in high demand, he moved to a new location on the Dam. After again outgrowing his quarters, the store's third relocation would be

the last. Now celebrating its 100th anniversary, this store on the Rokin was built from scratch by the Brothers Van Gendt to reflect the brand's prestige and heritage. The regal cigar house, constructed in German sandstone, remains an alluring time capsule of Art Deco glamour. Little has changed since the founder's heyday. Fine Italian marble, intricate ornament, and colossal chandeliers that date back to the time when Amsterdam was still lit by gas are just a few of the opulent details preserved inside. Steeped in tradition and synonymous with good taste, the Scandinavian Tobacco Group keeps Hajenius's spirit alive in this temple of cigars and pipe tobacco. If you can't make it to the tobacco farm, this is the next best thing. Go ahead and indulge a little, after all, you'll be smoking a part of Amsterdam history.

Little of the original turn-of-the-century splendor has changed inside this legendary tobacco shop

With origins dating back nearly two centuries, the legendary House of Hajenius has called Amsterdam's Rokin boulevard home since 1915. The timeless connoisseur of Dutch and South American varieties is one of Europe's oldest and most lauded cigar houses. The now iconic shop was conceived by the nineteen-year-old Pantaleon Gerhard Coenraad Hajenius in 1826. The young Hajenius left the forti-

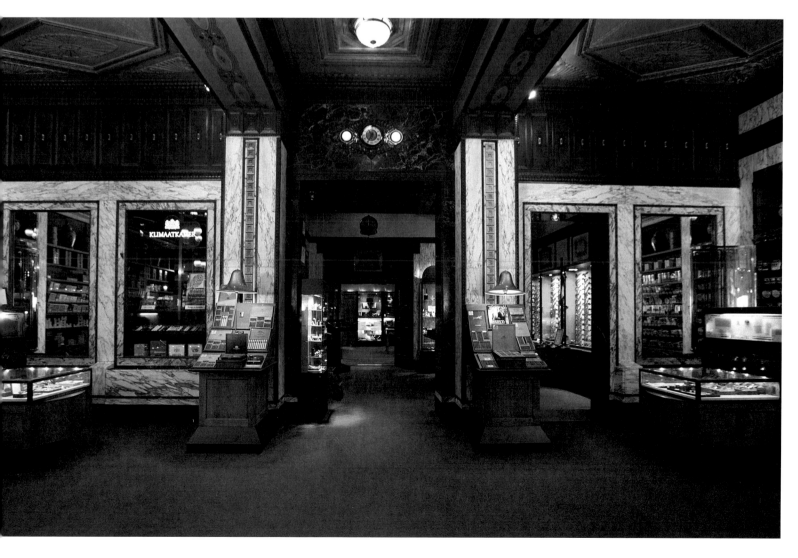

Sébastien Gaudard
Parisian Pâtisserie, Paris, France

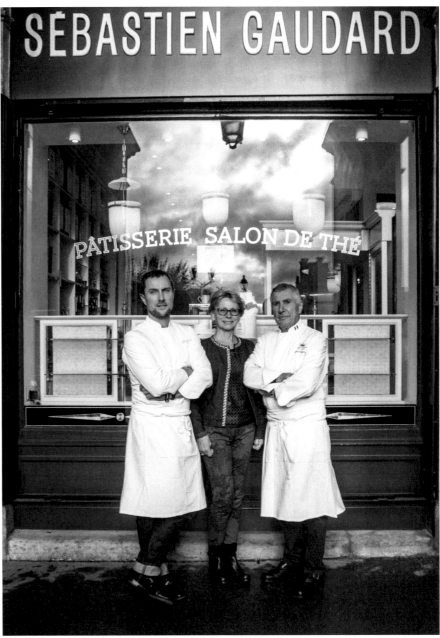

A visit to Paris and a visit to a bakery are one and the same. The world capital for tantalizing pastries retains its unrivaled status thanks to pâtisseries like Sébastien Gaudard. Learning the trade from his father Daniel Gaudard, another luminary local baker, Sébastien opened up this timeless pâtisserie in 2011. Embodying a classic old world Parisian spirit, the forest green storefront beckons passersby with its tempting window displays. Playing with marizpan even as a child, Sébastien began learning his father's trade from an early age. Before going into business for himself, Sébastien had a bright career in the industry first working with pastry master Pierre Hermé at Fauchon and then running Délicabar inside the Bon Marché. Word of his talent spread and he soon became known as "the little prince" of pastry. Délicabar closed in 2009 and his own shop opened just two years later to a warm reception. The painstakingly crafted desserts elevate the pastry into a delicacy and the craft of baking into an art. Almost too beautiful to eat, the tarts, éclairs, scones and more feature seasonal fruits, forgotten tastes, and a prowess that only comes with time. Infusing his father's legacy and trade secrets into every bite, Sébastien's nostalgia-inducing delights awaken our taste buds and our childhood memories.

Owner: Sébastien Gaudard
Founded: 2011
Location: 22, rue des Martyrs, Paris, France

Pastry chef Sébastien Gaudard opened his first independent location in 2011

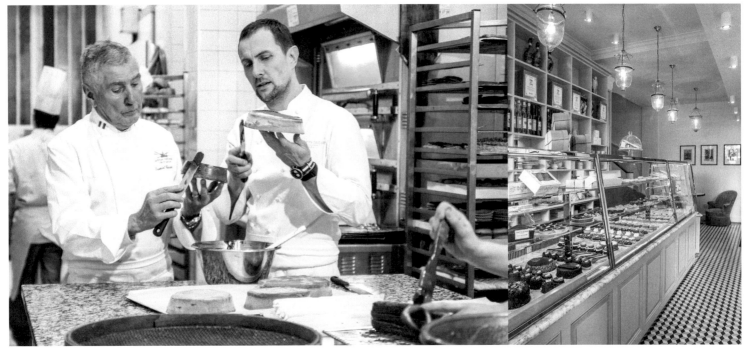

All of the delicacies are made by hand and crafted on-site

The legacy skin care and fragrance company has been in operation for over two hundred years

Armed with its founder's spirit of conquest and innovation, L'Officine Universelle Buly creates new skin care concoctions, drawing on the most innovative cosmetic techniques and the virtues of natural ingredients. Dreamt up in Paris in 1803 and relaunched in 2014, the French laboratory formulated products have kept up with the progress of contemporary cosmetics while staying faithful to the old recipes. Paraben and silicon free, the brand favors formulations which avoid ingredients that interfere with its pure scents. A universal trading post for beauty secrets amassed over the centuries, L'Officine transforms raw and potent materials from around the world and across history into oils, incenses, accessories, and more.

Jean-Vincent Bully's historic company began its legacy in the late eighteenth century, setting up shop on Rue Saint Honoré in Paris. Bully quickly made a name for himself with his coveted perfumes and scented vinegars and his perfumers kept his trade secrets intact through the turn of the nineteenth century. This period marked a renaissance in French perfumes, as novel and exotic flowers from around the world began to be imported and inspire olfactory delight. Napoleon helped usher in new requirements for perfumes and Bully, a distiller, perfumer, and cosmetician, welcomed the advances. His scents and skin care concoctions achieved lasting fame, with the "Vinaigre de Bully"—a patented aromatic lotion—earning a flattering reputation across Europe.

This classic beauty product ensured the brand's unprecedented stature for more than a hundred years. The brand's recent relaunch, which includes a slight modification to the spelling, moved the company of 12 (staff members) to a 645-square-foot storefront on rue Bonaparte in the sixth arrondissement. L'Officine Universelle Buly has since invented the first water-based perfume for the skin which now comes in eight fragrant combinations from Damask Rose to English Honey. Treat your nose to a piece of history—the long lasting fragrances will keep heads turning all day.

Owners: Ramdane Touhami and Victoire de Taillac-Touhami
Founded: 1803, relaunched 2014
Location: 6, rue Bonaparte, Paris, France

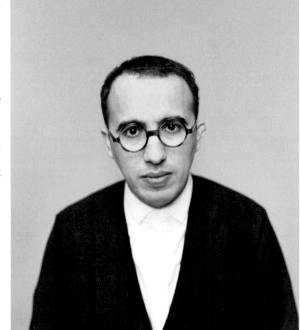

Ramdane Touhami, the owner

Tincan

Canned Delicacies, London, UK

Architects turned shop keepers, AL_A, acted as the client, curator, and designer of this tiny tinned seafood restaurant. The concept came about organically while the team was designing a new cultural center in Lisbon. Here, they discovered a former fishing tackle shop, which had been transformed into a vibrant micro eatery serving only tinned seafood. What started as a tasty lunch quickly became an idea, and subsequently a new project. Amanda Levete and her team brought this business idea back to London where they set up shop inside a 430-square-foot storefront in December of 2014. Levete, a Stirling Prize winning architect and founder of AL_A, grew out of Future Systems, a widely regarded and influential architecture practice. She trained at the Architectural Association in London and worked for Richard Rogers before joining Future Systems as a partner in 1989. Prolific and accomplished, Levete is a radio and TV broadcaster, writes for a number of publications, lectures worldwide, and manages Tincan. The compelling shop and restaurant elevates the tin to an object of desire. Operating without a kitchen, Tincan serves up 30 different tins of the highest quality seafood to enjoy in the restaurant or take away from the shop. The shop window and restaurant spaces feature a novel display of tins suspended in a playful, rhythmic pattern. Purposefully mismatched, the tins take on an exhibition-like quality, with each expressive graphic and illustration given its due respect. From the sea to the tin to your plate, Tincan mixes healthy delicacies with a taste for design.

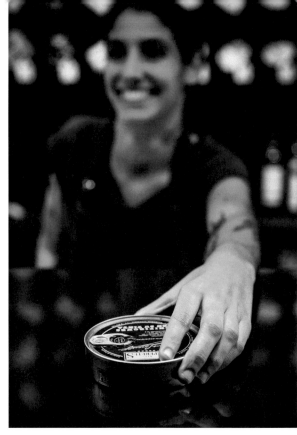

All seafood items come in their individual tins

Owners/Designers: AL_A
Founded: 2014
Location: 7 Upper James Street, London, UK

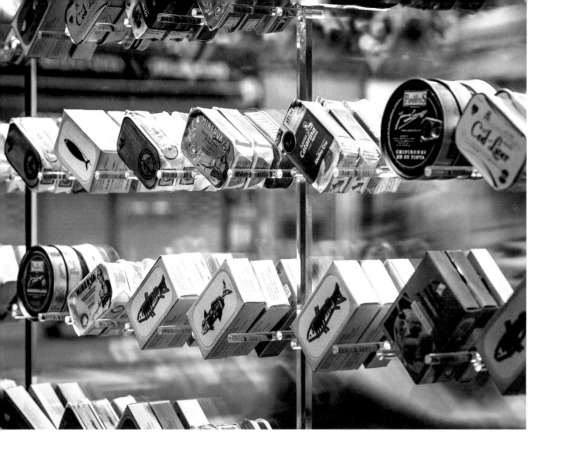

Fiona

Bennett

Chapeau!

Fiona Bennett is known as one of the world's most extravagant hat designers. While she received classical training as a milliner, her creations are by no means traditional.

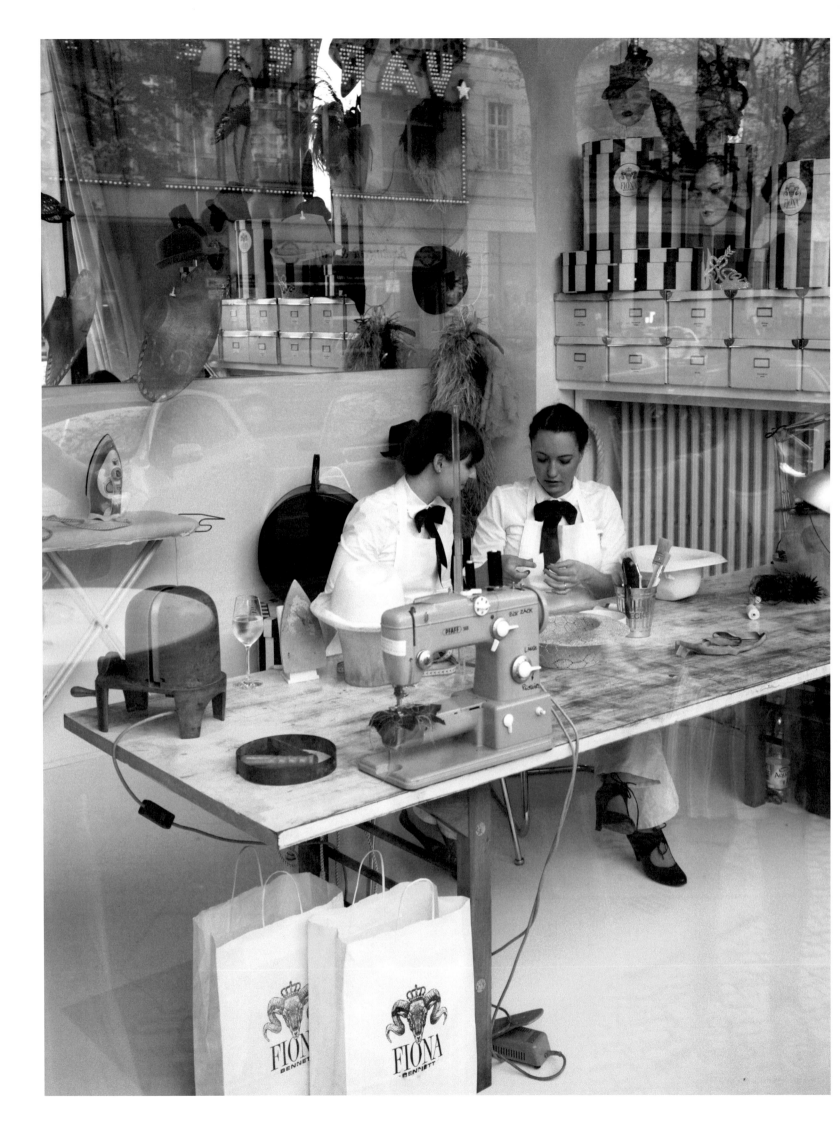

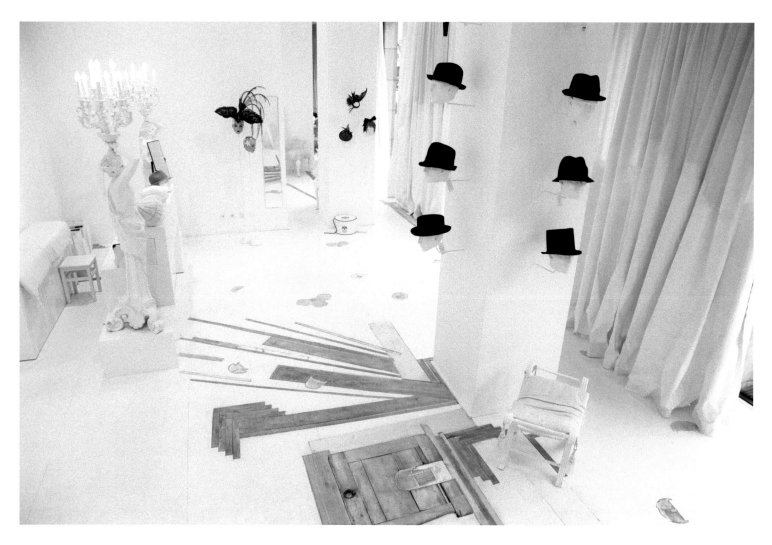

Fiona Bennett was born in England but has lived in Berlin since the age of six. The city's whirlwind of transformations throughout the decades has undeniably influenced Fiona's eclectic and eccentric style that she has become renowned for in Germany and beyond. When she was receiving her education as a milliner, Berlin was divided by a wall, and her life in the strange island that was West Berlin at the time greatly inspired her creations.

When the wall was torn down in 1989, the newly reunited city was oozing with creative energy. Fiona moved into an old soap factory in the former East, and started to invent her universe and develop her label. Her studio was in a dusty backyard and quickly became a melting pot of artists and the host of many wild ideas. Vivienne Westwood spent time there, and recommended Fiona for a position as lecturer at the University of Arts in Berlin, which Fiona filled from 1994 to 1996.

In 1999, the neighborhood of Mitte where Fiona opened her first store selling her handmade, highly individual hats gradually started attracting art galleries, specialized boutiques, and trendy restaurants. Berlin was beginning to find its own brand of glamour, and celebrities often passed by Fiona's shop when in the German capital to pick up their Fiona creations in her trademark black and white striped hatboxes. Big names such as Veruschka von Lehndorff and Brad Pitt came and increasingly put Fiona Bennett on the international fashion radar. As Mitte became more established and overly hyped up for some people's taste, Fiona closed her storefront and worked on a second line of hats with her fashion manager Emmy Urban, which they called Kiss. The line features

more casual and more affordable hats, though designed with the same care and attention, and also handmade in Berlin.

In 2012, Fiona opened a new shop on the famous Potsdamer Straße, the large east-west axis running through Berlin that is home to Turkish supermarkets, sex shops, and a variety theater. As the designer sees it, the street's diversity and upbeat rhythm are a welcome change in setting, fueling the type of atmosphere that Fiona is inspired by nowadays. More than a store, the Fiona Bennett shop is in fact a platform to showcase the brand's universe. Its large windows are an invitation into Fiona's world of whimsical creations, a door onto her atelier where talented and dedicated milliners carry out her designs by hand with exemplary handcraft skills and in uniforms reminiscent of turn-of-the-century ensembles worn by seamstress demoiselles in Paris. With passers-by and shop visitors as an audience, the milliners' work becomes a spectacle of quality and imagination, the result of which is displayed playfully in the shop's interior. The predominantly white space was designed by

Feathers are just one of the many materials that Fiona experiments with for her creations

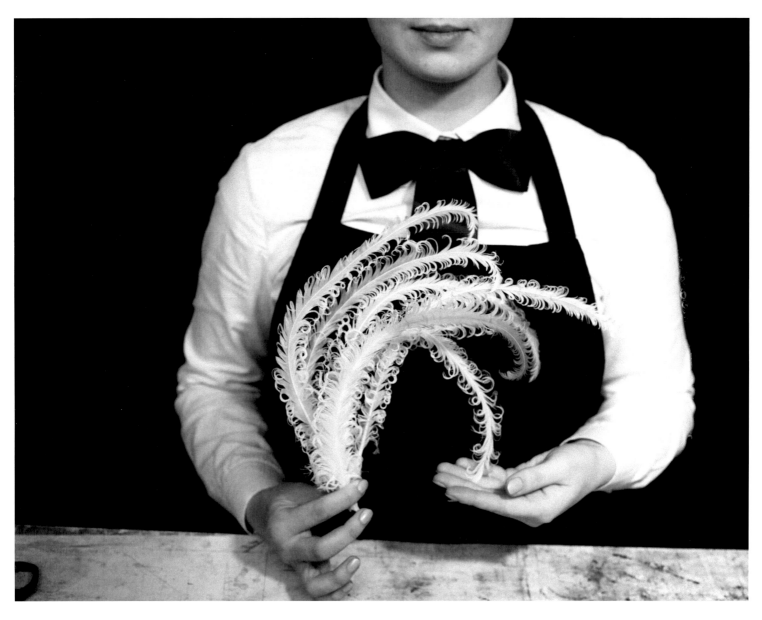

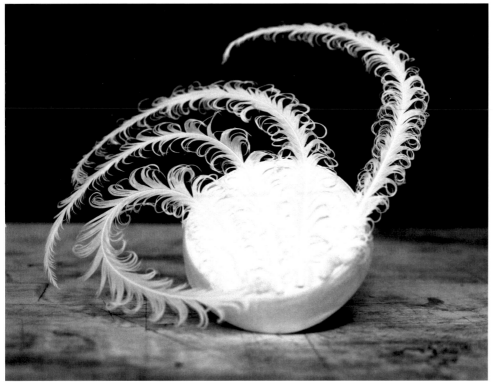

Fiona and Hans-Joachim Boehme, and is colorfully accented by her pieces.

Fiona's hats are often referred to as wearable works of art. Her imaginative designs truly stand out and have graced the covers of numerous high-end magazines such as *Vogue*, are housed in a few museums, and have even been a prime part of a concert tour when Christina Aguilera commissioned bespoke Fiona Bennett pieces to accompany her on stage during each performance in 2006. Fiona's hats exquisitely combine elegance with a touch of whimsy, integrating everything from flowers, bows, and feathers to silk, velvet, and rhinestones. She uses unusual materials and at times creates her own patterns and fabrics. Every collection is a journey into unknown territory for Fiona. She has been known to fold origami figures made of silk and to create cowboy hats from Sinamay. She embellishes classical forms with her own charm, breaking the boundaries of tradition while maintaining timeless excellence. Fiona Bennett hat wearers are dignified—they are not disguised, they are dressed.

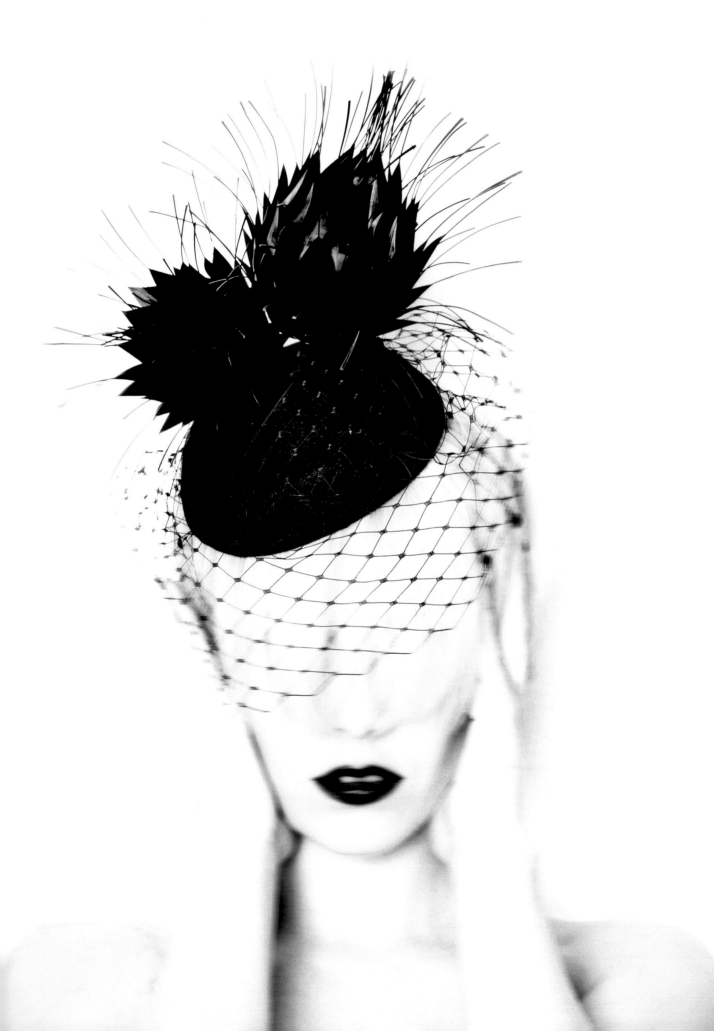

Each hat has a story, incites a certain mood, and makes the world a little more beautiful. "My style is elegant, high-class with a lot of humor," the designer shares. She sees her pieces as providing people with more confidence, a fun way to express themselves and make any day a little brighter. She is inspired by everything that surrounds her, by human beings, by nature, and by art. Fiona has always been drawn to Berlin's art scene and is most excited when meeting new artists or designers with whom she might collaborate. Her Potsdamer Straße storefront can be seen as a gallery space for her creations, which span from extraordinary headpieces to bridal headwear as well as stage hats.

Fiona's creativity seems to know no bounds and her imagination no end. From 1920s-inspired sculptural and glittering bird-shaped headpieces to more subtle veiled hats, the range of her talent is unlimited. Her storefront brings a dash of sophistication and glamour to a part of town that has a little bit of glitz and a taste for showmanship but that remains quite grounded in the historical remnants of its position as a crossroads within the once-divided city. Fiona's store enlivens the area with its bright lights and fun atmosphere. Anyone can walk in and immerse themselves in Fiona's universe that she envisions as a playground for adults. She can be found working in the atelier with her team of

milliners on any given day, and is always available for appointments to discuss a bespoke piece or just for good conversation and a laugh.

Owners: Fiona Bennett and Hans-Joachim Boehme
Founded: 2012
Location: Potsdamer Straße 81–83, Berlin, Germany

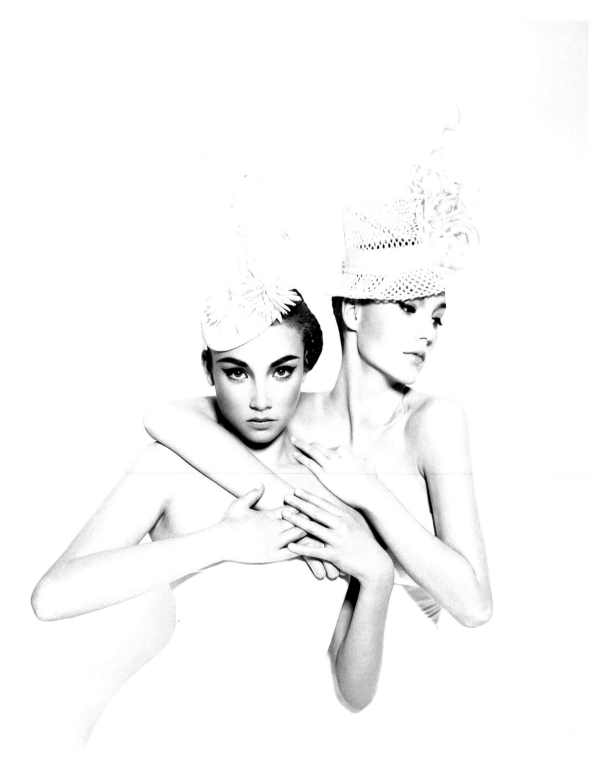

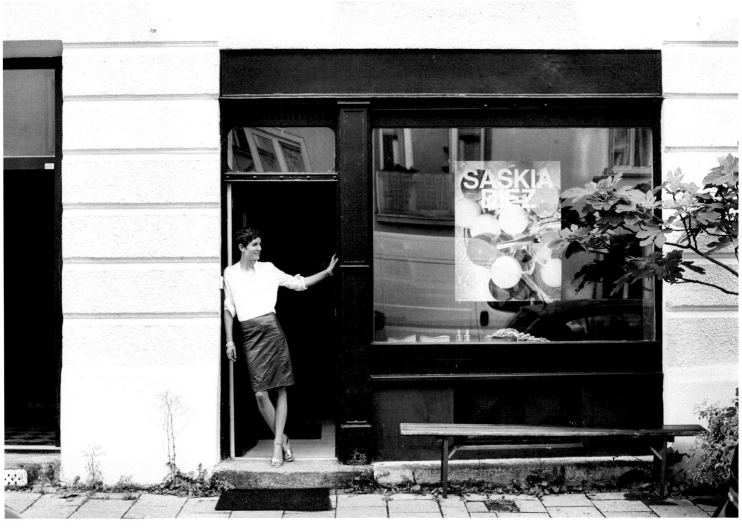

Storefront

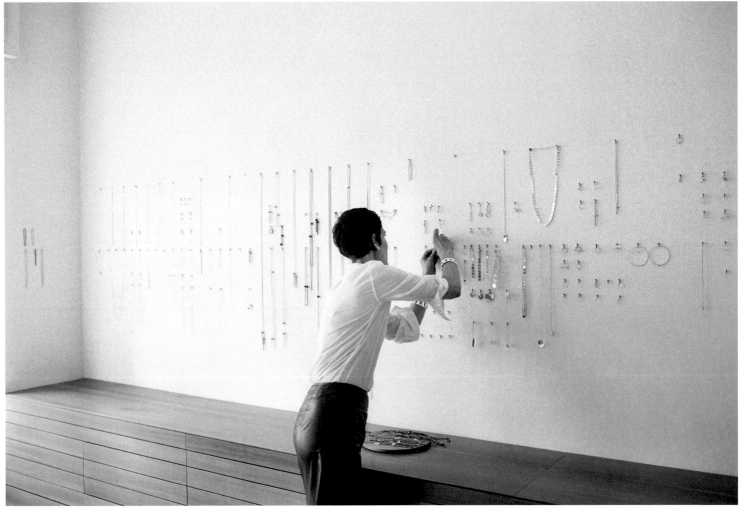

The minimalist interior and simple displays let the focus stay on the jewelry

The Jeweler, Munich, Germany

If diamonds are a girl's best friend, just think of the possibilities found in other rare stones and precious metals. Jewelry designer Saskia Diez opened her minimalist jewelry store and showroom in Munich in 2009, two years after launching her brand. Diez began her career as two people in the store and up to six in the back office, Diez displays her complete collection here. In addition to her jewelry line, she also develops a number of perfumes that she refers to as "invisible jewelry." These perfumes can also be purchased here as well as a selection of

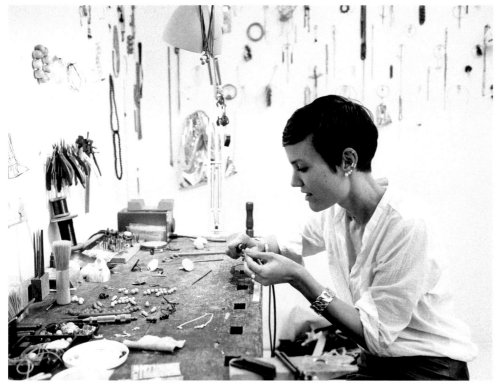

Owner Saskia Diez crafting in her workshop

a goldsmith, with a brief interlude as an industrial designer. She then found her way into jewelry and fragrance design, a niche she has flourished in ever since. Diez designs her intimate collections by starting with herself and what she feels drawn to. Without a specific target woman in mind, she crafts her pieces to suit a strong, independent, and ever elegant clientele.

Diez works together with a handful of goldsmiths in and around Munich, Pforzheim, and Werne to locally produce her jewelry. She develops close and lasting relationships with her producers that are reflected in the quality of her finished pieces. Most of the gold and silver used comes from recycled materials. When finished, the jewelry makes its way from her studio in the back to the 375-square-foot showroom and 215-square-foot adjoining space for appointments in the front. She created both spaces in collaboration with her husband, designer Stefan Diez. Supported by

accessories she designs for women, men, and children.

Her consistently high-quality work has made her a trusted brand throughout Germany and beyond. Each piece can be dressed up or down, striking a graceful balance between glamour and utility. From wedding bands and engagement earrings to signature bracelets, eye-catching necklaces, and more, Diez's designs satisfy even the most discerning collector. Opting for simple and understated over the flashy and ostentatious, these personal purchases soon become the key accent pieces reframing any wardrobe over time.

Owner: Saskia Diez
Designers: Saskia and Stefan Diez
Founded: 2009
Location: Geyerstraße 20, Munich, Germany

Poszetka

The Pocket Square Makers, Katowice, Poland

This husband and wife duo understand the value of a good tailor and the perfect accessory. Poszetka, which means "pocket square" in Polish, consists of a showroom and sewing shop that specialize in elegant handkerchiefs as well as neck ties and bowties for adults and children alike. The project began when a handsome pocket square caught the eye of Tomasz Godziek during one of his business meetings. Impressed by how something so simple could completely transform the appearance of a suit, he set off to find a local online supplier only to realize that there were none. After

learning that pocket squares were not available on the Polish market, Tomasz encouraged his wife to fill the gap.

The enterprise began simply enough, with Tomasz asking his wife, seamstress Joanna Krajewska Godziek, to make him his very own pocket square. She then used the leftover material to make a few more. To her surprise, the pocket squares quickly found buyers via the Polish internet auction portal Allegro. Tickled to respond to this untapped market, Joanna decided to leave her unsatisfying and demand-

ing career in a tourist agency to launch her own company and spend more time with her small child. After working out of their home for several years, the couple recently expanded their operations to their current location inside a converted sewing shop. Four years and 9,000 completed orders later, the popular atelier now serves as the go-to place for precision tailoring and craftsmanship. Joanna and her competent staff handle day-to-day activities while Tomasz takes care of marketing. Simple, timeless, and stitched to last, Poszetka's products inspire men to finally dress like gentlemen.

Joanna Krajewska Godziek and Tomasz Godziek

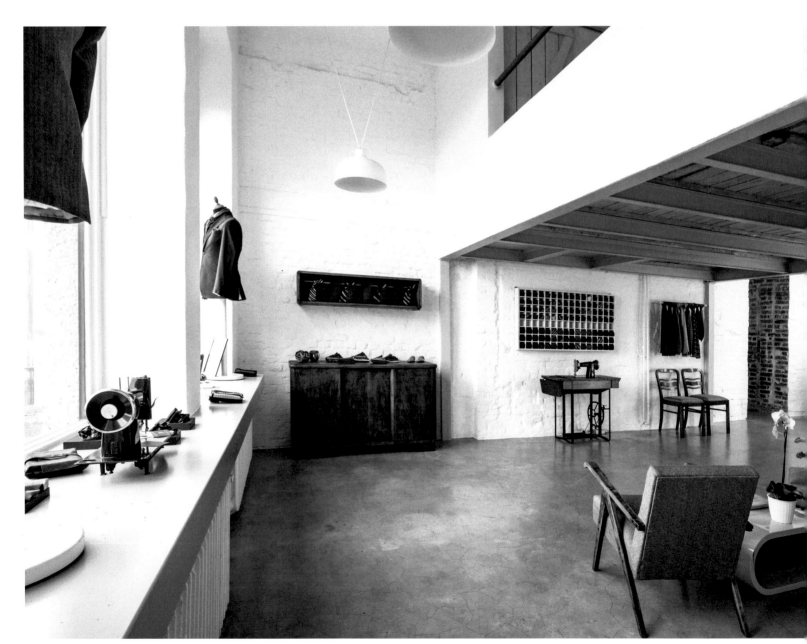

The showroom gracefully features a number of tailored accessories for the discerning gentleman

Owners: Joanna Krajewska Godziek and Tomasz Godziek
Designer: Grzegorz Layer
Founded: 2011
Location: Morcinka 23, Katowice, Poland

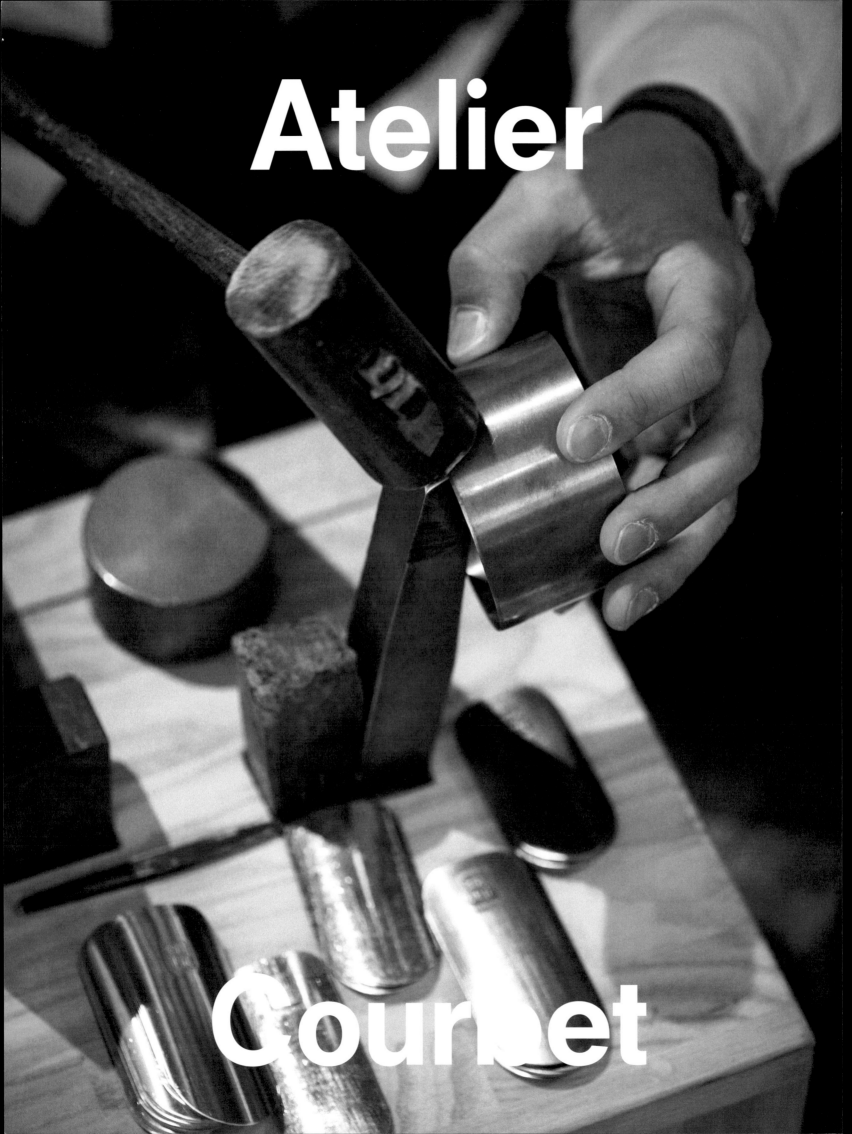

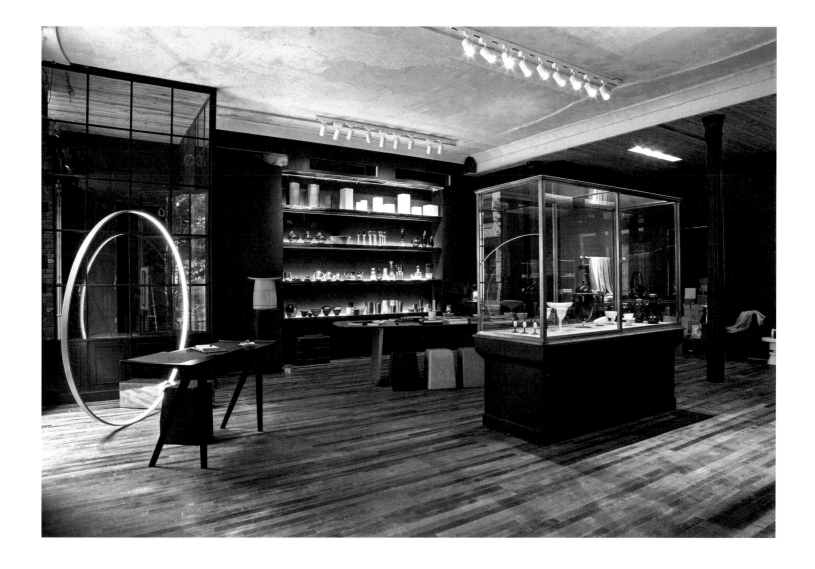

From her New York City storefront, owner **Melanie Courbet** and her multidisciplinary team forge fruitful partnerships with some of the oldest master artisans and heritage manufacturers from around the globe.

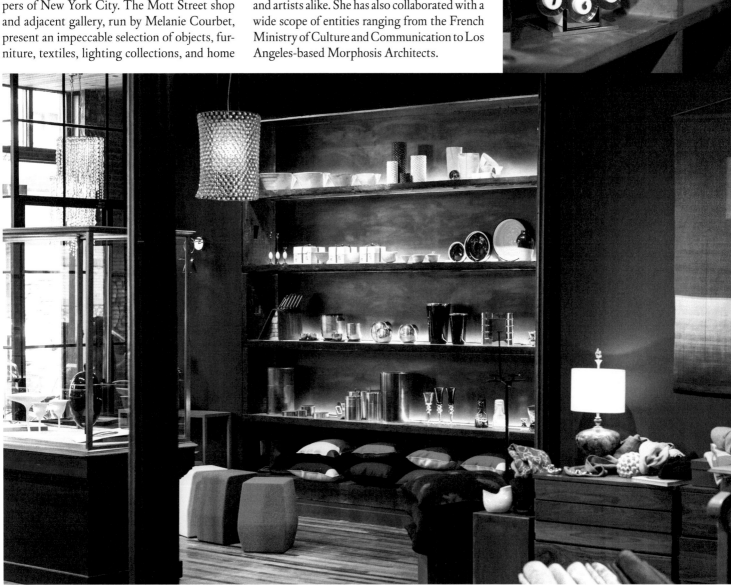

accessories scoured from the world's most revered workshops established as far back as the sixteenth century. Like galleries to artists, the team represents a portfolio of master craftsmen that carry on the traditional and painstaking work of extending their smithery into our modern lifestyle. Atelier Courbet brings its portfolio of workshops to a clientele of interior designers while creating exclusive collaborations between the masters and contemporary artists, designers, and other guest luminaries of the moment.

Before opening Atelier Courbet in 2013, Courbet worked as an independent curator and a consultant specializing in contemporary art and design. Exhibition programs developed by Courbet were shown at the MUBE Museum in São Paulo, the New Museum in New York, Jean de Merry and Cappellini in Los Angeles, Le Musée des Arts Décoratifs in Paris, Christie's, and the Los Angeles Municipal Art Museum. For 10 years, she has advised private clients both in France and in the United States. She has been responsible for the communication and business development of international designers and artists alike. She has also collaborated with a wide scope of entities ranging from the French Ministry of Culture and Communication to Los Angeles-based Morphosis Architects.

The enterprising Courbet smartly chose not to run her business alone. Similar to how she sources and represents her products and craftsmen, she put together a powerful team of creatives to assist in the rapidly growing enterprise. Showroom director Samantha Feder puts her past experience as national sales manager of the Venice-based textile company Fortuny, Inc. to good use at Atelier Courbet.

Dedicated to high-quality craftsmanship, the shop brings exquisite home and lifestyle goods to the astute shoppers of New York City. The Mott Street shop and adjacent gallery, run by Melanie Courbet, present an impeccable selection of objects, furniture, textiles, lighting collections, and home

Tantalizing handcrafted lifestyle goods beckon to customers

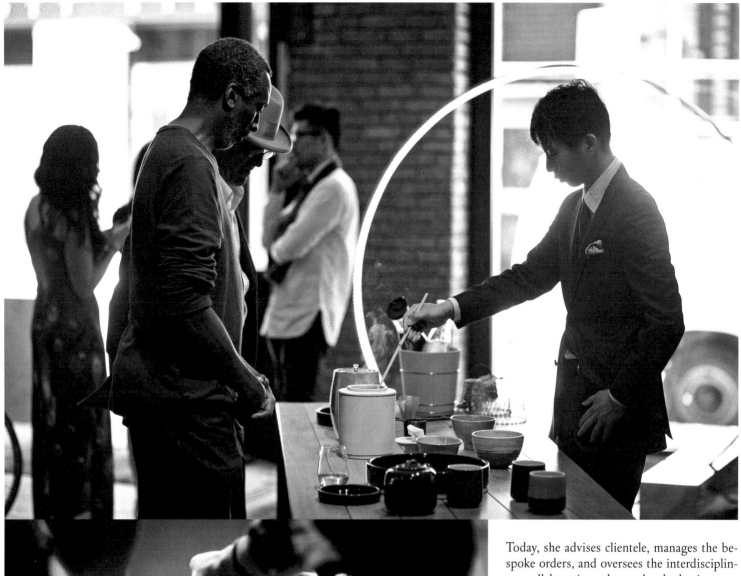

Courbet stocks exclusively handmade and heritage products

Today, she advises clientele, manages the bespoke orders, and oversees the interdisciplinary collaborations that make the business so unique and sought after. Consulting partner Ashlee Harrison advises a clientele of interior designers, individual patrons, and design enthusiasts. Harrison, an art history and visual culture major at Drexel University, sharpened her expertise consulting for international design fairs and industry-related entities while running the marketing and communication department of the Cohen Design Centers. Creative advisor Robert August manages the sleek company website and all creative assets related to the showroom and gallery exhibition programs. August has developed branding assets and experiences for luxury houses including Balenciaga, Coach, Givenchy, Hermès, Kiehl's, Manolo Blahnik, Michael Kors, Salvatore Ferragamo, The Row, Victoria's Secret, *W Magazine*, and countless others. A man of many talents, he also leads a dual life as a photographer and filmmaker with works exhibited at the Guggenheim Museum and the Museum of Modern Art in New York. International journalist extraordinaire Clara Le Fort rounds off the competent Atelier Courbet lineup. In addition to regular contributions at trend-setting magazines including *Numéro, Wallpaper**, and *Departures Magazine*, Le Fort tracks trends and new ventures around the world for the company.

Atelier Courbet brings its portfolio of workshops to a clientele of interior designers while creating exclusive collaborations between the masters and contemporary artists, designers, and other guest luminaries of the moment.

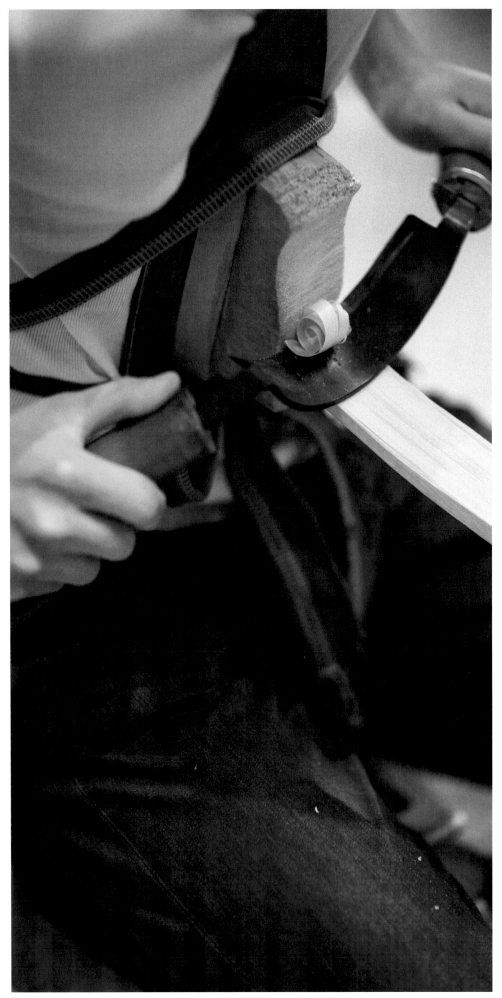

Traditional techniques are alive and well at Atelier Courbet

The widely published architecture and design critic and author of a series of Louis Vuitton City Guides also acts a consultant for luxury brands including Hermès, Louis Vuitton, and Le Meurice. She joined Atelier Courbet prior to the shop opening, and continues to act as its curatorial advisor.

Atelier Courbet grew out of Melanie's desire to share her passion for quality and heritage with the public. Courbet's belief that ultimate luxury rests in impeccable fabrication rather than mass production fuels her lifestyle, ethos, and business model. In addition to offering selected products culled from each of the workshops she and her team represent, the shop introduces exclusive collections resulting from their ongoing collaborations between their master-craftsmen and outside creatives. These fruitful collaborations carry on centuries-old techniques of the highest craft. A point of reference for finely constructed and timeless items that encompass the areas of lifestyle, textiles, furniture, and the decorative arts, the retail destination acts as a trusted resource for private patrons and trade clients. Individual customers find pieces that contribute to and accent their family heirlooms, while more commercial clientele gain access to some of the world's most revered manufacturers for bespoke merchandise.

The current retail experience inspires purchases based on an appreciation for the manufacturers' crests, product quality, and intrinsic value rather than acquisitions based on speculative values and trends. While anchored in cultural heritage, the selected pieces prove both timeless and contemporary. This tightly curated selection encompasses one-of-a-kind and limited edition pieces.

Set inside the Brewster Carriage House, a landmarked building located on Broome Street where SoHo intersects NoLita, Atelier Courbet's artfully arrayed goods spill over two adjoining salons. The nineteenth-century building serves as a fitting home for the time-honored wares. Before Courbet and her company took over the space just a few years ago, the building went through numerous manifestations, most notably as the workshops of famous coach makers, Brewster & Co. Many of the building's original details have been carefully refurbished and maintained by real estate developer and designer, Ross Morgan. Exposed brickwork, high ceilings, and generous glass façades produce a sophisticated atmosphere for staging the designer goods within. The 1,300-square-foot showroom displays made-to-order pieces, granting direct access to the most revered workshops for a clientele of collectors and designers. Just next door, the supporting 650-square-foot gallery space showcases rotating exhibitions highlighting a single, meticulous master at a time.

Courbet and her associates work closely with a handful of exceptional heritage brands around the globe that have kept their traditional crafts alive for generations. Sevres, the most respected French ceramicist carries on more than 350-year-old techniques developed under King Louis XV. Another partner, the revered D & P workshop in Paris, collaborates with prominent figures from Pharrell Williams to David Lynch. Atelier Courbet also partners with craftsmen in Asia, most notably sourcing from the Kyoto-based textile company HOSOO, which first went into business in 1688. Each carefully selected workshop brings a commitment to craft and quality that refreshes and personalizes our relationship to the goods that surround us.

Sinuous cast brass and wood figurines find their place alongside handsome rugs, large-scale furniture pieces, textiles, and more. Refined and whimsical, Atelier Courbet stocks the practical and the fanciful with equal intentionality. Numerous collectibles include intricate-ly-carved backgammon sets and eye-catching sterling silver card holders. Savvy hunters and curious window shoppers need look no further, Atelier Courbet keeps craft alive and our homes duly appointed.

Melanie Courbet, the owner

Owner: Melanie Courbet
Founded: 2013
Location: 175–7 Mott St, New York City, NY, USA

Another partner, the revered D & P workshop in Paris, collaborates with prominent figures from Pharrell Williams to David Lynch.

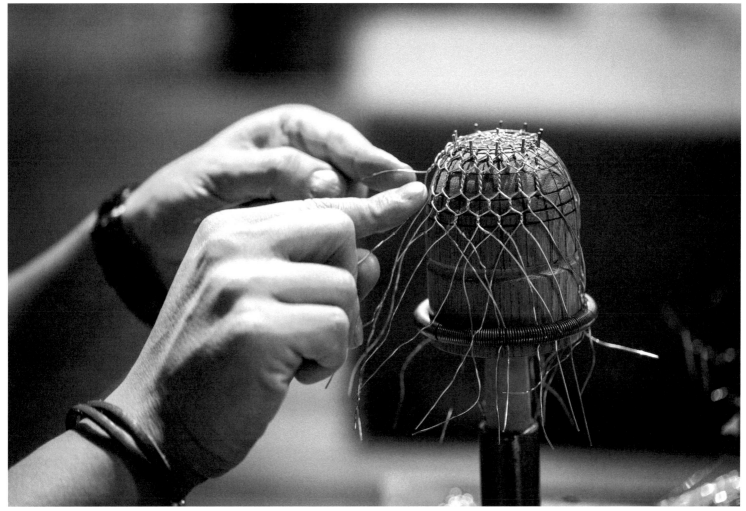

Each product originates from an experienced maker

Nalata Nalata

Contemporary keepsakes, New York City, USA

Founders Stevenson Aung and Angélique Chmielewski

New York City's new go-to place for all of its designer home accessorizing needs opened to the public in December of 2014. Co-founder Angélique Chmielewski and Stevenson Aung, a couple from Canada, take pride in crafting a retail experience that promotes the stories and people behind their curated lifestyle products. The New York transplants moved to the city in 2008 to pursue studies in design. Chmielewski graduated from the Fashion Institute of Technology in fashion design while Aung earned his masters in industrial design at Pratt. Upon graduation, the partners started their own respective, Brooklyn-based studios—a namesake womenswear label and a product design studio. Soon realizing that as designers they wanted to bring to light the stories behind the products many of their friends were creating, Chmielewski and Aung decided to open their flagship store Nalata Nalata in the Bowery neighborhood of Manhattan.

The versatile founders designed the interior of the shop as well as the corporate identity and visual language of the business. Welcoming and peaceful, the 600-square-foot storefront carries finely crafted products that range from dinnerware and kitchen tools to bath accessories and stationery items. The owners nurture personal relationships with many of the designers and makers they represent, giving their curation a distinctly personal touch. Rich woods, delicate porcelains, innovative textiles, and gleaming brass objects developed by talented designers and makers intermix with items from their own in-house label. Many of the products are handmade by small family-run manufacturers in Japan that have been in operation for generations. Each of the unique and minimalist products integrate seamlessly into any home. Combining function with a timeless sensibility, Nalata Nalata resurrects hand craft and storytelling inside a single, subtle storefront.

Owners/Designers: Angélique Chmielewski and Stevenson Aung
Founded: 2014
Location: 2 Extra Place, New York City, NY, USA

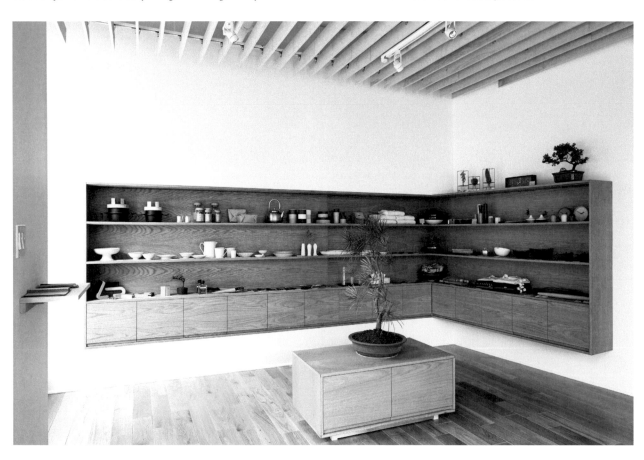

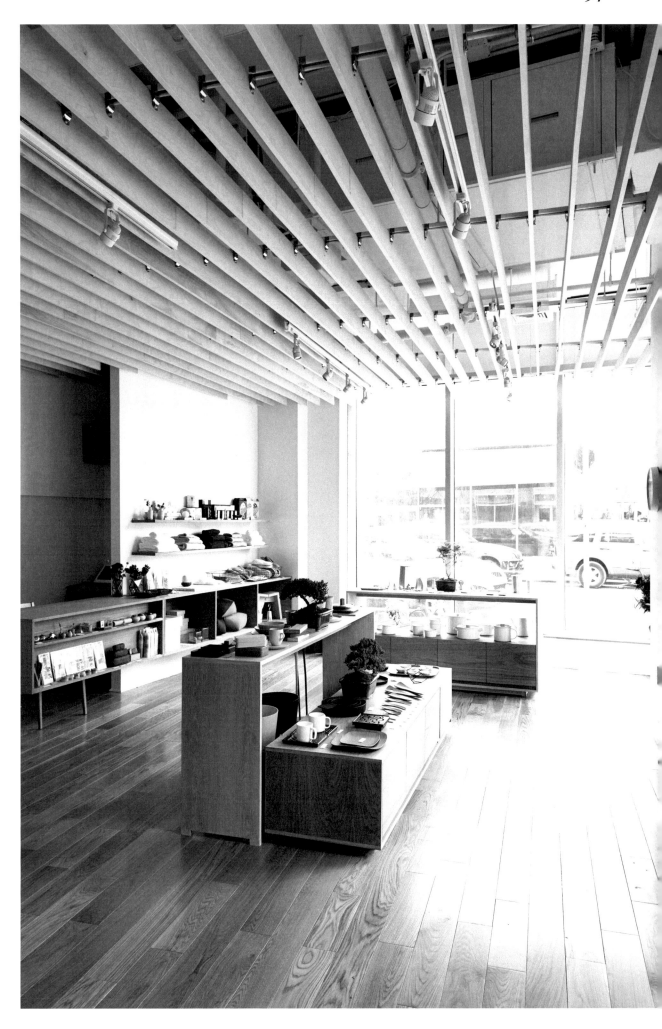

Native & Co.

Japanese and Taiwanese Houseware, London, UK

Founders Sharon Jo-Yun Hung and Chris Yoshiro Green

An independent homeware shop opened in 2014 brings the best of contemporary Asian design to London's discerning Notting Hill neighborhood. Founders and product designers Sharon Jo-Yun Hung and Chris Yoshiro Green personal-ly create and oversee every aspect of the shop. Green, of British and Japanese descent, crafts the minimalist shop interior and furniture himself while Taiwan-born Hung manages the graphic design and photography. Together they also develop the store's cohesive visual identity and branding. The shop's concept re-flects the aesthetic sensibility of the owners—simple pieces of a discreet nature filled with nuanced details. All objects selected by the duo maintain a refreshing purity, where the material's inherent beauty re-mains untarnished.

These homeware items comple-ment the interior without domi-nating it. The shop specializes in crafted home products sourced across Japan and Taiwan by the owners. Hung and Green work with small suppliers and special-ty workshops to promote local craftsmen. Offering simple and appealing tableware, kitchenware, textiles, and accessories, the part-ners highlight each object's her-itage. The refined product selec-tion features items produced with traditional methods that have been reinterpreted for contempo-rary life. Local and internation-al customers with creative back-grounds appreciate the inviting retail setting. Architects, interi-or designers, and those with an af-finity for Japanese products com-prise the shop's largest customer base. Giving Japanese and Taiwan-ese goods a chance to shine in an unpretentious setting, Green and Hung synthesize their distinc-tive upbringing and heritage in-to a successful and personal busi-ness model. The timeless objects and accessories sold here exude a touch of the romantic and wistful that accompanies the transition of a house into a home.

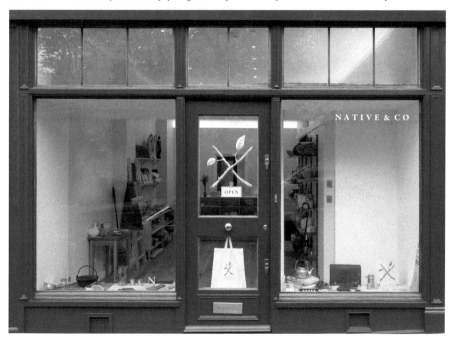

Owners/Designers: Sharon Jo-Yun Hung and Chris Yoshiro Green
Founded: 2014
Location: 116 Kensington Park Road, Notting Hill, London, UK

General Store Revival, Toronto/Vancouver, Canada

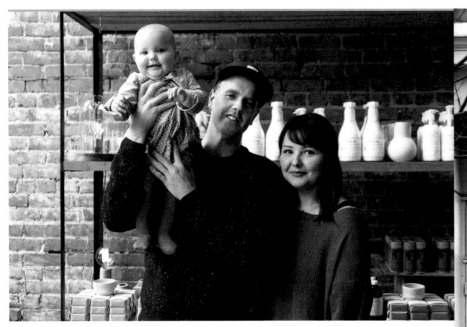

Co-founders Walter Manning and Savannah Olsen with their child

With a childhood spent in the back rooms of his grandparents' general stores, Walter Manning now oversees his very own shops with co-founder Savannah Olsen. Not only did Manning's maternal and paternal grandparents own and operate successful general stores, but his great-grandparents did too. This impressive general store legacy inspired Manning to develop a modern-day version stocked with quality goods that fosters an inclusive sense of community.

The enterprising duo have opened two bustling locations since 2010, one in Toronto and the other in Vancouver. Keeping the Manning family's general store tradition alive, these charming shops specialize in "good quality goods" for young creatives. The two contemporary general stores stock simple products for everyday living. Each shop stands as a labor of love, designed by Manning with a timeless and inviting sensibility. Attracting a discerning clientele of predominantly young female professionals, the two locations offer everything from rolling pins and dish ware to jars of pickles and bars of soap made the old-fashioned way. Building a sense of local pride through tried-and-true products and an old-timey atmosphere, the locations mix a love for the esoteric and practical with a spirit of yesteryear. The Old Faithful Shops specialize in Old Faithful products—heirloom items built to last.

Owners: Walter Manning and Savannah Olsen
Designer: Walter Manning
Founded: 2010
Locations: 886 Queen St. W, Toronto/320 W Cordova St, Vancouver, Canada

The no-frills storefront channels the best of the old general store spirit

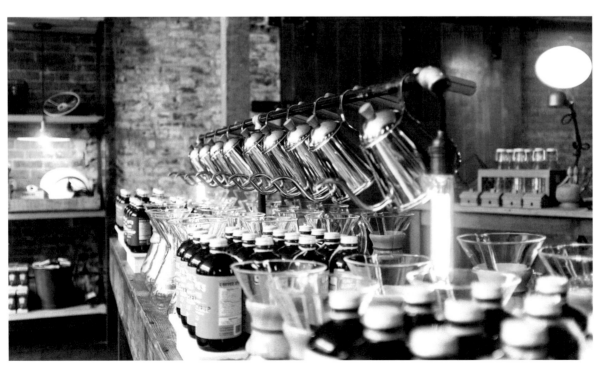

Ileana Makri Store

Jewelry Designer, Athens, Greece

Arguably the most well-known jewelry designer in Greece, Ileana Makri has just launched her achingly elegant flagship store in the heart of Athens. With a degree in business administration, Makri shifted courses in the 1980s to follow her true passion: jewelry design. She packed her bags and headed to the Gemological Institute of America in Santa Monica, California to begin her formative training. The globetrotting Makri returned to Greece after completing her program and opened her first retail venture in 1987. Still thriving three decades later, her first shop—Mageia, meaning "enchantment" or "magic" in Greek—carries an eclectic assortment of international fashion, art, and jewelry, including Makri's signature collection.

Her first big break came nearly ten years later in 1996 when Barneys New York picked up her collection. This milestone propelled her career as a high-end jewelry designer, attracting an avid following of upscale and celebrity clients. Makri's new flagship reflects her commitment to the bespoke and handmade. Natural unprocessed materials like gray sedimentary rock and window installations filled with smoke cloak the shop in a veil of alluring mystery. Brimming with objects of desire, the shop reflects Makri's worldly upbringing, interests, and inspirations. A beckoning cave of wonders, the one-of-a-kind jewelry shop has a knack for making its visitors forget their budgets. Money comes and goes but diamonds are forever, right?

Owner: Ileana Makri
Designers: Kois Associated Architects
Founded: 2014
Location: 15 Patriarhou Ioakim, Athens, Greece

Starkly elegant, raw stonework supports an stratosphere of mystery

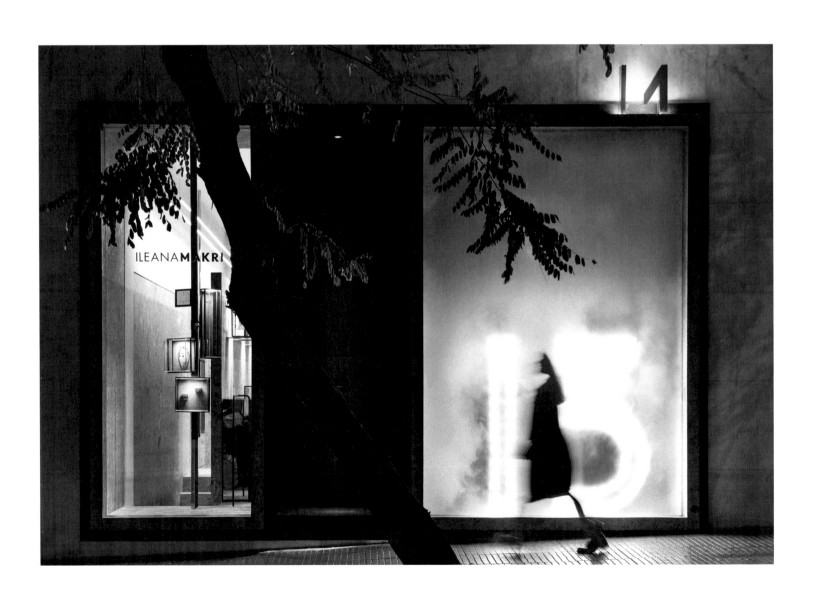

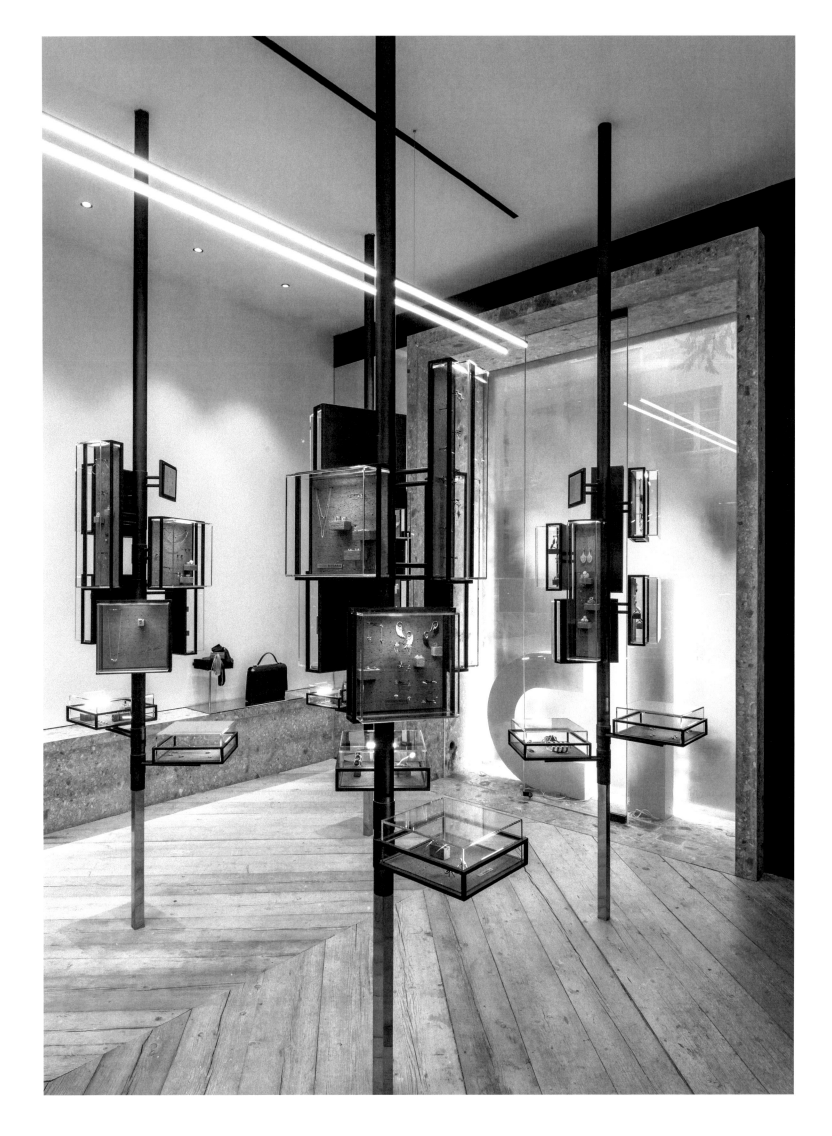

Pen Store

Writing Accoutrements, Stockholm, Sweden

Storefront

The descriptively named Pen Store has a knack for getting to the point. With the help of design studio Form Us With Love, the Swedish pen supply company recently opened its minimalist Stockholm flagship. The company's insatiable love of pens can be easily gleaned through their impressive assortment of writing instruments and top quality supplies. Markers, neon green Lamy fountain pens, mechanical pencils, and brush-tip pens in all shapes and colors are paired with a selection of thoughtfully curated notebooks and paper products. The multi-purpose space fluctuates between shop, gallery, studio, and warehouse. Invested in cultivating a creative hub for local studios and offices, the company stages a setting for the like-minded to gather, sketch, write, and share using the best materials on the market. Rather than just showing the products in the shop, the company asked their favorite artists and illustrators to demonstrate what the pens can do. These experimental collaborations with renowned artists including Lovisa Burfitt, Rasmus Wingård, Amelie Hegardt, Moley Talhaoui, and Clara Aldén developed into the store's first exhibition and poster series produced by Paper Collective. Take home your favorite and feel better knowing that 15 percent of the proceeds will be donated to save the rain forest.

Owner: Pen Store
Design: Form Us With Love
Founded: 2014
Location: Hornsgatan 98, Stockholm, Sweden

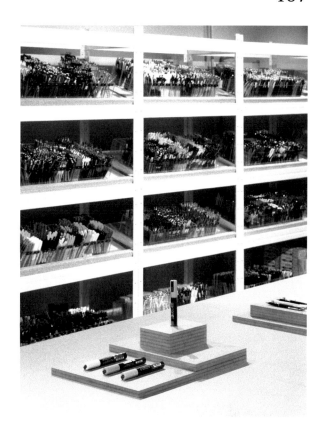

The minimalist and uniform interior treatment makes the colorful products stand out

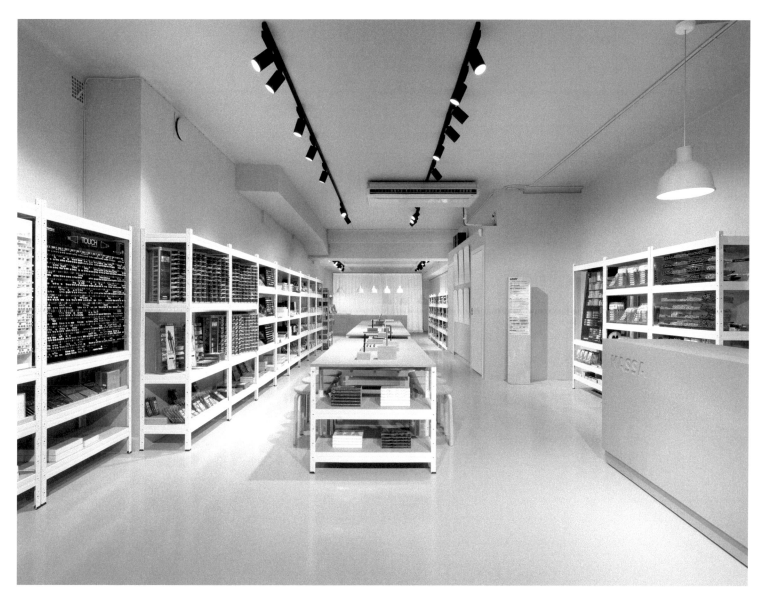

Pop-Up Book Shop, Brooklyn, NY, USA

The temporary newsstand awakened the commuter literary culture

In 2013, media and entertainment company Alldayeveryday launched The Newsstand, a seven-month takeover of a subway retail space located under Williamsburg, Brooklyn. The shop resided inside the Metropolitan Avenue Stop at the intersection of the G and L trains. Curated in partnership with Lele Saveri of 8-Ball Zines, the initiative quickly took on a life of its own.

The branding and identity of The Newsstand reflected Alldayeveryday's logo and aesthetic. Signage and message materials utilized the same typefaces and overall DNA of Allday to forge a natural dialogue

between the project and the company. Much of the concept was driven out of the desire to disrupt the dull vernacular of subway retail and revive our waning exposure to print media.

More than a store, The Newsstand functioned as a platform for independent publishers and the creative community to interact with a larger audience. With a daily exposure of 15,000 subway commuters, what began as a six-week retail experiment remained open for an additional six months in the wake of its unexpected success. The compact space hosted unique programming that positively transformed the listless subway culture. Developed as a platform for creativity and exposure, the space saw both frequent events and exciting guest clerks from the art world including Glenn O'Brien, Tom Sachs, Andrew Kuo, Cheryl Dunn, Jody Rogac, and many more. Opening with just 100 titles, the shop expanded to over 1,000 publications and art objects

by the time it closed in February 2014. A retail shop turned impromptu community center, the stand enticed collectors, creators, and the unsuspecting commuter alike. Before shutting its doors for good, the project was profiled in *The New York Times, USA Today, Paper magazine, Time Out New York,* and countless sites, radio shows, local news, and blogs resulting in over 150 million global media impressions. Not bad, for a store that prided itself in staying underground.

Owners / Designers: Alldayeveryday
Year: 2013 – 2014
Location: The Metropolitan Avenue Stop in Williamsburg Brooklyn, NY, USA

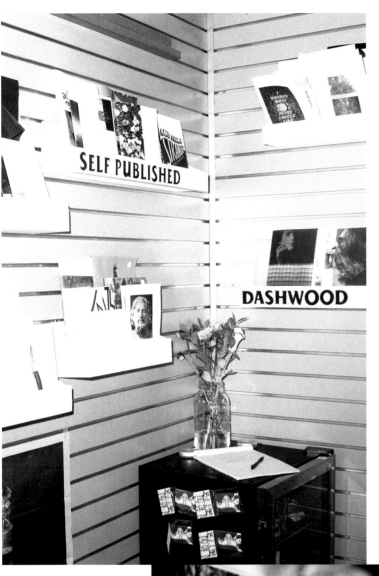

BOOK/SHOP
The Literary Corner, Oakland, CA, USA

Catering to East Bay bookworms, a vintage bookstore occupies a snug storefront in an industrial style building in Oakland, California. Owner Erik Heywood first launched the operation online in 2011. Two years later in 2013 he expanded into a physical 275-square-foot storefront. Heywood utilizes his background in interior and retail design to conceive all aspects of the shop. From storefront to website, logos to identity, furniture to products, he works meticulously to craft a basic, flexible, and approachable atmosphere. Heywood's experience working on small, concept-driven designs for larger brands informed his decision to keep his own shop design as open-ended as possible. This simplicity allows him the opportunity to continuously experiment with layout and display in a quick, easy fashion. Acting as more of an experimental wing of his website than a finished product, the shop constantly reinvents itself to accommodate changing projects, events, and new merchandise. In spite of its small footprint, the evolving storefront ensures a visitor's experience will never remain the same for long.

The collaborative Heywood works closely with Lauren Ardis, his two-person staff, and luminary designers and artists from around the world to develop special products and projects. This eclectic and multidisciplinary approach to shopkeeping includes projects with the LA-based design duo Building Block, the musician Toro y Moi, Tokyo woodworkers Raregram, and many more. More than a shop selling books, BOOK/SHOP celebrates book and reading culture.

Heywood sells a changing selection of rare vintage publications, around 80 to 100 at a time, that remains on display for just two weeks. Each collection of books pairs with an evolving range of book furniture designed in-house and produced locally, artwork and design collaborations based on books or the reading experience, as well as reading accessories, bookshelves, and small goods made exclusively for the shop. The ephemeral nature of the merchandise and surroundings gives customers incentive to come back often. A minimalist lifestyle brand with reading at its core, the work in progress attracts a following of creative professionals, design aficionados, and serious book collectors. Returning people to the best parts of themselves, the quiet and humble store rekindles the tradition of reading, selling only good books and everything that goes with them.

Owner/Designer: Erik Heywood
Founded: 2013
Location: 482D 49th Street, Oakland, CA, USA

Owner Erik Heywood with collaborator Lauren Ardis

BOOK/SHOP

The Stationery Stop, Berlin, Germany

Berlin's go-to source for all its stationery needs, R.S.V.P. has supplied the city with the finest paper and writing materials since its opening in 2001. Optimally located in the Mitte district near the Hackesche Höfe shopping hub, the small and neatly organized storefront expanded into its second location right across the street in 2014. This second shop carries an extended range of wrapping papers and accessories. A local favorite, the original 16-square-meter store was founded by illustrator Elisabeth von Treskow. Three years after its inception, von Treskow consigned the business to current owner Meike Wander. The cultural scientist had dreamt of running her own stationery shop ever since she

was a little girl. During family trips to Greece as a child, she searched for unique paper products to bring back to use during the school year. Fighting against the trend toward paperless everything, Wander resurrects our nostalgic fondness for pen and paper. She sifts through off-the-beaten-path stationery stores locally and abroad to source a collection of rare and handmade products from small manufacturers. She forges partnerships with producers who preserve classic letterpress and engraving techniques. These refined paper products are paired with equally elegant writing instruments from heritage brands. Whether you can drop by the store or choose to order online, R.S.V.P.'s commitment to quality and personal rituals motivates even the most tech-savvy client to swap their next email for a handwritten letter instead. With stationery like this, who wouldn't R.S.V.P.?

R.S.V.P. recently expanded to this new location on a busy shopping street in Berlin

Owner: Meike Wander
Designers: Stefan Sell and Manolis Iliakis
Corporate Identity: Stefan Müssigbrodt
Founded: 2000/2014
Locations: Mulackstraße 14/26, Berlin, Germany

Case for Making
Markers Mark, San Francisco, CA, USA

What began as an art collaboration between four friends has evolved into a light-filled storefront for art supplies in San Francisco's breezy Outer Sunset district. In 2010, the group received a grant from Southern Exposure and, over the course of the next year, curated numerous process-focused, site-specific installations. The results of this yearlong exploration culminated in the self-published catalog *A Case for Making*. In 2014, two of the original quartet began to conceptualize that same installation space as a storefront dedicated to the artistic process. Alexis Petty and Lana Porcello named the space after the group's catalog and treat the shop as the next natural phase of the founding project. The duo has experience and an interest in designing functional spaces, and Case for Making proves no different. With intimate knowledge of the storefront's strengths and idiosyncrasies, Petty and Porcello highlight appealingly patchwork features while creating an efficient and welcoming retail experience inside the 215-square-foot space. The shop, located on the bottom floor of a two-story commercial building, enjoyed a number of previous lives ranging from a restaurant and legal offices to an art gallery. When tasked with reimagining the space once again, the team made sure to honor the building's history. Instead of taking a tabular rasa approach, they instead kept intact the material traces of previous uses. The bright, utilitarian, and multipurpose design stands as a collaboration with master builder and family friend Eric Roberts.

The creative supply store features art basics and raw materials that encourage process-focused, creative exploration. The shop's carefully curated inventory includes supplies for drawing, painting, calligraphy, and sketching as well as handcrafted desk and studio wares. In addition to functioning as a store, the space also holds a variety of creative workshops. These workshops, taught by friends and clients with strong art backgrounds, focus less on a certain area of expertise and more on developing a setting for both instructors and participants to explore. Both partners recognize the presence of creative inquiry in multiple forms and provide space for engaging in and valuing this work. Seasoned studio professionals and newly inspired artists stop in to browse, chat, and pick up supplies, consulting with the owners about ideas, materials, and resources. With a collective background in everything from drawing and printmaking to food and small business, Porcello and Petty rely on play and habitual reflection to inspire creative process within any field. The belief that no wrong way exists to approach a medium or material influences all aspects of the shop, from the goods stocked to the conversations held and classes taught. Life is a process, and this shop makes art a celebration of every step.

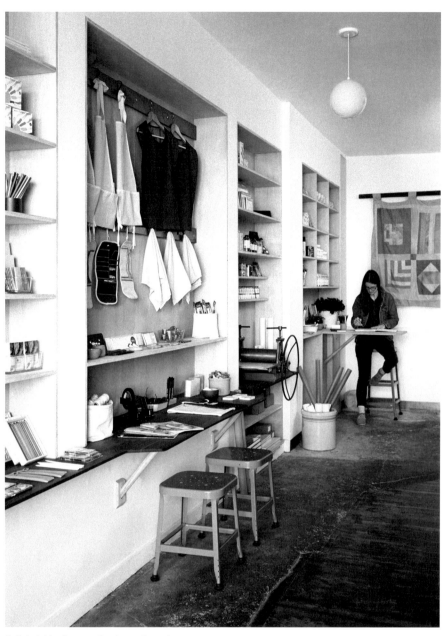

Built-in shelving features products in an understated manner

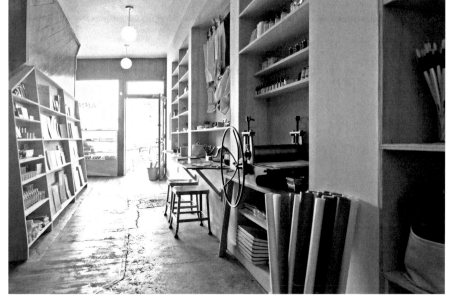

The mixed-use space purposefully remains a work in progress

Owners/Designers: Alexis Petty and Lana Porcello
Founded: 2014
Location: 4037 Judah Street, San Francisco, CA, USA

CW Pencil Enterprise

The Pencil Place, New York City, USA

The 24-year-old Caroline Weaver and her newly opened pen shop occupy a tiny storefront on the Lower East Side of Manhattan. Hailing from Marietta, Ohio, Weaver's insatiable love for pencils was instilled from an early age. She relocated to New York City shortly after finishing art school at Goldsmiths College in London. Fascinated by the rich and often unknown histories of pencils, Weaver now lives out her dream of sharing unusual pencils and their stories with the public. After launching an online pencil shop in 2014, her storefront location opened its doors a year later.

Designed by Weaver and influenced by her mother who is an interior designer, the modest 200-square-foot shop strikes a refreshing balance of playful utility. Upon entry, customers are greeted by the scent of cedar and graphite. The shop features a pencil vending machine, a testing station, and a 1960s Kingsley Machine that Weaver uses to personal-

ize pencils. Meticulously organized while encouraging disarray, this compact pencil mecca houses writing pencils from around the world, accessories, stacks of erasers and notebooks, a case brimming with antique and rare pencils from as early as 1900 through the 1970s, and sharpeners galore. Pencil collectors, stationery aficionados, students, journalists, copy editors, artists, designers, architects, writers, and even construction workers swear by the store. Whether attracted by pragmatism or nostalgia, a loyal clientele comes for the pencils and returns for the storytelling.

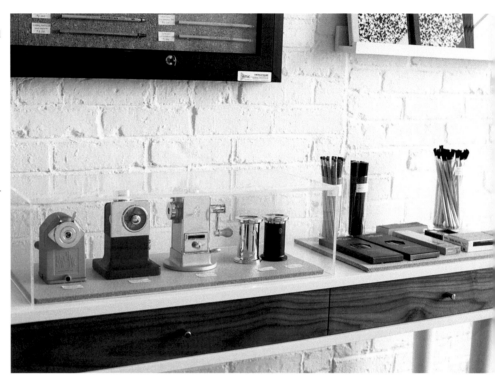

Owner/Designer: Caroline Weaver
Founded: 2015
Location: 100a Forsyth Street, New York City, NY, USA

Owner Caroline Weaver at her desk

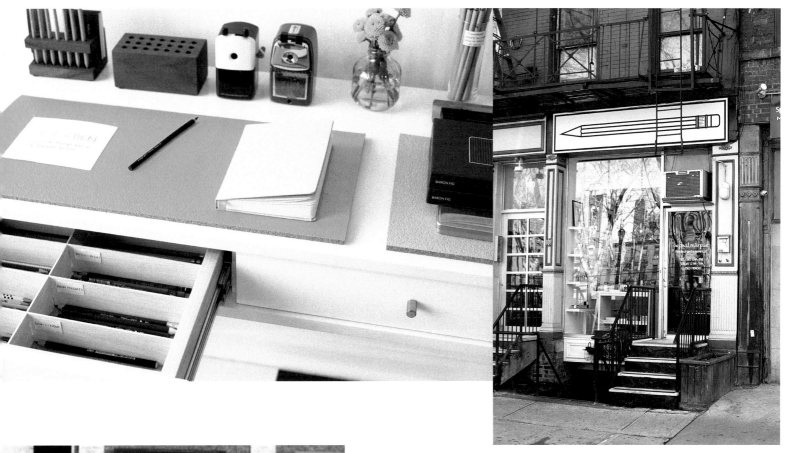

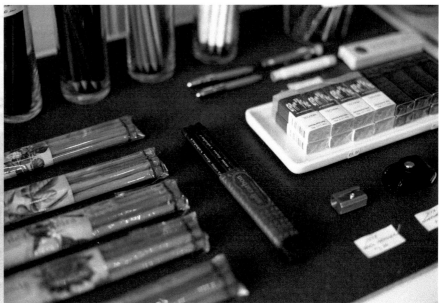

Store exterior

PENCILS

.50¢

Okomeya
The Rice Retailer, Tokyo, Japan

Rice, a Japanese staple, received its very own Tokyo corner storefront in December of 2014. Dedicated to the classic traditional ingredient, the store specializes in rice balls—a Japanese soul food. Founded by Atsuo Otsuka and managed by OWAN Inc., a design company committed to resolving issues in our daily living environment, the charming and tiny 170-square-foot shop is nestled into the shopping street of Miyamae. Staffed by a single employee, the shop's rice balls have quickly put Okomeya on the culinary map. *Musubi,* the Japanese word for the delicacy, means "to tie or bind something together." This translation also serves as Okomeya's mission, challenging issues regarding interregional exchange, agricultural production support, and food culture. Okomeya organizes and participates in numerous events and activities that bring the local community together through food. Convenient and ecological, compact and portable, the rice balls are made with 100 percent traditionally grown Koshihikari rice produced from Minami Uonuma in the Niigata Prefecture. In order to maximize freshness, new batches of polished rice get cooked every morning. Whether to supplement a meal or enjoy as an afternoon snack, the informal treat can and should be eaten with your hands. No chopsticks necessary.

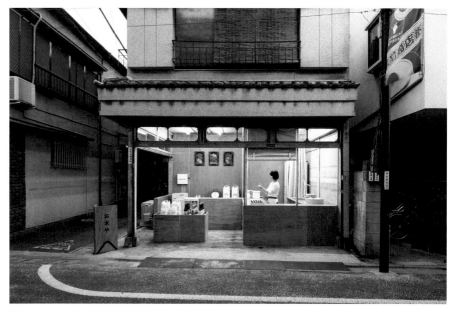

The tiny corner storefront has become the go-to place for a quick snack

Owner: Atsuo Otsuka
Design: Schemata Architecture
Founded: 2014
Location: 4–8–6 Togoshi, Shinagawa-ku, Tokyo, Japan

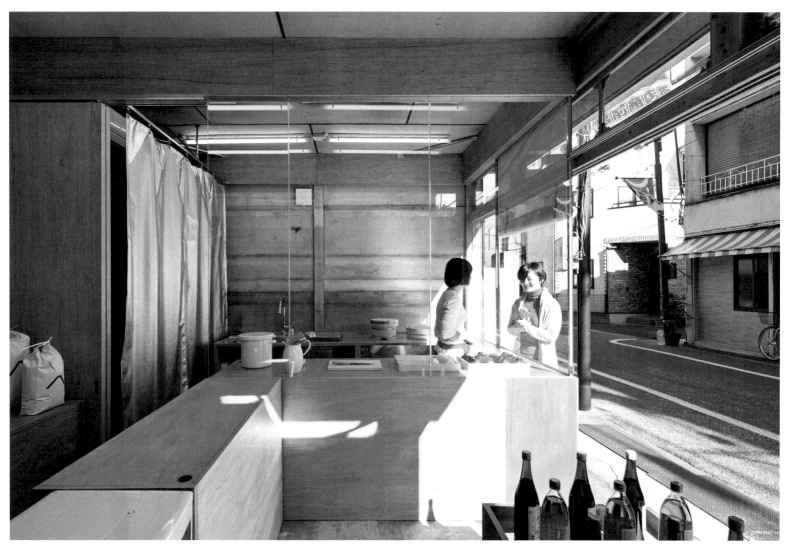

A single employee man's the walk-up counter

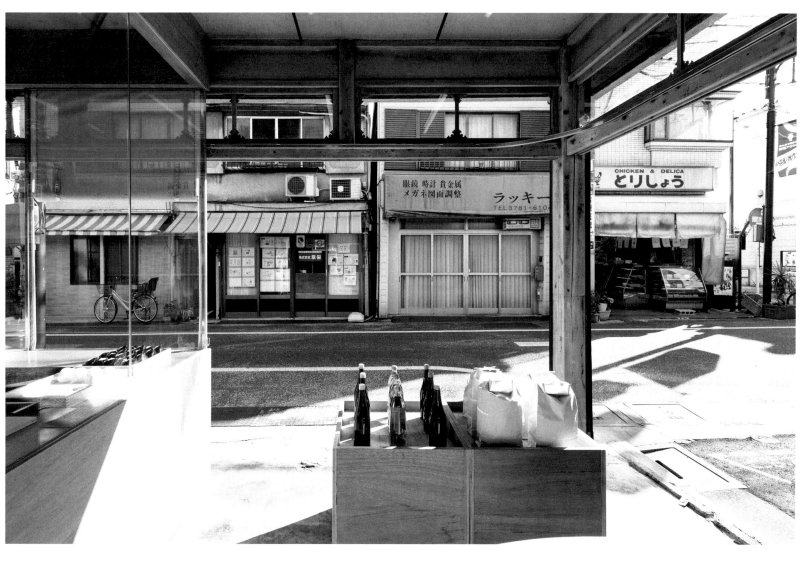

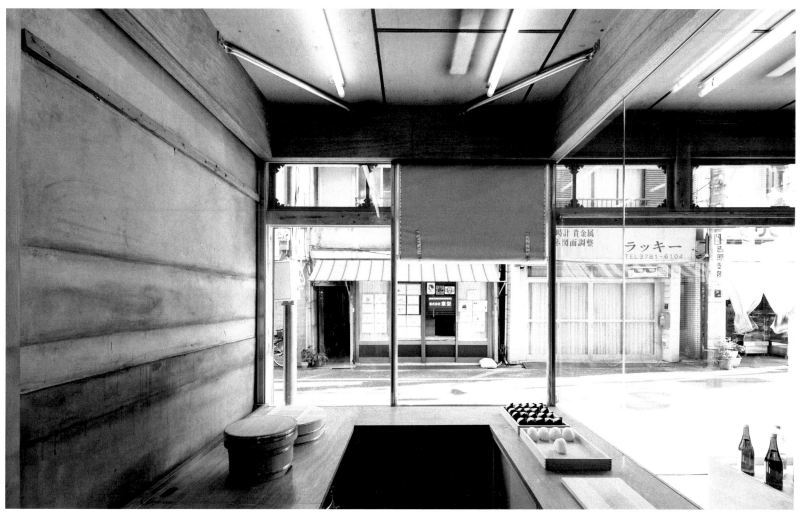

Bubble & Stitch

24/7 Laundromat, Amsterdam, The Netherlands

Going to your local laundromat has never looked more appealing or been more convenient. Bubble & Stitch, a new 24/7 concept laundry store taking Amsterdam by storm, allows people to drop off and pick up their clothes at any time of day or night. Maurits Tiethoff and Niels Pols founded the cheerful enterprise in 2015 after extensive careers in the laundry and dry cleaning business. Before the launch of Bubble & Stitch, Tiethoff operated a traditional laundry and dry-cleaning service in the same location for several years. Pols, also no stranger to the industry, ran a family-owned dry-cleaning business in operation since 1886. The two old pros recognized each other's talents and partnered for this new drop-locker service flagship.

The 36-square-meter mint green store invites customers at any hour to leave their garments in a designated locker for cleaning or repair. A series of supporting pop-up locations in several office buildings across the country take care of overflow demand and add to customer convenience. Cristina Zanon

and Naomi Thellier de Poncheville from BURO NANA took charge of the design and branding, working together to define the upbeat color palette, branding identity, and interior layout. Services span from wash and fold laundry and dry-cleaning to clothing and shoe repairs. A clientele of young professionals and expats enjoys the store and its services outside traditional 9–5 business hours. While the original target group focused on single men ages 20–35, the storefront's softer and friendlier design also attracts a loyal female following. Bubble & Stitch fulfills a common need of city dwellers living in smaller spaces without access to in-house laundry facilities. Adapting to today's faster-paced, tech-savvy lifestyle, this laundromat maintains its traditional function while updating logistics and usability. The days of dragging your clothes to the dry-cleaners only to remember its closed on a Sunday or after 5 p.m. is now a thing of the past. Night owls rejoice, Bubble & Stitch is ready to help you clean up your act.

A dedicated staff behind the scenes makes sure your laundry gets done on time

Owners: Maurits Tiethoff and Niels Pols
Design: BURO NANA
Founded: 2015
Location: Overtoom 438, Amsterdam, The Netherlands

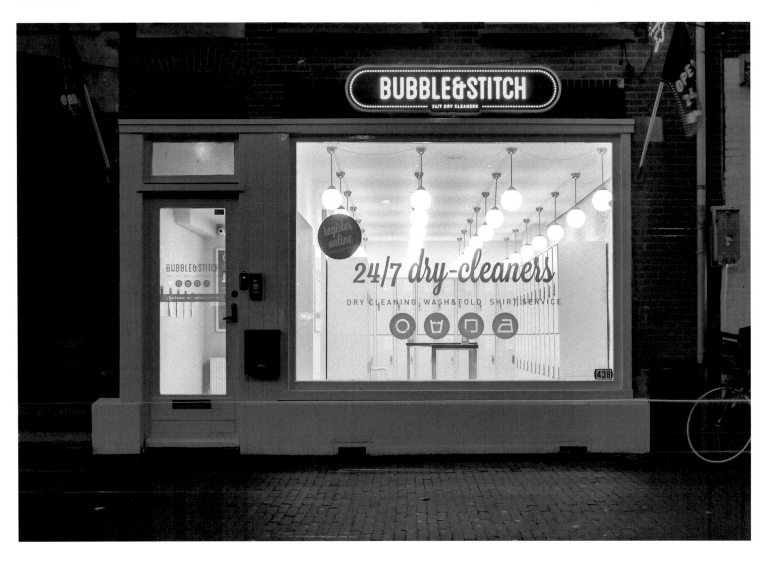

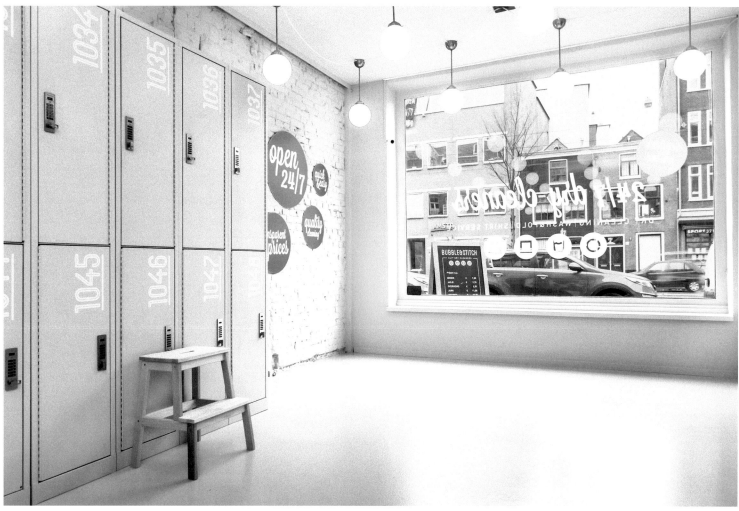

Mint green lockers let you stash your laundry and dry cleaning any time, day or night

Grab a form and fill out the service you would like

Little Catch

Urban Fishmongers, Shanghai, China

Two Singaporean-born, Hong Kong raised, United States university-educated sisters, transformed their experience with their family's seafood business into an upbeat fishmonger in a vibrant Shanghai neighborhood. Wenyi and Jiayi Huang were first immersed in the industry at a young age. As children, they visited fishing vessels, factories, traditional smokers, fish auction houses and markets, and countless seafood industry trade shows. To supplement their innate knowledge of the business and a shared passion for fish, the pair also attended various classes at the respected Billingsgate Seafood School in London to further learn the trade. These classes covered topics on quality control, sourcing, knife skills, and fishmongering practices. After polishing their skill set, the sisters opened up their shop in 2015.

The family enterprise, run by a staff of three employees, updates the old-school vernacular of the tradi-tional fishmonger. Linehouse executed the interior design of the compact space while Evelyn Chu developed the branding strategy and visual language. The Huangs take pride in sourcing and providing choice, high quality, and safe seafood to the Shanghai community. The shop carries more traditional items including Atlantic salmon, oysters, and Icelandic cod and mackerel as well as select specialty items such as house-cured Gravlax, Skagen, Crab Cream Cheese, and more. Attracting a youthful customer base in their 20s through 40s, the store brings in an even mix of expats and locals that care about nutrition. Interestingly, the sisters find that the expats tend to buy more daily necessities while the locals gravitate towards the exotic and premium items like the king crab. Whether you're a native, a transplant, or just passing through, this haven for seafood lovers combines quality with experience to serve the finest and freshest catch around.

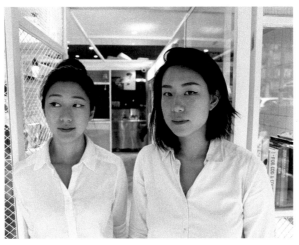

Sisters Wenyi and Jiayi Huang keep their family traditions in the fish business alive

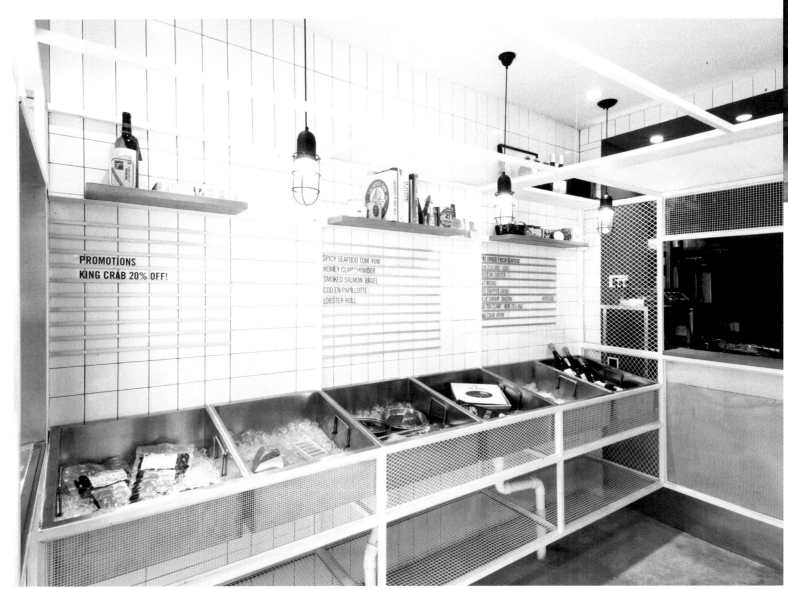

Clean and simple, the Little Catch interior makes the most of its tiny footprint

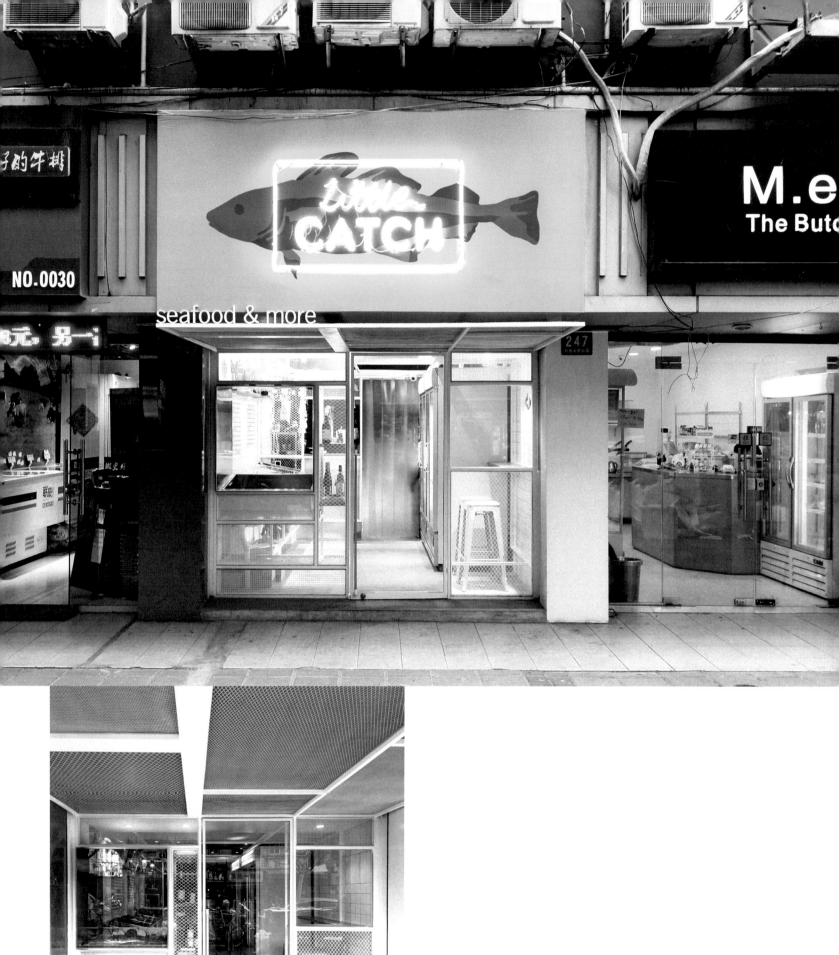

Owners: Wenyi and Jiayi Huang
Design: Linehouse
Corporate Identity: Evelyn Chiu
Founded: 2015
Location: 247–6 Wulumuqi Road, Shanghai, China

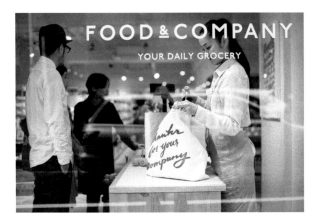

A grocery store created through the meeting of like-minded friends rethinks the everyday experiences and rituals associated with shopping. The young couple and owners Bing Bai, 28, and Maya Yatabe, 29, launched the idea in November of 2013 and opened their Tokyo location in March of 2014. Born in Beijing, China, Bai moved to Japan at the age of five. As an adult, she relocated to New York where she studied fashion marketing and management at a local university. After graduation, she began working at a major clothing brand and eventually quit to establish FOOD & COMPANY back in Japan with Yatabe. Born in Japan, Yatabe attended high school in the United States and studied international development at a university in New York as well. Yatabe then moved back to Japan and worked at an international development and consulting company before teaming up with Bai on their new business project. Following numerous lengthy discussions, the partners decided to build a grocery store that would gradually change the actions of consumers. Part elegant gathering place and part store, FOOD & COMPANY connects customers to both products and producers. The welcoming and interactive space sparks customer interest about where their food actually comes from and motivates them to return to learn more.

The 1,400-square-foot grocery store has gained popularity for carrying traditional Japanese vegetables that rely solely on natural cultivation. With even the use of organic fertilizers off limits, Bai and Yatabe source rare and hard to find items including a 600-year-old yam variety that only comes from one farm. Roasted peanut butter from Chiba, fish from Toyama, and Japanese wines demonstrate the variety of unconventional goods available that set the shop apart from other markets. Convenient and youthful, the grocery store attracts customers sensitive about what they eat and where it comes from. The predominately female clientele learns about the value of organic produce while they shop. Helping customers reimagine their diets and habits, the store helps preserve Japanese traditional agriculture while supporting a new approach to organic eating.

Owners: Bing Bai and Maya Yatabe
Design: Studio Doughnut
Corporate Identity: Launch
Founded: 2014
Location: Gakugei Daigaku, Tokyo, Japan

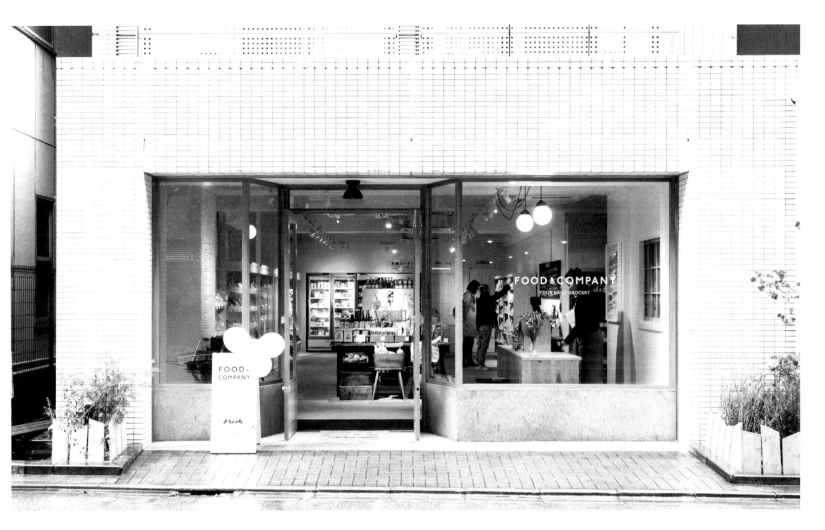

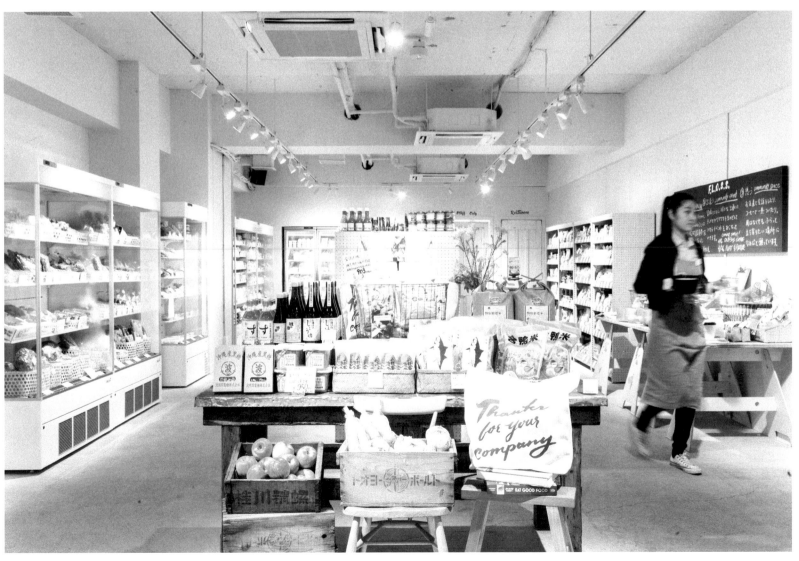

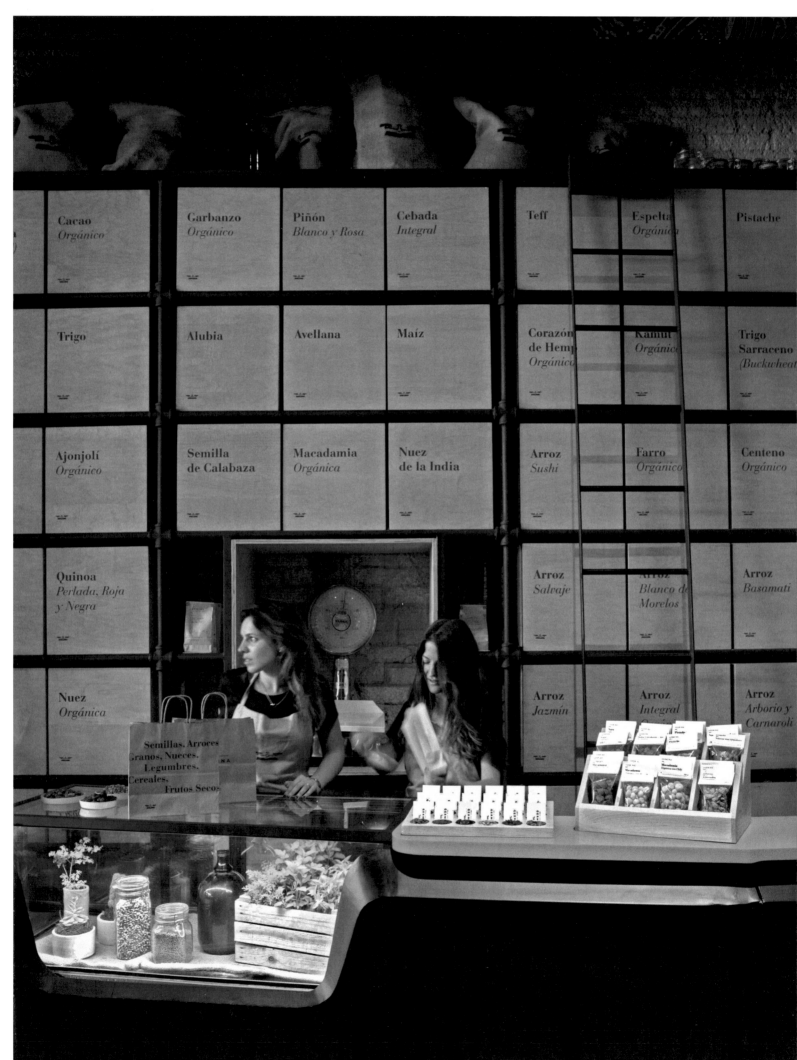

Mexican Market Stall 2.0, Mexico City, Mexico

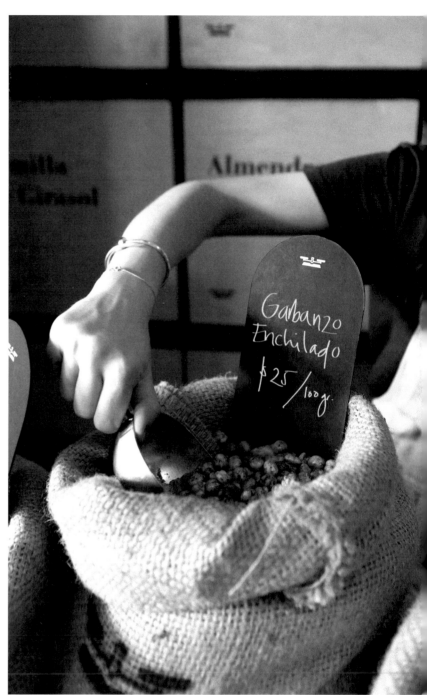

A delightful new grocer in Mexico City reinterprets Mexico's traditional market stalls. The enticing and elegantly designed storefront presents customers with a contemporary take on typical market aesthetics and experience. Before opening their shop in 2014, owners Ilana Ovadía and Tamara Kirchuk were no strangers to the food business. Opting to keep it in the family, the partners double, respectively, as sister and wife of Mexican Chef Daniel Ovadía. The family operation sells high-quality products in bulk with a wide range of seeds, grains, and cereals. From poppy seeds to different varieties of quinoa, dried spicy chickpeas or nutritious cereal bars, the shop caters to more health-conscious lifestyles. In addition to drawing a clientele of discerning customers looking for a nutritious snack or more balanced diet, Ovadía and Kirchuk also sell to larger businesses and restaurants as a reliable source for raw, organic products. The compact space promotes a direct relationship between customer and vendor. Making the most of the limited floor plan, all aspects of the design from layout to packaging support ease and pragmatism. Natural, almost rustic materials communicate the brand's core values in a very direct manner, highlighting the products and the trade's casual nature. A vintage weighing scale, the core of Germina's branding, sits almost altar-like at the center of the main display, connoting the shop's functional, human, and traditional essence. Elevating the rituals and habits of the market shopping experience, the sisters-in-law-turned-business-partners rebrand the act of bulk buying into an activity ripe with nostalgia and grace.

Owners: Ilana Ovadía and Tamara Kirchuk
Design: Savvy Studio
Founded: 2014
Location: Querétaro 225, Roma Norte, Mexico City, Mexico

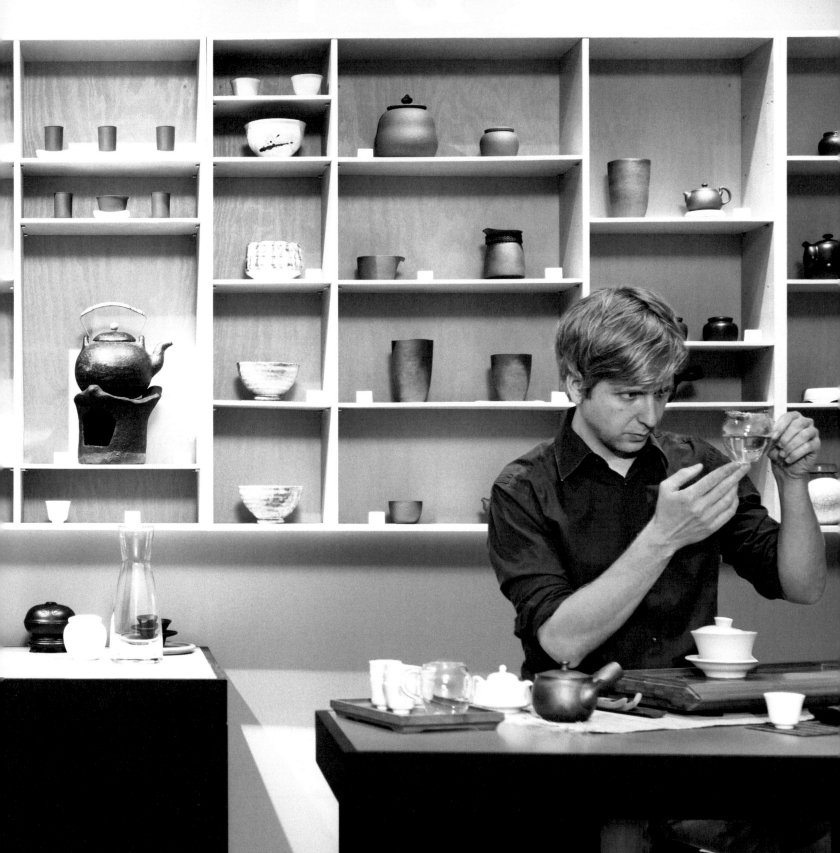

P & T

Paper & Tea

A simple glass façade brings in guests from the street

Tea connoisseur **Jens de Gruyter** left a prominent career as a photographer to pursue his passion for tea full time. Three years and two shops later, the Berlin phenomenon continues to transmit its infectious passion for tea to the community at large.

The experience inside P & T relies on customer interaction with the products

While coffee tends to get all the attention, P & T in Berlin has been letting tea (an often underrated elixir) take center stage since 2012. The five-member enterprise, with a staff of 15 running the back office, was founded by Jens de Gruyter after a career in the international photography industry. The nephew of a tea trader, Jens relished the care packages sent to him by his uncle when his family emigrated to Canada. As an adult, his daily ritual of tea drinking helped him balance his taxing, high-paced professional life. Over the years, de Gruyter transitioned from causal tea drinker to artisanal specialist as he delved into the nuances of taste, aroma, and tea's numerous health benefits. The more he learned, the more he wanted to share his knowledge with a wider audience. After two years of traveling through China, Japan, Taiwan, and South Korea to visit local growers and collect the best tea leaves, he spent another six months creating his first storefront. And so began the origins of P & T.

Jens starts each day with a cup of Japanese green tea. Rich in vitamin C, he enjoys the strong grassy flavor. Following this morning ritual, he moves on to different teas that reflect certain moments and situations occurring throughout the day. A mug of black Pu Er Bai Ya typically reaches his hands by the early afternoon. The highly caffeinated tea with its earthy aroma helps shake off mid-day lulls in energy. Another favorite, the Oriental Beauty, satisfies Jens's sweet tooth. Unlike other teas, the unusual variety develops its sweet flavor by beginning the oxidization process while still attached to the bush.

P & T's beloved first location and concept shop occupies an understated storefront in the upscale Charlottenburg neighborhood of Berlin. This flagship exudes a meditative quality and hosts frequent seminars. The consistently sold-out and modestly priced workshops take place in a dedicated, day lit seminar room where participants can gather comfortably around a shared table. Seminars impart

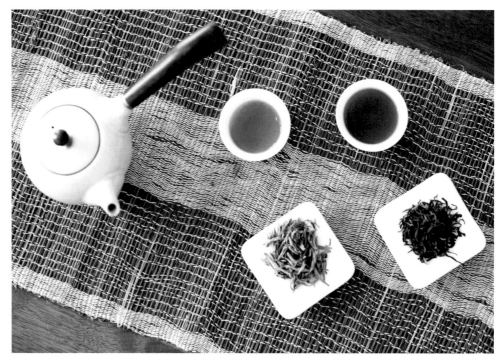

Special tea tastings enable customers to intimately know a product before purchase

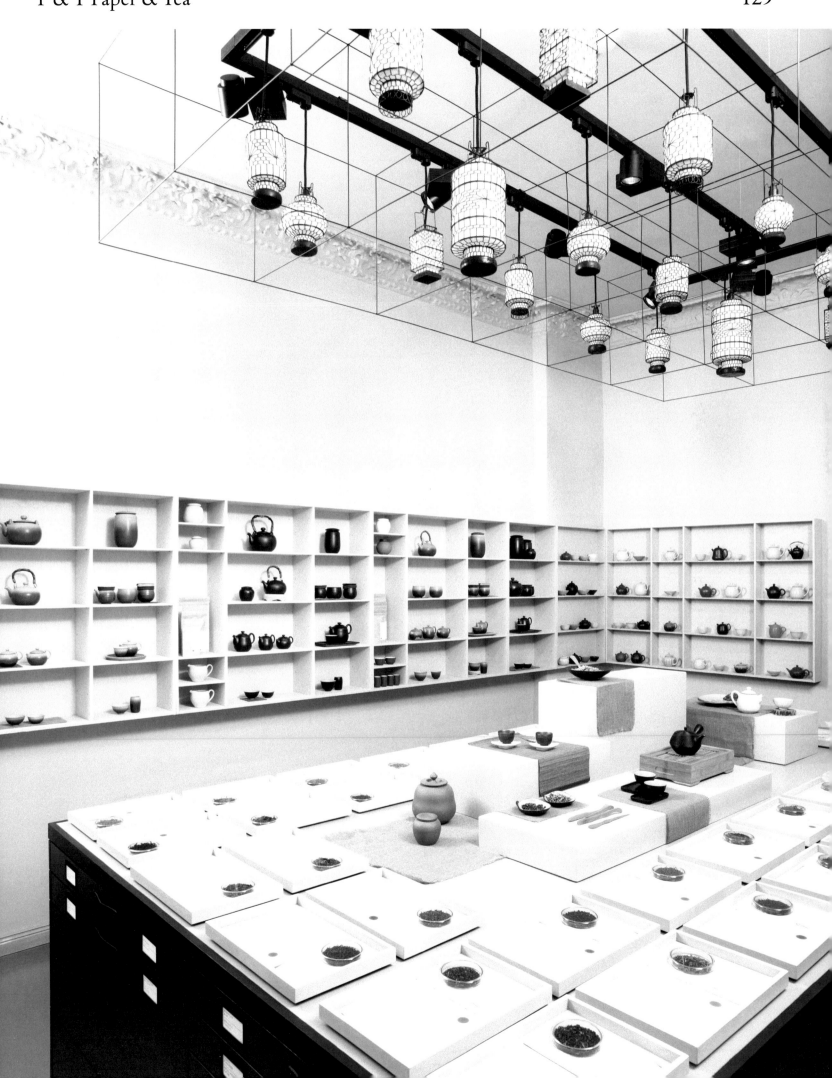

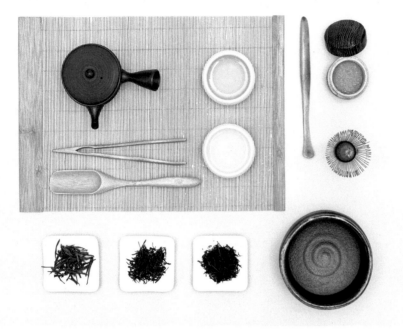

Specialty teas are sourced from around the world

was a child, Thomas encourages participants to indulge their senses as they dive into the complex and aromatic world of tea connoisseurship. His charm, warmth, impressive collection of bowties, and exhaustive tea expertise make him the ideal host for these hands-on sessions.

In October of 2014, Jens opened a second location in the bustling neighborhood of Mitte. The younger sibling to the original concept store, the Mitte boutique dedicates its efforts toward making the discovery of tea an engaging experience. The space, flooded with sunlight from generously sized windows, features a tea-tasting bar. This alluring bar serves a shifting selection of freshly brewed teas as it beckons to passersby on the sidewalks.

Centrally located, the spacious corner shop hosts numerous public events that foster community building around the shared interest of tea drinking. Daytime workshops and nighttime product launches, openings, and parties send tea enthusiasts spilling into the streets. De Gruyter's most recent event celebrated P & T's vodka tea infusion kits in partnership with the local brand Our/Berlin Vodka. At the opening, guests were served a refreshing summertime cocktail made from the white tea vodka and accented with tonic water and orange zest.

knowledge and appreciation for contemporary tea culture, covering focused topics and exploring the particularities of different tea varieties that range from Assam and Pu'er white tea to matcha and everything in between. Accessible yet thorough, the intimate gatherings consist of four to eight fellow tea enthusiasts. Arguably the best tea party you will ever attend, these seminars are hosted by P & T's chief tea expert, Thomas. Passionate about tea since he

P & T's chief tea expert, Thomas, leading a tea tasting seminar

The interiors of both locations, a collaborative effort between Jens and product designer Fabian von Ferrari, blend the aesthetics of a minimalist concept store with the atmosphere of a natural history museum. These temples of tea deliberately break from more traditional tea retail models. Instead of making customers dependent on staff to decode the rows of tea canisters behind the counter, de Gruyter opts for a proactive

ately encounter the olfactory qualities and multi sensory experience particular to each selection of tea leaf. What scents and flavors customers respond to prove deeply personal and varied. Teas are sorted based on their level of oxidation, gradually moving from white to yellow, green to black. For those concerned about caffeine or who are more drawn to a distinct flavor, staff can match each customer with their perfect tea.

These tasting stations afford visitors the chance to sample the product range without the obligation of having to pay first or commit before feeling completely satisfied. Rejecting the use of artificial or processed aromas, the fine and rare teas are exclusively whole leaf and handcrafted to stimulate the senses.

Lest we forget that the shop's name begins with a P, the store also carries a line of exclusive paper products. Made with love by letterpress, woodcut, and an assortment of artisanal printing techniques, these handsome paper products remind visitors that the most meaningful gifts originate from the analogue world. Many of the cards and stationery are paired with complementary teas that share a similar theme. This spring, Jens introduced a line of floral and herbal teas and combined them with a botanical paper set and greeting cards embossed with a graceful tulip illustration. For those wanting to refine their at-home tea practice, he also selects a variety of seasonal accessories for hot and cold brewing made by artisans with a passion for and deep knowledge of tea and its rituals. In keeping with the times, de Jens maintains a strong online presence. He develops his own original content in an effort to reach customers far beyond Berlin. These virtual materials include how-to videos of special brewing techniques for tea lovers that can't make it into the store. Quickly developing a name for himself internationally, Jens's fully stocked online shop ships worldwide and compliments these outreach efforts.

Jens works hard to dispel the myth—probably perpetuated by skeptical coffee drinkers—that tea is slow and complicated. With a daily average of seventy loose-leaf teas originating from seven countries, the teas offered at P & T tap into the legacy of the leaves as agents of communication, creativity, and culture. The approachable tea shop brings the elite world of specialty tea back to the people. More interested in spreading knowledge and inclusivity than keeping a high-end price point, de Gruyter and his loyal staff do just as well by keeping access to quality tea affordable. Give into the scent and take home a canister of your favorite tea and ream of handmade paper. This way the next rainy day that comes along, you can channel your inner Proust and rest easy knowing that you're well prepared for a cozy day of nostalgia.

Numerous product launches and events keep P & T an active participant in the community

approach as he puts the experience into the customers' hands. Highly accessible to shoppers, the welcoming retail spaces encourage them to explore every nook and cranny while they see, smell, and taste the goods. Waist-level product drawers double as informal display areas. These casual yet vaguely scientific displays place the specific type of tea leaves in small round glass dishes next to information sheets about the variety. By keeping the samples open to the air, customers immedi-

The storefronts fuse modern design with an ancient practice. Intimate and subdued, the shops appeal to both tea experts and novices alike. A sensibility for design and authentic flavors attracts an international clientele. Friendly and knowledgeable staff and an intuitive retail system promote a hands-on experience for the customer. Employees oversee several tasting stations, brewing teas of interest and teaching visitors about the diverse aspects of tea culture.

Owner: Jens de Gruyter
Designers: Jens de Gruyter and Fabian von Ferrari
Founded: 2012/2014
Locations: Bleibtreustraße 4, Berlin, Germany

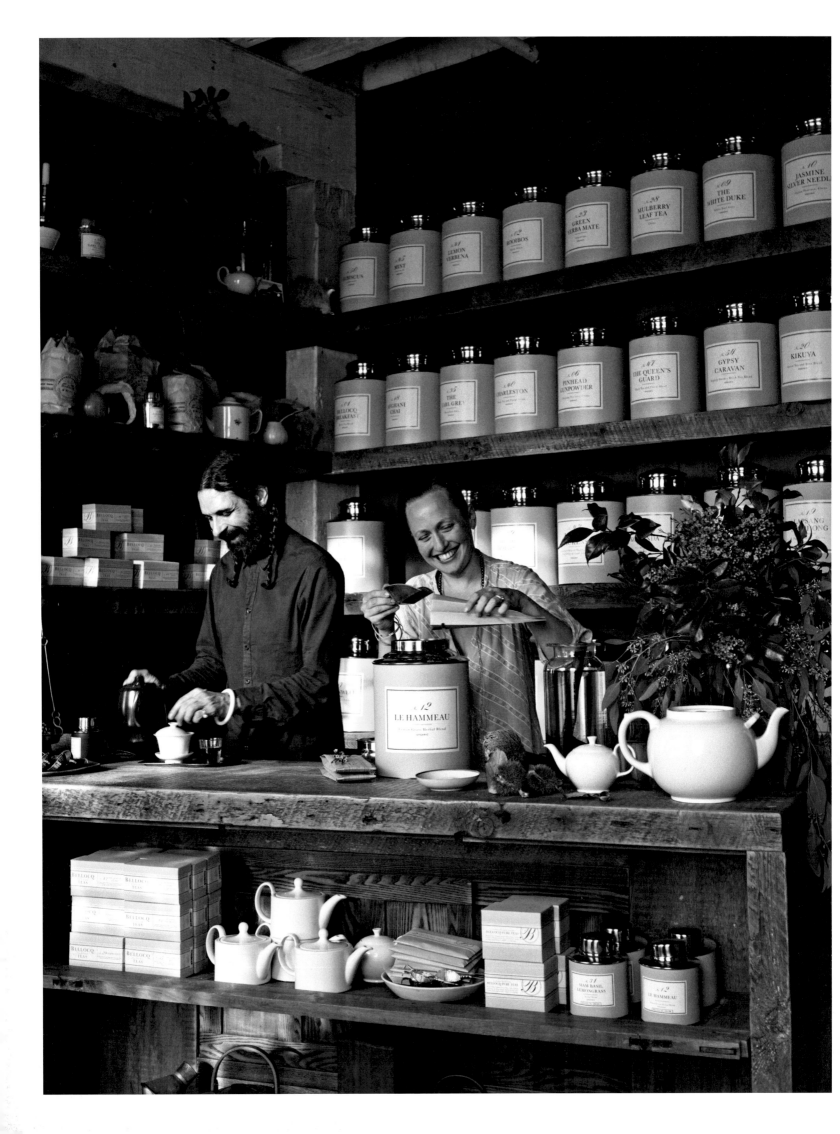

Bellocq Tea Atelier
The Tea Temple, Brooklyn, NY, USA

An inconspicuous jewel box tucked into a quiet corner of Greenpoint, Brooklyn has turned six years of sourcing and blending the finest teas and botanicals into a devoted and articulate hub for tea connoisseurship. Behind the hidden storefront, founders Heidi Johannsen Stewart and Michael Shannon sell exclusively whole leaf, organic, and single-estate teas. The partners met while working at a well-known lifestyle brand. At the time, Stewart embedded herself in the publishing side of the company as a food editor and stylist while Shannon worked as a product designer. Before launching their business, the duo often traveled the world buying tea and exploring its nuances. This delightful habit became a ritual and, along with a passionate appreciation of traditional artisan work, ignited the idea for their business. With their third partner, interior craftsman Scott Stewart, they discovered the perfect temporary space on Kings Road in London. Here, the trio seized the opportunity to reveal their first line of handcrafted tea blends. After their yearlong London pop-up, the partners moved their fledgling company and a growing product line to their current New York location.

The brand has since expanded its original line of tea blends to include over 50 varieties of pure teas, an assortment of herbal selections, and a growing number of in-house va-

rieties. This collection of hand-assembled teas stored in vintage style tins mingle with a series of expertly-crafted, perfumed candles inspired by the company's teas. These select items can be found against a backdrop of faded, aubergine walls. Shannon and Stewart devote several months of each year to visiting estates, sourcing new teas, and supervising the tea's cultivation and processing to make sure the highest quality standards are upheld. The carefully selected, single-origin offerings originate from high elevation gardens in China, Japan, India, Nepal, Taiwan, Sri Lanka, Vietnam, and Malawi. A serendipitous find for the earnest wanderer, the elegant shop threads a sense of imaginative nostalgia into its traditional tea blends, enlivening today's tea market and your favorite cup.

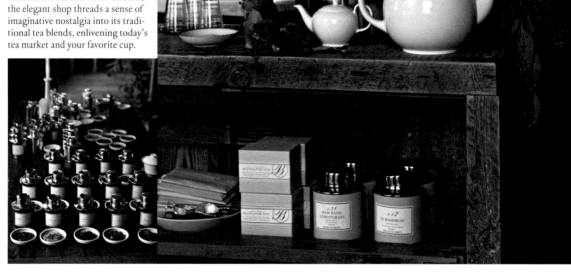

The store stocks over 50 varieties of tea

Owners: Heidi Johannsen Stewart, Michael Shannon, and Scott Stewart
Founded: 2009
Location: 104 West Street, Brooklyn, NY, USA

Mezcal Mecca, Oaxaca, Mexico

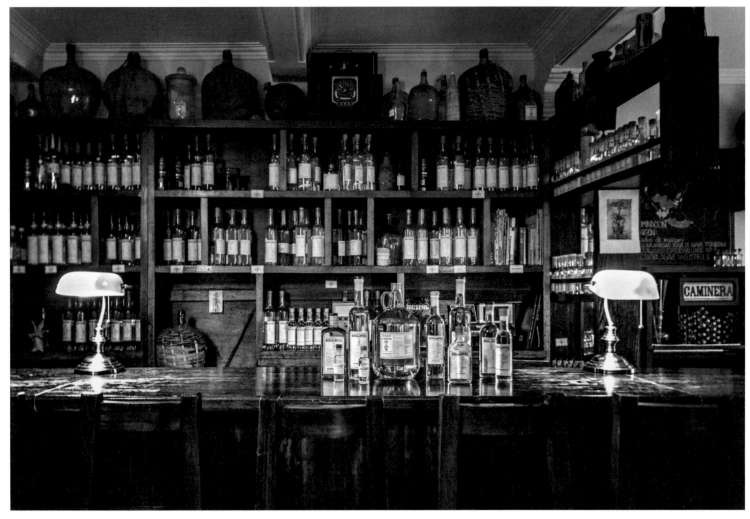

Pull up a chair and sample the dozens of mezcals sourced from across Mexico

Few things capture the spirit of Oaxaca better than the smokey flavor of mezcal. The traditional, locally made liquor uses mature, oven-cooked agave to produce its distinctive taste. Culled from over a dozen species of agave plants, the alcohol varies in flavor and aroma depending on the variety sourced. La Mezcaloteca transformed the local libation into a local institution in 2012, helping to promote the liquor's farmers, artisans, and small producers. The storefront and bar, situated in the city's charming old town, attracts mezcal aficionados to shop for quality products while learning about the drink's rich history and production. Dedicated to the conservation and dissemination of traditional mescals and to the financial prosperity of their producers, a knowledgeable staff of experts educates customer palates inside the handsomely relaxed storefront. Tastings reserved in advance help guests recognize the nuances between the different categories of spirit, make informed purchases, and learn about mezcal's place within Mexican culture. During a tasting, the host will serve three different traditional mezcales and explain how to best appreciate their aromas and flavors. While exploring the diversity of the agave plant, visitors will gradually detect differences between cultivated, domesticated, and wild blends. Informative guide materials illustrate the process of production and the distinctions between traditional, artisanal, and industrial grade products. The 45 percent proof alcohol can humble even the heartiest of drinkers, so learn from the pros, and sample away until you find the variety that suits you best. ¡Salud!

Owners: Marco Ochoa, Silvia Philion, and Alejandro Philion
Designers: Marco Ochoa and Silvia Philion
Founded: 2012
Location: Reforma No. 506, Col. Centro, Oaxaca, Mexico

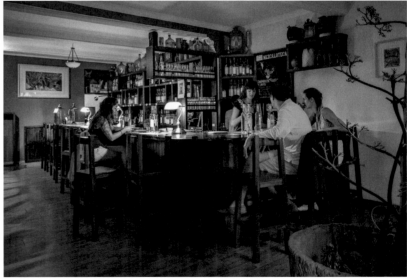

Mezcal tastings can be made by reservation

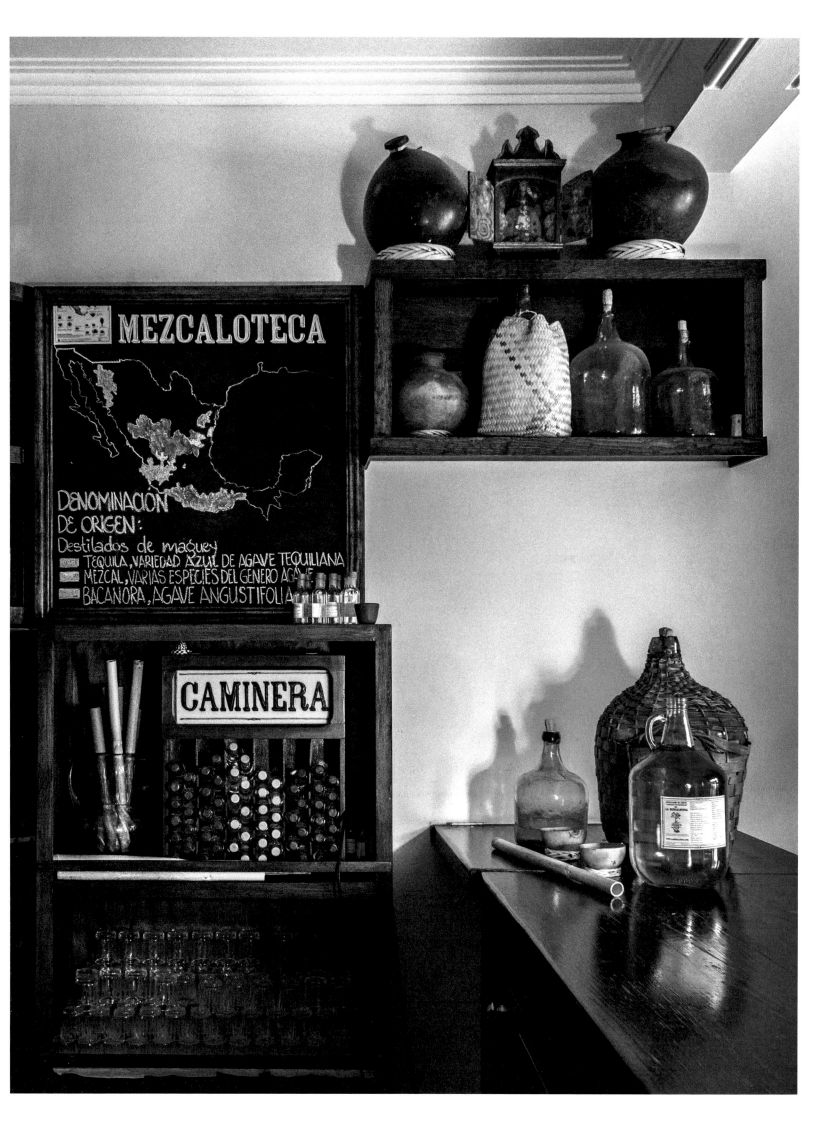

Mast Brothers

The Redheaded Chocolatiers, London, UK

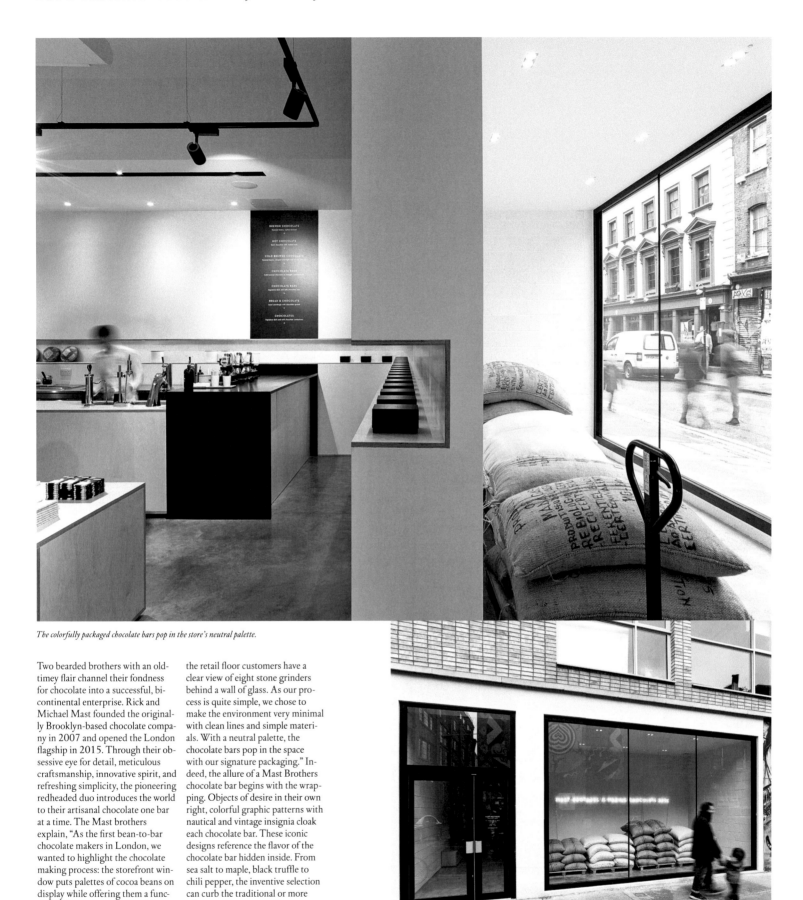

The colorfully packaged chocolate bars pop in the store's neutral palette.

Two bearded brothers with an old-timey flair channel their fondness for chocolate into a successful, bi-continental enterprise. Rick and Michael Mast founded the originally Brooklyn-based chocolate company in 2007 and opened the London flagship in 2015. Through their obsessive eye for detail, meticulous craftsmanship, innovative spirit, and refreshing simplicity, the pioneering redheaded duo introduces the world to their artisanal chocolate one bar at a time. The Mast brothers explain, "As the first bean-to-bar chocolate makers in London, we wanted to highlight the chocolate making process: the storefront window puts palettes of cocoa beans on display while offering them a functional place to be stored, and from the retail floor customers have a clear view of eight stone grinders behind a wall of glass. As our process is quite simple, we chose to make the environment very minimal with clean lines and simple materials. With a neutral palette, the chocolate bars pop in the space with our signature packaging." Indeed, the allure of a Mast Brothers chocolate bar begins with the wrapping. Objects of desire in their own right, colorful graphic patterns with nautical and vintage insignia cloak each chocolate bar. These iconic designs reference the flavor of the chocolate bar hidden inside. From sea salt to maple, black truffle to chili pepper, the inventive selection can curb the traditional or more adventurous sweet tooth.

Owners: Rick and Michael Mast
Designer: Nathan Warkentin
Founded: 2015
Location: 19 – 29 Redchurch Street, London, UK

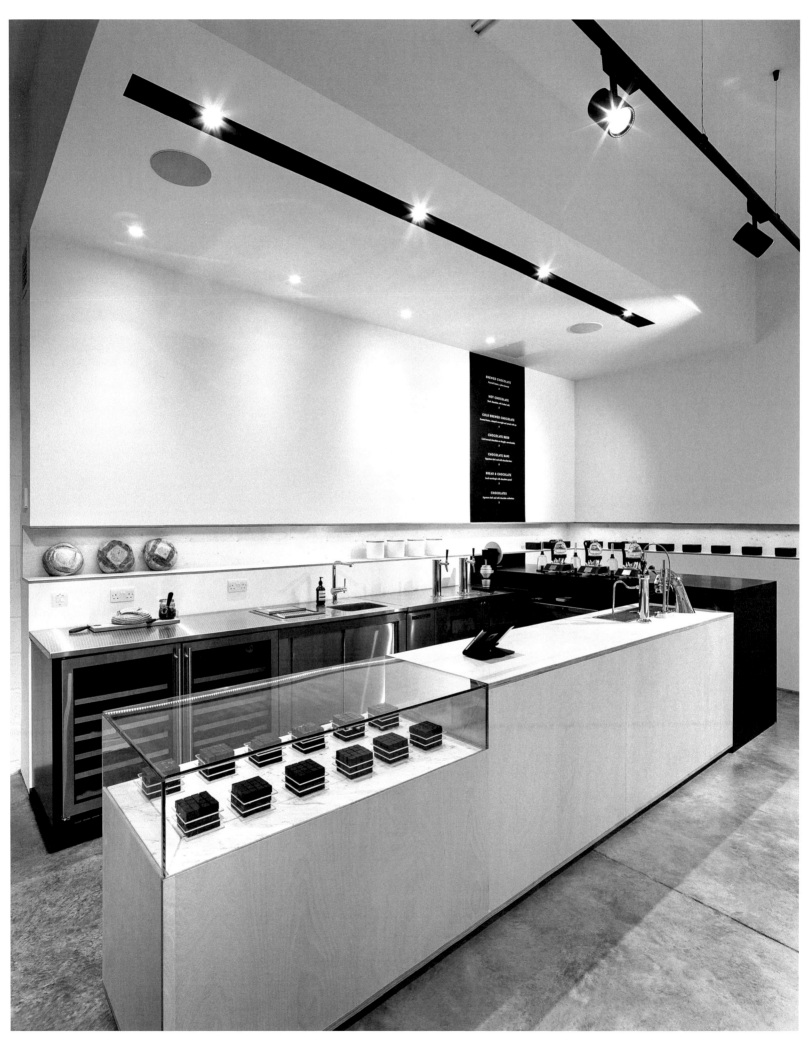

Veganista

Vegan Ice Creamery, Vienna, Austria

Who says ice cream has to have dairy in it? Not these girls. The vegan sisters have been serving scoops of dairy-free ice cream since 2013 from their two bright Viennese storefronts. Cecilia Havmoeller is CEO of the en-

terprise while her sister Susanna Paller crafts tantalizing flavors as head chef. The brunette sisters have been vegan for more than

twenty years (a.k.a. before it was easy or popular). Growing up in a small rural community, they still vividly recall their home-cooked meals and the excitement of buying sweets at the village general store on Saturdays.

These fond memories of a simpler time and shopping experience inspired the pair to pour their heart and soul into their enticing flavors

and locations. Made fresh daily in small batches, the artisanal ice cream features only natural high-quality ingredients. The sisters refer to their business as "honest ice cream" and refrain from using any artificial or prefabricated pastes and enhancers. Instead, customers are treated to unique and innovative flavors including matcha, Austrian cottage cheese, basil, poppy seed, and olive-saffron. Attracting vegan and non-vegan ice cream lovers alike, the shops are also earning street cred for their decadent hand-crafted ice cream sandwiches. So satisfy your sweet tooth and pile on that extra scoop. No need to be shy, your guilty pleasure has nothing in it to make you feel guilty anymore.

Owners: Cecilia Havmoeller and Susanna Paller
Designer: Peter Paller
Corporate Identity: lenz+
Founded: 2013
Locations: Neustiftgasse 23 / Margaretenstraße 51, Vienna, Austria

Cecilia Havmoeller and Susanna Paller, the owners of this booming ice cream business

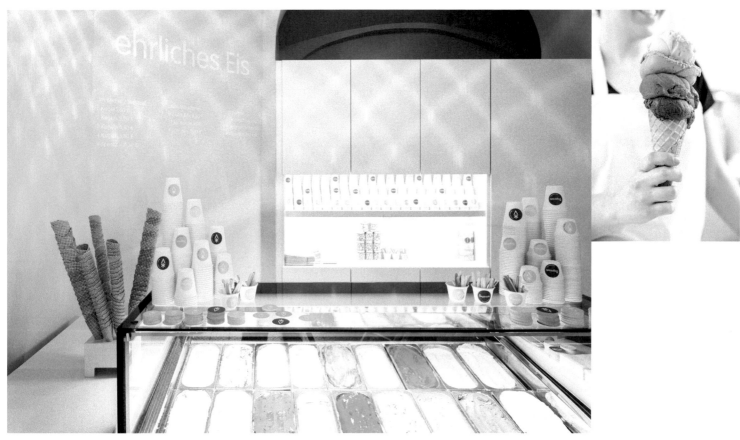

Veganista Shop II interior

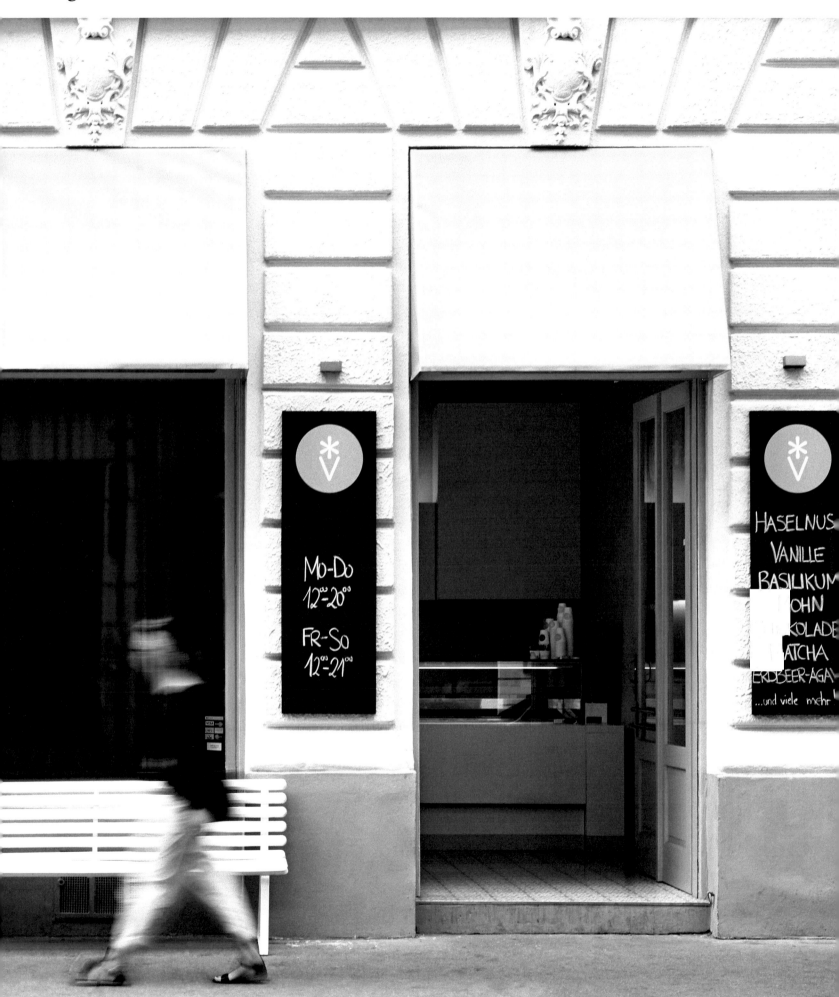

Veganista Shop I exterior

Alice McCall

Womenswear, Melbourne, Australia

Alice McCall's feminine, flattering, and playful clothing line has been inducing double takes and making hearts skip a beat for more than a decade. Beginning her career as a stylist, McCall now prides herself in designing clothing with girlish charm, bohemian flair, and a dash of rock and roll. Enjoying international success and a celebrity clientele from Kate Moss to Chloë Sevigny, McCall operates four flagship boutiques in Sydney and Melbourne. Each shop and the online store carry a diverse spectrum of womenswear from the fun and flirty to the sultry and show-stopping. The Melbourne location designed by the Australian architecture practice Wonder expresses the brand's youthful yet glamorous style in an appealing tiled storefront. White square tiles wrap the bright space and provide a gridded rhythm to the shop. Custom golden clothing racks gracefully meander through the store. These elegant bespoke racks enhance the shopping experience as they gleam in the afternoon light. Retail therapy never looked so good … or made you look so good for that matter.

Owner: Alice McCall
Design: Wonder Design Studio
Founded: 2012
Location: 549 Chapel Street, South Yarra, VIC, Australia

Exterior

A grid of white tiles wrap up and over the space

An Amsterdam-based lifestyle brand builds their business model around their philanthropic goals. The progressive company believes everyone should have access to a source of clean drinking water and makes sure to do their part in making that happen. Marie-Stella-Maris donates part of all proceeds from its natural care products and mineral water sales toward clean drinking water projects worldwide. Founder Patrick Munsters and co-founder Carel Neuberg moved the skin, body, and hair care line into a bright storefront in Amsterdam in 2014. The contemporary design combines the best of today's graphic and aesthetic languages with a touch of the old-world apothecary style. Munsters, the former creative director of Scotch & Soda, left his career in fashion to explore new ways to empower people to consume more consciously. His call to action came in 2010 when the United Nations declared access to clean drinking water and sanitation a human right. With this resolution, the UN also called upon

international organizations to provide financial resources to assist developing countries with these efforts. A year later, he founded the company with Neuberg—a leader in the information and communication technology field—to make a direct contribution to water-related issues on an international scale.

For the first three years, the brand focused on the production of natural mineral water. By sourcing the water as close to the consumer as possible, Munsters and Neuberg minimize transportation distances and limit the brand's impact on the environment. The direct link between clean drinking water and hygiene inspired an expansion into the personal care industry in 2014. Now a successful business model, the shop attracts both men and women between the ages of 25–50 who care about their lifestyle and the planet. Spread over two levels, the welcoming space hosts the store on the first floor and a Parisian-style café below. A long wall of light boxes featuring the UN

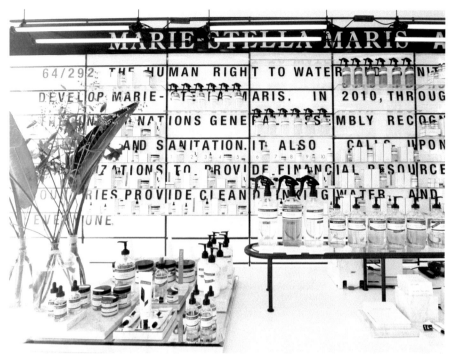

Resolution 64/292 "The Human Right to Water and Sanitation" gives the space its striking visual manifesto. Customers test products and take home samples of the unique and cruelty-free soaps, lotions, scrubs, creams, oils, and home fragrances. The Marie-Stella-Maris Foundation supports six clean drinking water projects,

which service more than 11,000 people around the world. Each guilt-free purchase enables you to quench your thirst and someone else's within a single transaction.

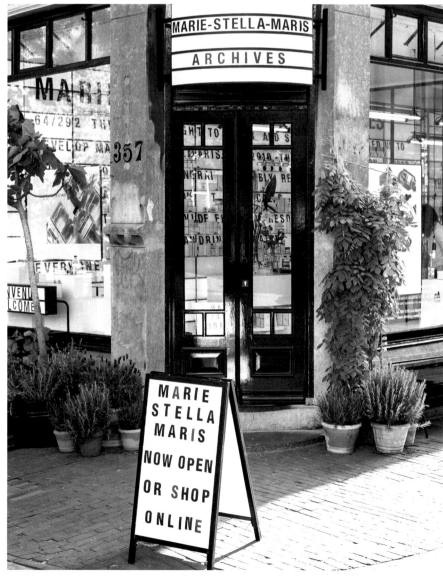

Storefront

Patrick Munsters the founder of Marie-Stella-Maris

Owners: Patrick Munsters and Carel Neuberg
Designers: Patrick Munsters and Anton de Groof
Founded: 2014
Location: Keizersgracht 357, Amsterdam, The Netherlands

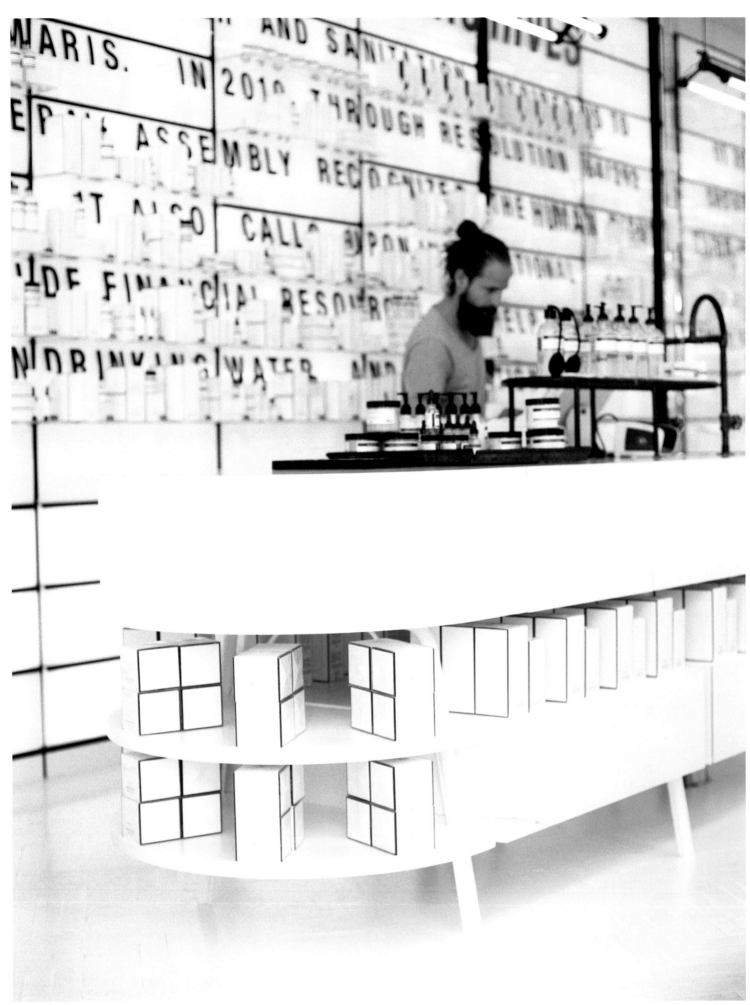

The company's mission statement acts as an interior graphic branding the space

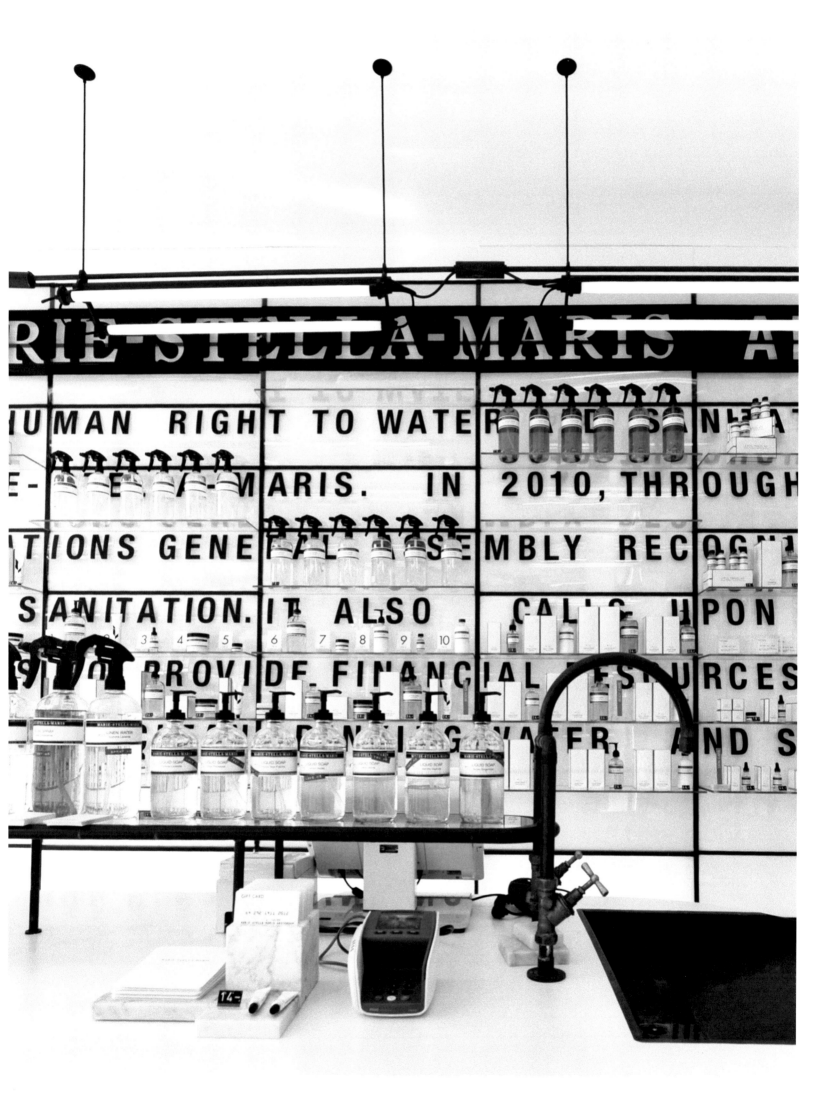

MDC

Cosmetic

Taking the time to visit the source of each product she carries, **Melanie dal Canton** brings the finest skin care products to a loyal clientele of Berliners and international costumers. On-site beauty therapists provide a total body experience.

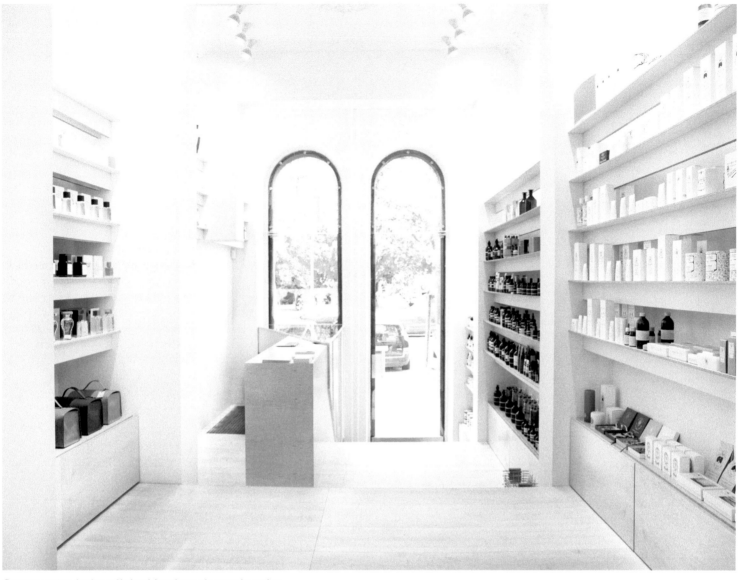

Compact yet spacious, clean lines and built in shelving showcase the various skin care lines

We take care of our bodies in countless ways and yet know so little about the products we put on them each day. A Prenzlauer Berg cosmetics shop has been working to change this glaring gap between product and consumer knowledge since 2013. Company founder Melanie dal Canton used her own initials, a degree in political science from the Freie Universität Berlin, and an intimate knowledge of skin care to launch the brand in 2012. Until the end of 2014, she led a double life, continuing to work as manager for Andreas Murkudis—an upscale concept and lifestyle store. She spent ten years with the company, starting out in marketing and PR and moving all the way up to managing director. Her time spent in the fashion and retail industry fueled her awareness of the increasing need for honest cosmetics, wellness products, and the accompanying consulting needed to make an informed purchase. As none of these items was available within a clothing and accessories retail setting, dal Canton saw an untapped market for a curated boutique focusing solely on cosmetics and

cosmetic, and acted on it. The welcome addition to the neighborhood and its creative class carries her exclusive skin care lines and includes an intimate space for on-site beauty treatments.

Inside the bright and simple 730-square-foot shop, two on-site therapists offer a spectrum of treatments in the back while two experienced consultants advise customers about the particularities of their skin in the front. MDC serves as a classic apothecary with a unique touch. Much of the product range, barring the Berlin classics by Susanne Kaufmann and Aesop, prove difficult to come by. MDC products originate in Australia, the east and west coasts of the United States, and Europe. While many cosmetics companies claim organic and all natural origins, few live up to their word. At MDC, dal Canton takes it upon herself to visit the place of manufacturing for all products before she brings them into the shop. Nearly all products in stock are made by small, traditional manufacturers, many using time-honored production methods and recipes handed down through the generations. The selection of products sup-

ports dal Canton's conviction toward concepts of beauty, well-being, and wholesomeness. Her deep interest in how things are made stems from her childhood in the Lake Constance region of Germany. Bordered by scenic lakes and mountains, her hometown still maintains a thriving culture of quality craftsmanship.

The store caters to the daily needs of locals while also stocking hard to get and exclusive items from brands such as Malin + Goetz, Parfumkunst, and Officina Santa Maria Novella. In addition to attracting a diverse customer base from Berlin and abroad, a comprehensive webshop delivers MDC products worldwide. MDC does offer set treatments performed in-store, but the staff adjusts each service to the needs of each client according to company principles and a thorough consultation. After an analysis and assessment of the skin, the aestheticians set up a customized care plan. These personalized cosmetic treatments use the store's own product lines and range from regenerative facials to classic salon offerings like mani-pedis and eyebrow tinting. Treatment times range from 40 minutes

up to an hour and a half depending on the level of pampering desired.

From conceptualizing the space onwards, the atmosphere of the shop remains a crucial focal point for dal Canton. She understands that as a client, one can only confide in a consultant in the proper setting. The nurturing and inviting space of MDC developed out of a close collaboration with architects AA Gonzalez Haase. The same architects responsible for the Andreas Murkudis space took care of the renovation of the historic location with its memorable Neo-gothic shop windows, regal eggplant purple and cream exterior, and minimalist interior with built-in shelving. The understated shelving system runs along both of the main walls of the store, showcasing the wide variety of self-care products in an almost exhibition-like manner. A proud gingko tree out front remains visible inside the store, giving the space a more private and vaguely romantic air. The slender shop moves from front to back, with generous windows on either end that flood the stepped space with soft daylight.

Regular clients will drop by, simply looking for conversation and advice about their skin care regime. Over months, relationships form, stemming from a sense of satisfaction with purchased items and treatment packages. For many locals, MDC has become an integral new part of their private lives and a resource for improving general well-being. Clients between 28 and 60 years of age grow to rely on the quality and effective skin care products crafted by traditional manufacturers and the stories behind them.

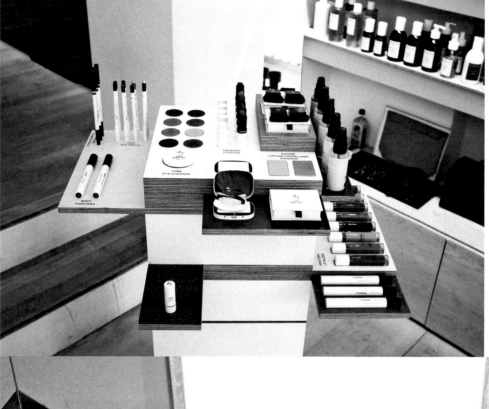

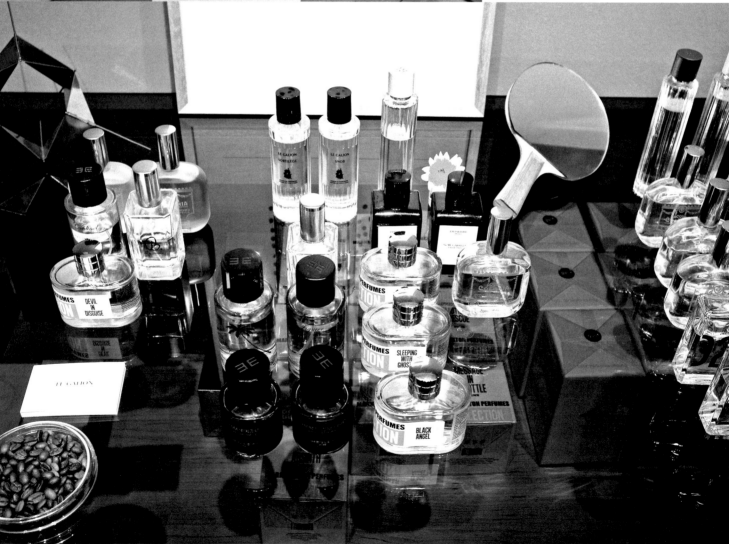

MDC stocks a range of fragrances as well as the popular ping-pong paddle hand mirror

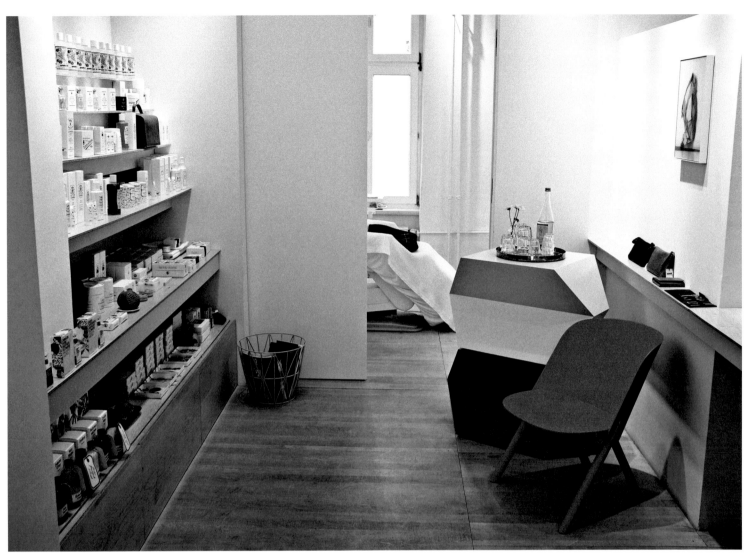

A treatment room in the back offers a spectrum of beauty services

Exfoliating hand washes to gold glitter nail polish, incense sticks to Portuguese toothpaste and Italian toothbrushes, MDC advocates for a holistic approach to self care. Rather than focusing just on the face, the company presents thoughtful solutions for mind, body, and spirit. A few of the more unexpected items in stock range from caffeinated hair water used for generations to slow hair loss to wool slippers that pad one's feet and knit cashmere water bottle covers. Such diverse pampering options supplement the more expected, yet equally high-quality lotions, serums, and creams. Dal Canton also hand-picks a selection of specialty fragrances to enhance the sensorial quality of the beauty care regimen. For many clients, the choice behind a perfume underscores their personality. At MDC Cosmetic, the aestheticians take the time to match each customer with the scent that suits them best. Not just for women only, the apothecary sells a number of gentlemen's products. Shaving creams and foams, colognes, and full skin and hair care lines cater to the store's somewhat less common, yet equally valued, male clients. An in-depth assortment of household goods and personal accessories compliment the shop's skin, hair care, fragrance, and makeup lines. Many of these home improvement items tap into the power of olfactory stimulation for influencing and enhancing one's mood. MDC supplies room scents, candles, and air fresheners as well as fragrant teas to give the nose a treat.

MDC offers something valuable that shopping online for cosmetics can't—personalized and thorough consultations for every client. The patient staff answers any and all questions, guiding customers to the optimal products that will enhance and refresh their skin type. For those unable to make it into her store, dal Canton makes it a point to promote dialogue with her therapists via phone and email.

Stock up on basics from shampoo to lipstick or splurge on one of the delightful ping-pong paddles that have been converted into hand mirrors exclusively for the store. MDC's tantalizing and ever-expanding collection of products and pampering treatments transforms an apothecary into a haven for its customers. Treat yourself or someone else—the impressive and well-sourced items and spa packages make for the perfect gifts, so good in fact that you'll think twice before giving them away.

Scents for both body and room inspire the senses

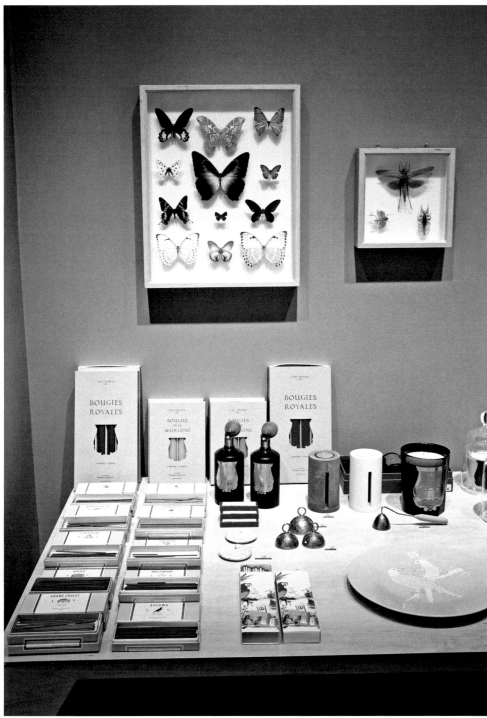

MDC curates a range of select and lifestyle products to compliment the apothecary line

Owner: Melanie dal Canton
Designer: AAS Gonzalez Haase
Corporate Identity: Studio Quentin Walesch
and untitledproject/Mischa Bitten
Founded: 2012
Location: Knaackstraße 26, Berlin, Germany

Exfoliating hand washes to gold glitter nail polish, incense sticks to Portuguese toothpaste and Italian toothbrushes, MDC advocates for a holistic approach to self-care.

Otsuka Gofukuten Kobe
The Kimono Company, Kobe, Japan

Storefront at night

A store dedicated to the kimono comingles Japanese tradition with an of-the-moment minimalism. Founded by the kimono retail trade company Misawa Ltd in 1972, owner Naoto Otsuka reintroduces kimono culture to a new generation with the opening of this concept store. Frustrated that kimonos are now worn only by high society for special occasions, Otsuka strives to bring the kimono back to everyday life. Enchanted with the stunning garments for decades, he believes that kimonos should be worn by everyone regardless of class and as an integral part of a daily modern fashion regime. The refined store with its Noren façade and light wooden shelves with carefully folded garments makes the most of its 320-square-foot space. Welcoming customers with a variety of budgets, Otsuka prices the items from low to high. With a suitable choice for everyone, this elegant kimono store acts as an effective reminder of why the garment has been in existence for more than a thousand years. The word kimono literally translates as "thing to wear," and with designs like these who needs anything else in their closet?

Owner: Naoto Otsuka
Designer: Yusuke Seki
Founded: 1972
Location: 1–8–1–147, Sannomiyacho, Chuo-ku Kobe-shi, Hyogo, Japan

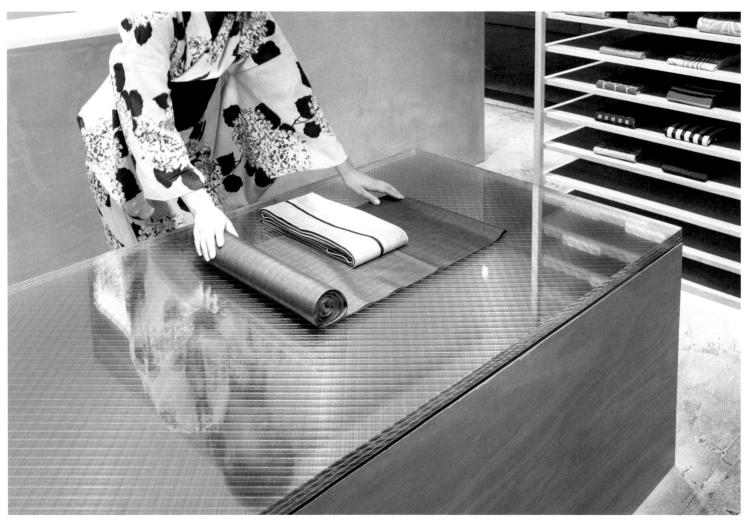

The finest fabrics reintroduce the kimono into daily life

Schwarzhogerzeil

Fashion Police, Berlin, Germany

Storefront

The go-to place for the fashion-conscious Berliners since 2005, SCHWARZHOGERZEIL has at last consolidated its two storefronts into one tantalizing retail experience. Owner and store manager Nicole Hogerzeil has turned her chic selection of women's designer fashion goods into a glamorously contemporary new 1,600-square-foot storefront. Located on the bustling Torstrasse and designed

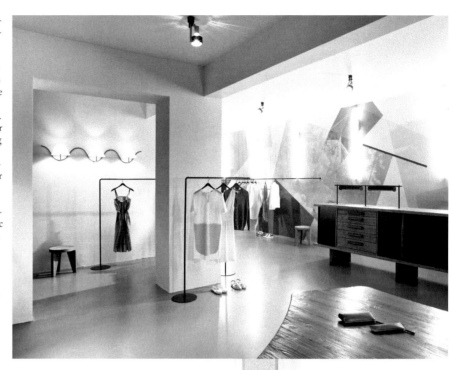

by Sylvester Koziolek, the new flagship opened in 2015. A film industry veteran, Hogerzeil always nurtured her interest in fashion. Once she finally decided to cross over into the industry, her first idea was to open a temporary shop. At the time of the pop-up shop's launch, Berlin had become a desert for fashion. Design starved locals flocked to her shop, and what began as something impermanent quickly morphed into a mainstay. Now more than a decade in, Hogerzeil carries a number of high-end collections and smaller accent labels, and displays each piece with great artistry and conviction. The new shop, full of dramatic fluorescents and royal blue accents, reads as much as a gallery of desire as a retail store. Targeting stylish, confident, and ambitious women, Hogerzeil and her staff of five help each customer find something special and unique. From a new show-stopping dress to an intoxicating fragrance, each item for sale makes even the most humble woman feel like a queen.

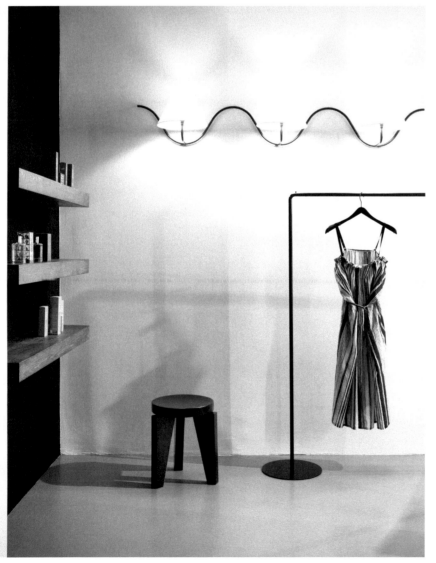

Owner Nicole Hogerzeil

Owner: Nicole Hogerzeil
Designer: Sylvester Koziolek
Founded: 2015
Location: Torstraße 173, Berlin Germany

The contemporary interior design treats each product like a work of art

The Chilewich Store

The Placemat Place, New York City, USA

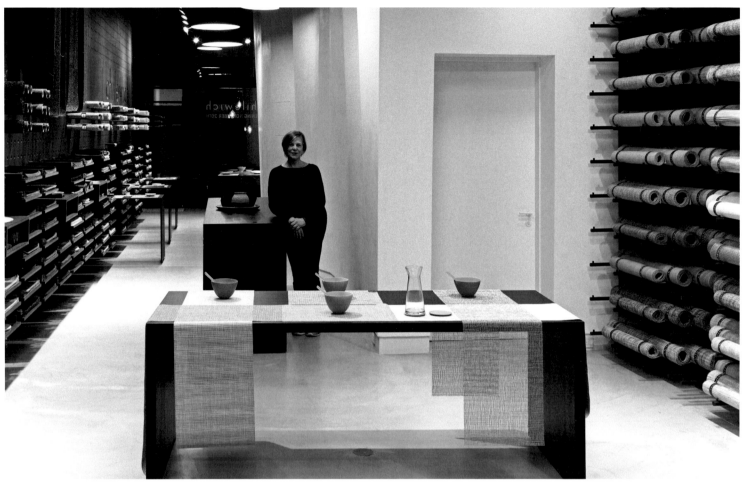

Sandy Chilewich in her brand's flagship store

The art of table setting reaches new levels inside an enticing shop in New York City's Flatiron district. Opened in November 2014, the 820-square-foot storefront and its staff of five provides the most comprehensive collection of the brand's signature placemats and flooring designs under one roof. Sandy Chilewich founded the company in 2000 after a successful career as the co-founder of HUE® legwear. Her passion for reinterpreting underutilized and overlooked manufacturing processes and breathing life into product categories that have grown tired from design neglect led her into the legwear industry in 1978. Conceived at her SoHo loft, HUE revitalized the lackluster women's hosiery and sock industry with innovations in color, product, packaging, and merchandising for the next thirteen years. Chilewich and her partner sold HUE in 1991 and each stayed on as co-presidents until 1994. After leaving HUE behind, Sandy experimented with a number of prototypes for other products in need of revitalization. A fruit basket, which began with a wire hanger and pantyhose, ultimately became her next design innovation. Sandy introduced the RayBowl® in 1997 at the MoMA Design Store. The success of the bowl took Sandy out of the fashion world and into the home, paving the way for a new business and brand.

In a quest to find other suitable fabrics for her bowls, Sandy stumbled upon a woven textile produced for outdoor furniture upholstery. After visiting the factory in Alabama, Sandy became fascinated with the design potential of this off-beat manufacturing process and material. In addition to its inherent design versatility, the textile is stain-resistant, washable, water repellent, and durable. Her infatuation with the material endures and led to the launch of her Chilewich product line of woven placemats three years later. Reinventing how people dress their tables, her placemats take the tablecloth off the table. Now that white linen no longer defines fine dining, her striking Manhattan store, designed by De-Spec, celebrates the rainbow of possibilities for enlivening one's eating areas. Revamp any indoor or outdoor dining experience with a splash or two of color in bright indigos, crimsons, citrus shades, and more. These tantalizing textiles, rugs, and floor treatments are designed to impress and built to last.

The storefront resides in Manhattan's Flatiron District

Placemats and fabrics come in a variety of vibrant colors

Owner: Sandy Chilewich
Design: De-Spec; *Corporate Identity:* Chilewich Sultan LLC
Founded: 2014
Location: 23 East 20th Street, New York City, NY, USA

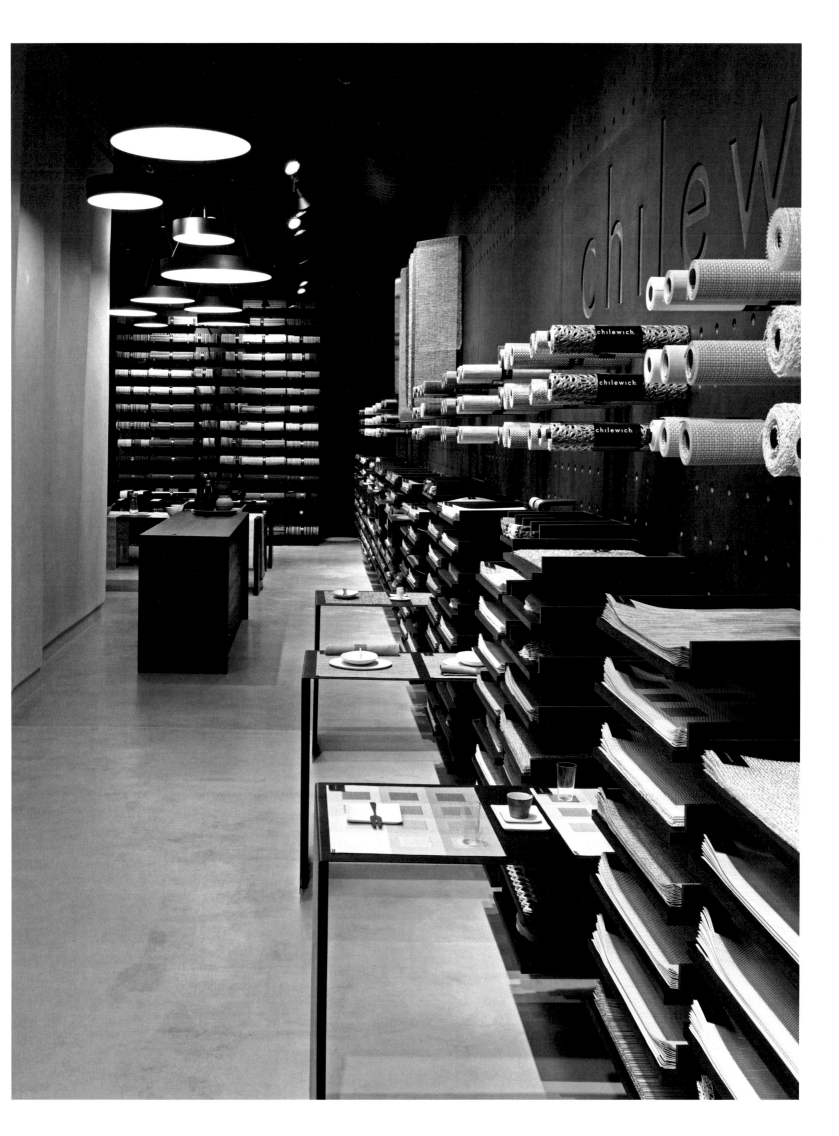

3x1

The man behind Paper Denim & Cloth launched his latest fashion label, **3×1**, just four years ago. California native Scott Morrison transforms his innate knowledge of jeans into a bespoke denim flagship in New York City's SOHO district.

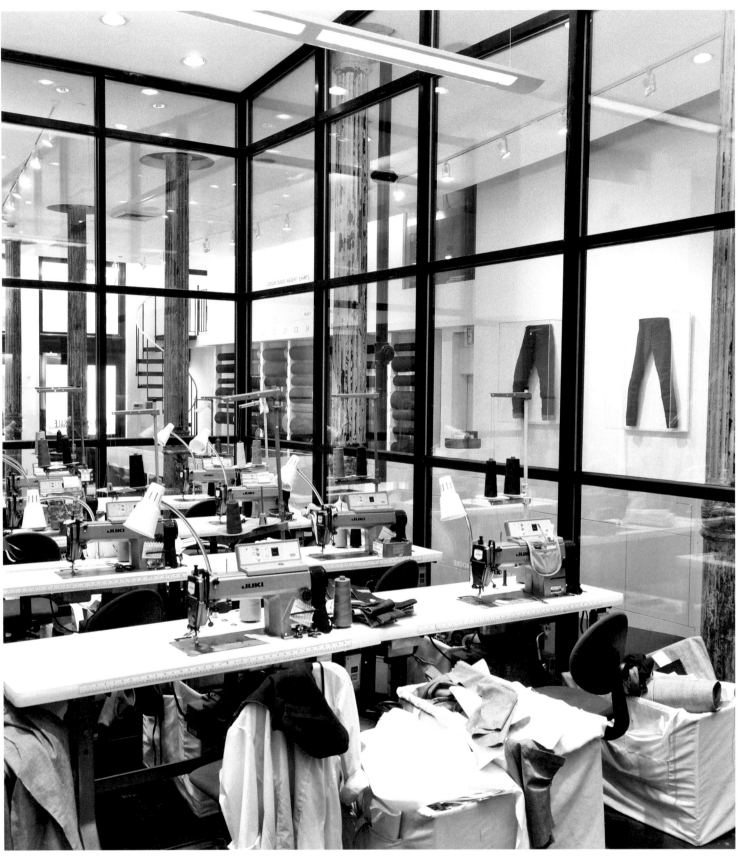

Customers can watch their clothing being made on-site

In 2011, denim designer and entrepreneur Scott Morrison launched his third denim line and unconventional retail concept store, 3×1. The man behind a denim empire fell into his niche matter-of-factly. Guided by his lifetime of knowledge accrued from wearing jeans as his staple uniform, Morrison designs his jeans first and foremost for himself. Growing up in Southern California, his style as a kid was defined by three key items: a pair of jeans, a T-shirt, and some flip-flops. Not much has changed for Morrison as an adult. Running his operations out of New York City, he still keeps his distinctly casual West Coast attitude intact and embeds that laid-back style into each of his projects. Morrison, a proponent of jeans for any occasion, has made his life's work about facilitating just that. The company name derives from denim's standard weaving construction, the 3×1 Right Hand Twill. The term "three by one" also alludes to Morrison's third jeans concept after launch-

ing the wildly popular Paper Denim & Cloth in 1999 and Earnest Sewn in 2004. Following the success of his first two brands, Morrison wanted to reinvent the way people see denim, and in doing so create a retail environment that captured customers' imagination in a completely new way.

Based in Manhattan's SoHo district, 3×1 began as part retail store and part factory space. The handsome and demure white storefront houses a glass enclosed jeans factory at its center staffed by forty employees. The Mercer Street flagship holds the distinction of being the world's first denim atelier, specializing in bespoke and custom-made jeans. Home to the world's largest collection of selvedge denim, the unprecedented concept store stitches the production process into the retail environment. Ostensibly the only place offering such an experiential fashion retail landscape, 3×1 enables customers to watch their jeans being sewn behind three glass-walled rooms. Inside these rooms, sewers, cutters, pattern makers, and finishing staff immerse themselves in their process. The fishbowl-like quality of the in-house factory space forges a striking visual connection between what the consumer buys and where it comes from. This refreshing transparency brings customers into the fabrication process and encourages them to design and request what they actually want.

Each new style of jeans gets product-tested by Morrison himself before it goes on the market. Committed to the idea of not selling anything he wouldn't wear himself, he tests new products for four months up to a year before sending them into production. 3×1 fabricates more than 100 types of jeans for men and women each season, providing several levels of service within the store. Ready-to-wear jeans consist of the brand's best-selling styles and fits. This basic line can also be purchased at select high-end retailers including Barneys, Bergdorf Goodman, Sak's Fifth Avenue, Neiman Marcus, Le Bon Marché, and more. Special editions, found exclusively in-store, are introduced each week during the summer. Custom-made items represent another sought-after service available at 3×1. This process allows customers to pick one of the brand's products or fits and select each detail including fabric, thread color, buttons and rivets, back and front pockets, belt loops, and so on. A custom-made item from 3×1 typically takes two to three weeks from start to finish. The final, and highest, level of service encompasses the company's bespoke offerings. Using the in-house pattern-making and digitizing process, 3×1 creates a unique fit tailored just for you. Similar to made-to-measure suiting, once the fit has been finalized, they can create an infinite number of denim possibilities. Morrison himself has archived three fits: the SM1, SM2, and SM3. Digitizing

your individual pattern enables the company to remake a particular jean to your specifications anytime and from anywhere in the world. This one-of-a-kind experience and supporting process typically takes between one and two months to complete.

Since its launch just a few years ago, the company has introduced more than 600 selvedge denims to its customers. 3×1's SoHo atelier now houses the largest collection of selvedge denim in the world. Adapted from the original term "selfedge," this style of denim features the narrow, tightly woven band on either edge of the denim fabric, parallel to the warp. A selvedge end prevents the edge of the denim from unraveling. This type of finishing detail only occurs on narrow width shuttle looms producing 28-inch to 32-inch-wide denim. Larger modern weaving machines, on the other hand, generate fringed edges that must then be sewn to prevent unraveling. Selvedge shuttle looms are used exclusively at 3×1 to craft each of the 3×1 men's products, including the signature denims, twills, chambray, shirting, and corduroy.

This refreshing transparency brings customers into the fabrication process and encourages them to design and request what they actually want.

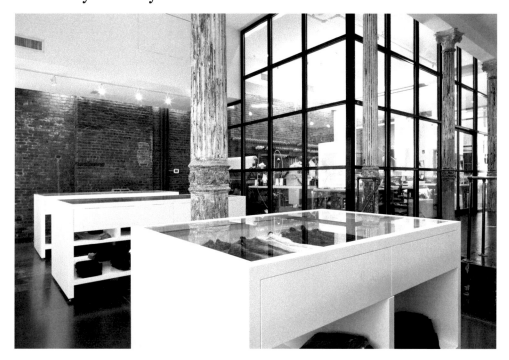

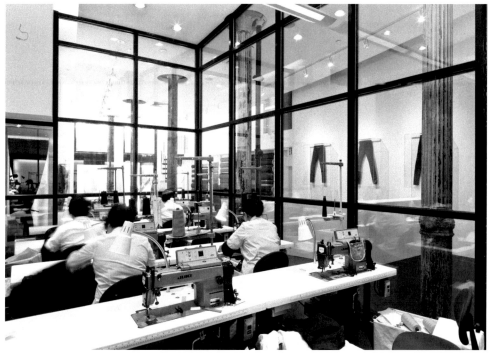

Forty employees staff the on-site denim atelier

Morrison tests each new product line himself

materials combined with the most flattering fabrics and slimming silhouettes will reshape the future of women's denim. Much of the inspiration for this collection comes from Morrison's wife Gracileia, a former denim model he met while working at Earnest Sewn. These artfully constructed pieces integrate durable zippers and thoughtful trims that will wear well over time. The men's collection focuses on Morrison's love and knowledge of selvedge denim. Combining timeless styles with designed updates, Morrison and his team smartly refine the wardrobe of the modern man.

3×1's uncompromising commitment to producing the finest jeans ever made shows in each and every item with their label on it. Their unique sewing style begins with a single needle sewing machine. If two rows of stitches are visible, know that it was sewn two separate times, each without guides or automation. This trademark and top quality crafting approach allows the denim workers at 3×1 to increase the number of stitches per inch (SPI). While most jeans are sewn at 79 SPI, Morrison and his company sew their denim at 1113 SPI. This exponentially higher stitch count requires 40 percent more time to sew and significantly more skill from the sewer. Bring in your favorite pair of vintage jeans and have them recreated down to the last stitch, dream up something entirely new, or trust in one of Morrison's time tested ready-to-wear options. Built to last, these staple items easily upgrade any and every closet. Dress them up or dress them down, either way, you'll never want to wear anything else.

Owner: Scott Morrison
Founded: 2011
Location: 15 Mercer Street, New York City, NY, USA

Introduced as a retail concept focused initially on the making of limited-edition, custom, and bespoke jeans to be sold in the 3×1 atelier, the opportunity quickly arose to develop a small wholesale range for a few of the world's finest retailers. Four seasons later, 3×1's wholesale business reached 100 accounts worldwide and Morrison then decided to expand into both men's and women's collections. The women's collection is designed with the idea that the best

Combining timeless styles with designed updates, Morrison and his team smartly refine the wardrobe of the modern man.

The store offers a range of services from ready-to-wear to full bespoke orders

Luke Deverell, master darner

Who says men can't sew? Working from a small studio in South London and the Edwin store in Shoreditch, Luke Deverell stitches, patches, and darns a second life back into his customers' favorite garments. Deverell learned the art of mending clothes from his grandmother. Starting at a young age, his work began with the simple tasks of replacing rogue buttons and mending tears in his school uniform. Once his skills improved, his grandmother then taught him how to darn. Since then, whenever wear and tear gets the better of his clothes, he mends them by hand in the same way he learned as a child. His grandmother's influence inspired Deverell to launch Darn and Dusted in 2013. Offering a completely bespoke service with all mending done by hand, Deverell uses traditional methods and ma-

terials and finishes them with carefully executed personal touches. All services and finishes are tailored to his customers, allowing them to preserve and continue wearing their most beloved pieces. Over the years, he has acquired a number of choice vintage pieces that have been lovingly repaired by their owners. This process allows for the garment to take on its own individual character. Such pieces have helped Deverell develop his unique understanding of fabrics and hone his skills in mending them in a traditional way. Committed to the idea that sometimes the best work must be done by hand, the one-man enterprise resurrects worn items a stitch at a time. Redirect your tired items set for the trash to Deverell's workshop and marvel as he skillfully prepares them for the beginning of your second life together.

Owner: Luke Deverell
Founded: 2013
Location: Charlotte Road, Shoreditch, London, UK

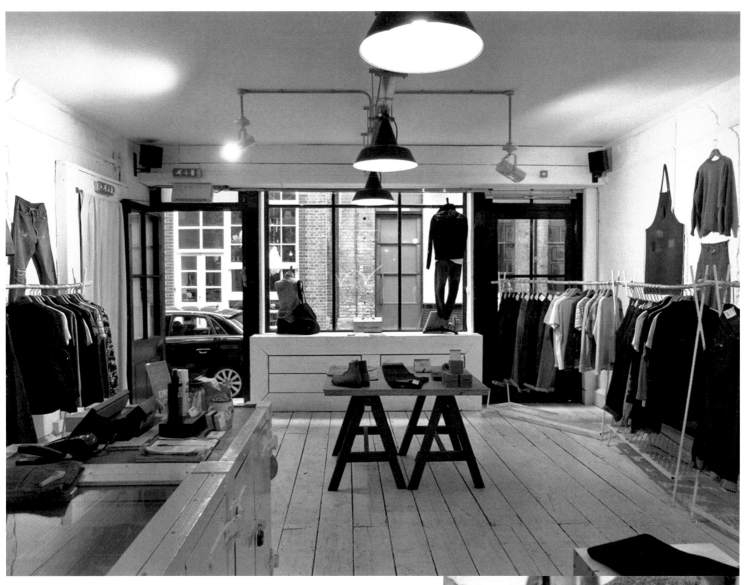

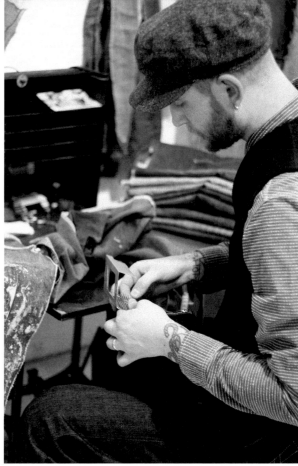

Rustic Menswear, Berlin, Germany

Shane, Maria, and Tim

This Berlin-based shop appeals to the man's man—the motorcycle riding, leather jacket wearing, beard sporting cosmopolitan adventurer. Frankfurt born Shane Brandenburg founded the store as a passion project in 2007. With more than 25 years of experience in denim clothing, Brandenburg now acts as the store's buyer and sources only the highest quality pieces with a rugged edge. Maria Klähn, the owner and CEO of the company, was born and raised in Berlin. Committed to quality-conscious menswear and craft, Klähn runs both the store and online shop.

The shop, located in a thriving retail district, places a selection of rugged menswear against a backdrop of rustic interiors. When exploring the savvy offerings from a collection of international brands, customers may also admire the vintage Harley casually propped in the space, as well as a range of other masculine-themed collector's items. These accent artifacts include everything from a rusty anchor to a retro scooter and lend the shop its distinctive appeal. Specializing in denim and raw materials, the store stocks a unique range of timeless classics and their contemporary reinterpretations from brands including Iron Heart, Indigofera, Edwin, Stetson, Tellason, Alexander Leathers, Filson, Buzz Rickson's, and Red Wing Shoes. Drop in for a fresh pair of work boots, accessories for your bike and man cave, or an entire wardrobe overhaul. For those gentlemen not in or around Berlin, don't despair, Burg & Schild's online store maintains a comprehensive selection of well-made items that ship worldwide and last a lifetime.

Owners: Shane Brandenburg and Maria Klähn
Designer: Christian Gröschel
Founded: 2007
Location: Rosa-Luxemburg-Straße 3, Berlin, Germany

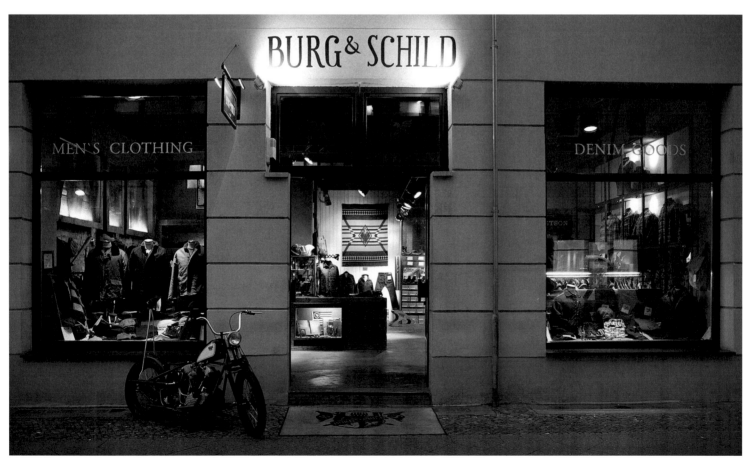

Storefront

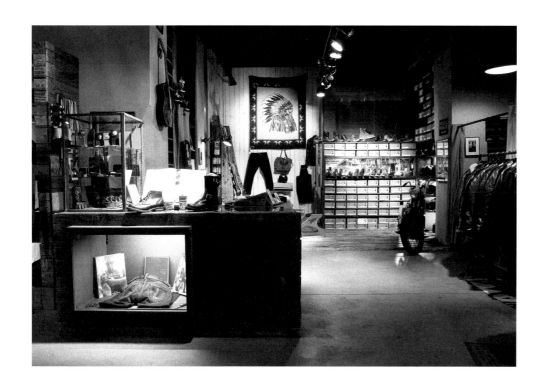

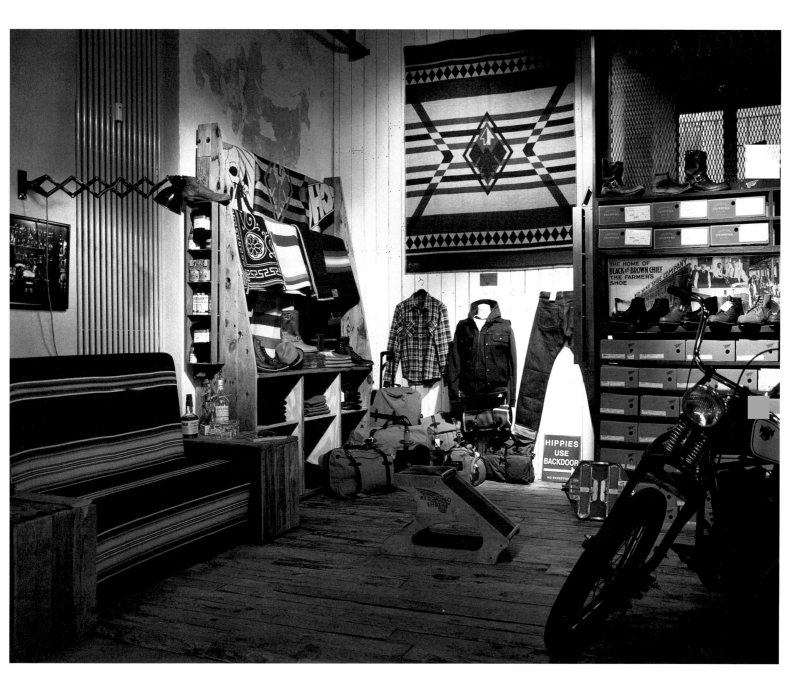

A trio of expats oversees Shanghai's first fixie boutique. The stylish 1,300-square-foot shop caters to Shanghai's biggest bike enthusiasts. Partners Drew Bates (UK), Jeff Liu (USA), and Tyler Bower (Canada) each relocated to Shanghai in 2009 and met by chance on the street. Sharing a passion for cycling and tinkering, they began riding and organizing events together. This collaboration evolved into refurbishing old Chinese bikes. The rehabilitated bikes sold out immediately, inspiring the friends to quit their jobs and start a business together in 2010. After renting a studio apartment to serve as a community workshop and business incubator, Factory Five was born.

The partners' combined business, design, and product management skills allow everything to be handled in-house. In addition to the three founders, Factory Five also consists of a photographer, designer, copywriter, business developer, web developer, and product engineer. The five-year-old company has grown organically into its impressive new storefront. Factory Five builds custom fixed-gear and road bikes using the finest components from around the world. The unique bikes are tailored to each rider's individual needs. A fully operational workshop acts as the heart of the space and compliments the parts, frames, and accessories lining the walls.

Best known for their Lattice Chainring, now sold in over 25 countries, the owners merge their interest in bike culture with their commitment to community outreach. Tapping into the city's growing soft spots for fixed gears, Factory Five acts as Shang-

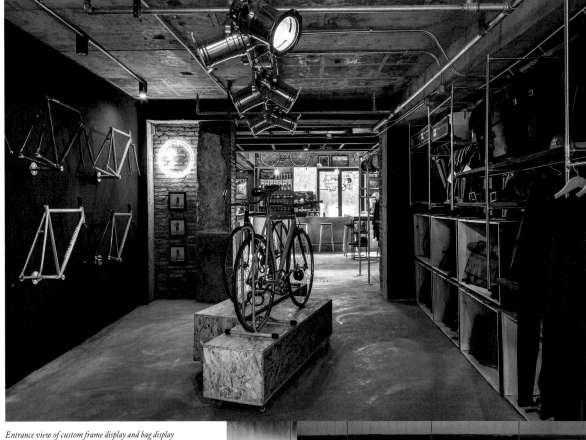

Entrance view of custom frame display and bag display

hai's clubhouse for cycling with a full bar and casual atmosphere. The shop caters to a diverse demographic of local and energetic creatives that approach cycling as both a means of transport and expressive lifestyle. Full of ideas, the friendly founders will help you find that spare part or build your dream machine from the ground up. All you have to do is ask.

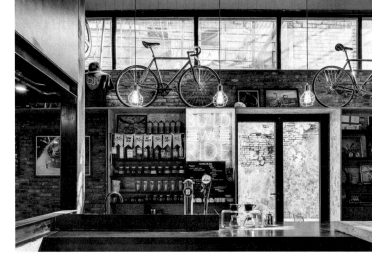

Close-up of bar counter

Drew and Tyler

Jeff

Owners: Drew Bates, Jeff Liu, and Tyler Bower
Design: Linehouse
Corporate Identity: Factory Five
Founded: 2014
Location: 667 Changhua Road, Shanghai, China

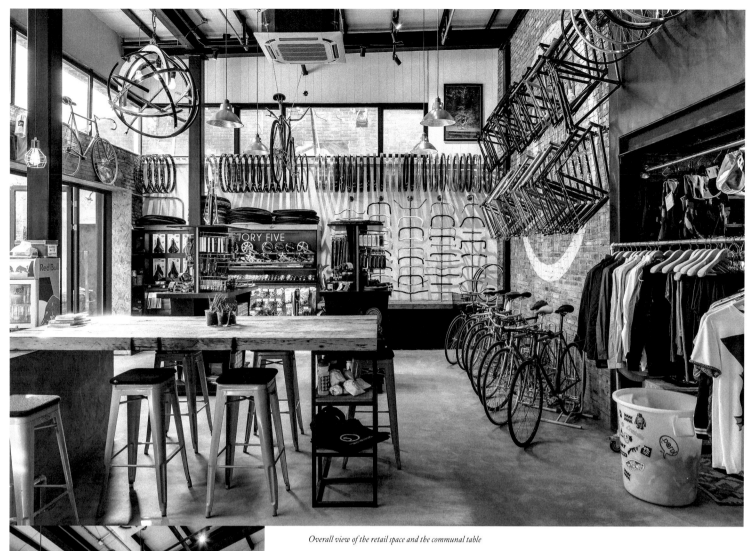

Overall view of the retail space and the communal table

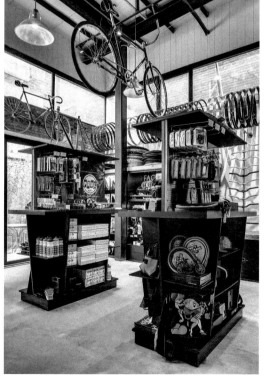

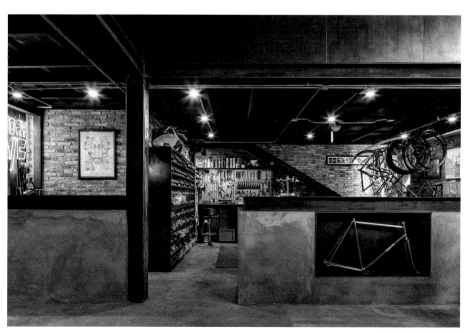

Workshop counter

Coffee and Bicycles, Berlin, Germany

In a city known for its bicycle culture, the team at Standert Bicycle Store & Café designs, builds, repairs, and rides its bikes across Berlin. The shop, founded by Max von Senger, runs as a showroom of his brand, a community hub, and a source for quality coffee and cold beverages. After studying industrial design, von Senger began designing his own bicycle frames that give new track bikes a classic look. Low key with exposed brickwork, the shop has quickly made a name for itself among bicycle enthusiasts since its opening two years ago. The brand proudly designs, produces, and builds steel frames and complete bikes for various disciplines including urban commuting, road cycling, and track/fixed gear street riding. Each team member believes in the bicycle as the main source of transportation for the urban centers of the future and works diligently to bring bike culture to the community at a fair price point. Since 2015, Standert even offers leasing options on all bikes as a solution for customers on more limited budgets.

The showroom carries a fine selection of bike-related goods. Offering both frame sets and full builds, customers can choose each parts themselves and then have the team of skilled mechanics put together their custom ride. All bikes are built in-house, with a few choice frames from other companies rounding off the selection. The café serves as a lively stop for cyclists to gather and exchange tips and share adventures. The straightforward menu satisfies both the quick needs of the stop-by courier with its famous 1-buck-filter coffee as well as those who appreciate fine, fair trade coffee and something small and simple to go with it. While you mingle and sip your latté, Peter tends to all your bicycle needs in the workshop. The savvy bicycle whisperer can build your dream bike, repair your beloved old steed, nurse your dad's old racer back to its former glory, or help you along on your latest project. Classic in their demeanor, and ultramodern in their essence, Standert bicycles continually keeps the bar high and the standard raised.

Max

Owner/Designer: Max von Senger
Founded: 2012
Location: Invalidenstraße 157, Berlin, Germany

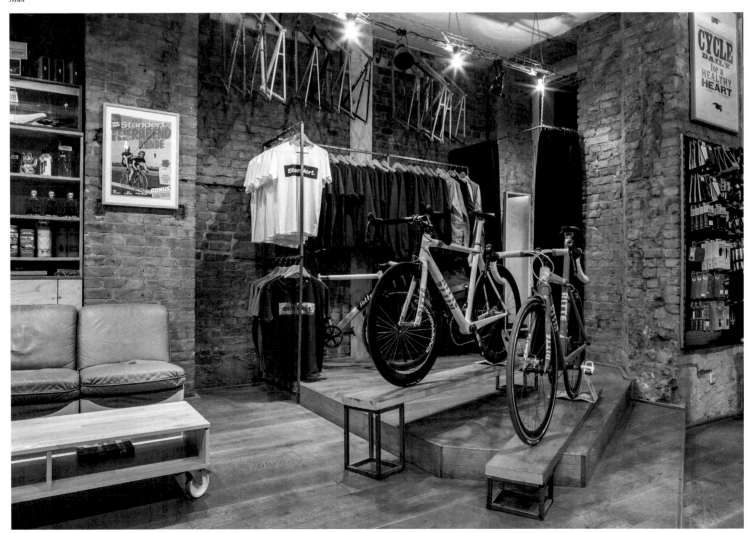

Standert Bicycle Store & Café

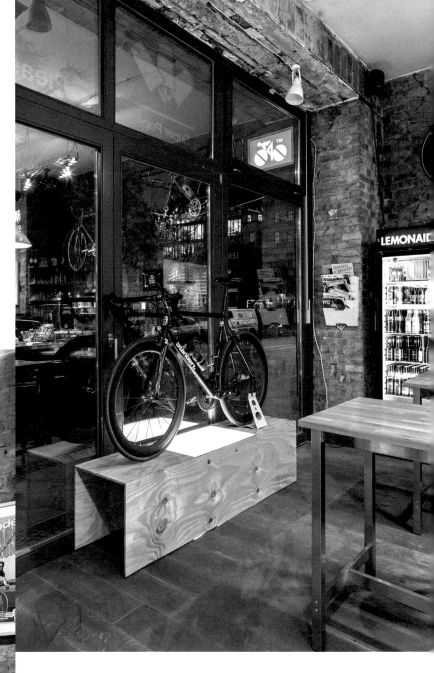

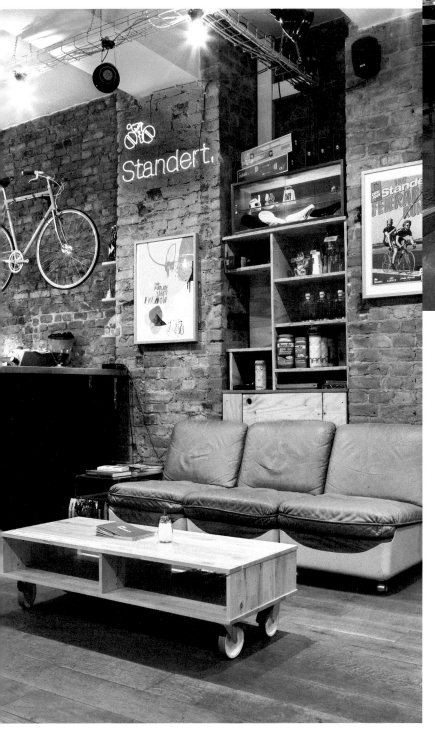

A bike shop in the Prenzlauer Berg district of Berlin specializes in traditional steel racing bicycles. Founder Dustin Nordhus opened up his first bicycle shop ten years ago, but soon outgrew the original location. From here, he moved to his current premises on a quaint, tree-lined street. An avid bike collector, Nordhus holds a particular soft spot for Italian bikes. A collector of stylish hand-built frames and forks, he uses these prime pieces to builds complete bikes with lightweight components from top manufacturers. The distinctive Cicli Berlinetta aesthetic revolves around the traditional steel road racing bike, which gave way to more modern manufacturing techniques and materials over the last few decades. Leaving contemporary carbon monocoques and oversize aluminum to other retailers, Nordhus carves out his niche by remaining true to the style of the golden era of racing bicycles. Gear levers belong on the down tube, svelte brake levers wrapped in colorful bar tape grace drop handlebars, and a suitably colorful saddle completes the composition.

Nordhus and his team breathe new life into old used bikes and frame sets. Stripping each bike back to the original pieces, these elements then get a thorough cleaning followed by the replacement of warn and tired parts. These refreshed components are then reassembled into stylish and affordable recycled bicycles with the flair and panache of the past. In addition to affordable used bikes and high-end vintage racing bikes, the storefront also offers hand-built, made to measure bicycle frames. These custom frames enable the discerning customer to create their own unique and distinctive machine. The process commences with a consultation where the buyer specifies each element, shape, color, size, and finish. These orders take several weeks to move from the waiting list into completion, but these waits always prove worthwhile. Crammed full of colorful Italian steel road and track frames from years gone by, the shop also carries an assortment of choice components including the odd "new old stock" item sought after by enthusiasts. Nordhus also stocks a thoughtful selection of cycling clothing, from handmade Italian leather cycling shoes and classic wool jerseys to the ever-popular cloth cycling cap in various colors and styles. Lights, locks, mudguards, pedal straps, and more round off the comprehensive selection of bike related accoutrements. No stranger to single-speed conversions, the crew prides itself in being able to fix almost anything. A full online store caters to cycling fans from further afield, or those who simply can't wait for the actual shop's Tuesday through Saturday opening hours. In person or online, pay a visit to the home of cycling chic and rediscover the timeless style and universal appeal of the traditional road racing bicycle.

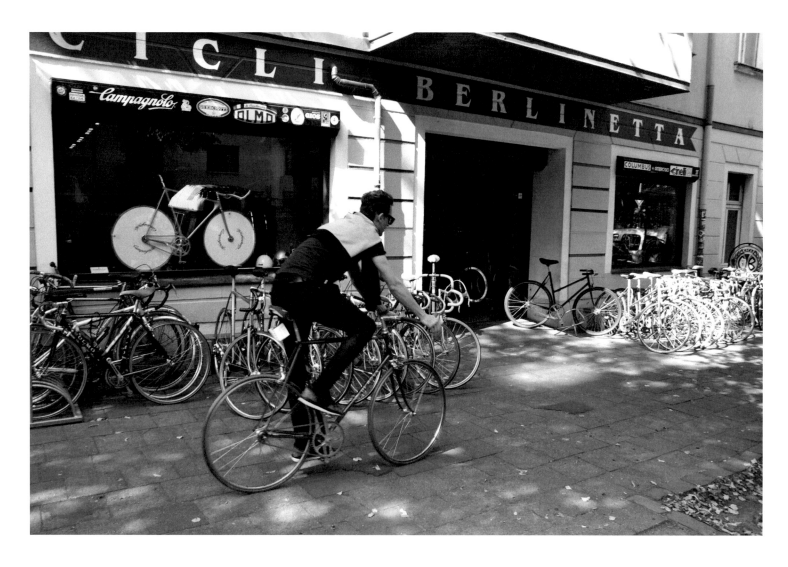

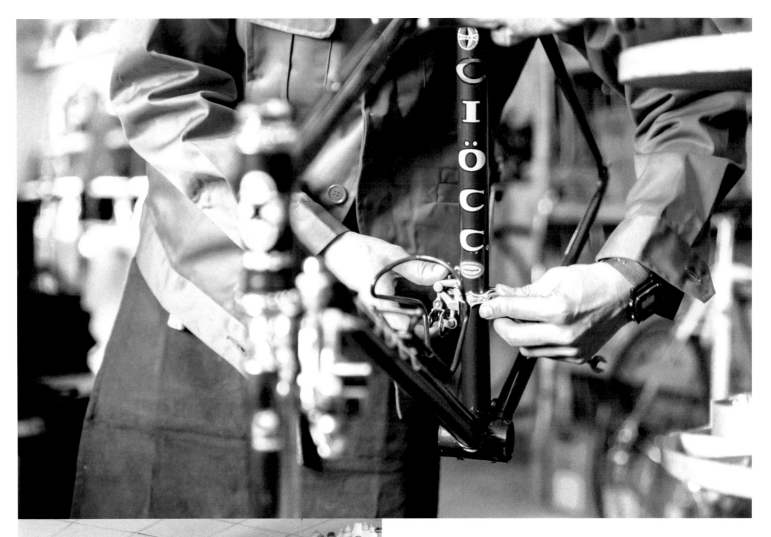

Owner: Dustin Nordhus
Founded: 2005
Location: Schönfließer Straße 19, Berlin, Germany

The Bicycle and Coffee General Store, Chicago, IL, USA

Mike Salvatore, owner

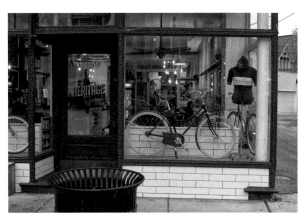

12 hours a day, seven days a week. Come in for a cup of coffee and walk out with a vintage-inspired, handcrafted bicycle or the other way around.

Free wi-fi and a stellar show put on by the bike mechanics in the garage make this the local place to linger. In between sips, peruse the retail space filled with American-made bike racks, bags, ponchos, T-shirts, helmets, and jewelry crafted out of recycled bike parts. Don't be surprised if that the guy ringing you up is the owner himself.

If you had asked a young Mike Salvatore what he wanted to be when he grew up, the answer probably wouldn't have included bikes, coffee, or any combination thereof. Fortunately, somewhere along the way, Mike hatched a plan to seamlessly integrate biking and coffee cultures. Since 2011, he and his wife Melissa have worked diligently to bring his plan to life. Before opening Heritage Bicycles, Mike spent five years establishing and growing Bowery Lane Bicycles in New York City. As a fifth-generation Chicagoan, however, he eventually felt called to return home. Mike and Melissa, along with their newborn, Bennett, trekked back to the Midwest to open up shop in their new neighborhood. With

an infectious, community-oriented family feel, the hybrid bike and coffee shop flourishes in its ability to bring people together. A place for work, artistic exploration, and gathering, the 1,400-square-foot storefront encourages customers to bring their kids, their laptops, or both and make new friends by elbowing into the community table.

The driven couple designed the Chicago store and its corporate identity together. Aided by a staff of 25, the Salvatore approach centers around a sense of community, right down to the manufacturing. Heritage bikes are designed, welded by hand out of American steel, and assembled in Chicago. Emphasizing eco-friendly transportation and local manufacturing, the company takes pride in being the first completely Chicago-made bike since Schwinn production left the city in the 1970s. Focusing on full customization, each bike proves entirely unique. Whether sparkly colors or Italian leather accessories float your boat, the team can always find something to match your style.

A shop that feels like home and smells of coffee serves up a mashup of the two concepts and cultures

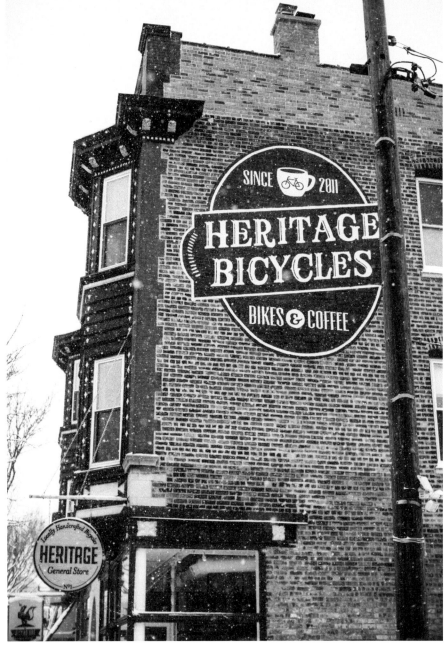

Old-timey graphics welcome the community

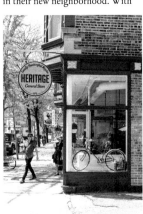

The Storefront's corner location

Owners/Designers: Michael and Melissa Salvatore
Founded: 2011
Location: 2959 N Lincoln Ave, Chicago, IL, USA

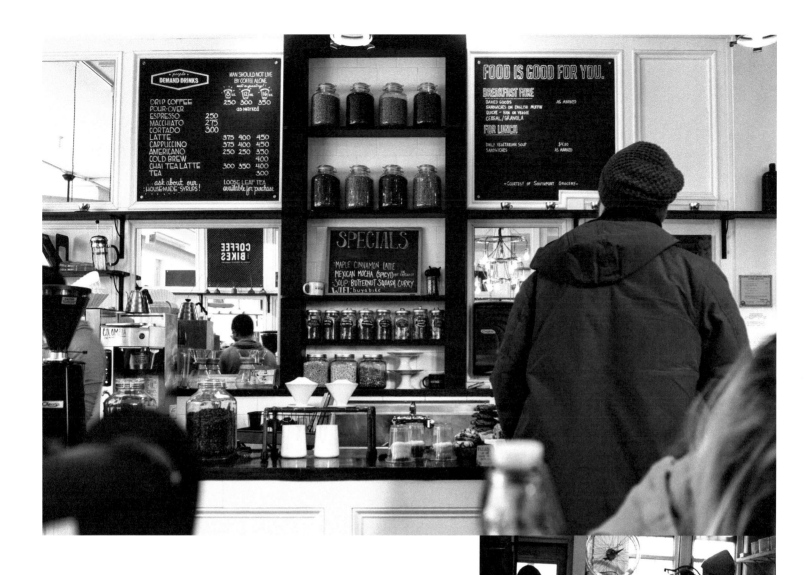

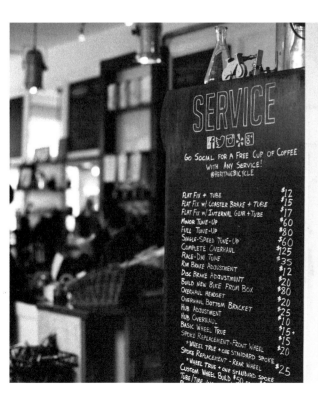

Boutique Barber, Monterrey, Mexico

No one understands the value of a clean close shave or a proper trim better than the barbers at Musk and Moss. Presenting an edgy update to the classic barbershop tradition, the personal style experts on staff provide the discerning gentlemen of Monterrey, Mexico with a top-notch barber experience. The shop, open since 2014, exudes a retro, high-end atmosphere with a distinctive masculine touch. In addition to offering full barbershop services at three workstations, the space also functions as a men's spa—an exclusive retreat for relaxation. The glamorous man cave encourages meaningful connections between customers, staff, and their surroundings. Whether a new look is in order or just sprucing up the status quo, the team of image assessment and style experts will make you feel right at home. Kick back on the leather sofa if there is a wait and strum a few bars on the company guitar. Even the most rugged man's man deserves a little pampering from time to time. Treat yourself, you'll be in good company.

Owners: Musk and Moss
Designer: Jakob Gómez / Kobs & Co
Founded: 2014
Location: Monterrey, Mexico

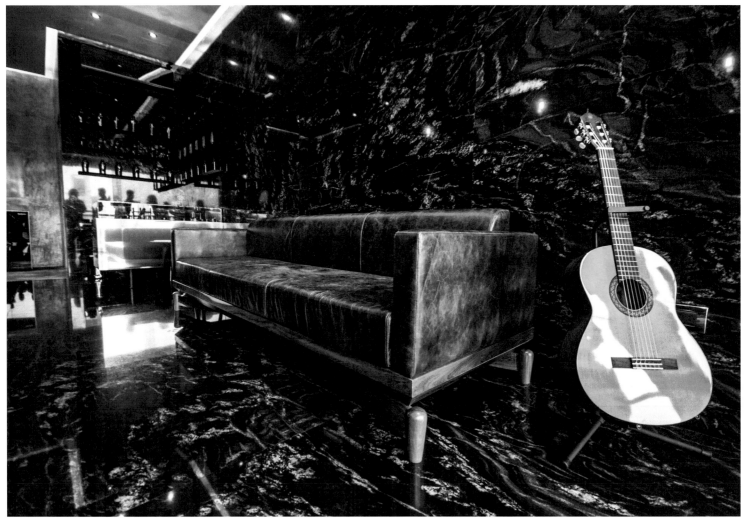

Waiting area with leather chair and guitar

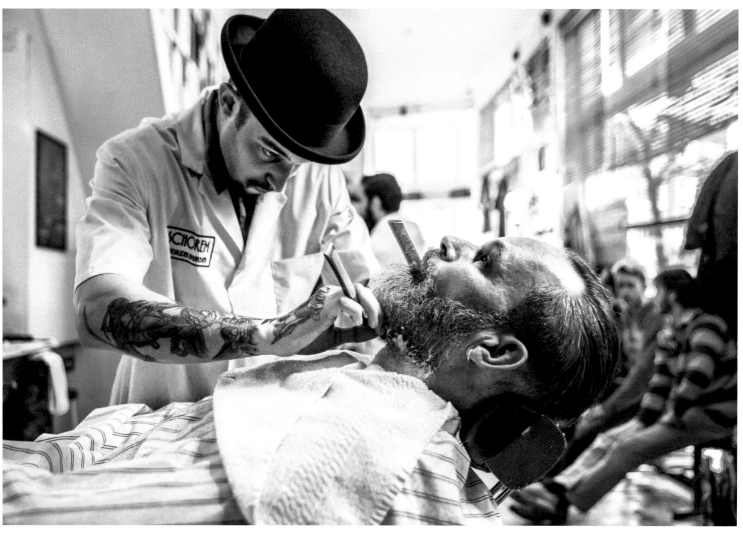

Master barbers brimming with character tend to your every grooming need

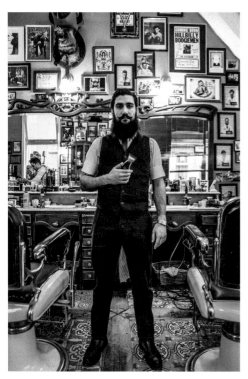
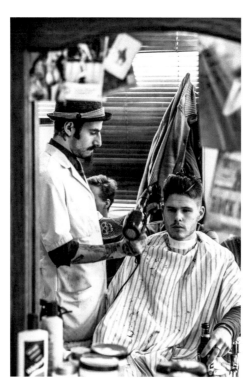
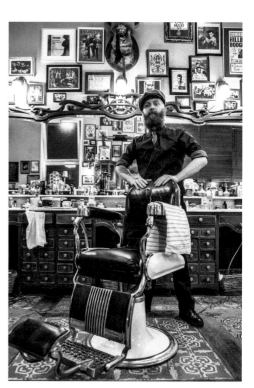

Steeped in nostalgia, framed photos cover every inch of wall space

Rockabilly Barbers, Rotterdam, The Netherlands

This old-school, men's-only barbershop with a rockabilly attitude resides in the heart of the working-class city of Rotterdam. The shop specializes in the classic cuts that have proven themselves over the decades. Pompadours, quiffs, flattops, and contours represent just a few of the throwback looks the dapper and heavily tattooed barbers specialize in. Embracing the rock 'n' roll subcultures, the lively barbershop skillfully thumbs its nose at current fashions and trends as the dedicated staff continue to snip and shave to the beat of its own drums.

Unlike most salons and barbershops, Schorem Haarsnijder En Barbier celebrates the authentic, unabashed style and talents of each of its barbers. Rockabillies to psychobillies, gentlemen to vagabonds, ruffians to bikers and rockers, this barbershop has them all. Seeming-

ly demure from the outside, the raucous and jovial interior presents a spirited place for men to unwind, enjoy a beer, and socialize with like-minded comrades. Those of you on a tight schedule should head elsewhere, as current wait times can average around three hours. For loyal customers, this is time well spent. Make sure to leave your wives and girlfriends at home, the only women allowed in the place are the pin-ups on the bathroom walls.

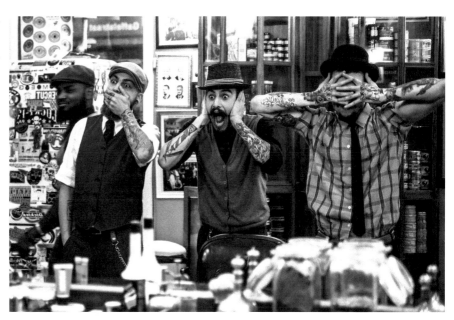

Owners: Leen En Bertus Barbier
Founded: 2010
Location: Nieuwe Binnenweg 104, Rotterdam, The Netherlands

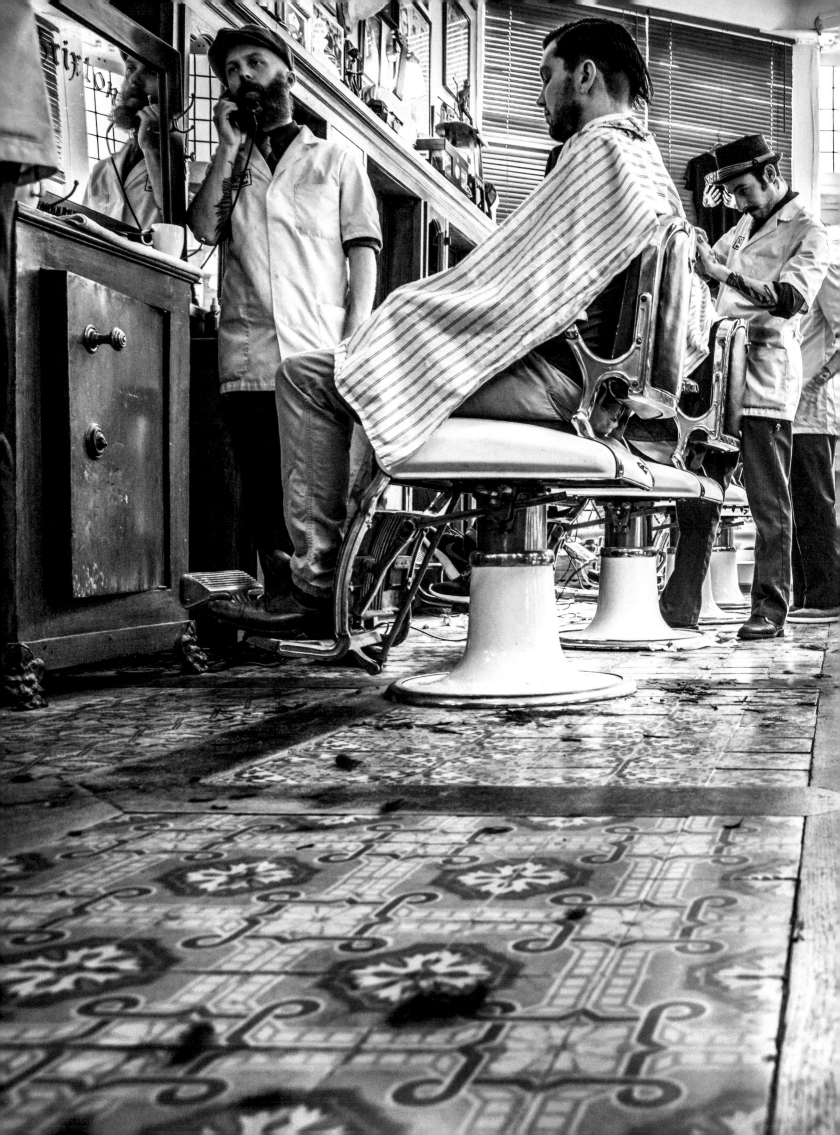

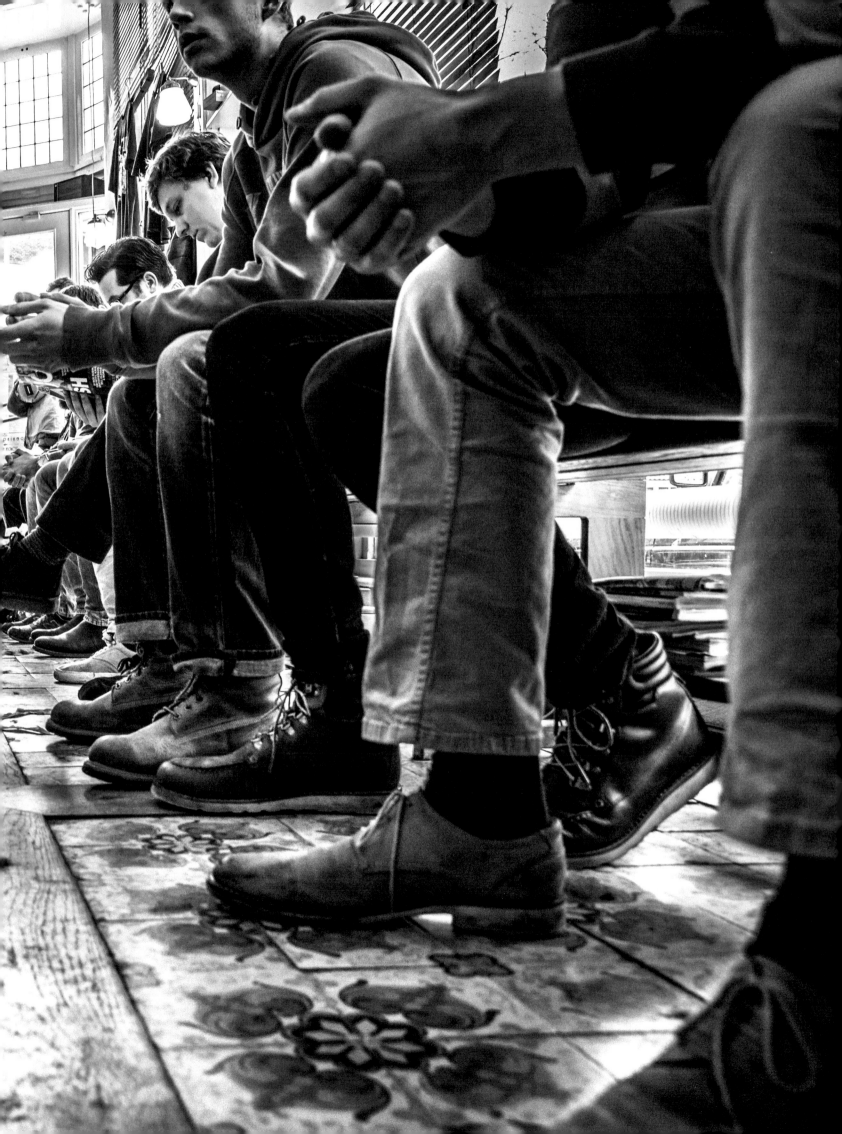

The Family Barbers, Rotterdam, The Netherlands

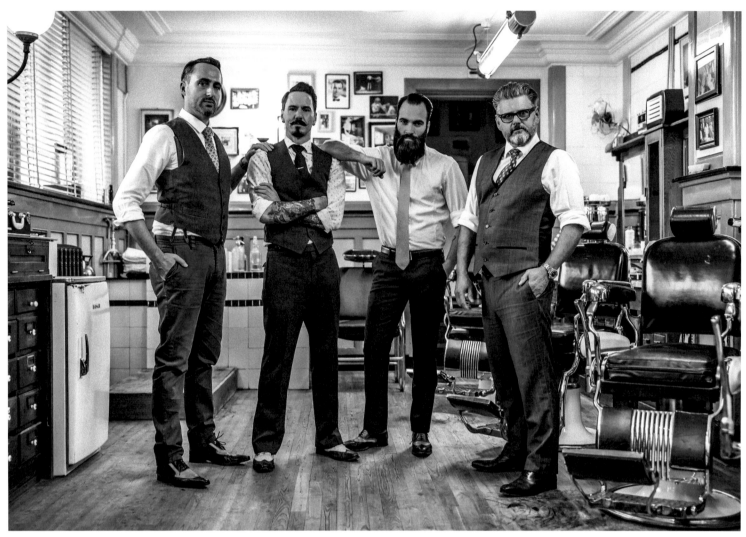

A fourth generation family barbershop evokes the spirit of yesteryear

Don't be fooled by the name, New York Barbershop is a 100 percent Rotterdam institution. Established inside Hotel New York back in 1884, the traditional barbershop has only gotten better with age. The fourth generation family business employs only master barbers to take care of each gentleman's individual grooming needs. Lost in time, little has changed since the shop first opened more than 130 years ago. Filled with classic details, the space acts as a treasure trove of the way things were from vintage light switches to nostalgic framed photos documenting the business's storied history. The scents of Acqua di Parma, Floris London, and Proraso waft through the space, punctuated by snips of sharp scissors and the lather of shaving cream. Stylish master barbers in their crisp white uniforms each exude a vintage flair, adding to the uncanny sensation of stepping back in time. Come in for a hair-cut and stay for a luxurious straight razor wet shave or a classic beard and mustache treatment. Round off the manly pampering with a shoe shine and one of the shop's quality takeaway skin, hair, and fragrance products.

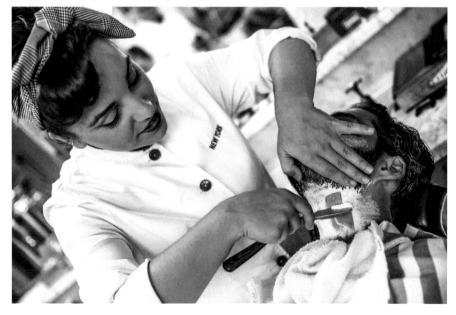

Owner: Robert Lagerman
Founded: 1884
Location: Koninginnenhoofd 1, Rotterdam, The Netherlands

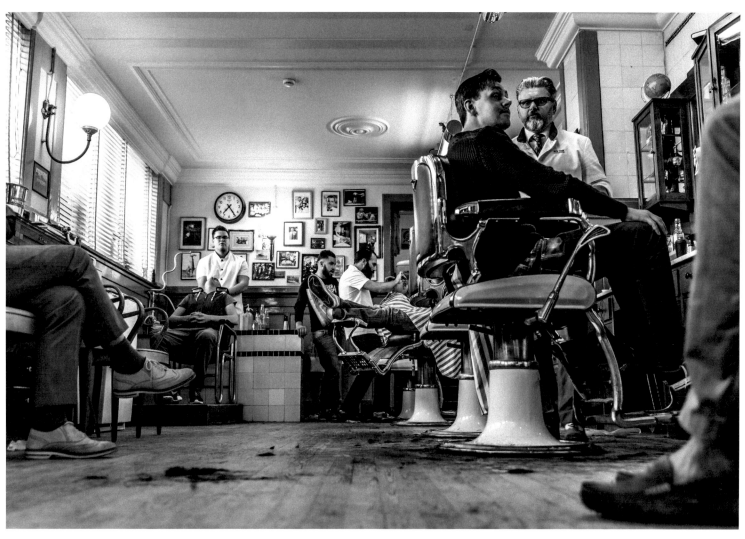

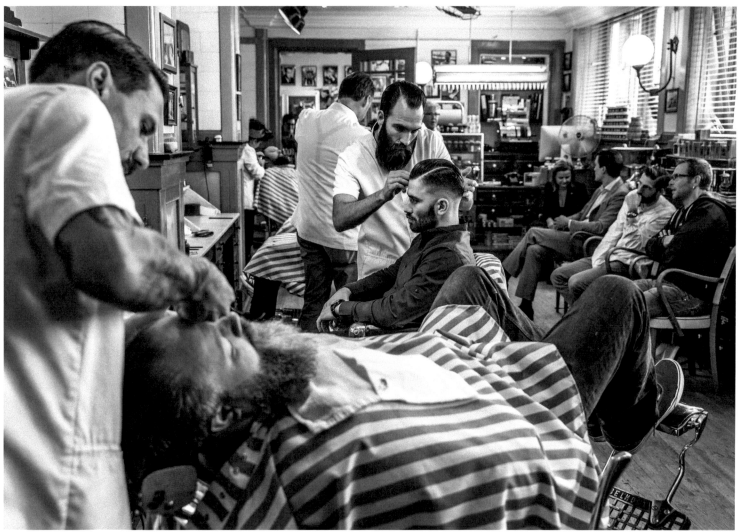

Fellow Barber

Borough Barber, Brooklyn, NY, USA

Less concerned with what is trendy and more concerned about the craft of grooming, Sam Buffa's Williamsburg outpost of his chain of urban barbershops turns the men of Brooklyn into gentlemen one haircut and shave at a time. The entrepreneurial owner designs all of his shops himself, infusing each with its own personality and source of inspiration from the local neighborhood. Situated on a tree-lined residential street, this 3,000-square-foot location also hosts the company headquarters, product development, and the FellowBarber.com warehouse. The shop, open since 2012, has embedded itself in the local community. Opting for interior details that reflect the relaxed yet fash-

ionable neighborhood, the barbershop serves as a vibrant hangout spot for the discerning fellow. The Williamsburg location includes a coffee shop inside for guys to caffeinate while waiting for a cut, or linger and/or evade going back to work post-shave.

Designed as a large open space, a skylight and select greenery add to the clean and fresh ambiance. Old and new elements tastefully combine with custom pieces that set the discreet and stylish shop aesthetic. Vintage barber chairs from different eras round off the design, granting the space a timelessly utilitarian nature. Buffa employs a team of expertly trained barbers, offering a select menu of high-quality,

hassle-free grooming services. Both his brick-and-mortar and e-commerce shops operate as one-stop destinations for men's apothecary products, tools, and accessories. Maintaining Buffa's mission to provide a modern, service-focused and contemporary experience with a touch of romance, the skilled staff inspires a steadfast clientele of discerning, fashion-conscious gentlemen. Fellow Barber elevates the act of grooming into an art form, in all its masculine splendor.

Owners: Sam Buffa and William Tigertt
Designer: Sam Buffa
Founded: 2012
Location: 101 North 8th Street, Brooklyn, NY, USA

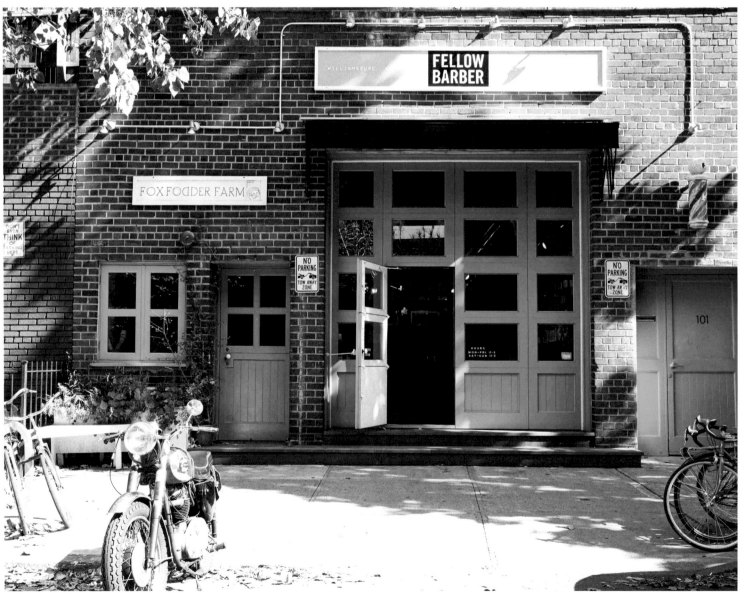

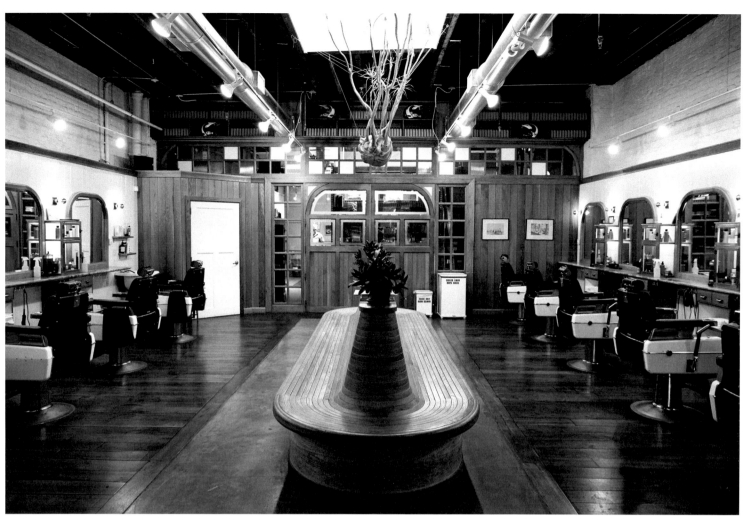

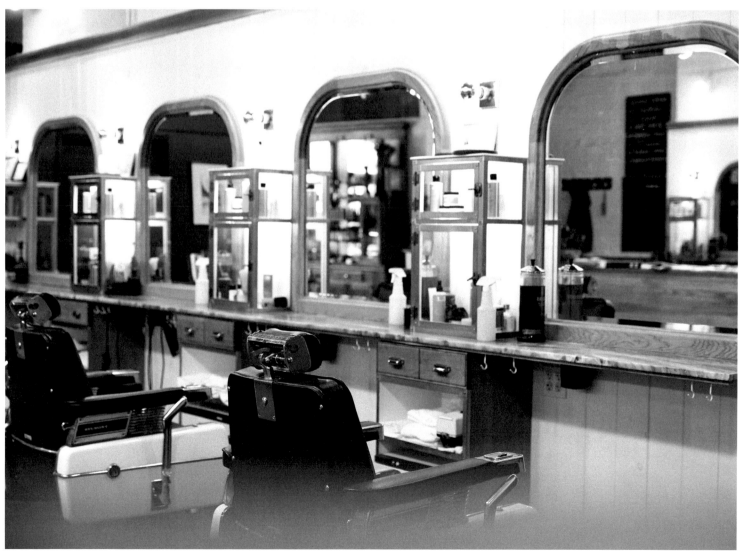

MIWA
The Gift Wrappers, Paris, France

What is the fun of a gift without its festive or heartfelt packaging? Origata, the ancient and intricate Japanese art of wrapping, includes more than 2,000 techniques to communicate added emotion

ceremony, the celebrant, receiving the member and the gift they wish to offer. She listens carefully to their impressions, as members share their thoughts and feelings about the person who will receive

Japanese strings of minutely twisted red and white paper. These two colors act as the Yin and Yang; once tied, they mark the birth of a new thing, being, or event. Considered much more than an

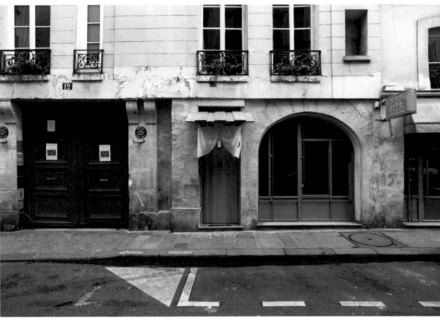

MIWA exterior streetview

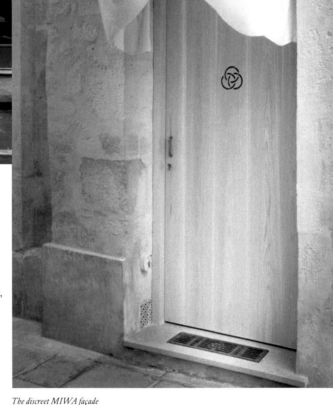

through one's gift. MIWA Associates has introduced the city of Paris to this seven-hundred-year-old tradition with the opening of an exclusive, members-only gift-wrapping boutique specializing in Origata. A slender wooden door with a traditional Japanese awning serves as the sole marker of the 168-square-foot shop hidden just inside. Teaching members about Japanese culture and rituals, a staff of two Origata experts conducts these private gift-wrapping ceremonies Monday through Saturday by reservation only.

The simple and profound experience begins with the mistress of

the gift. Establishing a sense of calm, the process allows guests to step back and review what unites them to those they hold dear. The celebrant then performs the contemplative wrapping ritual, renewing the gift giver's profound feelings of friendship towards the gift's recipient.

Several elements combine to create the language of Origata, a way of transmitting the warmth of a person's heart with a gift. The ceremony of creating the package focuses on the art of folding the enveloping paper. Each fold corresponds to a movement of the giver's heart, tied by a knot of fine

ornament, the knot symbolizes the relationship between the gift giver and receiver.

Time, the most precious element of modern life, represents the greatest gift one can offer. By devoting one's time to someone dear, a gift takes on an added value. As such, the ceremony cannot be completed or delegated in the gift giver's absence. Tap into your inner zen, this sacred space assures meaningful participation in the ceremony and lasts from 40 minutes up to an hour.

The discreet MIWA façade

Owner: MIWA Holdings
Design: Fumihiko Sano studio PHENOMENON
Founded: 2012
Location: 12, rue Jacob, Paris, France

Interior

The gift wrapping process

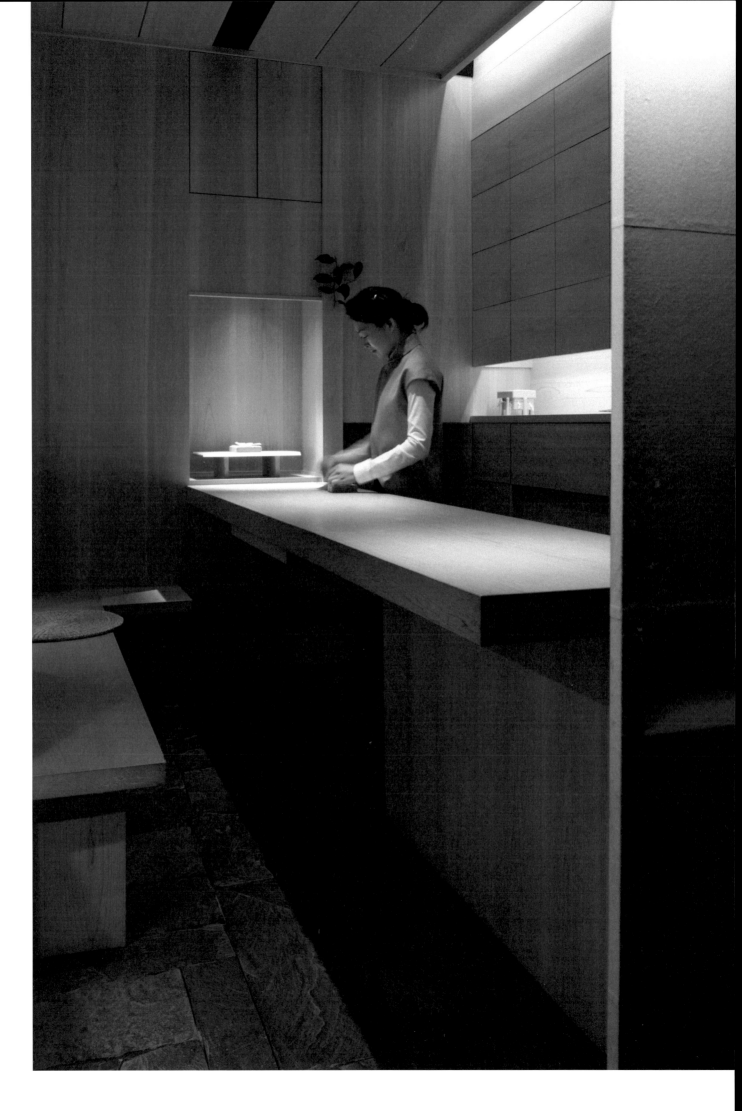

Hand-Eye Supply

The Creative's Corner, Portland, OR, USA

A supply store for Portland's creatively inclined set up shop in this impressive 4,500-square-foot space back in 2010. Owner Eric Ludlum founded the multipurpose space as the brick and mortar extension of his long-running industrial design website Core77.com. Hand-Eye Supply has since expanded into its own brand, but remains part of the Core77 family. In addition to a retail zone filled with art and drafting supplies, hand tools, work clothing, books, and research materials, the store dedicates more than half of its real estate to an in-house fabrication and education workshop. Since opening, Ludlum's loyal team has grown from 2 to 10 people. A community mainstay, the enterprise boasts a long list of local craftspeople, artists, and designers who have collaborated on projects, lectures, and photo shoots.

The shop motivates customers from all walks of life to do better and more meaningful work. To that end, every item carried and every project engaged must meet Ludlum's standards for utility, story, and design. Considering the quality, novelty, and backstory of the in-ventory, his careful vetting ensures long-lasting, satisfying, and ethically made products. Ludlum and his team promote an atmosphere of perpetual learning and creative living. Committed to engaging with the community, the store hosts a Curiosity Club speaker series, educational workshops, and other enticing free events. Casual pen lovers, architects, scientists, tattoo artists, and motorcycle mechanics represent just a few of the diverse clients the store attracts. Working closely with many small scale and traditional manufacturers, Ludlum prides himself in showcasing products from under-the-radar craftspeople and supporting their traditional methods. Great for people watching or locating that obscure tool, Hand-Eye Supply awakens the maker in us all.

The 4,500-square-foot shop has turned into a community mainstay for Portland locals

Owner: Eric Ludlum
Designer: Laurence Sarrazin
Corporate Identity: Hand-Eye Supply/Factory North
Founded: 2010
Location: 427 NW Broadway, Portland, OR, USA

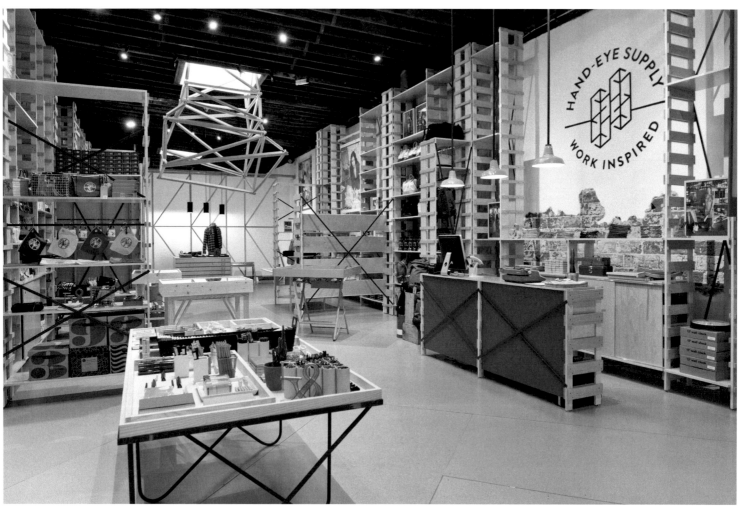

Interior

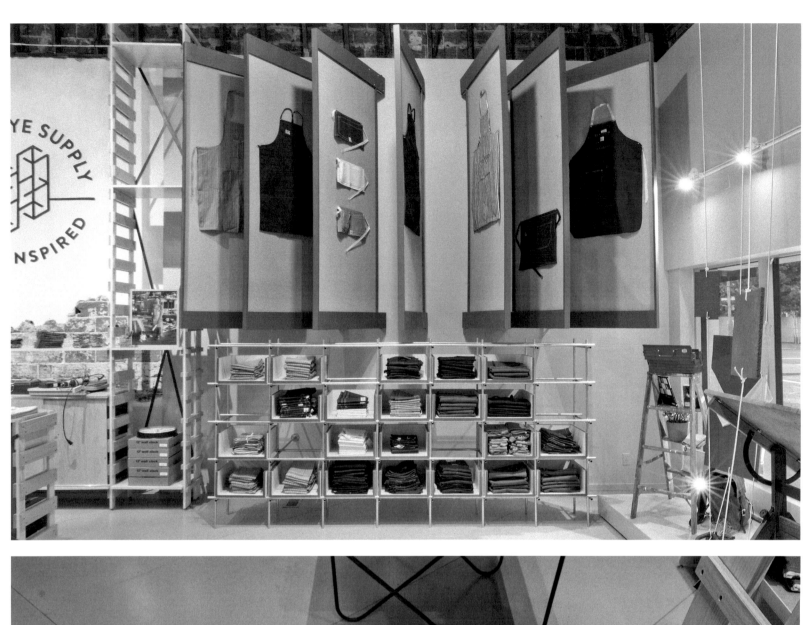

Le Typographe

The Pen Pal Place, Brussels, Belgium

Do you appreciate the difference in quality between your run-of-the-mill piece of paper and a bespoke page of stationery? If the answer is yes, then the next time you find yourself in Brussels make sure to pay a visit to this paper lover's paradise. Le Typographe embraces the lost art of the letterpress with an infectious zeal since 2009. Owner and printing expert Cedric Chauvelot runs the successful, throwback operation out of a 540-square-foot storefront supported by a bustling workshop in the back. The stationery, office supply, and printing shop takes pride in designing and producing everything by hand in-house. Committed to keeping it old school, Chauvelot and his dedicated team hand-arrange lead letters on vintage Heidelberg presses to achieve the company's distinctive and timeless quality. Paper enthusiasts swear by the shop's letterpress techniques and subtle effects, which include embossing, special cuts, and unusual reliefs and hollows. Twice a year Chauvelot invites offers a behind-the-scenes tour of the workshop. With a line of custom designed stationery now carried in fine stores around the world, Chauvelot and his letter press are rapidly making a name for themselves outside of Belgium.

Owner/Designer: Cedric Chauvelot
Founded: 2009
Location: Rue Americaine 67, Brussels, Belgium

All designs and production are done in-house

Type Hype

Typography Concept Store and café, Berlin, Germany

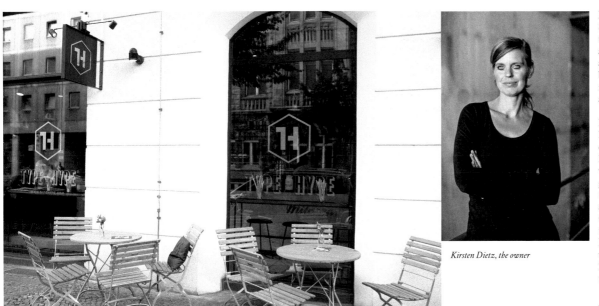

Kirsten Dietz, the owner

Having studied graphic design in Stuttgart, Kirsten Dietz went on to co-found Strichpunkt, a design agency that quickly grew in size and reputation. TYPE HYPE was born from this momentum, and it's no surprise that it is a typography and design lover's paradise.

Kirsten describes the concept behind the store and café as such: "It's quite simple: We love letters. We love Berlin. We love quality. And we love to share good food and a good cup of coffee with our friends. So we combined all of that, and asked skilled workshops around Germany that we personally know to craft five product series with Berlin-inspired designs, each product adorned with a letter from A to Z, and we created an environment to present them in."

A beautiful storefront in the fashionable Mitte district, TYPE HYPE attracts neighborhood residents, design students and professionals, culture enthusiasts on their way to the famous Volksbühne theater nearby, and Berlin visitors with an eye for distinctive, specialized shops.

Owner /Designer: Kirsten Dietz
Founded: 2013
Location: Rosa-Luxemburg-Straße 9, Berlin, Germany

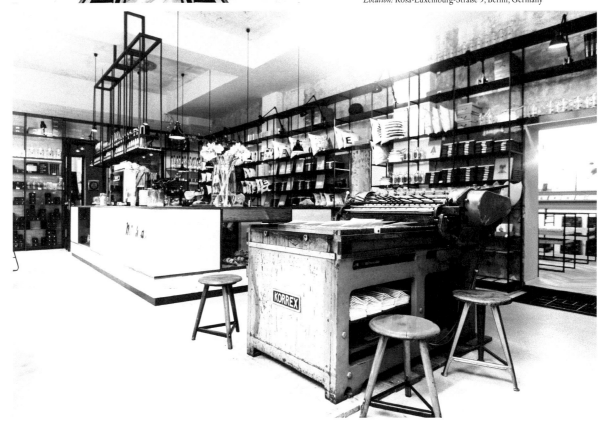

Krumulus

Creative Kid's Bookstore and Illustration Workshop, Berlin, Germany

A bookstore, gallery, and printing studio for children instills the value of reading at an early age. The newly opened Berlin bookshop provides a wide range of children's books as well as select specialty toys and games. Founder and owner Anna Morlinghaus manages the spirited 1,180-square-foot shop with the help of two part-time employees and a course instructor that runs the print workshops. Morlinghaus studied graphic arts at the Academy in Kraków, focusing on photography and hand-printing techniques. During and after her studies, she organized larger group exhibitions, which led to the opening of a gallery in Berlin for contemporary Polish art. Due to the birth of her first two sons, she left the gallery business only to rediscover her passion for children's books and illustration art. Her idea to start a children's bookstore that also offers printing courses and runs exhibitions came to her over night, acting quickly to make it a reality in 2014. Her and her team's

passion for illustration influences the visually stimulating book selection as well as the topical exhibitions that change four times a year. These exhibited works as well as an additional selection of original prints can also be purchased at the shop. Krumulus organizes a slew of events from readings to plays. For each exhibition, the team invents a special program for children's groups from kindergarten to middle school ages. On weekends and afternoons, Morlinghaus and her staff schedule courses for children to learn classic or experimental printing techniques and the basics of book binding. The name and philosophy of the store references the famous little pills that Astrid Lindgren's Pippi Longstocking swallows in order not to become a boring grown-up. Awakening a sense of delight and curiosity in old and young alike, the ambitious children's bookstore brings out the playfulness in kids and parents alike.

Owner, Anna Morlinghaus

Owner: Anna Morlinghaus
Designer: Carsten Kraemer
Founded: 2014
Location: Südstern 4, Berlin, Germany

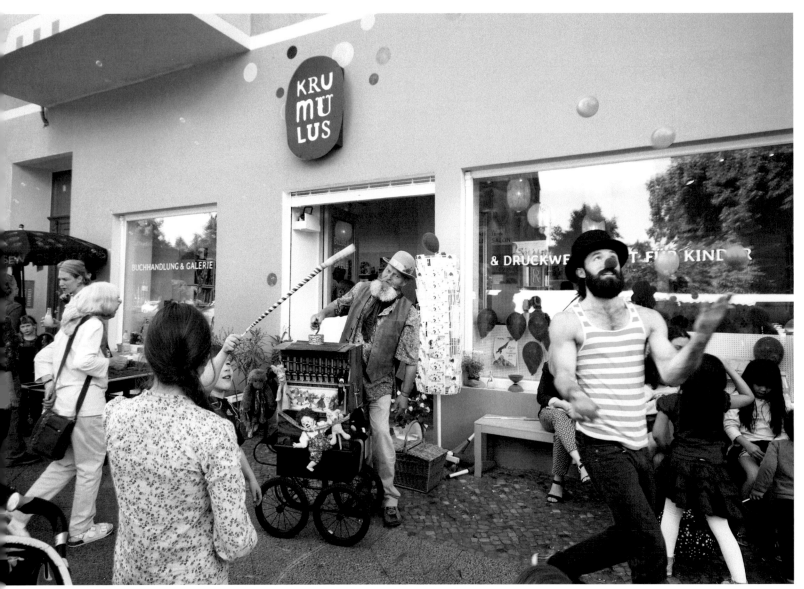

Krumulus opening party

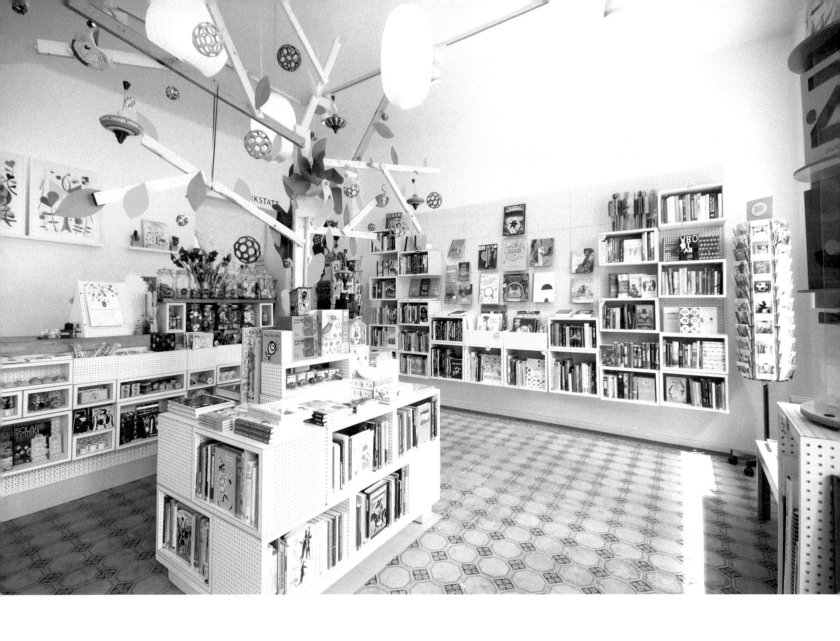

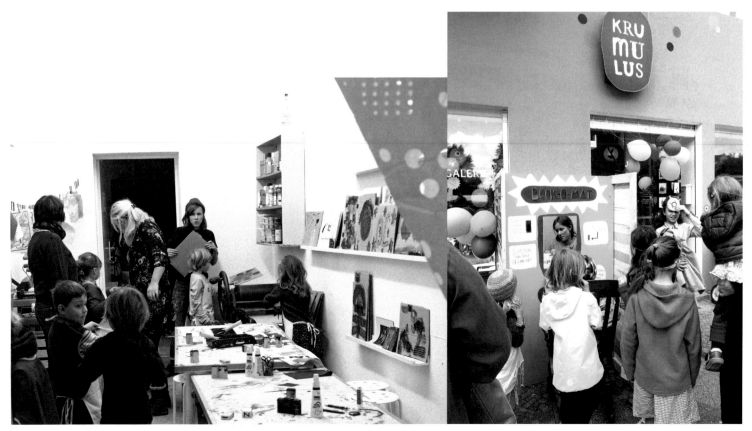

Marisa Bihlmann giving a print workshop

Marisa Bihlmann is drawing in the BOOK-O-MAT

Convenience store for time travelers. Los Angeles, CA, USA

Students are working on their own cyanotypes for the Community Photoworks project.

"Whenever you are, we're already then," goes the slogan for these two Los Angeles concept stores. The aptly named Time Travel Mart, opened in 2007 and 2014, function as the go-to convenience stores for all of one's time travel needs. Brainchild of the Pulitzer Prize nominated author, publisher, and philanthropist Dave Eggers, both shops serve as part of his nationwide student tutoring program 826 Valencia. Born in Boston, Eggers relocated to a Chicago suburb as a child. After completing high school, he entered the University of Illinois at Urbana-Champaign with the hopes of studying journalism. His studies were cut short at the age of 21 following the deaths of both of his parents within a year of each other. This sudden change in his family structure left him as guardian of his eight year old brother. Together, they relocated to Berkeley, California and Eggers began work on his unprecedented memoir, A Heartbreaking Work of Staggering Genius. This book, published in 2000, catapulted him into the literary spotlight where he has remained ever since.

In 2002, Eggers co-founded the 826 Valencia project. Tutoring school children ages 6 – 18 in the back and selling whimsical thematic goods in the front, this successful nonprofit model now has seven chapters across the country.

The Echo Park and Mar Vista locations, run by executive director Joel Arquillos, hurl curious customers through time. Ending up in the unknown future or traveling back to some bygone era, guests will find a quirky selection of merchandise to fit the time period. Here you can buy some extra time on your expired parking meter, stock up on canned Mammoth Chunks or Robot Milk, and buy a onesie for the newest addition to the family with the words Future Adult proudly silk screened across the front. In case you need something to read on your journey, the esoteric shops also sell writing made by the students at each location. All proceeds from the stores help support the free programs at 826LA so don't feel shy about those impulse purchases, it's all for a good cause.

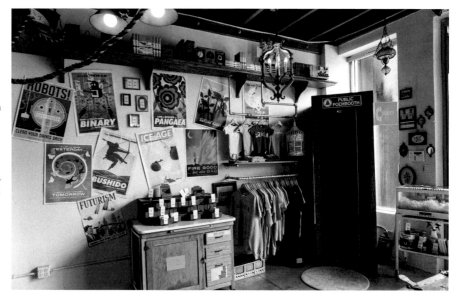

Owner: 826LA
Designer: Stefan G. Bucher
Founded: 2012
Location: Mar Vista, Los Angeles, CA, USA

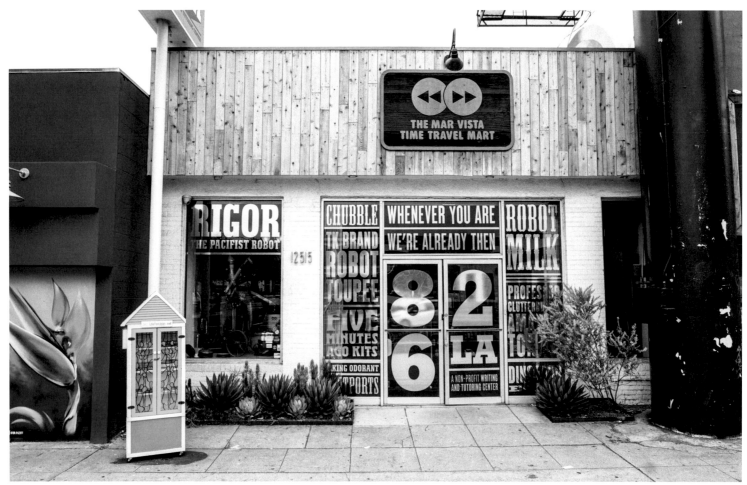

Mar Vista Time Travel Mart

Analogue Curiosities, Santa Monica, CA, USA

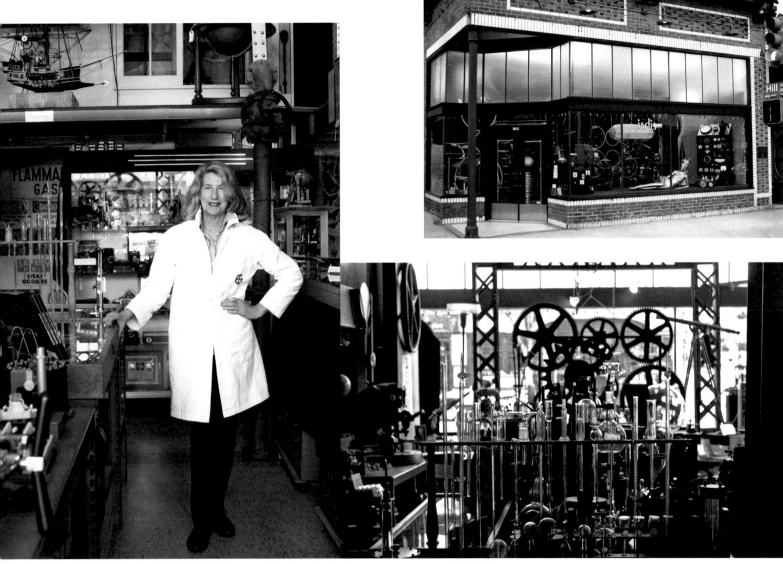

Susan Lieberman, the owner

A corner storefront has kept Santa Monica's curiosity piqued for nearly forty years. The shop, looked after by owner Susan Lieberman, functions as part museum of pre-computer era technologies, part steampunk prop rental house for mad scientist sets, and part-cabinet of curiosities. Lieberman co-founded the quirky and deeply personal endeavor with her late partner Parke Meek. Born in California and raised in Geneva, Switzerland, Lieberman earned formal degrees in both art history and French literature. Meek grew up in Indiana. He moved out west as an adult where he met the iconic design team of Charles and Ray Eames. After working for the Eameses for more than twenty-five years, Meek and Lieberman decided to go into business together.

While the 1,200-square-foot shop has changed in content since its inception in 1976, the goal of stopping people in their tracks remains the same. Many things are for sale, including vintage microscopes and cameras, airplane and automotive models, books on Tesla, Edison, and science, vintage chemical lab glassware, early electrical equipment, silent movie posters, and mechanical flip books. Some things are not for sale but serve to enchant the crowd. These rare show-stopping items range from mechanical airships to revolving gear wheels and lit control panels that are reserved for prop rentals. jAdis rentals have made cameos in countless major motion pictures over the years, appearing in *The Prestige*, *Batman and Robin*, and *The Artist*, just to name a few. Now a local institution, the shop draws an international crowd of all ages. Meek's long tradition of showmanship remains an integral part of the jAdis experience and the sense of wonder people feel inside the store. He made sure that whatever he did in life, he did it well enough to make people stop and look. And so they have, with one generation of amazed customers leading into the next. Since Meek's passing in 2010, Lieberman has devoted herself full-time to carrying on his legacy and the tradition they built together on Santa Monica's vibrant Main Street.

Susan Lieberman with children and mother

Owner: Susan Lieberman
Designers: Susan Lieberman and Parke Meek
Founded: 1976
Location: 2701 Main Street, Santa Monica, CA, USA

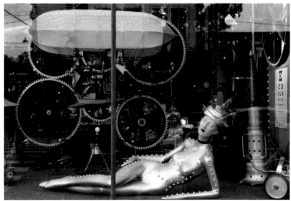

jAdis front window

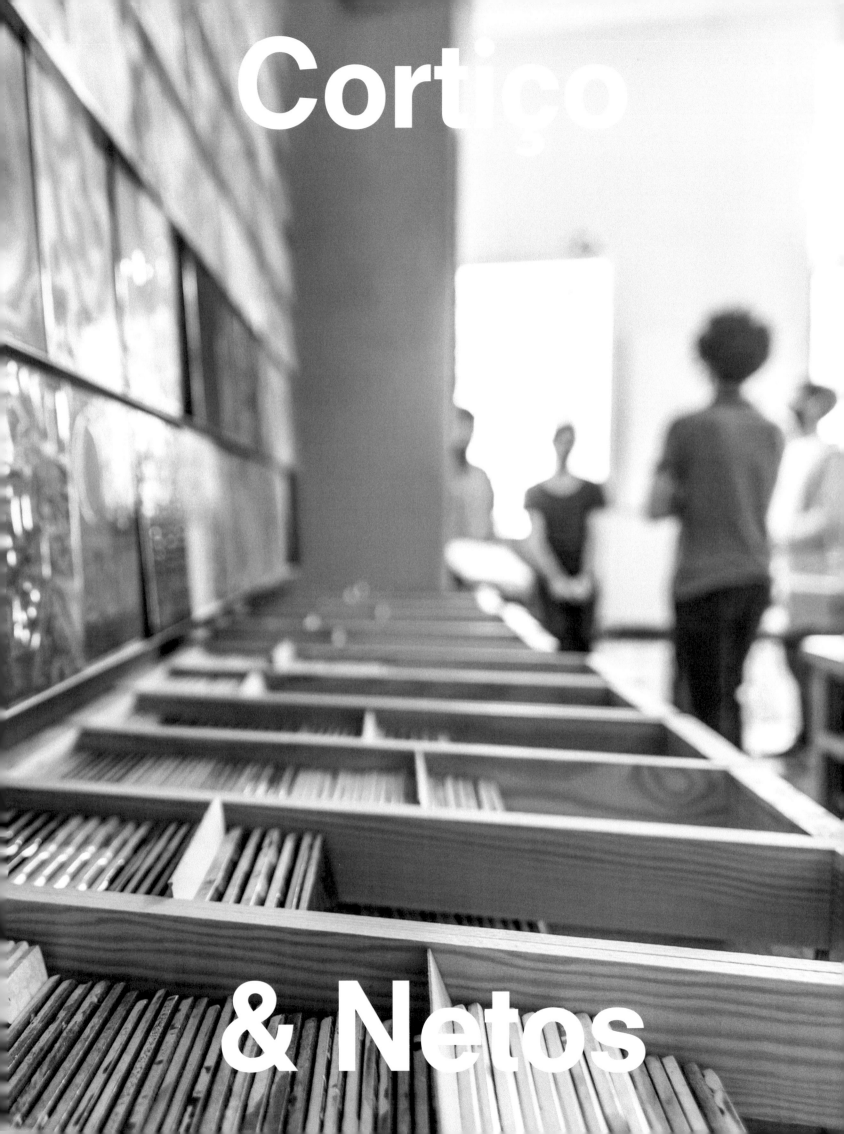

Cortiços

& Netos

Owners and brothers Pedro, João, Ricardo, and Tiago Cortiço

A tile tradition dreamt up by Joaquim José Cortiço was resurrected by his four grandsons following his passing in 2013. Brothers **Pedro, João, Ricardo,** and **Tiago** bring the family specialty of discontinued tiles to the locals of Lisbon.

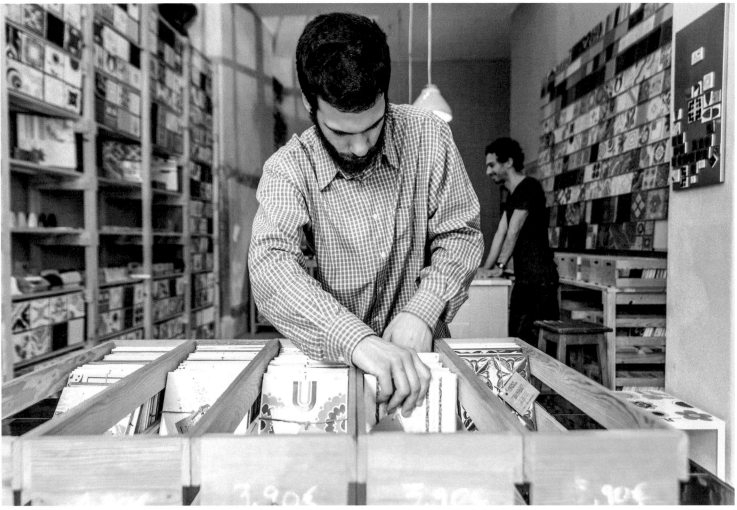

Tiles arranged similar to records in a record store encourage persusing

In a country known for its exceptional tile makers, four industrious brothers work together to carry on the family business their grandfather started back in 1979. Pedro, João, Ricardo, and Tiago took over the celebrated tile company following the passing of their grandfather and founder Joaquim José Cortiço in 2013. Originally from Alentejo, Grandfather Cortiço came to Lisbon in the mid-fifties to work as a grocer and wholesaler. He rented a grocery shop in one of the old buildings in town. In 1963, he converted the space into a coffee shop, which he ran until 1979. Always the collector, he opened up a warehouse to store his many homewares and various tools and equipment. Cortiço became increasingly involved with his warehouse operations and eventually sublet the coffee shop so he could expand. His narrow, three-story warehouse needed tiling and Cortiço bought a batch of end-of-the-line materials to do the job. After buying more material than he needed, he began to offer the leftovers to people working on other small jobs. "If you want to jumble the materials," he mused, "It's fine by me." So what began as a favor for a few local builders evolved into Cortiço & Netos—a company dedicated to the buying and selling of discontinued lines of Portuguese industrial tiles. The business

So what began as a favor for a few local builders evolved into Cortiço & Netos—a company dedicated to the buying and selling of discontinued lines of Portuguese industrial tiles.

brought him a widespread reputation as a trustworthy source for quality out-of-stock products, and the occupation allowed him to stockpile an enormous collection of rare tiles. For more than 30 years, he consistently acquired these tiles, resulting in a unique kind of business as well as a one-of-a-kind collection. During the later part of his career, his grandson kept a close and loving eye on both him and his business. In 2012, Ricardo spotlighted his grandfather's unusual trade in a short documentary he directed as the final project for his cinema degree.

The tile business's new generation of owners view their collective career move as an opportunity to preserve their important heritage developed by their grandfather. In 2014, the brothers opened the business's first storefront in Lisbon to bring their family tile collection to a broader audience. The bright store with vaulted industrial archways bathes in light during a typically sunny Lisbon day. Executed on a barely existent budget, the store's only decorations are the tiles themselves. The several

hundred different tiles available stand proudly on display atop custom-made pine shelves that run from top to bottom along the store's main wall. These shelves take advantage of the 430-square-foot shop's high ceilings, presenting customers with a mesmerizing and vibrant array of the countless available tile colors and patterns. Simultaneously functioning as both exhibition and storage space, the densely packed shelves display a tile on the front of each cardboard box. The resulting effect of this large and impromptu tile wall saturates visitors with a compelling spectrum of varied colored and intricately ornamental motifs and graphics. To further reinforce the tile's aesthetic presence in the store, the purposefully gray painted space contrasts elegantly with the sheen of the exquisite glazes on the tiles. The neutral tones of the pinewood shelving and gray walls give the store a gallery-like atmosphere, elevating the tiles into works of art. Taking a hands-on approach, the brothers also custom built the store's prominent counter. This key furniture piece consists

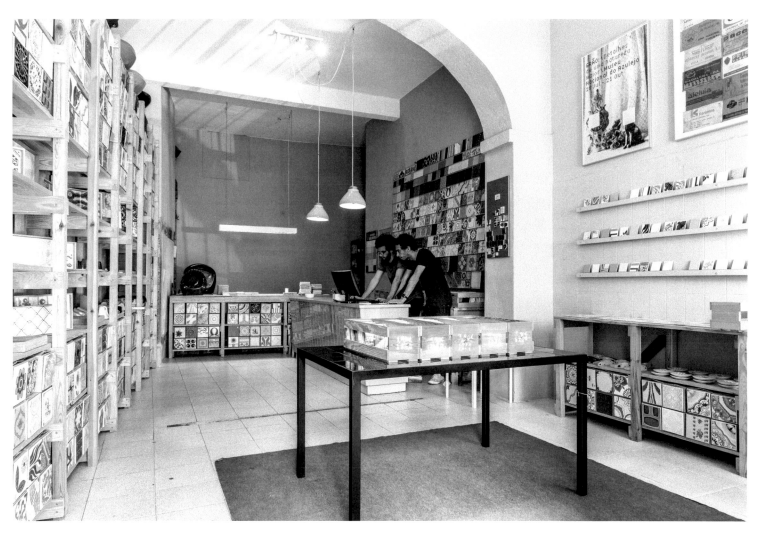

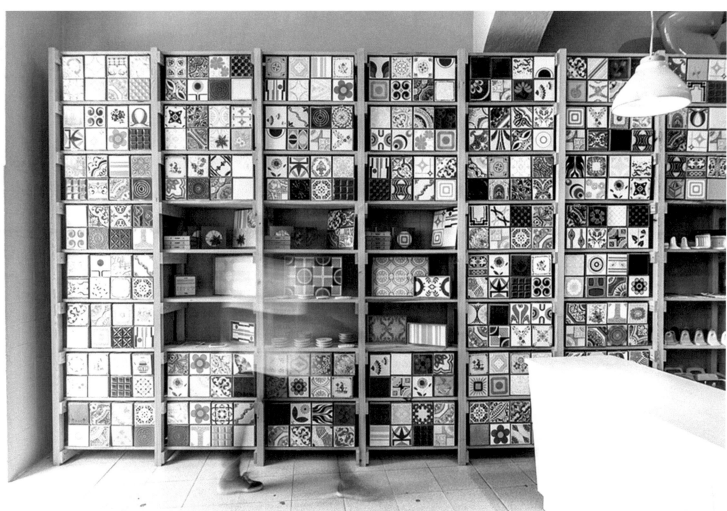

The brothers let the tiles speak for themselves

Family pride and a reverence for the historical and cultural value of Portuguese tiles motivate the brothers to give back to their trade and the community. Part of the store's revenue goes toward funding the preservation and dissemination of their unparalleled collection started by their grandfather. The owners also nurture partnerships with Portuguese universities, promoting academic research on the historical background of tiles. Aware of the scarcity of the research on the subject, the owners promote investigation into the topic of the industrial tile by facilitating access to their estate. The brothers hope that the scope, dimension, variety, and age of their collection can become a topic of study for many areas of research including industrial design, graphic design, architecture, museology, and art history among others.

Attracting the attention of artists, designers, and architects, countless creatives use the hard-to-get stock in their own projects. The collection comprises original items manufactured from the 1960s through the present day. Unfortunately, most of the factories that produced these tiles have been shut down, which means that the majority of items for sale are sold in limited and one-off batches. Fortunately, Portuguese tiles visually thrive when mismatched. The store itself operates as an interac-

of a simple wooden framework covered with gray tiles. Relatively unnoticed at first glance, the discreet counter skillfully steers customers' attention to the tiles on display. In front of the counter, a large table supports four wooden boxes that showcase tiles in a similar fashion to the vinyl section in a record shop. This more informal display system promotes a participatory and exploratory role on the part of the guests as they thumb through square after square of color and pattern. A table behind the counter for daily projects and meetings leads further back into a workshop area used to develop new products and packaging solutions.

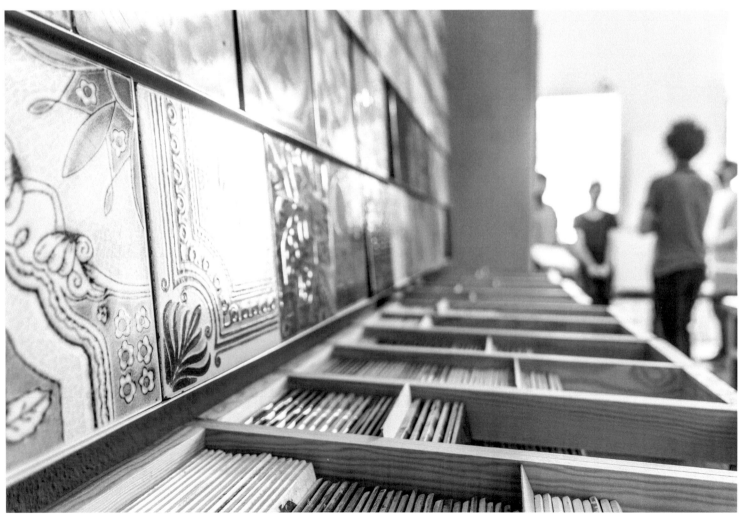

Your best bet for finding that replacement tile

tive demonstration of the striking patterns and their inherent ability to mix and match. These irreplaceable and vintage varieties from now-defunct brands and manufacturers represent important milestones in the history of Portuguese industrial tile production. The invaluable and unrivaled collection of the Cortiço estate acts both as a comprehensive archive and as a business model.

The Cortiço brothers are at once keepers of their family legacy and a crucial part of Portuguese history. As a part of the Association for the Interpretation of the Industrial Tile, the brothers' primary goal centers upon the preservation of the Portuguese tile and the waning craft that supports it. Developing solutions for custom-made projects and interventions for both indoor and outdoor spaces, the brothers' intimate knowledge of the stock streamlines the conception and execution of even the most challenging design riddles. After inheriting the tile business, the grandsons have since also expanded the brand's portfolio by developing a line of decorative tile-based products ranging from pot stands and coasters to tables and trays. Still the best and most reliable source for matching old tiles, Cortiço & Netos continues to build and refresh their inspired product catalogue. The brothers recontextualize the vintage product,

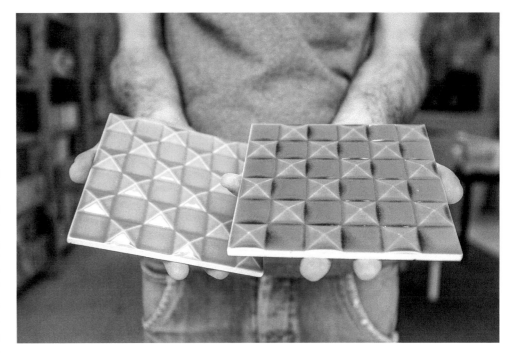

giving it new life in a contemporary setting. By bringing these old tiles into today's spotlight, the family renews a Portuguese tradition and excites a new guard of design-minded and craft-friendly clientele. The hardworking and dashing brothers will help you find your extant tile's long lost friends, a statement piece that no one else will ever have, or curated patchwork for your wall and floor finishes. Cortiço & Netos excel in making the old new again.

Owners /Designers: Pedro, João, Ricardo, and Tiago Cortiço
Founded: 2014
Location: Calçada de Santo André 66, Lisbon, Portugal

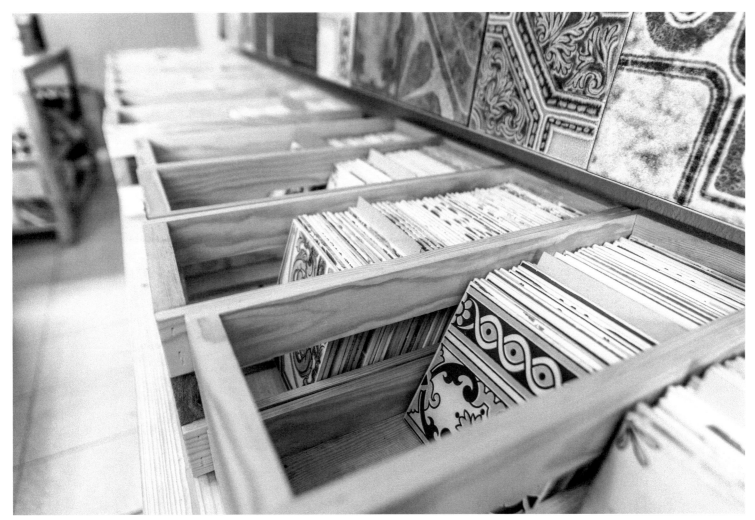

A great place to find what you're looking for and what you didn't know you were looking for

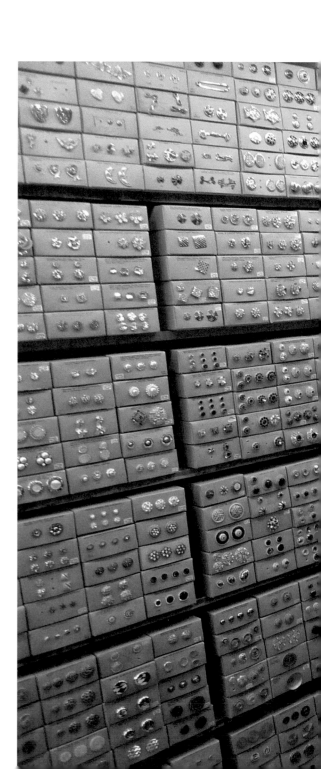

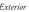

Exterior

Tender Buttons

The Button Hole, New York City, USA

This charming button shop has occupied the same narrow space on the same tree-lined street of the Upper East Side for more than fifty years. Owner Millicent Safro cofounded the store in 1964 with the late Diana Epstein. Epstein worked as an editor while Safro specialized in antiques restoration. Both ladies came from the New York art scene and fell into the world of buttons after discovering and purchasing a collection of old and eccentric pieces from a shopkeeper going out of business. The owners designed by the unpretentious shop with the help of their artist friends from the 1960s. Ray Johnson, one of the luminary pop artists of the period, designed the store's well-worn logo. Manned by a staff of two to three

knowledgeable employees, the shop walls are lined from floor to ceiling with buttons—a fashionable solution for every outfit and occasion.

Committed to selling one item and one item only, you'll have to look elsewhere if you're in search of a zipper or, god forbid, Velcro. The shop's owners travel extensively in search of these tiny objects of luxury and quality. Many of the buttons available were designed by Safro and Epstein and are sold exclusively at the shop. Over the decades, the twelve foot wide store has added a few antique and decorative objects to the inventory that directly relate to the button family. These rare accent items include a selection of unusual cuff links, considered

a fastener, meticulously gathered from around the world. Fashion designers, artists, costume designers, knitters, sewers, craftspeople, and the savvy few who remember that the devil is in the details continue to flock to the store to upgrade their wardrobes and accent their garments. Over half a century later, Tender Buttons represents one of the few tried-and-true mainstays in a city constantly reinventing itself.

Owner: Millicent Safro
Designers: Millicent Safro and Diana Epstein
Corporate Identity: Ray Johnson
Founded: 1964
Location: 143 East 62nd St, New York City, NY, USA

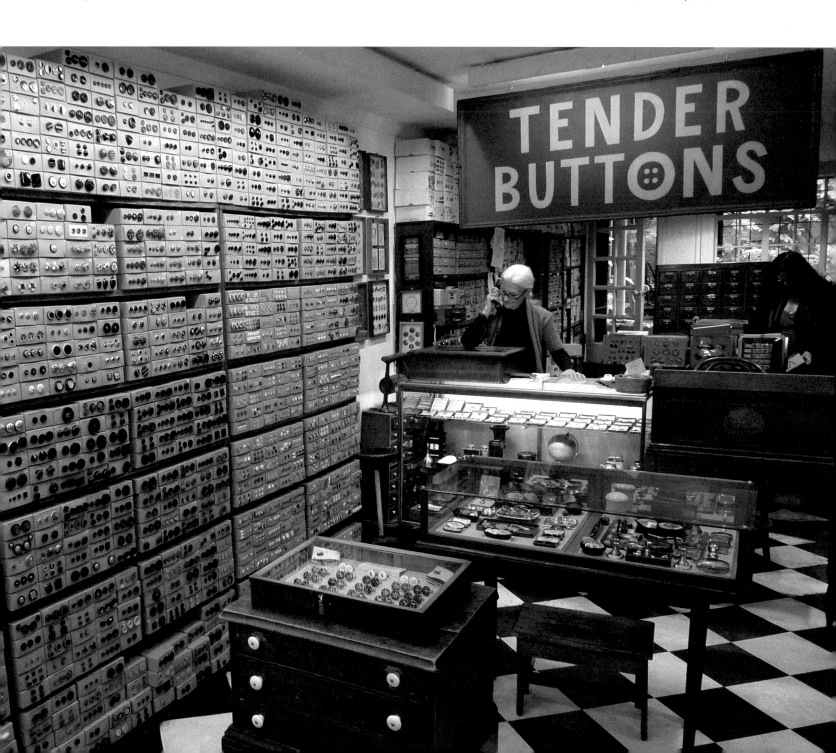

The last glove shop of Antwerp was established in 1884

A time capsule inside and out leaves no detail uncared for

Glamorous Gloves, Antwerp, Belgium

The last remaining glove shop in Antwerp, and one of the few left in Belgium, also stands as one of the oldest stores of its kind. Established in 1884 by two Italians, the store changed hands in 1920 to Arthur Boon, the shop's namesake. Selling crafted gloves for nearly 120 years, the family business has now been passed down for four generations. Little has changed over the decades, granting the store an exceptional and timeless charm. The original Art Deco character of the shop remains intact as do the period, turn-of-the-century glove boxes, countertops, cabinets, and chairs. Working closely with small manufactures in Italy, France, and Hungary, the Boons champion a high quality level for their merchandise that depends exclusively on handcraft. The small team regularly travels to these locations to choose the skins and models of the gloves. Keeping standards high, the company strives for quality over quantity. The handmade gloves require skill and artistry to cut the leather resulting in no two ever being exactly alike. Perfectly tanned and smooth leather ensures that each glove literally fits like a glove.

With tasteful options for men and women, the in-store selection offers something for everyone. The shop stocks a wide range of colors and types of leathers. Traditional citizens of Antwerp, members of the fashion industry, hip thirty-somethings, and tourists alike all swear by Ganterie Boom. Owner and shop manager Sofie Possemiers and her team work with every customer to find the ideal glove and the perfect fit for the occasion. From high fashion to simply keeping one's fingers warm, this Belgian institution keeps the versatile accessory in style one hand at a time.

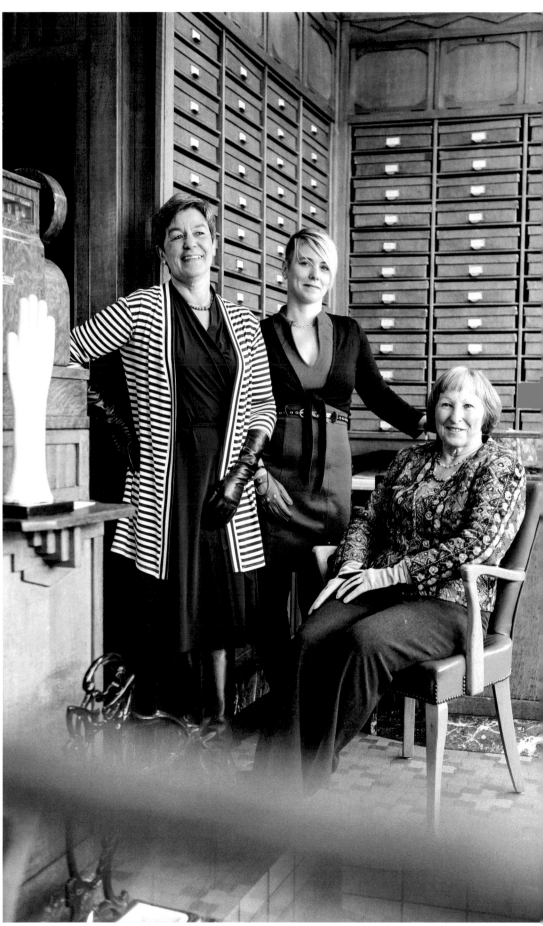

Owner: Sofie Possemiers
Designer: Arthur Boon
Founded: 1920
Location: Lombardenvest 2, Antwerp, Belgium

The business has stayed in the Boon family for four generations

Vintage Sweets, Stockholm, Sweden

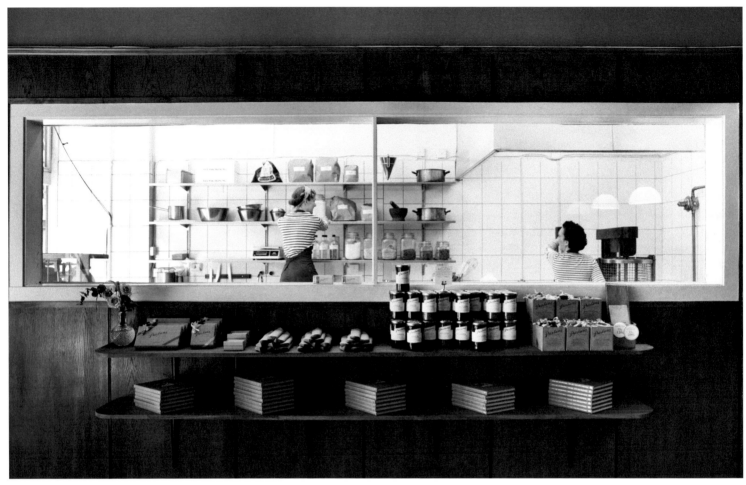

The owner's fondness for the 1930s and 40s permeates every nook and cranny from uniforms to product labels

In a city known for its world-class sweets, candy maker Lisa Ericson stands out from the crowd. The founder, owner, and CEO of Pärlans Konfektyr manages her classically inspired storefront and a staff of five full-time employees. With a degree in food science, Ericson first worked as a product developer within the food industry. Her experience as a product developer continues to hold a great value in her approach to building and running her candy company. Armed with insight into all aspects needed to launch a new product and a stickler for detail, Ericson specializes in consumer interest, concept development, production, regulations, sales, and marketing from her chic Södermalm location.

The artisanal caramels she is now famous for came about after a long trial and error period in the kitchen. Her elegantly packaged artisan caramels and caramel sauce treat the tongue with their smooth and buttery flavor. Made with the finest ingredients, Ericson's caramels slowly simmer in a copper kettle

to the sound of jazzy tunes wafting through the small kitchen behind the shop. All of the sweets sold at the store evolved out of traditional French methods and rely on French equipment to be made. After mastering the French way of doing things, Ericson added her own Swedish twist to the recipes to give her products their distinctive quality.

A visit to Ericson's shop transports customers back in time. Her love for the music, fashion, and design of the 1930s and 1940s permeates all aspects of the storefront, including the flattering employee uniforms. Inside the 645-square-foot store, her creative staff help run the kitchen and shop, while also working closely with sales, marketing, design, and communication. Ericson and her team create nearly everything in-house from new flavors and products to the vintage-inspired packaging design, interior design, shop display, and promotional material. Making old things new again, Ericson's pale emerald green storefront attracts young and

old, men and women, tourists and locals in equal helpings. Peel open a caramel or bring home Ericson's new cookbook to learn how to do it yourself. A stop at the shop serves as a refreshing reminder that some things never go out of style.

Owner: Lisa Ericson
Founded: 2010
Location: Nytorgsgatan 38, Stockholm, Sweden

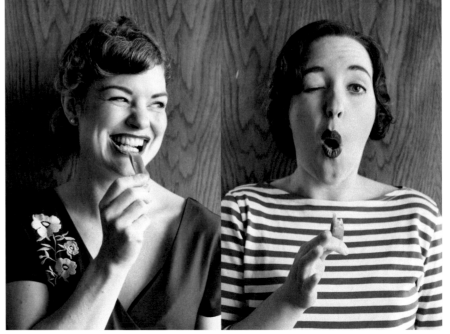

Emma Sjöberg, the girl in charge of the shop *Vanessa Fransson, the girl in charge of the kichen*

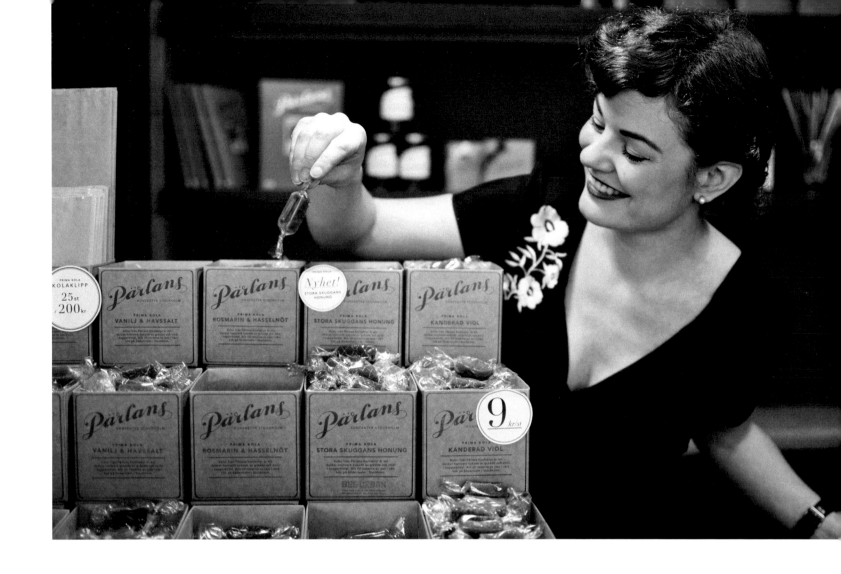

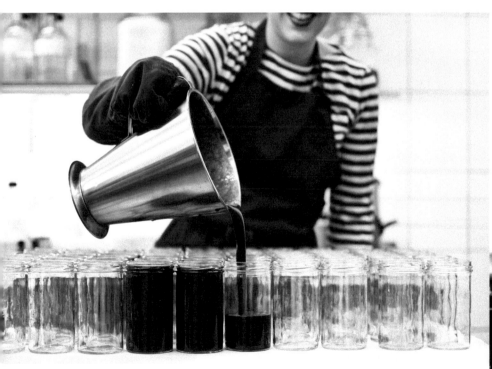

All delicacies are crafted with love in the store

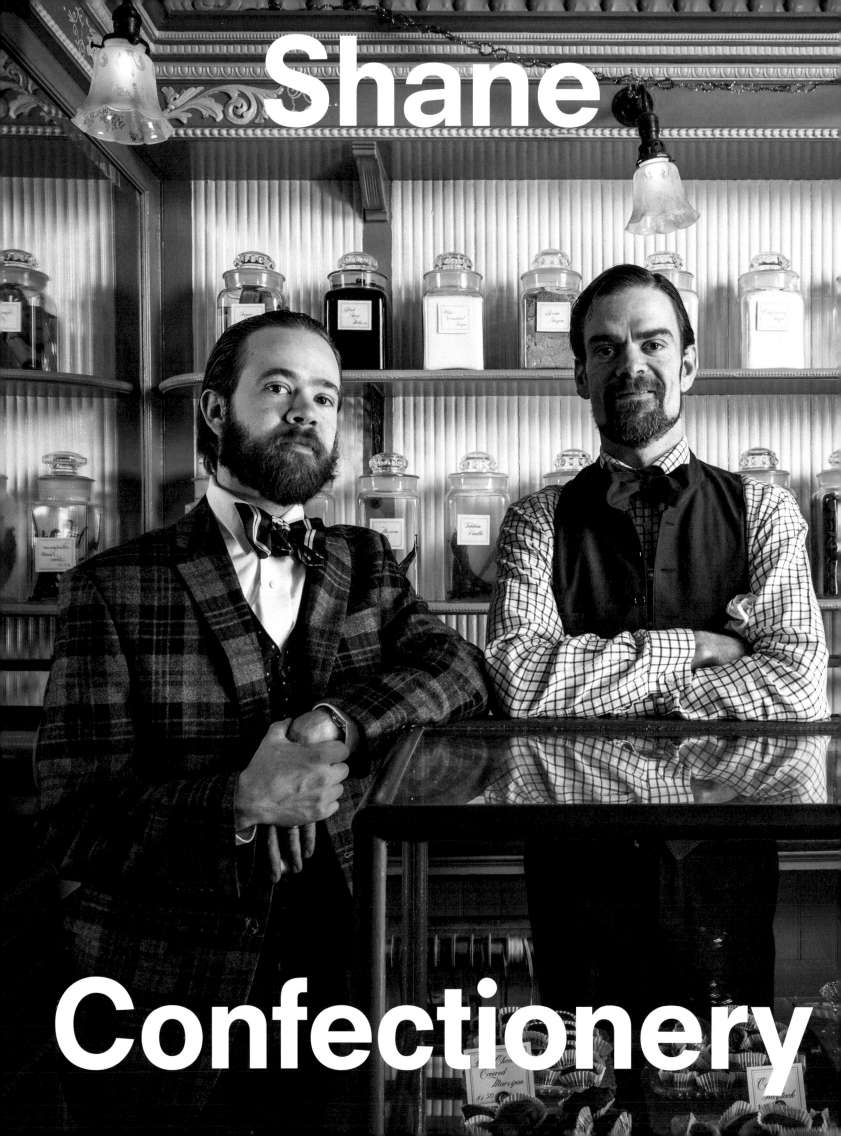

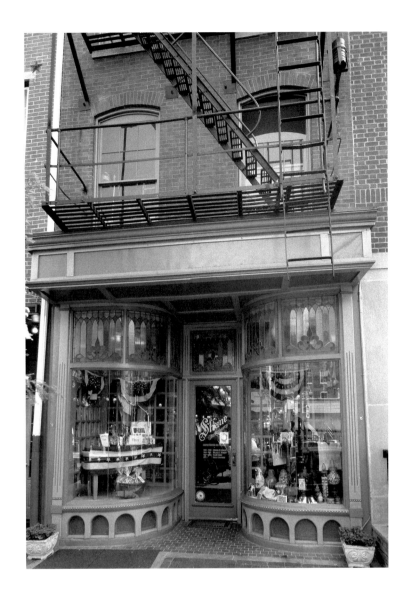

After a century in the Shane Family, brothers **Ryan** and **Eric Berley** took over this Philadelphia candy institution in 2010. The blast from the past transports its generations of avid customers back to a simpler and sweeter time.

A candy lover's paradise for over one hundred years, this idyllic shop in Philadelphia continues to channel the sweetest parts of the good old days. The shop has stood in the same spot you'll find it in today since 1911. Current owners and brothers Ryan and Eric Berley took over the business in 2010. The dedicated new owners have worked diligently to preserve and recapture Shane Confectionery's period splendor from when it first opened more than a century ago. An impressive time capsule stocked with vintage flavor and charm, the Berley brothers have renewed the City of Brotherly Love's sweet tooth.

The new owners share an insatiable love for yesteryear. Their first business endeavor, Franklin Fountain, sits just two doors down from Shane Confectionery. The conveniently located ice cream parlor gave the brothers a chance to get to know the candy business intimately from afar before deciding to make their move. Between the successful and historically influenced ice cream and candy shop, the Berley's employ a three-person design team, headed by Sarah Eberle. This creative design team develops signs, ads, interior design, marketing, and displays that showcase Edwardian and Victorian style and aesthetics.

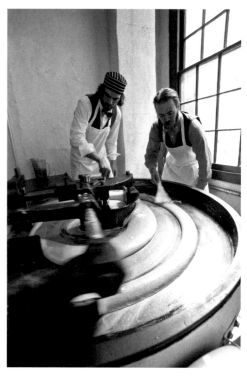

The kitchen uses original equipment and recipes that often date back nearly 100 years

As the oldest continuously-operated candy shop in the United States, the building began producing its signature sweets back in 1863. That year, the freshly completed building became home to Samuel Herring, a confectionery wholesaler. Herring then passed over the business to his son Samuel and his trusted employee, Daniel Dengler. The partners specialized in shelled almonds and peanuts, figs, dates, coconuts, chocolate liqueur, and a host of other items. Following the passing of Herring, Dengler decided to move his operations across the street and sold the business to William T. Wescott, a descendent of glass blowers with a fondness for chocolate, in 1899. The building changed hands one more time in 1910, at last reaching the company's namesake, Edward R. Shane. The canned-fruit broker and his family took over the space and opened Shane Confectionery. Having spent much of his childhood in his mother's store, Shane was well accustomed to the chiming ring of the cash register and the interplay of aromas wafting from the kitchen. Shane cooked his chocolates over a coal fire and enjoyed his booming business. Over 20,000 people passed by his shop daily as they waited for the ferry to Camden, which, at the time, was the only means of transportation to and from New Jersey. In the 1950s, his son Edward Jr. purchased the business. Thirty years later, Edward Jr.'s son Barry, the last of the Shane confectioners, bought it from him. After ninety years in the Shane family, thirty of which were under Barry's reign, he handed the company keys over to the Berley brothers. The perfect successors to his family legacy, the brothers made sure nothing changed, including the name.

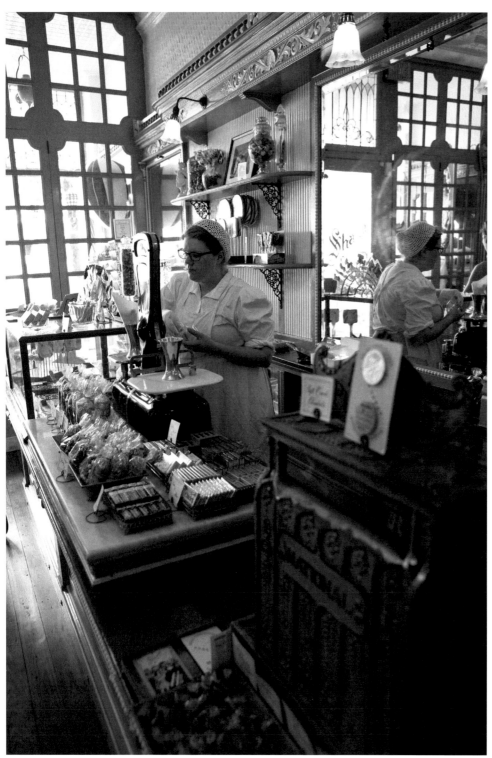

A candy lover's dream, the shop carries seasonal specialties and everyday favorites

No detail goes unconsidered as the Berleys continue to turn back the clock. The brothers renovated the largely original interior, bringing it back to its former splendor. Hardwood display cases proudly present selections from the hundreds of seasonal and staple sweets for sale inside the shop. Dusty blue, built-in shelves hold vintage glass jars filled with various delights ranging from sugary bonbons and candy canes to finely crafted individual chocolates. Curved glass display windows lead customers into the shop and onto its freshly varnished pinewood floorboards. Inside, the sound of candy clerks stepping on the rungs of wheeled ladders to fetch boxes of chocolates from the uppermost shelves intermingles with the clack of jelly beans filling a brass scale and the crinkle of wrapping paper as it gets formed into tidy takeaway candy packages. The familiar old clang of an original and ornate metal cash register cuts through this sonic ambiance with its upbeat tune.

The seasonally dependent staff oscillates between ten employees during off-season and up to fifteen during peak holiday times. Shane Confectionery crafts a wide range of house-made, chocolate-covered candies. Buttercream, the shop's most famous and popular recipe, is also its oldest. The original hundred-year-old recipe features a wide variety of flavors,

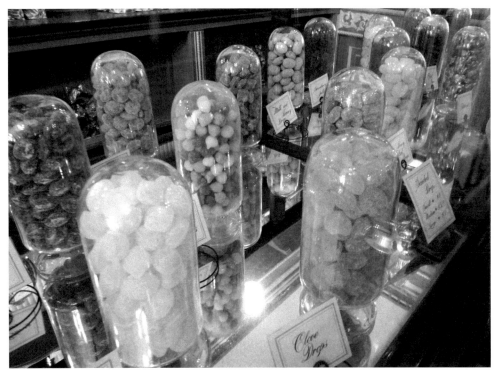

A scweet or two? Don't mind if I do

No detail goes unconsidered as the Berleys continue to turn back the clock.

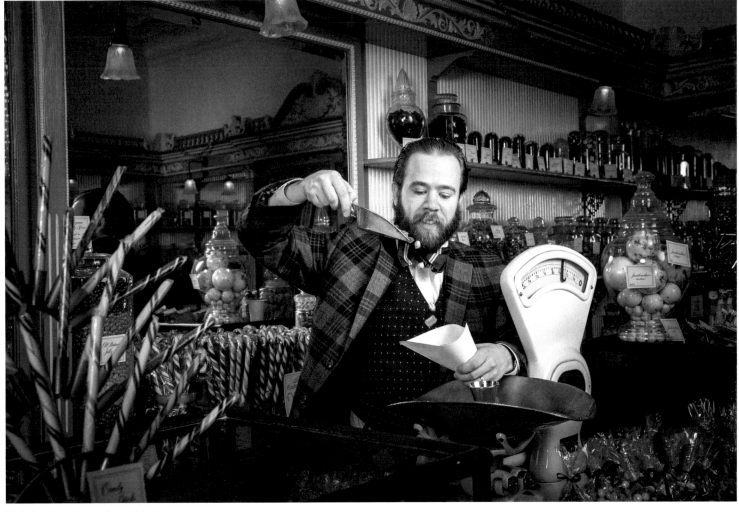

The Berleys utilize a vintage scale to weigh candy

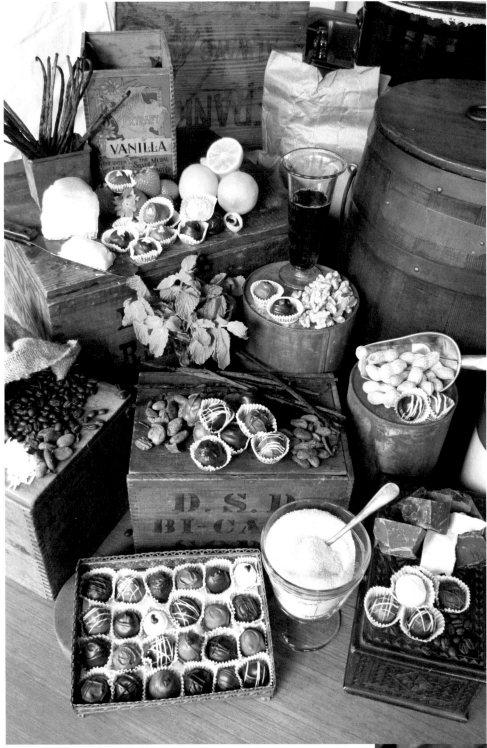

Clear Toy Candy, a regional specialty, comes in many familiar and unfamiliar shapes

from lemon and coffee to chocolate and vanilla. Clear Toy Candy, another in-house specialty, ranks as the next top seller. The Pennsylvanian German traditional Christmas confection remains a popular regional delight. Little known outside of the state, this hard candy found in multiple bright colors gets cast into a variety of whimsical shapes from sailboats and elephants, to anvils and presidents.

The business has stayed around for so long that locals have grown up and grown old on Shane candies. First sharpening their sweet tooth as kids, the same customers later bring back their children and eventually their grandchildren. These committed customers, some of whom have been frequenting the store for 75 years, intermingle with brand new customers who just happened to stumble upon the candy institution when walking down the street. While the brothers have only been part of the company for a fraction of its existence, they strive to share and educate people on Shane Confectionery's lengthy history.

The meticulous revival of the city's beloved candy store includes a tantalizing menu of treats made and presented the old-fashioned way. Both the products and decor remain deeply rooted in the American candy tradition of the past 200 years. Some of the recipes the store has

Individually wrapped house-made choclates are just one of the sweets you can take home

The business has stayed around for so long that locals have grown up and grown old on Shane candies.

been employing for a century, while others—still a century old—have only recently appeared at the shop. The stoves and many of the kitchen tools are antiques, underscoring the Berleys' reverence toward the past and its traditional candy-making methods. The shop's well-loved hard candies begin with sugar melting into copper kettles. This molten sugar then gets transferred into one of 1,200 original molds that have been in use for generations. As the sugar cools, it takes on a number of familiarly fanciful shapes.

The brothers, like their store, seem lost in time. Bow ties, suspenders, and vintage three-piece suits represent the daily attire. Separated by four years, Ryan and his younger brother Eric, even sport facial hair and haircuts that hearken back to early grooming styles donned in the early twentieth century. Their genuine love for the past permeates all aspects of their shop and their personal lives. This careful preservation of the bygone keeps the atmosphere authentic rather than gimmicky. Upholding the stories and traditions of the great confectioners that came before, the Berley brothers carry on the company's longstanding mission to bring a familiar sweetness and the exoticism of distant lands to the palettes of their loyal clientele. Surviving for a century and a half, the humble store

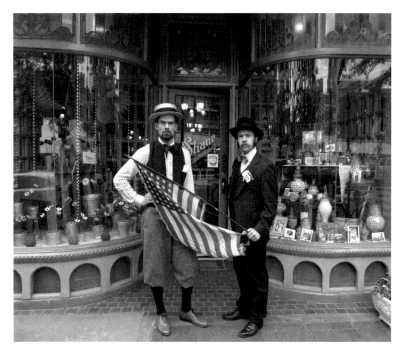

Owners/Designers: Ryan and Eric Berley
Founded: 1911
Location: 110 Market St, Philadelphia, PA, USA

has withstood a rapidly changing world around it. In no hurry to modernize, the inheritors of this confectionery tradition take the responsibility seriously. Carrying on the values that sustained this business for generations, the motivated brothers have picked up the hard work of handcrafted candy making right where their predecessors left off.

Milk Jar Cookies

Cookie Connoisseurs, Los Angeles, CA, USA

C is for cookie, but it's also for Courtney Cowan, the baking mastermind behind Los Angeles's best cookie shop. Cowan left her job as a television producer to pursue her dream of opening a milk and cookie establishment. In 2012, her husband decided to join her for the adventure, and by spring of 2013, Milk Jar Cookies opened in LA's Miracle Mile district. Cowan's homegrown concept builds on the premise that the simple combination of milk, cookies, and a tasteful heap of nostalgia makes for an unforgettable dessert experience. The shop, run by an enthusiastic

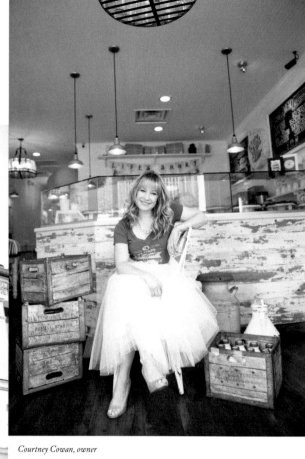

Courtney Cowan, owner

staff of 15 employees, includes a tempting display case where guests can debate over which of the tantalizing flavors should end up on their plate.

Cookies are baked in small batches in the back of the shop throughout the day. This small batch baking technique keeps the bright space filled with an aroma of authentic freshness. A selection of rotating seasonal cookies rounds off a menu brimming with classic and specialty flavors. Whether you decide to keep it simple with a Chocolate Chip or are in the mood for the more daringly delectable Banana Split or Rocky Road, Cowan's menu satisfies every style of sweet tooth. Highly addictive seasonal specialties include Pumpkin Pie in the fall and Salted Butterscotch in the spring. Pair your selection with an ice-cold glass of milk from a local Los Angeles dairy farm or upgrade those cookies into an ice cream sandwich.

Cowan managed the interior design and left no detail unconsidered. Mismatched tablewear, rows of saucers set in a rustic frame, and lighting fixtures made out of collections of old milk bottles give the store an endearing home away from home feeling. 1950s music wafts through the cozy space adding to the cheerful and timeless appeal. Cowan's slogan "Life is short, eat cookies," inspires the jovial atmosphere. Cookie monsters rejoice, the Milk Jar stays open until 11 p.m. on Fridays and Saturdays to satisfy all late night cravings.

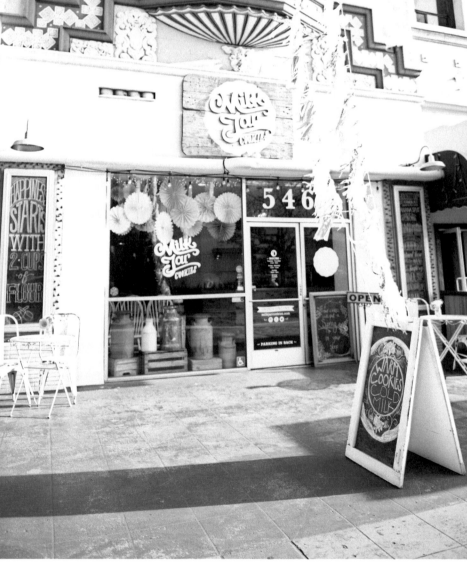

The welcoming storefront serves up fresh out of the oven cookies until 11 p.m. on Fridays and Saturdays

Owner/Designer: Courtney Cowan
Corporate Identity: Adam Tiller
Founded: 2013
Location: 5466 Wilshire Blvd, Los Angeles, CA, USA

Sometimes, the best fruits should be saved for later. Inside a tiny 270-square-foot storefront, Lillie O'Brien has been offering up small batch preserves for the past two years. O'Brien, an Australian expat, moved to London where she first worked as a pastry chef at St John Bread & Wine. As a pastry chef, she developed a fondness for jam's ability to preserve the season. This fondness for crafting and jarring jams quickly materialized into a business plan. The company, often simply known as LBJ, launched in 2011. Before moving into her cheerful blue storefront with its inviting lemon yellow outdoor bench, she operated out of a stall in Chatsworth Road Market. The bright and simple white space displays O'Brien's coveted jams and a range of handmade products, both edible and non-edible. Best known for her fig and plum jams as well as more unusual varieties like cardamon and rhubarb, her products are all handmade in Hackney, London using only seasonal ingredients. Supplemental food related products including african baskets, aprons, food magazines, wines, ceramics, chocolate, chutneys, sauces, wooden spoons, and more make for fine gifts and kitchen improvements. Jazz up your morning toast or indulge in a LBJ filled donut, your taste buds will thank you now and later.

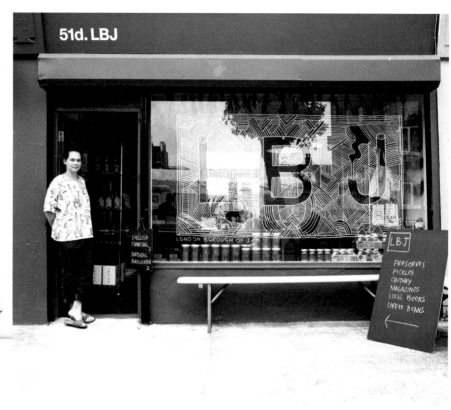

Lillie O'Brien in front of her shop

Owner: Lillie O'Brien
Designers: Lillie O'Brien, Marcus Haslam, Fred Rigby, and Rob Lowe
Founded: 2013
Location: 51d Chatsworth Road, London, UK

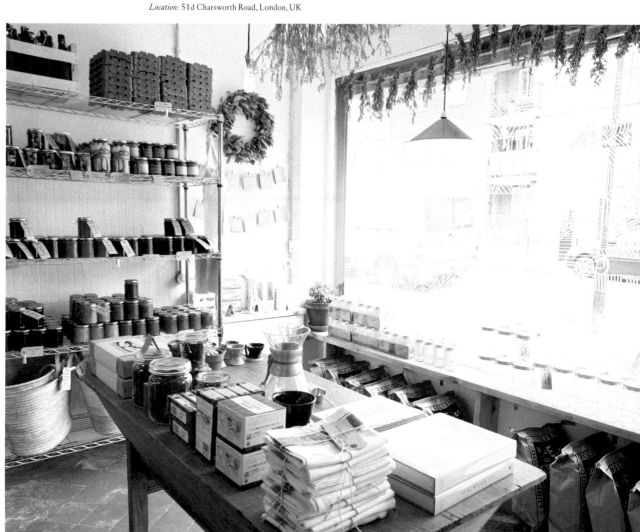

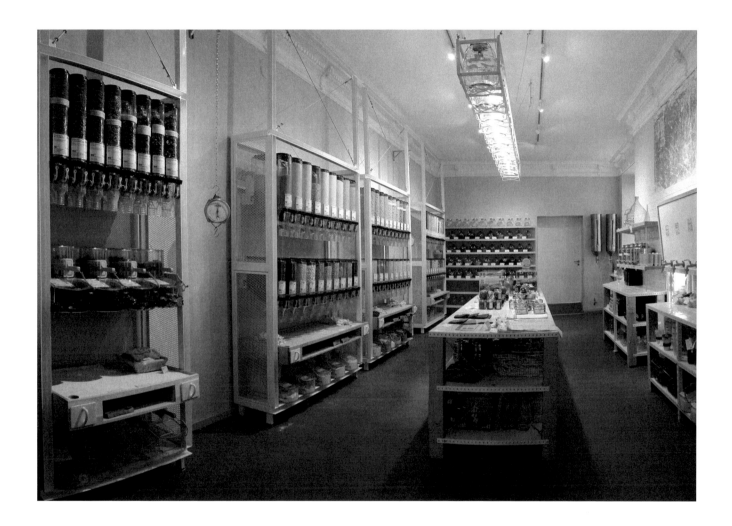

Tired of all the packaging that goes to waste every time they go shopping, partners **Sara Wolf** and **Milena Glimbovski** decided to develop a supermarket where everything comes unwrapped. Doing away with excess, people can at last buy what they truly need—nothing more, nothing less.

Customers bring in their own baskets to take home their purchases

The average person produces 550 pounds of trash per year. While that number might sound like a lot, take a moment to consider how much we actually throw away on a daily basis. Each item we buy comes with its respective container, a container meant to be discarded. Bulky plastics and cardboards accompany even the simplest items. By the time you have finally unwrapped your goods, how much has ended up in the recycling bin? Sure, it's mainly recycling, you tell yourself. At least it's not going into a landfill. But how much energy does it take to turn that cookie box or vegetable wrapper into something else? Berlin-based Sara Wolf and Milena Glimbovski present a drastic yet effective solution to our culture of over-packaging: unwrap it. Their recently opened zero-waste grocery store, Original Unverpackt (OU), has revolutionized the way residents of the Friedrichshain and Kreuzberg neighborhoods of Berlin go shopping. The package-free store sells in bulk, encouraging customers to buy what they need in the exact quantity they need it. Keeping prices down and quality up, the OU team is undressed for success.

Wolf and Glimbovski stand as refreshing reminders to never underestimate university dropouts. Troubled by the amount of packaging wasted each day, the two put their school books aside to focus on the problem full-time. Their project first took shape in November 2012 when Glimbovski shared an idea that had been on her mind with Wolf over a glass of wine. The first seeds of the idea were planted while Glimbovski worked in the marketing department of a chain of vegan grocery stores. Her decision to partner with Wolf turned out to be a match made in culinary heaven thanks to Wolf's background in project management and communication strategy at Fairtrade

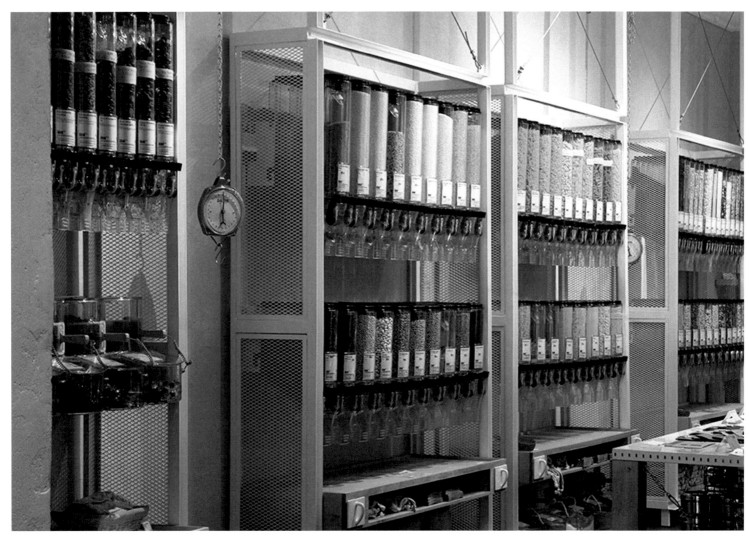

Bulk bins line the walls, empowering customers to only buy as much as they really need

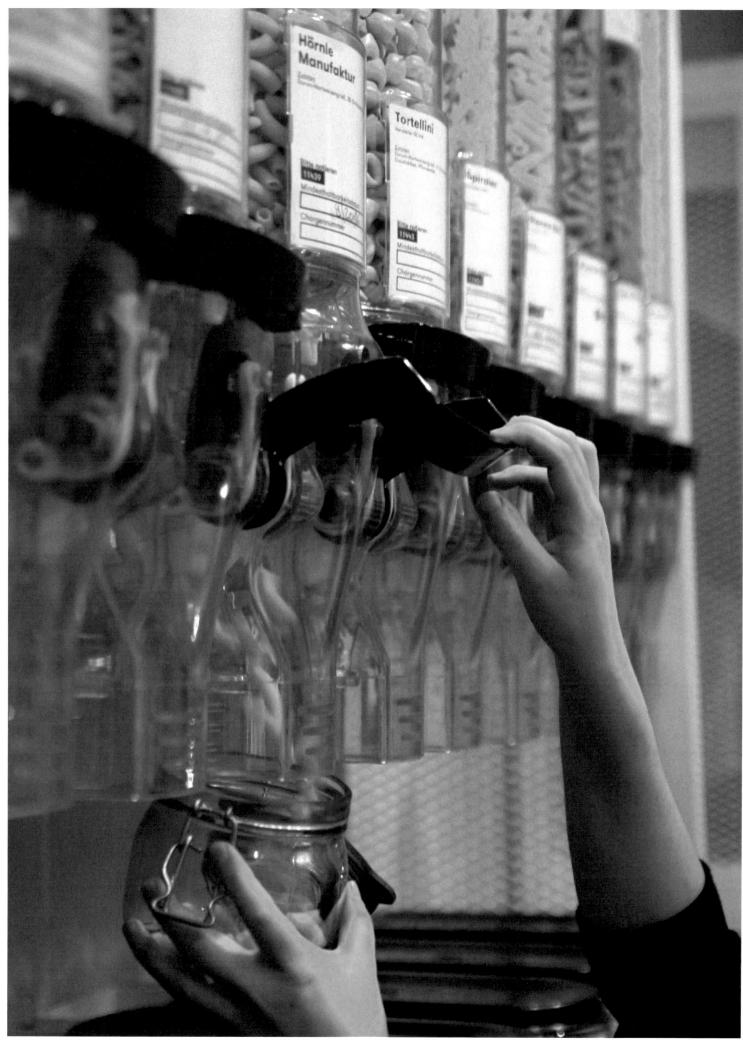

Jars of all sizes and shapes appear to transport and store the bulk goods

International and the United Nations. The two socially-conscious young women then worked steadily over the course of the next two years with an ever-growing team to develop the pared-down shopping concept. They then tested the idea through the crowdfunding site Startnext to see if they could raise enough capital to open a real location. The concept was met with overwhelming success. Not only did they reach their startup goal of € 45,000, they doubled it. More than 4,000 prospective customers contributed

mental experiment, Wolf and Glimbovski will continue to refine and expand their selection according to customer feedback.

Simple and straightforward, the supermarket's aesthetic language reflects the partners' minimalist consumer philosophy. Light wooden shelves hold rows of bulk goods. The more popular the item, the emptier the container. A long table runs through the center of the space displaying a range of featured products and storage items available for purchase. The

helps finance the market's growth and costs participants 400 euros per day per day. Those still interested in attending but unable to meet the steep price point can reach out and the partners will work out a fair solution tailored to that person's financial situation.

"The current way of shopping is not sustainable," co-founder Wolf points out. Driven toward effecting real social change, the savvy businesswomen put their money where their mouths are. While the duo tackles the issue of how we relate to and access our food, their vision doesn't stop there. By first changing the way we select, buy, transport, and store our groceries, the team at OU hopes that this zero-waste form of shopping will soon permeate all aspects of our daily lives. The movement toward minimizing waste continues to gain ground thanks to dedicated anti-packaging crusaders like Glimbovski and Wolf. Encouraging more people to buy in bulk and supporting waste management initiatives from the food retail sector, the model of the OU supermarket represents a viable alternative to classic consumer options. Here, unnecessary waste is avoided and unavoidable waste is recycled.

The model of the OU supermarket represents a viable alternative to classic consumer options. Here, unnecessary waste is avoided and unavoidable waste is recycled.

to the campaign. With that startup money the partners opened up a first location four months later in September 2014.

The search for the perfect space to house their testing laboratory took half a year. Situated in the middle of their favorite neighborhood, a former hundred-year-old butcher shop provided an enticing historic backdrop for the new business. The girls fell in love with the tiled walls and embarked on an extensive renovation to revive the storefront's faded sparkle. Applying a back-to-basics approach, the supermarket fuses innovation with style. Attracting a diverse pool of customers, the market resides in a colorful part of Berlin near Görlitzer Park, full of contradiction and excitement.

Less than a year after opening, the market now carries more than 400 carefully selected unpackaged items. In addition to an assortment of fresh produce, bulk grains, and other food items, the store also stocks cosmetics, cleaning detergents, personal care items, and books all without their usual wrapping. If you forgot to bring your own gear to transport and store your selections, Glimbovski and Wolf also offer a selection of reusable jars, containers, and bags for daily use and long-term storage at home.

The partners source food locally to reduce transportation costs and energy use. Many items are stored in self-service, drop-down bins that let gravity do the work when dispensing the product. These clear bins, tubs, and jars line the walls of the market, doubling as both product and subtle design element. The duo's refreshingly uncluttered approach results in a striking visual impression—a supermarket free of advertising. Rather than the rows of garish and competing product branding that typically lines the shelves of markets, only the items in their purest form stand on display here. Doing away with colorful wrappings, misleading promotional photographs, and corporate logos, the girls simplify the shopping experience so that what you see is actually what you get. Approaching the market as an ongoing social and environ-

Bring in a basket and fill it with only what you need

prices of all grocery items are calculated against the weight of the containers used, so customers only pay for what they truly purchase.

More than just entrepreneurs with a social vision, Wolf and Glimbovski double as educators and champions of the zero-waste movement. The two run a series of two-day seminars where they pass on their specialized knowledge to the public. These workshops cover how to open your own franchise, the ecological and economic benefits of unwrapped shopping, samples and sources for bulk food supply, and how to deal with hygiene issues and quality management. The comprehensive, hands-on workshops

Upending the ingrained psychology of shopping, the testing laboratory turned grocery store remains a work in progress. The team at OU consistently adapts the store to make it as user-friendly as possible. Understanding that by unwrapping the shopping experience they are exposing shoppers to an unfamiliar new set of practices, Wolf and Glimbovski have noticed that signage becomes increasingly important the more you strip away. These clear and slightly retro graphics serve as a how-to guide for first-time customers to orient themselves in the logo- and packaging-free market. Hesitant at first, new converts gradually build up confidence and creativity in their shopping approach. The partners enjoy seeing first-time customers timidly begin with just one or two containers and shopping bags brought from home and gradually grow more confident after watching more seasoned shoppers navigate the store. Soon, these same people bring in novel solutions for transporting and protecting their goods. From storing chia seeds in empty rum bottles to filling an old Pringles can with pasta, the ladies of OU have seen and love it all. With all excess strategically removed, the bare bones that remain inspire customers to reinvent their consumer habits. This more mindful approach to shopping not only helps the environment but encourages guests to literally think, buy, and store outside of the box.

Owner: Sara Wolf and Milena Glimbovski
Founded: 2014
Location: Wiener Straße 16, Berlin, Germany

Set on Lower Clapton Road in Hackney London, a craft beer and growler refill shop celebrates local and imported brews. Co-founders William Jack and Tom McKim launched the 430-square-foot store in 2014. Descendants of family in the wine industry, Jack's respect for and interest in wine and beer began at an early age. He started his career in New Zealand as a wine maker. He later became manager of Borough Wines in London and eventually partnered with McKim, another beer and wine veteran. With the help of friend and furniture designer Fred Rigby, the business partners designed and fitted out the shop themselves. The team kept as many of the existing features of the storefront as possible, highlighting the exposed brick, Victorian floorboards, Belfast sink, and the globe light fixtures above the counter. Concrete masonry, plywood, wooden battens, and ample planting support these extant elements and give them an updated look. Jack and McKim sell a wide range of local beers from the United Kingdom as well as imported bottled beer. Eight rotating taps fill up recyclable brown glass growlers for take away. A state-of-the-art counter-pressure system ensures the beer stays fresh for up to six weeks without loss of carbonation or flavor. Marvel at the extensive product range as you peruse craft beers from the United Kindom, Europe, the USA, and beyond. In addition to this broad selection, the shop also showcases favorite local breweries including Pressure Drop, Beavertown, and Five Points. Beer, a fairly democratic drink, even in its craftiest iteration, attracts a diverse and lively pool of customers. So drink up, and visit the website for an up-to-date growler menu.

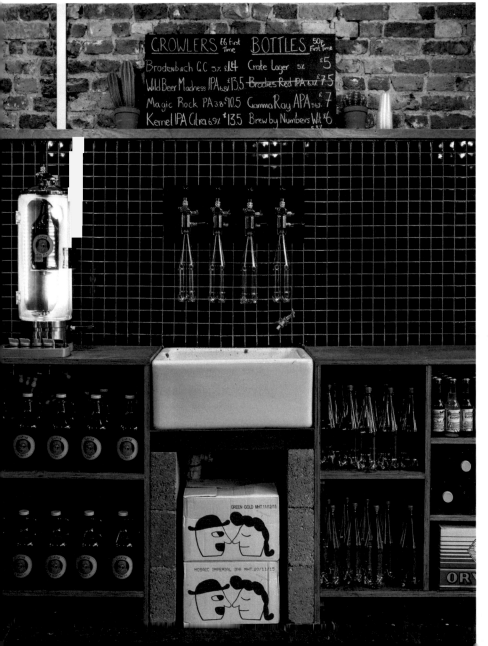

Owners/Designers: William Jack and Tom McKim
Founded: 2014
Location: 97 Lower Clapton Road, London, UK

Butcher and Boulangerie, London, UK

Owners: Josie Stead and Will Lander
Design: Fraher Architects
Founded: 2013
Location: 88–94 Farringdon Road, London, UK

A contemporary counterpart to a restaurant that has been a London staple since 1869, this butcher and food shop opened up just next door in 2013. The quaint corner location sells a range of British meats and produce from daily provisions to fresh produce, homemade condiments to pies. Run by Josie Stead, Will Lander, and two part-time staff members, the shop welcomes input and cross-over knowledge from the restaurant team. Stead, previously general manager of Dinner by Heston Blumenthal at the Mandarin Oriental, also worked at Sketch, The Ivy, and several restaurants in Melbourne. Lander, another industry aficionado, has been immersed in the world of food and wine all his life. He worked at Vinoteca and St John Hotel, and most recently for the Mandarin Oriental Hotel Group. In 2012, the two joined forces taking ownership of The Quality Chop House restaurant— a partnership born of a love of excellent wine, honest food, and humble service. In 2013, they opened the shop next door as an extension and reflection of the restaurant. Designed by Fraher Architects, the

classically inspired interior with its clean lines integrates black stained plywood joinery and cable lighting to reference the packing and wrapping of the food produced.

The butchers share Stead and Lander's ethos of whole-carcass butchery. The relatively unique approach results in the use of interesting old English butchery cuts and rare breed animals. The shop also stocks house-made products such as pork pies, family pies, terrines, jams, chutneys, chocolates, and pastries. Daily lunch items include sausage rolls, sandwiches, seasonal drinks, and hot roast sandwiches and donuts on Fridays, A wide selection of products reflect the restaurant menu which include cheeses and charcuteries, seasonal fruits and vegetables, artisan oils, wines from the restaurant list, craft beers, and more. Loyal restaurant guests visit the shop to take home produce showcased on their dinner menu while locals drop by during lunch breaks for a pastrami and Montgomery cheddar sandwich, sausage rolls, cakes, and salads. Local and not so local residents also come for

Owners Will Lander and Josie Stead with Head Chef Shaun Searley

weekly shopping due to the ample quality produce and hard to find, unusual cuts of meat. Straight from the farm and butchered by Oliver, the head butcher and his team

on site, the meats then begin their aging process in the cold room in the back. Lander and Stead source goods for the store and restaurant in the same way, working with four

or five select English farms. Come hungry and leave with enough goodies to fill your fridge through the rest of the week.

Window cabling

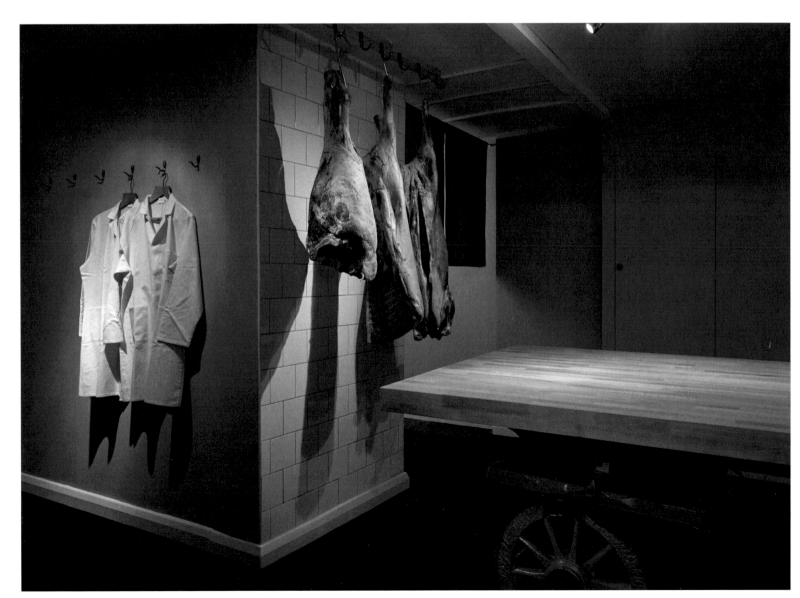

Butchery classroom

The Quality Chop House Shop & Butcher

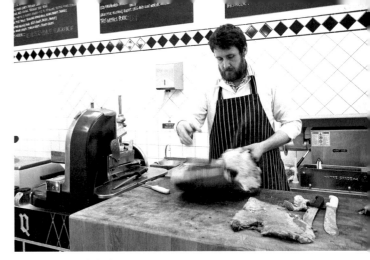

Head Butcher, Oliver Seabright

Head Chef Shaun Searley, in the kitchen

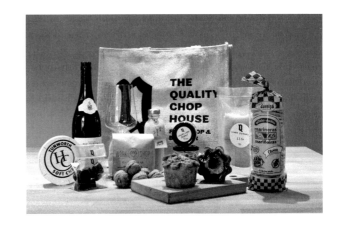

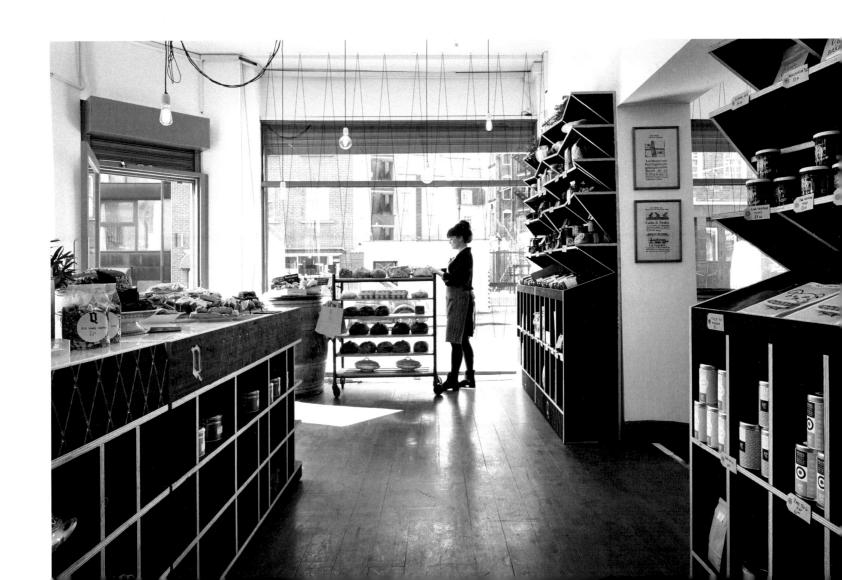

Kochhaus

Cookbook

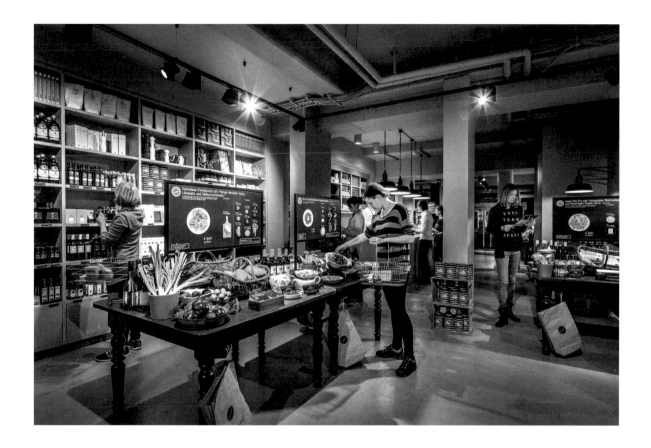

An ingenious concept that allows anyone to feel like
a talented chef, **Kochhaus** provides customers with
everything they need to make a restaurant-worthy
dinner on any given night.

ounder Ramin Goo conceives of Kochhaus as a walk-in cookbook that enables people to have a restaurant-worthy, fussfree dinner after a long day's work. The store is set up in such a way so that upon entering, customers find 18 different recipes with all of their respective ingredients delightfully laid out on individual tables accompanied by a picture of the resulting dish. "These recipes are never extremely difficult or very time-consuming," explains Ramin, "but always innovative and surprising—something you would never think to cook on a Wednesday night!"

The concept was well received as soon as Kochhaus opened five years ago, and the Berlin-based store has expanded into several other locations in Germany, including Frankfurt, Munich, and Cologne. Each store retains the same low-key yet very elegant aesthetic, with a focus on the recipes and their ingredients in the foreground, which are highlighted with the use of bright spotlights, and neatly arranged shelves in the background that carry quality products

to enhance your dinner such as Italian wine. The store's gray and cream color palette lets the fresh produce, merchandise, and packaging shine, while the café corner adds a convivial aspect to the atmosphere.

Kochhaus's customers are loyal and conceive of the store as the perfect way of getting a restaurant-like meal with the added satisfaction of knowing that they cooked it themselves. Ramin and his team make sure that there's a reason to return regularly by changing three of the displayed recipes every week, and present a fresh assemblage of 18 new recipes every six weeks. Whenever possible, Kochhaus carries locally produced ingredients, and all recipes are seasonal with lighter dishes offered in the summer and heavier, more ambitious recipes near Christmas time.

Kochhaus works with six chefs in Berlin to create their featured meals. Every recipe is cooked at least three times in the Kochhaus offices before arriving at the stores. The first round is handled by a chef (they have

preferred chefs that they go to for different kinds of meals, whether vegetarian or Asian-inspired, for instance), followed by a second round during which the recipe is cooked by a staff member who was not involved in the recipe-development process and who is therefore discovering the meal for the first time. If this second round goes well, then the team makes the recipe a third time, and this is the final dish that is photographed for display. This cycle results in a foolproof recipe that the average customer can enjoy making—and eating! Ramin notes that these three steps are also there to allow for changes along the way, improving recipes until the team is completely satisfied.

While the public was immediately won over by Kochhaus's original approach to grocery shopping and food preparation, Ramin shares that it took almost a year to get the required financing in order to turn the idea into a reality: "It's an unusual area for a start-up: it's grocery, it's food, it's retail ... In Germany, where discount supermarkets are everywhere and very well-liked, there was this sense that people wouldn't want to spend a little extra on good food. Once we opened though, getting a customer base was rather easy because people were attracted to the concept and the store itself. The challenges we faced were in fact more on the

These recipes are never extremely difficult or very time-consuming, but always innovative and surprising—something you would never think to cook on a Wednesday night!

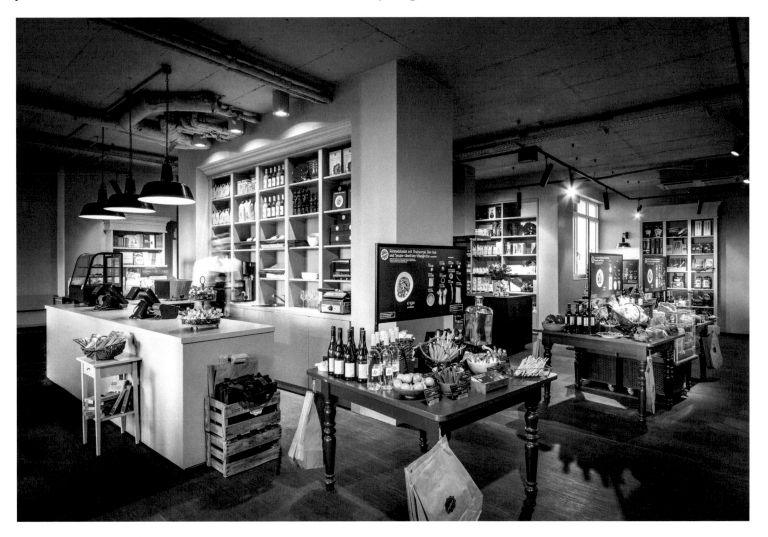

operational side since none of us had a background in retail. We had to learn how to organize the logistics, negotiate with wholesalers … things that the customer wouldn't notice. Luckily, we learned and are continuing to grow."

Ramin had studied business administration and started a PhD in entrepreneurship before meeting the two people he would go on to found Kochhaus with. What they lacked in retail experience they compensated for in perseverance and a rock-solid concept. In fact, when asked what advice he would give to someone thinking of opening their own storefront, Ramin says, "Don't make too many compromises: there will always be people pulling you in different directions who tell you 'why don't you do this' or 'why don't you add this feature to your idea'? Especially in retail where there are so many key decisions to make from the location to the team or the amount of funding you need to start, the danger is that you will make certain decisions that water down your concept." Ramin adds that you should "stick to that one area where you are

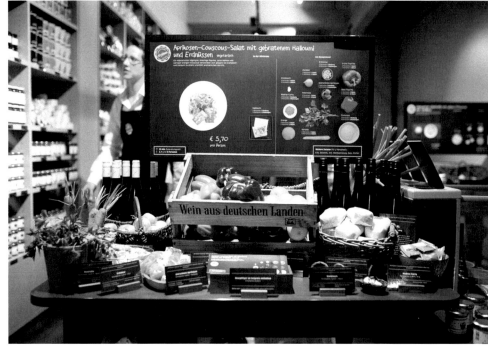

Each recipe is clearly laid out with all necessary ingredients

great and where you are innovative—concentrate on doing one thing really well rather than being somewhat successful at several things at once." It certainly worked for Kochhaus!

The store's motto is "Life is too short to eat badly," and while Ramin admits that even he occasionally succumbs to the appeal of junk food, he believes that Kochhaus helps people eat better food more often by providing an easy and delicious solution to people who are tired, lack inspiration, and enjoy a home-cooked meal. The recipes on display cost less than a meal at a restaurant, sometimes even equaling the amount you would pay to make the same recipe from ingredients bought at an organic supermarket. The average customer is between 25 and 55 years old, 35 percent of whom are male. The store's concept also appeals to environmentally conscious people who like the fact that Kochhaus enables you to buy the exact quantities you need to make the number of portions you want,

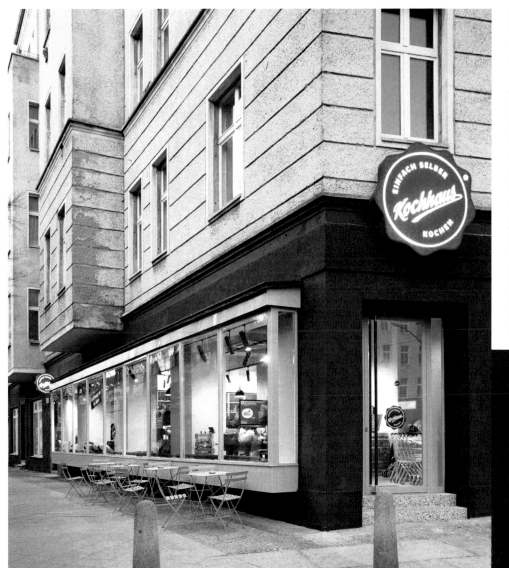

The store in Berlin's Schöneberg neighborhood

The store's concept also appeals to environmentally conscious people who like the fact that Kochhaus enables you to buy the exact quantities you need to make the number of portions you want, thereby diminishing the chances of any food waste.

€ 2,90
pro Person

Feige
Einzelpreis: 1,30 € / Stück

cycle ends in stores.

Ramin also shares that a key component to the Kochhaus identity is the staff members who are at the stores and interact with customers: "They don't necessarily need prior retail experience," he explains, "because an engaging personality and an interest in food are much more important to us." The in-store teams are there to help first-time customers navigate the store's layout and introduce the Kochhaus concept, and to warmly welcome their returning fan base, which is continuously growing.

Founder: Ramin Goo
Founded: 2010
Location: Akazienstraße 1, Berlin, Germany

Ingredients are always seasonal

thereby diminishing the chances of any food waste. In a world where our attitude toward waste urgently needs to be recalibrated, every little bit helps, and this makes a difference.

The aesthetic of the twelve Kochhaus stores is also reflected in its signage and packaging, which are all understated yet attention-grabbing. Each recipe is photographed with a stark black background, emphasizing the vivid colors of the ingredients on every plate. Kochhaus's website and mobile app follow the same visual codes, presenting their concept and providing different access to their recipes in a coherent and compact way. Kochhaus has also published a few cookbooks that feature the recipes that have been available in stores throughout the years, so that customers can have access to Kochhaus creations long after their six-week

Kochhaus recipes are easy to follow and look restaurant-worthy

Licorice Lovers, Berlin, Germany

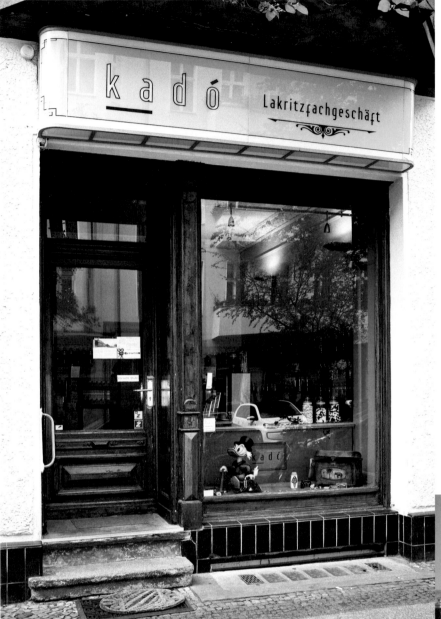

Whoever thought economics and licorice don't go together has obviously never met Ilse Böge. The economist turned shopkeeper opened the first licorice store in Germany in 1997. Böge grew up on the Dutch border where the treat was plentiful and was drawn to the unusual candy since childhood. After relocating to Berlin as an adult, she sorely missed having an adequate licorice selection and decided to find out if other people felt the same way.

Soon, Böge began offering her distinctive Dutch licorices at a few local markets in Berlin. She drove her friend Frank's old Volvo Amazon to Holland to buy goods. The popularity of her handmade sweets led to the opening of her first shop inside a converted storage space in Kreuzberg. With the help of designer Dirk Soboll, the simple shop began selling 60 licorice varieties. Ten years and 340 varieties later, Böge outgrew the space and moved the shop to its final location just a few doors down from her old storefront. The new shop lets the candy play the starring role. Set in glass containers on wooden shelves, the tried-and-true sweet brings a level of vintage nostalgia to the modern shop. Kadó, which translates to "present," stocks licorice from Iceland, Sicily, and beyond. Known for their ginger and cinnamon flavored licorice crafted in-house, the diverse inventory can convert even the most skeptical tastebuds. From the tangy and sweet to the salty and chocolate-coated, the licorice offerings at Kadó will remind you why this "black gold" has been around for hundreds of years.

Owner/Designer: Ilse Böge
Corporate Identity: Dirk Soboll
Founded: 1997
Location: Graefestraße 20, Berlin Germany

Owner Ilse Böge founded the licorice shop in 1997

Casa Del Agua

Local Water, Mexico City, Mexico

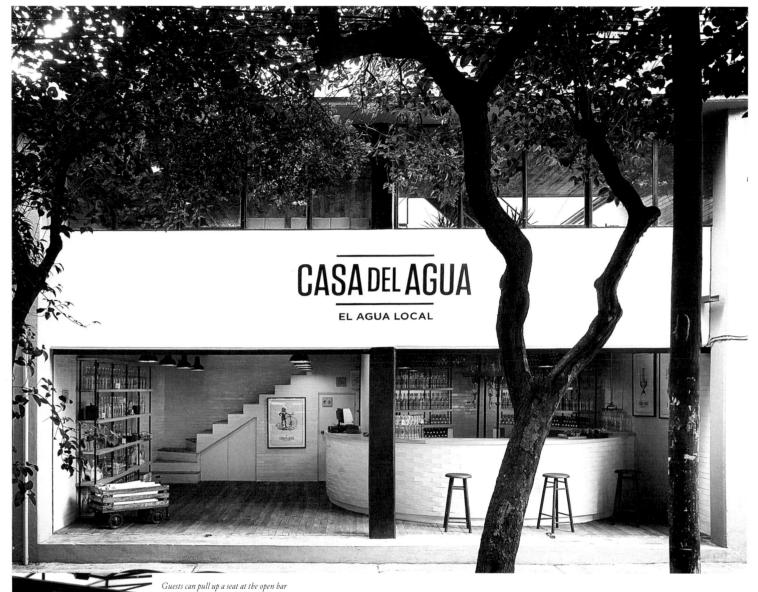

Guests can pull up a seat at the open bar

Bosco Quinzaños, president and founder

A water, tea bar, and roof garden provide a needed refuge from the bustling street life of Mexico City. Inspired by traditional processes, Casa del Agua emerges as a nostalgic brand that appeals to a customer base drawn to the well made, the practical, and the timeless.

Man, machine, and nature come together in this tranquil oasis. The refreshing concept, created by Bosco Quinzaños in 2012, came about after a twenty year career in finance. Ready to do something more meaningful with his time, he decided to transform his personal convictions about ecology, sustainability, wellness, and lifestyle into a business model. Quinzaños's 1,075-square-foot storefront with the help of its 1,505-square-foot roof garden produce 105 gallons of water per day. The artisanal factory of sorts supplies local neighbors, restaurants, and families with high-quality, locally produced water. Quinzaños and his staff of six collect rainwater on the rooftop. This water then undergoes a filtration process that involves vapor distillation, re-mineralization, ionization, and concludes with on site bottling. Glass bottles with old-time looking lettering developed by Ignacio Cadena store the purified drinking water and grant the product its distinctive branded identity. A laboratory-like double-height retail and social space on the ground level invites customers to interact with the product and its covetable packaging. The plentiful glass bottles accent the rustic interior finishes designed by Hector Esrawe. Above, the lush rooftop garden integrates light wooden shaded seating areas for visitors to relax, mingle, and unplug from the stress of metropolitan life. Come thirsty and leave feeling renewed in both body and spirit.

Owner: Bosco Quinzaños
Designer: Hector Esrawe; *Corporate Identity:* Ignacio Cadena
Founded: 2012
Location: Calle Puebla 242, Cuauhtemoc, Roma Norte, Mexico City, Mexico

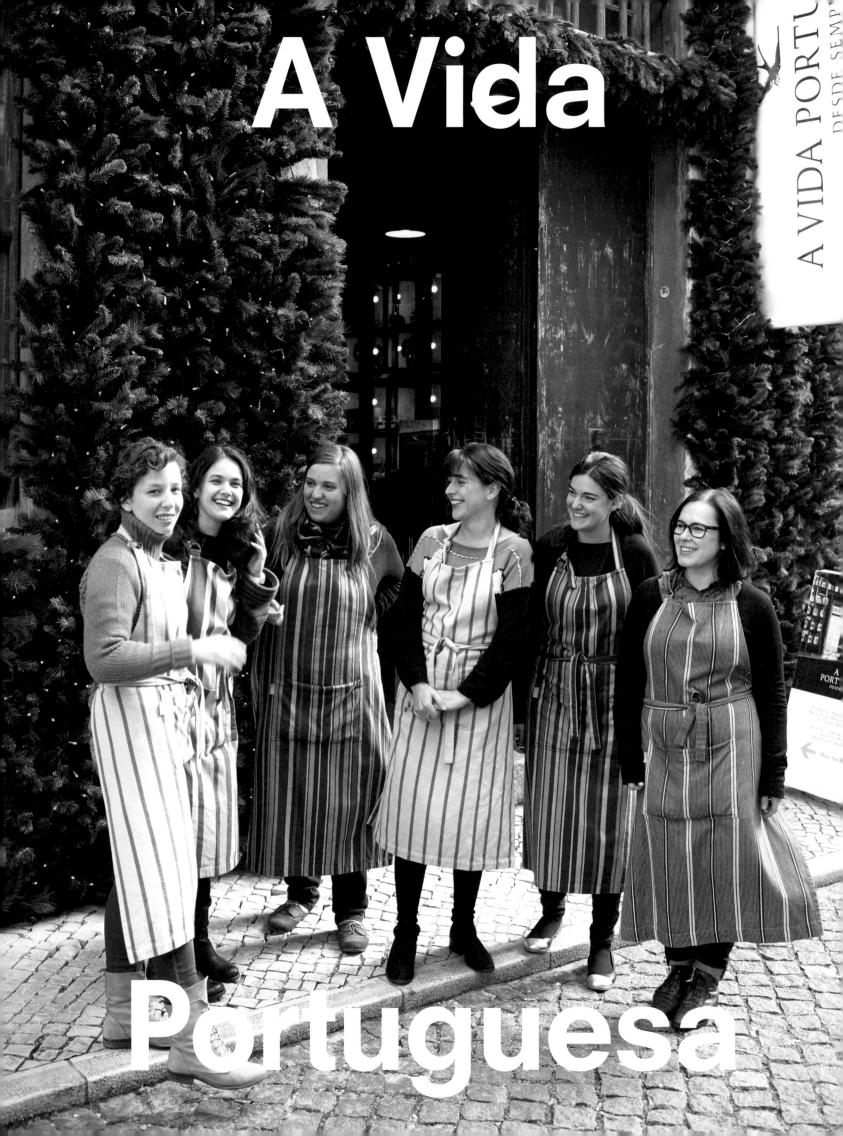

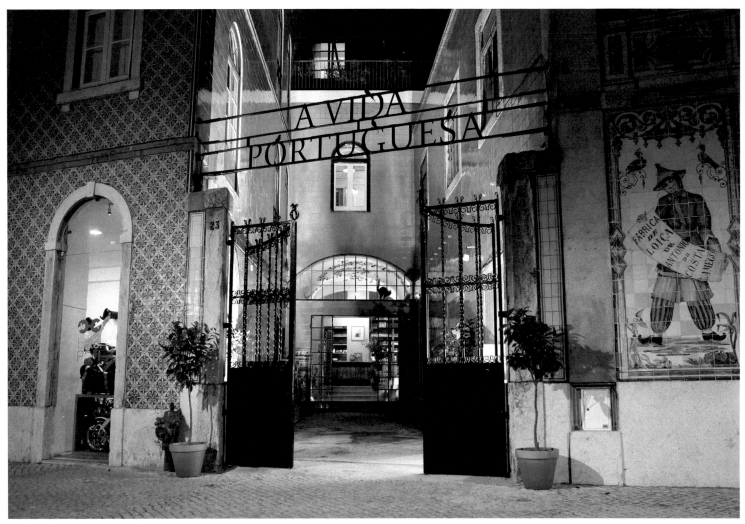

Cast iron gates lead into a courtyard and the impressive shop within

Journalist and author **Catarina Portas** redirected her skill for research on Portuguese traditions into a business model. Showcasing only legacy brands that still make things the old-fashioned way, her shops celebrate Portuguese craft while saving their dying industries.

Celebrating the best of Portuguese products, A Vida Portuguesa, which translates to "The Portuguese Life," brings Portugal's distinctive legacy of goods and wares together under a single roof. The flagship store, named the most beautiful shop in town by Time Out Lisbon, stems from an investigation undertaken by the then-journalist and author Catarina Portas into old Portuguese products. The Lisbon-born founder became a journalist in 1989 and wrote actively over the next years about society and culture for numerous newspapers and magazines. Her research began to focus on heritage goods that have been around for decades, that have kept their original packaging, and that

are still made involving handcraft and quality manufacturing techniques. In November 2004, these products were gathered in boxes according to different themes and Portas launched the brand Uma Casa Portuguesa. Three years later, in May 2007, the brand was reborn as A Vida Portuguesa in the Chiado neighborhood of the capital city of Lisbon.

This first flagship location occupies the significant centennial warehouse and perfume factory of David & David. The scrupulous renovation kept as much of the historic and bewitching interior intact as possible. This careful preservation includes everything from the original cabinetry to the jars of powder left behind. The

The old-fashioned architecture compliments the old-fashioned products

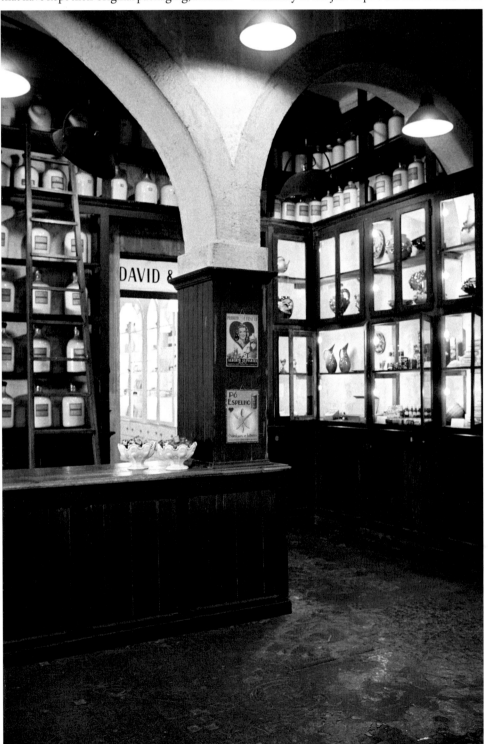

This shop reclaims the antique perfume factory, David & David

spirited restoration displays unique everyday products rescued from the memory of the country: A demonstration in how retailers can open new stores while fully preserving and honoring the past. Customers can explore selections of Portuguese jewelry, embroidery, ceramics, toiletries, stationery, books, and toys. A wide range of cleaning products, food, and drink complete the comprehensive retail experience. The staging of the atmospheric interior with its arched

walkways and vintage apothecary look feels purposefully untouched by time.

Surprising and enchanting its visitors, the store met with such success that Portas opened a second shop in November 2009 in the Clérigos neighborhood of the northern city of Porto. This storefront, a result of a partnership with Ach. Brito, neighbors the famous Lello bookstore. The location can be found on the first floor of the building's hundred year

old shop Fernandes Mattos, which still operates out of the ground floor. A Vida Portuguesa Porto sits at the top of an elegant interior

staircase. Inside, the restored and impressive 3,230-square-foot space boasts gracious windows and original period furniture. A sofa, the

Her research began to focus on heritage goods that have been around for decades, that have kept their original packaging, and that are still made involving handcraft and quality manufacturing techniques.

The expansive stores sell thousands of Portuguese goods

The team behind A Vida Portuguesa believes that objects can tell extraordinary stories.

only added furniture element, allows guests to take a moment to admire the view of the Clérigos tower beyond. Here, customers will find all the sections, brands, and products available in the Lisbon shop that sum up the best of Portuguese production. 2009 also marked the launch of A Vida Portuguesa's online shop.

Believers in collaborative efforts, the company launched the website in partnership with Feitoria. The online shop specializes in a refined collection of the same Portuguese handcrafts and brands found in the stores. Those who don't live in Lisbon or Porto can enjoy the same access to the local goods worldwide. Many of the

exclusive products available in the two stores can also be found in other partner shops both in Portugal and abroad.

The team behind A Vida Portuguesa believes that objects can tell extraordinary stories. These product back-stories reveal a culture's particular taste and lessons about a society's context, history, and common identity. "Saudade," Portuguese for a nostalgic and untranslatable longing, plays a key part in the experience of these stores. Classic wrappers

and unchanged details awaken memories and sensations buried deep inside their customers' psyches. The deeper visitors delve into the store and respond to the products, the more they end up revealing about themselves and their past.

A Vida Portuguesa was born out of the will to create an inventory of the brands that survived the passage of time, to highlight the quality of Portuguese manufacturing, and to showcase Portugal in a new and surprising light. Portas and her team have spent the past few years searching the coastal country from the north to the south in pursuit of locally created and fabricated products. The goods that find their way back to the shops have been in production for generations and retain their handsome native packaging. These historic items owe their longevity to their undeniable and unsurpassed quality recognized both nationally and abroad. With time, inventiveness, and hard work, these staple goods have reached a level of indispensable perfection that makes today's trend of mass production pale in comparison. Trademarked memories, such specialty items represent a way of life and reveal the spirit of the industrious Portuguese people.

Portas has established fruitful partnerships with several old Portuguese brands to develop exclusive A Vida Portuguesa products. A few of these custom products include soaps crafted by Ach. Brito and Confiança, pencils fabricated by Viarco, ceramics made by Secla, as well as notepads and notebooks specially designed by Serrote and Emílio Braga. Arguably the company's most interesting and ambitious

Large industrial windows illuminate national crafts

Products retain their original packaging

initiative, the ongoing collaborative effort involves research, design, development, and promotion of the quality brands and their touching nationally made products.

Investing in the future of the past, the rapidly expanding company opened a homewares shop in Lisbon's Largo do Intendente in 2013. This location began by selling soaps and has since expanded all the way up to bathtubs and wood ovens. More than 3,000 products sourced from all corners of the country come together under the same roof inside the extraordinary Viúva Lamego tile factory.

Customers gain an intimate understanding of the Portuguese life told through and recreated by its products. Portas channels the love of her country into a business model that supports and honors her country's handcrafts and traditional production methods. The products she carries in her stores, designed by and for the Portuguese people, depend on a flawless knowhow that has been passed down from one master craftsman to another over decades. The company runs on a model of commerce that Portas describes as "delicate trade." This simple business concept centers on the notion of respect for those who sell, those who purchase, and the goods that change hands in the process. A model

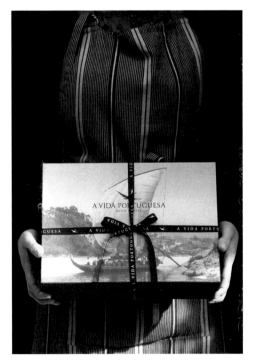

The perfect piece of Portugal to take home

that works, the business has inspired a number of new shops throughout Portugal to rediscover the value of the venerable brands of their country. Reviving the economy around regional and local craft, A Vida Portuguesa acts as a form of retail conservancy for endangered production houses and family businesses across Portugal. A source of national pride for local customers, the shop empowers the community to support its finest craftsmen through these new channels of exposure and distribution.

Owner: Catarina Portas
Founded: 2014
Location: Largo do Intendente Pina Manique 23, Lisbon, Portugal

Portas channels the love of her country into a business model that supports and honors her country's handcrafts and traditional production methods.

A close-up of the charming vintage product wrappers

Ceramics are just one of the national trades on display

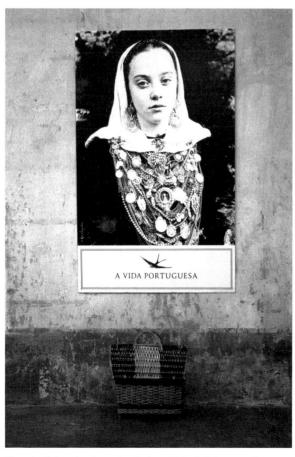

The company's elegant branding exudes a timeless and distinctly Portuguese quality

Natalie Warner, owner

From law school to cold-pressed juice connoisseur, one's career trajectory need not be linear. Melbourne natives Steve and Natalie Warner both began their professional journeys in the hyper creative city of New York. Natalie started a corporate law career but eventually realized that her heart just wasn't in it. Opting to follow her dreams instead, her new trajectory included qualifying as a yoga teacher and integrative nutrition expert. From here, she found her permanent calling exploring a holistic approach to health that addresses the mind, body, and spirit. After the pair decided it was time to change their lifestyle, they let go of old habits and searched for a fresh perspective. Hoping to share what they learned with their hometown, the duo returned to Australia in late 2013. By 2014, they opened the Greene Street Juice Co.—a juice shop that brings the taste of their New York experience to a new set of customers down under.

Now a local icon for residents of Victoria, the juice shop captures the best of New York City's juice culture. The storefront, manned by three full-time employees, intentionally stands out from the city's flourishing organic juice-press scene. Not only a standard grab-and-go juicery, the shop encourages customers to linger and add the space into their lifestyle and daily routine. Travis Walton Architecture completed the elegant yet understated store design and 21–19 developed the corresponding and straightforwardly refined branding strategy.

The former expats craft nutrient-rich, cold-pressed organic elixirs bottled in signature glass packaging. In the short time since opening, the company has developed an avid following and demand for their wellness formulas in a bottle. Capturing the attention of those looking for quality in product and design, the pair currently offers a range of twelve elixirs. Each bottle contains nutritious juice from locally sourced, 100 per cent organic vegetables and fruits, infused with herbal extracts, medicinal grade essential oils, and consciously selected superfoods. The vibrant shades of green and red juices taste as good as they look, so put away that can of soda and start drinking your vegetables.

Owners: Steve and Natalie Warner
Design: Travis Walton Architecture; *Corporate Identity:* Cassette
Founded: 2014
Location: 36 Pran Central, Prahran, VIC, Australia

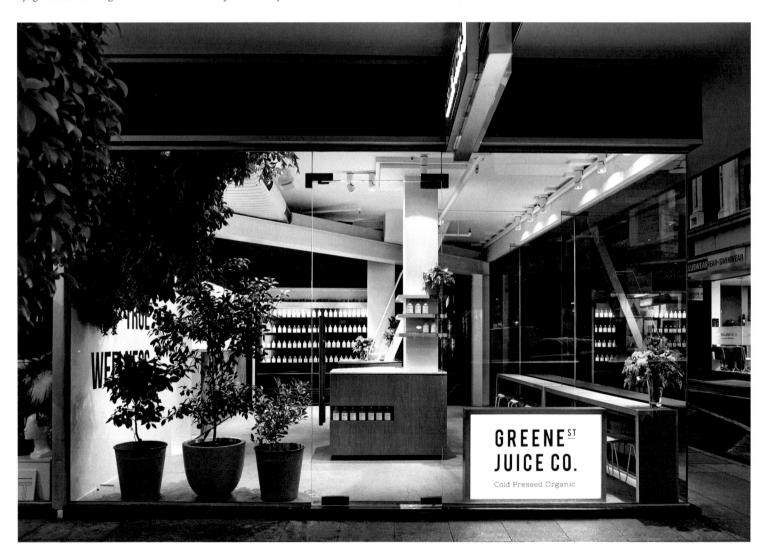

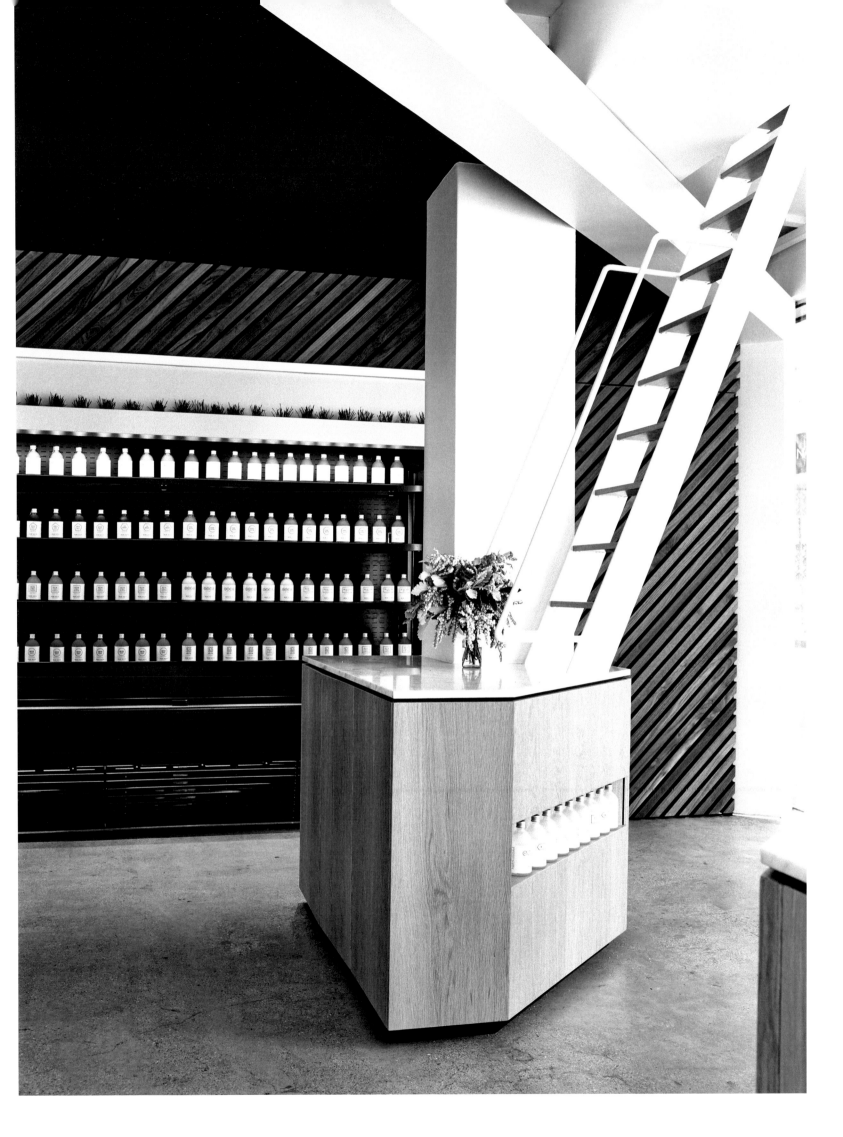

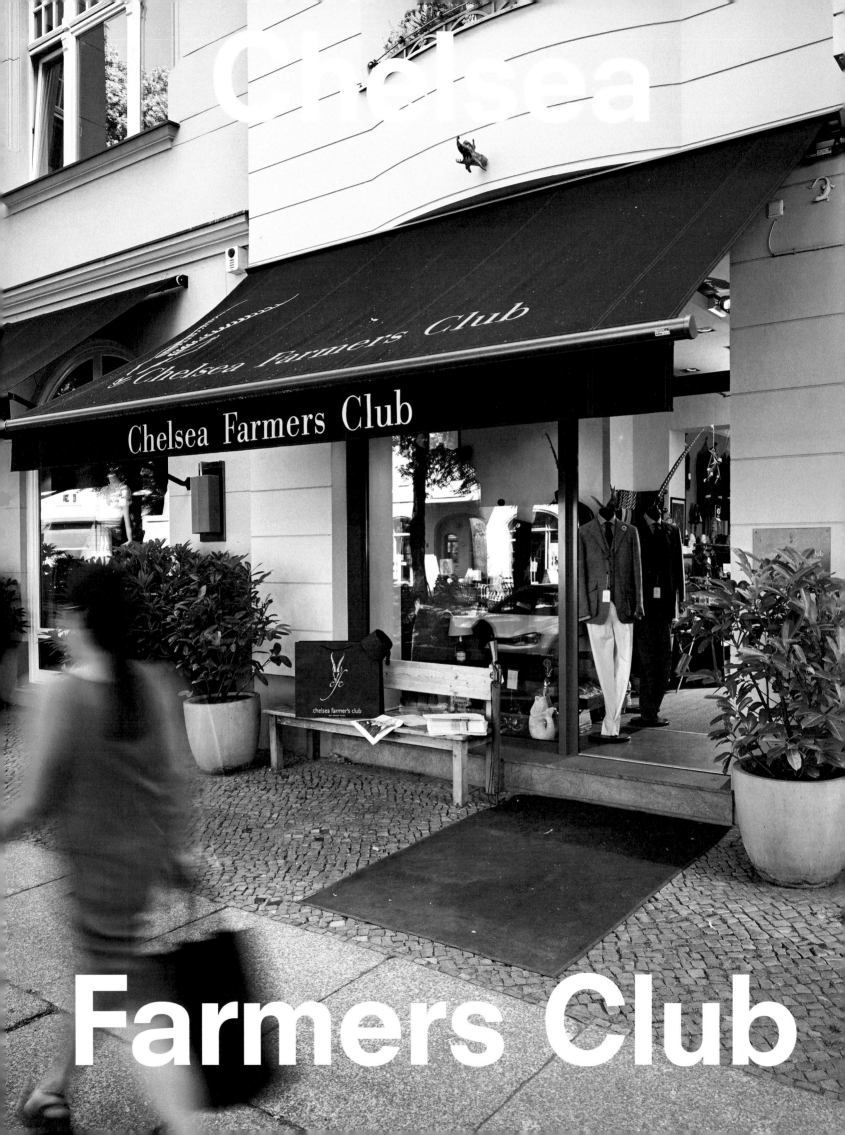

The Suited Entertainer

Christoph Tophinke is more of an entertainer than a shopkeeper

A cut above the average retailer, Berlin-based **Christoph Tophinke** supplies exceptional suits, luggage, and gin.

Christoph Tophinke is not your average storeowner. In fact, he doesn't see himself as a retailer at all. He's more of an entertainer who happens to supply Berlin with impeccably cut suits and wellington boots. When asked to describe Chelsea Farmer's Club, he muses that it's "very much a place for people who are not interested in fashion. We basically think that there are thousands of things more important in life than a jacket or some pants. Still, it's nice not to have to run around naked. If you need some decent clothes, you can get them here. If you already have everything you need, we'll find other ways to stimulate your creative energy. We run our own bar, publish our own newspaper, develop fair trade concepts, and the occasional TV show." Far from average indeed.

If you already have everything you need, we'll find other ways to stimulate your creative energy.

Christoph Tophinke's sense of humor is very much part of the store's atmosphere.

The name of the store is derived from the famed Chelsea Farmers Market off of King's Road in London, where an off-beat collection of shops and restaurants offer refuge away from the hustle and bustle of the commercial high street. Christoph spent a lot of time there: "In the beginning of the nineties I thought it was a pretty great mix of things, like our store is today." The British way of life undeniably has great influence on what you find in Christoph's store, whether it be corduroys, tweed jackets, or shaving cream. The best of Britain's long-established brands can be found there. "I think with British fashion it's always about the cut and the shape. If those are right, I'm allowed to wear colorful socks with a pinstripe suit," Christoph shares. "And also they have great weather," he adds with unmistakable British humor. Yet, fifteen years ago when Christoph was so inspired by this nook in London's Chelsea neighborhood that he secured the domain name Chelsea Farmer's Club in all its variations, he wasn't even sure how he would come to use it. And it turned out that initially it had nothing to do with a store.

At first, Chelsea Farmer's Club was the name Christoph and his friends gave to a series of black-tie parties they threw (think sophisticated debauchery on a boat, for instance.) They soon realized that many people no longer own tuxedos in Berlin and that it's a disaster to try to get one that is well tailored, even on the fancy Kurfürstendamm avenue that supplies some of the German capital's most dapper clients. "That was the moment when we had the idea to order them for about twenty people. We made a list of ten specific points describing how we wanted the tuxedos to look, and added a stick figure drawing with some arrows around it to show that they should be fitted at the waist with smaller armholes and a side slit. We sent the sketch to a manufactory in Ireland. They didn't respond, but four weeks later we received a package containing the jackets with a sign saying "Tefloncoated." It was then that I knew this was the right direction to take. The fabric is coated and therefore you can roll around on the lawn without wearing plastic. To this day I don't understand why no one else makes these. But this was all pure coincidence; I never thought the Irish company would produce something for us at all, not to mention that the cut would be so incredibly great!"

It wasn't long before Christoph decided he would open a storefront to share his design, a shop both sophisticated and welcoming with a touch of eccentricity that is recognizable as Christoph's trademark. The first store opened in 2005 and was housed in a hidden corner of Berlin's Mitte neighborhood, which was far

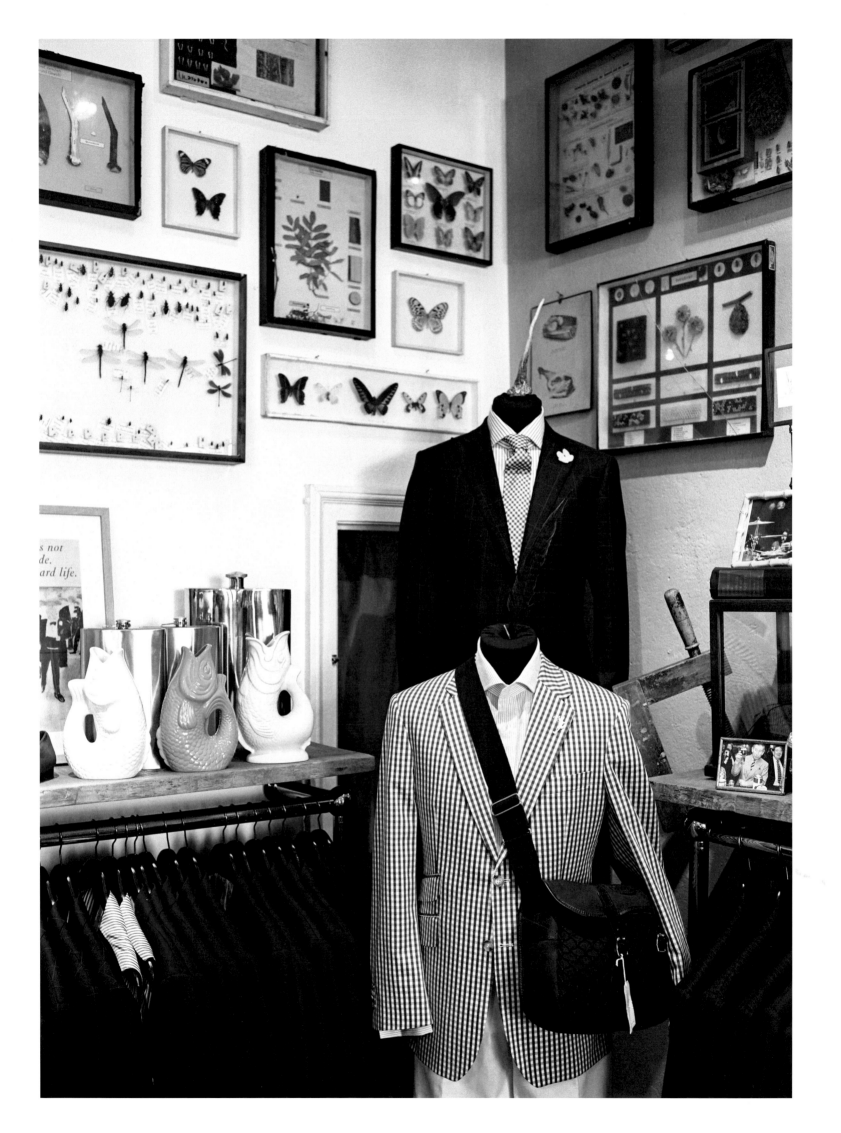

from the trendy spot it is now known to be. "We were the only store opening at ten in the morning where everyday someone wearing a suit and tie was present. For the neighbors, it was as if a UFO had landed among them. We quickly realized that the concept belonged in Charlottenburg." Customers started flocking to the shop at its new location, and through word of mouth gained a great reputation. Digital platforms helped along the way as well: "We started to take part in social media very early on. It's a perfect marketing tool for what we do. We upload a picture of a box on Facebook and after five minutes the phone rings in the store. I love that."

Christoph worked as a successful TV producer for 15 years prior to opening the Chelsea Farmer's Club shop and while one would think the two professions have very little in common, Christoph notes that "What is interesting is that the theatrical elements in television are almost the same as those in retail." Christoph is without a doubt an expert at setting the scene

The store is just the more visible part of a larger adventure that continues to include wild parties and other endeavors.

and making shop visitors feel welcome, inviting customers to help themselves to a gin and tonic from the shop's mini bar and share a laugh with the impeccably-dressed, friendly staff. "Unfortunately, you cannot touch 'things' in television. That was a major reason to start something new. The feeling of scratchy tweed is incomparable," Christoph shares in his usual tongue-in-cheek manner that he has become known for across the city of Berlin.

While Chelsea Farmers Club is indisputably a retail location, it encompasses so much more than that. The store—or kiosk, as Christoph likes to call it since "the word boutique sends cold shivers down my spine"—is just the more visible part of a larger adventure that continues to include wild parties and other endeavors, such as a newspaper with headlines like "Who's really who. And what really matters. A collection of really fine TV heroes." In a world that is brimming with great ideas, Christoph feels that limiting yourself to one field is simply quite boring, and that there is so much to be done under the umbrella of the Chelsea Farmers Club. When it comes to the actual "Club" part of the name, though, Christoph is quick to

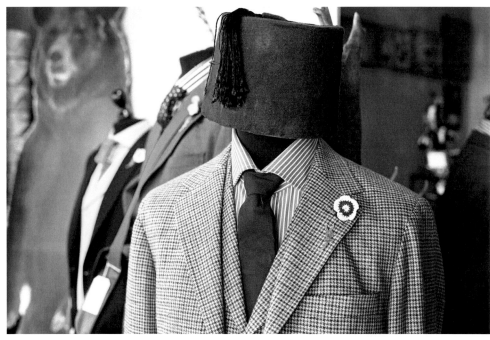

The best in long-established British brands can be found here

demystify its implied sense of exclusivity and explain that you don't need a membership to join this club—the ability not to take yourself too seriously is the only entry ticket you need.

Owner/Designer: Christoph Tophinke
Founded: 2005
Location: Schlüterstraße 50, Berlin, Germany

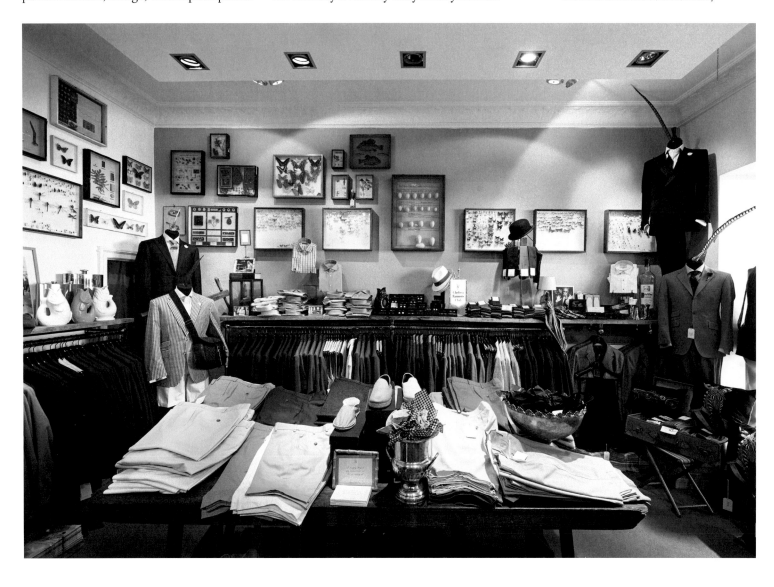

Index

The Shopkeepers

Storefront Businesses and the Future of Retail

This book was conceived, edited, and designed by Gestalten.

Edited by Robert Klanten, Sven Ehmann, and Sofia Borges
Texts by Sofia Borges and Noelia Hobeika
Preface by Sofia Borges

Cover and layout by Floyd E. Schulze
Editorial management by Silvena Ivanova
Text edited by Noelia Hobeika
Proofreading by Transparent Language Solutions

Cover photography: Chris Crisman
Back cover photography (clockwise from top right): Heritage Bicycles General Store, Marissa Cox, P.G.C. Hajenius, Walter Manning, Diego Berruecos, Bernard Touillon, Kenta Hasegawa, and Matei Plesa
Typefaces: DTL Elzevir by Gerard Daniëls and Neuzeit by Wilhelm Pischner

Printed by Offsetdruckerei Grammlich, Pliezhausen
Made in Germany

Published by Gestalten, Berlin 2015
ISBN 978-3-89955-590-5

For more information, please visit www.gestalten.com.

Bibliographic information published by the Deutsche Nationalbibliothek: The Deutsche Nationalbibliothek lists this publication in the Deutsche Nationalbibliografie; detailed bibliographic data are available online at http://dnb.d-nb.de.

This book was printed on paper certified according to the standard of FSC®.

MIX
Paper from responsible sources
FSC® C011712